AMERICAN ARTS & CRAFTS

VIRTUE IN DESIGN

AMERICAN ARTS & CRAFTS

Los Angeles County Museum of Art

in association with

Bulfinch Press/Little, Brown and Company

Boston New York Toronto London

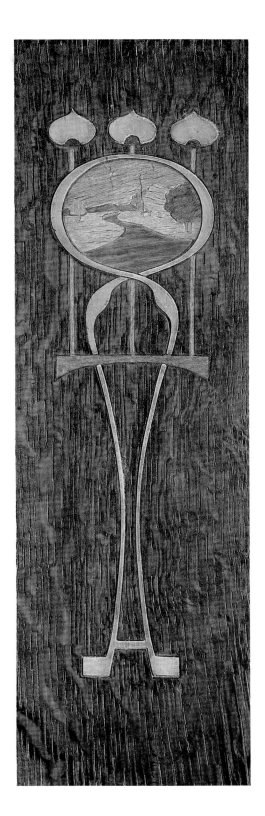

VIRTUE IN DESIGN

A Catalogue of the

Palevsky Collection

and Related Works

at the Los Angeles County

Museum of Art

■ ■

Leslie Greene Bowman

Organized by the Los Angeles County Museum of Art, the exhibition *American Arts & Crafts: Virtue in Design* will travel nationally under the auspices of the American Federation of Arts.

Published by the Los Angeles County Museum of Art, 5905 Wilshire Boulevard, Los Angeles, California 90036, in association with Bulfinch Press/Little, Brown and Company, 34 Beacon Street, Boston, Massachusetts 02108.

Bulfinch Press is an imprint and trademark of Little, Brown and Company (Inc.)
Published simultaneously in Canada by Little, Brown and Company (Canada) Limited

First Edition
Second trade paperback printing 1995

Editor: Gregory A. Dobie
Designer: Deenie Yudell
Production artist: Eileen Delson
Photographers: Peter Brenner, Barbara Lyter

Text set in Fournier by Andresen Typographics, Tucson, Arizona, and Exposition by Paul Baker Typography, Evanston, Illinois. Exposition is based on letterforms used for an inscription found at the base of a 1919 statue commemorating the 1893 World's Columbian Exposition in Chicago.

Printed in Hong Kong by Dai Nippon

Library of Congress
Cataloging-in-Publication Data

Bowman, Leslie Greene.
American arts & crafts : virtue in design / Leslie Greene Bowman : preface by Max Palevsky. — 1st ed.
p. cm.
"A catalogue of the Palevsky Collection and related works at the Los Angeles County Museum of Art."
Includes bibliographical references and index.
ISBN 0-8212-1824-7 (hardcover) —
ISBN 0-8212-1920-0 (trade paperback)
1. Arts and crafts movement—United States—Exhibitions.
2. Decorative arts—United States—History—19th century—Exhibitions.
3. Decorative arts—United States—History—20th century—Exhibitions. 4. Palevsky, Max—Art collections—Exhibitions.
5. Evans, Jodie—Art collections—Exhibitions. 6. Decorative arts—Private collections—California—Los Angeles—Exhibitions. 7. Los Angeles County Museum of Art—Exhibitions. I. Los Angeles County Museum of Art. II. Title. III. Title: American arts and crafts.
NK1141.B64 1990
745'.0973'07479494—dc20
90-38064

Photographs courtesy of:
p. 12, Henry E. Huntington Library and Art Gallery; pp. 16–17, National Portrait Gallery, London; pp. 23–24, T. & R. Annan & Sons, Glasgow; pp. 32, 35 (Stickley), D. J. Puffert; p. 38, Erie Art Museum; p. 39, Tod M. Volpe, L.A./N.Y.; p. 40, Gift of Robert and Kitty Turgeon-Rust, Roycroft Associates, East Aurora, New York; p. 41, D. J. Puffert; p. 43, Collection of Robert and Kitty Turgeon-Rust, Roycroft Associates, East Aurora, New York; p. 46, D. J. Puffert; p. 48, Greene and Greene Library, Gamble House/USC; p. 52, Don Marek (photo by David Lubbers); p. 56, Kenneth Cardwell (Maybeck), San Francisco Swedenborgian Church (church interior); p. 58, D. J. Puffert; p. 64, Collection of Robert and Kitty Turgeon-Rust, Roycroft Associates, East Aurora, New York (Hubbard), gift of the same (*The Fra*); p. 68, Don Marek (photo by David Lubbers); p. 72, Couturier Gallery, Los Angeles; p. 95, Frank Lloyd Wright Foundation; p. 101, Alice Blanchard Wise; p. 103, Clemens Friedell, Jr.; p. 104, Gorham Archives, Brown University Library; p. 106, Greene and Greene Library, Gamble House/USC; p. 113, D. J. Puffert; p. 115, Grove Park Inn, Asheville, North Carolina; p. 119, D. J. Puffert; pp. 121–22, Richard Nickel Committee, Chicago; p. 123, Oakland Museum History Department; p. 126, Collection of the Oakland Museum, Dirk van Erp Archives (photo by M. Lee Fatheree); p. 127, California College of Arts and Crafts, Oakland; p. 140, New York State College of Ceramics Archives, Alfred University; p. 146, Collection of the Newark Museum, gift of the Jordan-Volpe Gallery 1983 (photo by Armen Photographers); p. 153, Neville Thompson, Winterthur, Delaware; pp. 160, 163, University Archives, Howard-Tilton Memorial Library, Tulane University; p. 166, Couturier Gallery, Los Angeles; p. 169, Kathleen R. Postle; pp. 176, 179, Erie Art Museum; p. 186, The Temple of the People; p. 188, Wellman Family; p. 192, Everson Museum of Art, Syracuse; p. 197, Cincinnati Historical Society; p. 201, Robert Hurley and Joan Hurley O'Brien; p. 202, Cincinnati Historical Society; p. 204, Chicago Historical Society (photo supplied by the Museum of Fine Arts, Boston); p. 208, Rochester Institute of Technology; p. 213, Couturier Gallery, Los Angeles; p. 218, D. J. Puffert; p. 220, Robert Koch (Favrile), D. J. Puffert (Wright); p. 222, Frank Lloyd Wright Foundation; p. 226, Mary Tonetti Dorra.

Photographs not included in this list are the property of the Los Angeles County Museum of Art or are in the public domain.

Front cover:
Greene and Greene
Living Room Armchair from the Robert R. Blacker House, Pasadena, 1907 (detail)
Cat. no. 16

Back cover:
Rookwood Pottery
Vase, 1920
Cat. no. 212

Title page:
Gustav Stickley's Craftsman Workshops
Settle, 1903 (detail)
Cat. no. 53

Los Angeles County Museum of Art
September 23, 1990–January 6, 1991

CONTENTS

FOREWORD

The American arts and crafts movement was a crucial link between Victorian historicism and twentieth-century modernism. The decorative arts preceding it were labeled the minor arts; those that came after were incorporated into the field of design. The movement first flowered in late nineteenth-century England but took on a distinctively American character when transplanted to the United States in the 1890s.

American Arts & Crafts: Virtue in Design celebrates the donation of one of the premier private collections of arts and crafts objects in the country, that of Max Palevsky and Jodie Evans. It includes more than two hundred artworks by the period's most gifted architects and craftsmen. Including furniture, metalwork, ceramics, glass, books, drawings, and textiles, it is further distinguished by a special emphasis on California artisans.

Due to the altruism of Max Palevsky and Jodie Evans, the collection has doubled in size since they decided their assemblage should become a museum collection. Their unwavering commitment and discriminating connoisseurship are richly reflected in the following pages. The Los Angeles County Museum of Art is pleased to have been selected as the recipient institution for this outstanding and comprehensive grouping.

The exhibition and accompanying catalogue are the result of six years of work by Leslie Greene Bowman, curator of decorative arts for the museum. Since 1984 she has assisted in the development of the collection with Max Palevsky. Our thanks go to her for her longstanding dedication to this project.

I am especially pleased to acknowledge this collection as the inaugural gift honoring the twenty-fifth anniversary of the museum's founding. The extraordinary growth of the institution in the last two and a half decades has resulted from gifts of precisely this nature, collections that have added new dimensions and national distinction to our holdings.

EARL A. POWELL III
Director

PREFACE

I grew up in the age where "modern" was defined as the International Style. Characterized by the works of Mies van der Rohe, Saarinen, and Breuer, modern design was severe and simple, with lots of chrome and high seriousness. In the early 1970s I started to notice pieces of American arts and crafts furniture. Made of quarter-sawn oak instead of chrome, they shared, I saw, the same sense of austere simplicity. The thirty or so years that separate the arts and crafts and International Style movements in the United States represent not only a change in furniture technology but also in outlook. Those thirty years altered the insular, inward-looking attitude of American society (and art) and moved the country, with some resistance, into an international role (and into the avant-garde). After acknowledging the crucial influence of the English arts and crafts movement, American arts and crafts designs are, perhaps, the closest embodiment we have of the "American style." This is the style of that idealized country that politicians often recall—simple, honest, laconic, quaint, and sometimes movingly beautiful.

The quaintness of the furniture (the ceramics and stained glass are rarely quaint) seems to stem from the straightforward, sometimes exaggerated manner in which each object's method of construction is exposed. There are no hidden seams or bracings, no attempts to disguise either the materials employed or the manner in which they are held together. Tenons and dowels are lovingly detailed; butterfly joints are often enlarged and, in the process, beautified. Unlike European period furniture, with its endless cunning and artifice, American arts and crafts objects are honest. This honesty is no mere accident: the arts and crafts movement started as a powerful ideology.

The arts and crafts movement began in England as a reaction to the transformation of an essentially agrarian society into an industrial one. As early as 1804 William Blake was speaking of the "dark satanic mills"; Dickens would later describe the impoverished workers and their gloomy slums. John Ruskin and William Morris continued the commentary, equating society's ills with industrialization and a return to craft as a return to a sane and balanced order. It is this underlying philosophy that imbues the arts and crafts object with a forthright character.

Ruskin and Morris preached an idealized vision of the Middle Ages as a model for imitation. Exemplified by the works of Morris and Company, this new style was a mix of simplicity and the Gothic. In comparison, arts and crafts in the United States had a stricter image—more Calvinistic than High Church. Best illustrated by the works of the various Stickley brothers, this more sober approach explains the American movement's visual relationship to modern design. American arts and crafts did have occasional Gothic touches, as in

the furniture of Charles Rohlfs and the pottery of the "wizard of Biloxi," George Ohr, who began his career as a demented potter and ended it as a Cadillac dealer.

For all of these reasons I began collecting American arts and crafts pieces in the early 1970s. In 1984 I determined that my collection should become a museum collection. Since that time I have had the invaluable assistance of Leslie Bowman, curator of the Decorative Arts Department of the Los Angeles County Museum of Art. My first interest, as I have explained, was in the rather severe furniture forms of the period. Leslie broadened that interest to include more decorative pieces and further introduced me to the enormous range and beauty of arts and crafts ceramics. Without her expert advice this collection in its present state could never have been formed.

Because the English genesis of the movement was crucial to my understanding and appreciation of American arts and crafts, I acquired selected English pieces to facilitate that necessary comparison and contrast. Artworks from Glasgow and Vienna illustrate the further elaboration of English arts and crafts ideology, elaborations that in turn produced American responses. But irrespective of place, arts and crafts objects, aside from their aesthetic pleasures, allow us to glimpse the intensely human and deeply experienced reaction to a revolution that still seems beyond human control.

MAX PALEVSKY

ACKNOWLEDGMENTS

I met Max Palevsky in 1984 when he first approached the Los Angeles County Museum of Art about donating his arts and crafts collection. I am deeply indebted to Max and his wife, Jodie Evans, for allowing me to participate in the shaping of that collection. Both the exhibition and its accompanying catalogue are a tribute to their shared vision, connoisseurship, and generosity.

Many individuals at the museum assisted with this project. I am especially grateful to the director, Dr. Earl A. Powell III, and to the Board of Trustees for providing such enthusiastic encouragement, advice, and support.

The staff of the museum's Decorative Arts Department deserves considerable recognition. Judy Mowinckel expertly orchestrated the cataloging and management of the collection, in addition to providing tireless research assistance. Preliminary cataloging was done by Martha Lynn, who also helped investigate the European objects. Jeanette Hanisee deserves an award for her expertise in locating many elusive statistics and facts. Research intern Ruth Penka provided invaluable assistance with the California art potteries. Her exhaustive findings have since been submitted as a master's thesis at the University of California, Riverside. Former department heads Timothy Schroder and Peter Fusco warrant special mention for their abiding support and advice. Departmental secretaries Susan Lindner and Sandra Ley cheerfully and competently kept the office running smoothly while everyone else was working on the exhibition and catalogue. Special thanks go to the many volunteers who aided with research and collection information management, including Marilyn Gross, Mary Maag, Ben Rinaldo, and Barry Shifman.

It is my belief that editors should be credited on the title page with authors. No editor is more deserving of such recognition than Gregory A. Dobie. I am also grateful to managing editor Mitch Tuchman for his support and guidance throughout the project.

For designing a book worthy of these wonderful objects, I thank Deenie Yudell. The stunning photography is due to the patience and creativity of Peter Brenner and Barbara Lyter. (Both D. J. Puffert and David Reneric provided period rugs, books, and accessories for use in the photographs.) The conservation staff, including Adam Avila, Sharon Blank, Victoria Blyth-Hill, Maureen Cassley, Steven Cristin-Poucher, John Gebhart, Catherine McLean, Pieter Meyers, Andrea Morse, Joanne Page, Stephanie Petty, Marie Svoboda, Shirley Thomas, John Twilley, and Rosanna Zubiate, deserve recognition for expediting the treatment and cleaning of the objects in time to coordinate with photography. Furniture conservators Don Menveg and Neil Rhodes warrant special thanks for skillfully and amiably tackling the largest portion of the collection's conservation tasks. Two out-of-house conservators, Johannes van

den Brink and Tony Wuichet, deserve acknowledgment for their furniture and upholstery treatments.

I also extend my gratitude to Carl Baker, Anne Diederick, Eleanor Hartman, Larry Margolies, Grant Rusk, Nancy Sutherland, and all the members of the library staff for ordering interlibrary loans and helping to guide the research. Thanks also go to the members of the registrar's office, Cynthia Burton, David Cline, Cory Gooch, Chandra King, June Li, and Renee Montgomery, for facilitating the transportation of the objects. For expert handling and installation I thank Roma Allison, Paul Hernandez, Gloria Hills, Mee Mee Leong, Mary Loughlin, Arthur Owens, Bill Stahl, Michael Tryon, Willie Williams, and their staffs. For designing the exhibition with sensitivity and eloquence, I am grateful to Bernard Kester.

Without the pioneering research of Timothy Andersen, Robert Blasberg, Robert Judson Clark, Martin Eidelberg, Paul Evans, Wendy Kaplan, Randell Makinson, Eudorah Moore, and Robert Winter, this catalogue would have been a daunting undertaking. I also owe gratitude to the scores of experts who patiently fielded questions and assisted me in refining my ideas. These include the following colleagues in museums, universities, libraries, and other institutions: Catherine Zusy, Bennington Museum; Annette Carruthers, Cheltenham Art Gallery and Museums; Anita Ellis, Cincinnati Museum of Art; John Vanco, Erie Art Museum; Richard Fyffe, Essex Institute; Emerson Shaw, Forbes Mill Museum; Simon Cottle, Glasgow Museums and Art Galleries; Dr. Klaus Wolbert, Mathildenhöhe, Darmstadt; Alice Cooney Frelinghuysen, Morrison H. Heckscher, and Craig Miller, Metropolitan Museum of Art; Sharon Darling, Motorola Museum; Thomas Michie and Christopher Monkhouse, Museum of Art, Rhode Island School of Design; Ned Cooke, Museum of Fine Arts, Boston; Judith Prendergast, National Portrait Gallery, London; Ulysses Dietz, Newark Museum; Kenneth Trapp, Oakland Museum; Dr. Christian Witt-Dörring, Oesterreichisches Museum für Angewandte Kunst; Christian G. Carron, Public Museum of Grand Rapids; Stella Beddoe, Royal Pavilion Art Gallery and Museums, Brighton; Arda Haenszel, San Bernardino County Museum Association; Patricia Moore, Santa Catalina Island Museum; Norma Sindelar, St. Louis Art Museum; Richard Edgecumbe, Simon Jervis, Clive Wainwright, and Christopher Wilk, Victoria and Albert Museum; Bert and Ellen Denker, Cheryl Robertson, and Neville Thompson, Winterthur Museum; Richard Kavesh, Alfred University; Robert Winter, Occidental College; Robert Judson Clark, Princeton University; Martin Eidelberg, Rutgers University; Jessie Poesch, Tulane University; and Juliet Kinchin, University of Glasgow; Joe Fuchs, Brand Library; Sarah Addison, Virginia Martin, and Phyllis Worl, Cambridge City Public Library; Barbara Boyd, Glendale Public Library; Gordon Olson, Grand Rapids Public Library; Linda Poe and Robert Sherer, Howard-Tilton Library, Tulane University; Beryl Manne, John M. Olin Library, Washington University; Victor Dyer, Marblehead Library; Bill Sturm, Oakland Library; Carolyn Garner, Pasadena Public Library; Ronald Baker, Riverside Public Library; Linda Allard and Linda Belford, University City Public Library; and staff members of the A. K. Smiley Public Library, Corona Public Library, Gamble House Library, Getty Archives, Huntington Library, and Lake Elsinore Public Library; Tim Samuelson, Commission on Chicago Landmarks; John O'Hearn, Darwin Martin House; Cindy Swanson, General Federation of Women's Clubs; Virginia Kazor, Hollyhock House; Betty Hunt, Marblehead Historical Society; Virginia Smith, Massachusetts Historical Society; Theresa Hanley, Mission Inn Foundation; Carol Kelm, Oak Park and Lake Forest Historical Society; Jonathan Kinghorn, Pollok House, Glasgow; Pamela Young, Rancho Los Alamitos Founda-

tion; Karen Mangelsdorf, San Diego Historical Society; Mark Hall-Patton, San Luis Obispo Historical Society; Crombie Taylor, Van Allen Foundation; and staff members of the Dedham Historical Society.

The following individuals proved to be equally invaluable: Mr. and Mrs. Allan Adler, Mrs. Scott Allen, Jimmy Bakker, Dr. Francis Ballard, Alan Batchelder, Daisy and Daniel Belin, Linda Hubbard Brady, Betty Brown, Charles Carpenter, Garth Clark, Theodore C. Coleman, Nancy and Robert Daly, Dr. Donald Davidoff, Colonel and Mrs. Paul Deems, Mrs. Henri Tonetti Dorra, Lynn Downey, Robert Edwards, John Eifler, Delleen Enge, Paul Evans, Patricia M. Fletcher, Clemens Friedell, Jr., David Geffen, Stephen Gray, Dr. Howard Hammond, David Hanks, Dr. Robert Hilpert, Samuel Hough, Robert A. and Betty Hut, William Iselan, Diana Ives, Michael James, Bruce Johnson, Rae Johnson, Lois Alexander Kelley, Mr. and Mrs. Mortimer Kline, Patricia Lester, Elaine Levin, Joven Lombardo, Boice Lydell, Susan and Robert F. Maguire III, Don Marek, Phyllis and Larry Margolies, Jim and Janeen Marrin, James H. McCarthy, Thomas McGlynn, Jr., Duncan McNeill, Forrest Merrill, Irving Mills, Warren Moffett, Joy Morrell, Edgar Morse, Mr. and Mrs. Roger Moss, Pam O'Connor, David Ogle, Doug Pinnell, Kathleen Postle, Graham Powell, Mrs. Julius Randahl, Jr., Carlyn Ring, Ron Roell, Mr. H. E. Rose, Robert Rust, Scott Schaefer, Jim Shepard, Elsa Shoemaker, Eleanor Shumway, Duncan Simpson, Laurence and Terry Sterling, Mrs. Joseph Tonetti, Kitty Turgeon, Susan Turley-Moore, Mrs. Harold Ullman, Martin Weil, Peg Weiss, Helen Wellman, Mark and Jill Wilcox, Mr. and Mrs. Lewis Wise, and Bill Wyatt.

I would also like to thank the dealers and auction specialists who aided in the search for special pieces. Particular recognition goes to D. J. Puffert for not only finding elusive artworks but also sharing so generously of his own archives, collections, expertise, and research contacts. Nancy McClelland deserves mention for her long association and assistance with this project. Others deserving of notice include Bryce Bannatyne, Jr., Roger Billcliffe, Beth Cathers, Darrel Couturier, Stuart Feld, George Levy, Don Magner, Marilee Meyer, Jack Meyer, Jack Moore, David Rago, Robert Schmid, Tod Volpe, Mike Weller, and Michael Whiteway. And finally I wish to thank my family and friends, who so generously permitted me to steal time away from them for this projec T.

LESLIE GREENE BOWMAN

There has been of late a noteworthy change in the estimation in which art and artistic matters are held. The standard of taste has advanced, and the art producers have risen to meet the new demands....

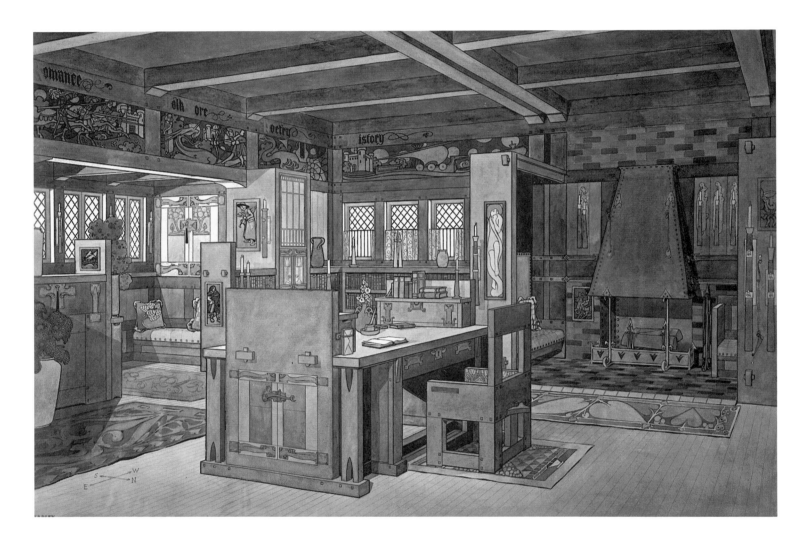

Nowhere is the gain more apparent than in the field of what we term, in a somewhat too explanatory way, the applied arts. The expression itself is less in vogue than it was, and it has become apparent that art is the same whether expressed in a picture, in architecture, or in a piece of pottery. It is no more applied in the one case than in others.

—*The House Beautiful*, March 1899

INTRODUCTION

As the nineteenth century drew to a close, a quiet revolution protested the mechanized replacement of craft. In an unprecedented show of artistic solidarity major art movements in England, Scotland, Austria, Germany, Belgium, France, Italy, and the United States focused on the decorative arts. Not before or since have the minor arts enjoyed such universal cultural acclaim. Apart from any of its social concerns the arts and crafts movement initiated a new paradigm in Western art history, redefining craft as art and craftsmen as artists. Although caste systems still exist in art history, the admission of the decorative arts into the hieratic realm of the fine arts was a monumental achievement.

Drawing of library by Will Bradley, 1901

By 1875 the world was dramatically "smaller" than in 1775, seemingly reduced in size due to advances in communication, education, and transportation. A coppersmith in upstate New York could copy motifs from a Glasgow tearoom, a Cincinnati housewife could expand upon the techniques of French ceramic painting, and a woodworker from Buffalo could exhibit his furniture in Turin. Americans no longer waited three months for ships to arrive from London nor were they solely reliant on England for cultural tutoring. England certainly provided primary inspiration for the American arts and crafts movement, but Glaswegian, Viennese, and French infusions shaped its character and contributed to its multiple manifestations. America's size ensured regional variations, but even these could be contradictory. Within the state of New York, for example, interpretations as diverse as those of Louis Comfort Tiffany and Gustav Stickley flourished. The challenge and satisfaction for today's observer lies in recognizing this diversity, discerning a common denominator, and recognizing how social and economic realities shaped the products of the movement.

The collection presented here offers a rich array of objects that invite exploration and engagement on any number of levels quite apart from mere admiration. How did a Boston potter create a bowl so utterly native to the California desert while working for a massive clay-mining plant? How did the tradesman son of a German stonemason arrive at modern design while focused on preindustrial concepts and examples? How did a Grand Rapids furniture maker persuade middle-class consumers to buy "handcrafted" goods for their homes, goods that were mass-produced by an assembly line of men and machines?

Such ironies of the American arts and crafts movement are as intriguing as the objects themselves. The movement was a complex entity, like the organic design it promoted, and defining its nature is difficult. Nevertheless, definition is essential to this study, if only to nullify the platitudes that label the movement as merely an opposition to machinery or a desire for handmade goods.

The American arts and crafts object can be defined as one produced in the late nineteenth century or early twentieth century whose conception and character resulted from its maker's awareness of some or all of the following tenets: the art value of everyday objects; hand-craftsmanship; quality construction; solid, straightforward materials; design dedicated to function and environmental harmony; ornament derived from nature and subordinated to form and function; and the therapeutic influence of beauty and creativity in society. Few adjectives can be applied to all works. One cannot state that American arts and crafts objects *must* be simple, sturdy, and handcrafted, only that their appearance results from the maker's consciousness of and response to certain of these lofty ideals.

Indeed the second essay in this book portrays the American movement as a phenomenon characterized by unexceptional craftsmanship and few traditional artists. One might then reasonably ask why an art museum would go to the trouble of collecting, exhibiting, and publishing ostensibly mediocre works. The answer is twofold, with the first part lying in the field of ceramics.

Much of the movement's workmanship was serviceable but undistinguished. Isolated, virtuoso examples by Gorham, Greene and Greene, and others attested to the movement's possibilities, but in most mediums craftsmanship rarely equaled preindustrial standards. In contrast, American ceramists collectively extended the boundaries of their medium far beyond Western preindustrial limits. Their study of and experimentation with glaze formulas and firing processes enabled them to begin codifying the secrets of the fire into reliable scientific methods, dramatically increasing artistic control. An enormous competitive gulf with the Europeans was closed in a matter of decades.

The second part of the answer lies in design. Ironically when English arts and crafts proponents crusaded for equality between the decorative and fine arts on the basis of crafts-manship, they unwittingly established the dominance of design over craft. The acceptance of common objects as art rested on visual appeal, not process, a criterion that aided style in gaining precedence over workmanship. The best arts and crafts objects pass muster as artworks because of their superior design, illustrating a unity of form and function that celebrates both the nature of the materials and the concept of construction as decoration. Such philosophies were revolutionary in the decorative arts, and their effects are still percep-tible almost one hundred years later.

The collection documented here results from the desire of Max Palevsky to expand and develop his personal holdings into a comprehensive assemblage for the Los Angeles County Museum of Art. This publication and the corresponding exhibition celebrate his gift to the museum. It is a tribute to Max Palevsky and his wife, Jodie Evans, that they have encouraged the inclusion of everything owned by the museum from the American arts and crafts move-ment, making this a comprehensive permanent collection catalogue of objects from the period. Neither the collection nor the catalogue attempts to detail the history of the move-ment; rather they purport to present the movement's finest expressions. Because of the museum's location in California special emphasis has been placed on artworks from this state. European objects are included to enhance the understanding of the American works and are discussed in the first essay. This essay does not try to summarize the history of the arts and crafts period in Europe; instead it seeks to acquaint the reader with the intellectual leaders and major centers that informed America's unique response.

This volume is organized to facilitate reference use and is first divided by medium and then alphabetized by manufacturer or artist. In cases where this has separated works made by the same firm in different mediums, section guides enable the reader to locate these examples. When an artist worked in one medium for several companies (like Frederick H. Rhead), the firms are ordered chronologically under the artist's name (by date of the artist's tenure). Common usage or marks determine placement. Hence Gustav Stickley's furniture is found under his name, not under Craftsman Workshops, and Teco pottery is listed in the T's, not under Gates Potteries. Whenever possible period terms or titles are used for the objects. Provenance is always elusive with the decorative arts, and the middle-class nature of many of these works compounds the problem. Where original ownership is known or attributed, it is indicated in the entry. The appendix of marks includes all artist markings that are capable of being photographed and reproduced.

The arts and crafts movement was a reformist phenomenon, concerned with the saving of society through art, especially the decorative arts. This quixotic dimension contributes further to the undeniable romantic appeal of arts and crafts objects. Despite the movement's brief tenure and unfulfilled ideals, its story remains relevant to the study of art, machinery, and design in our society. A century later, its impact is still palpable.

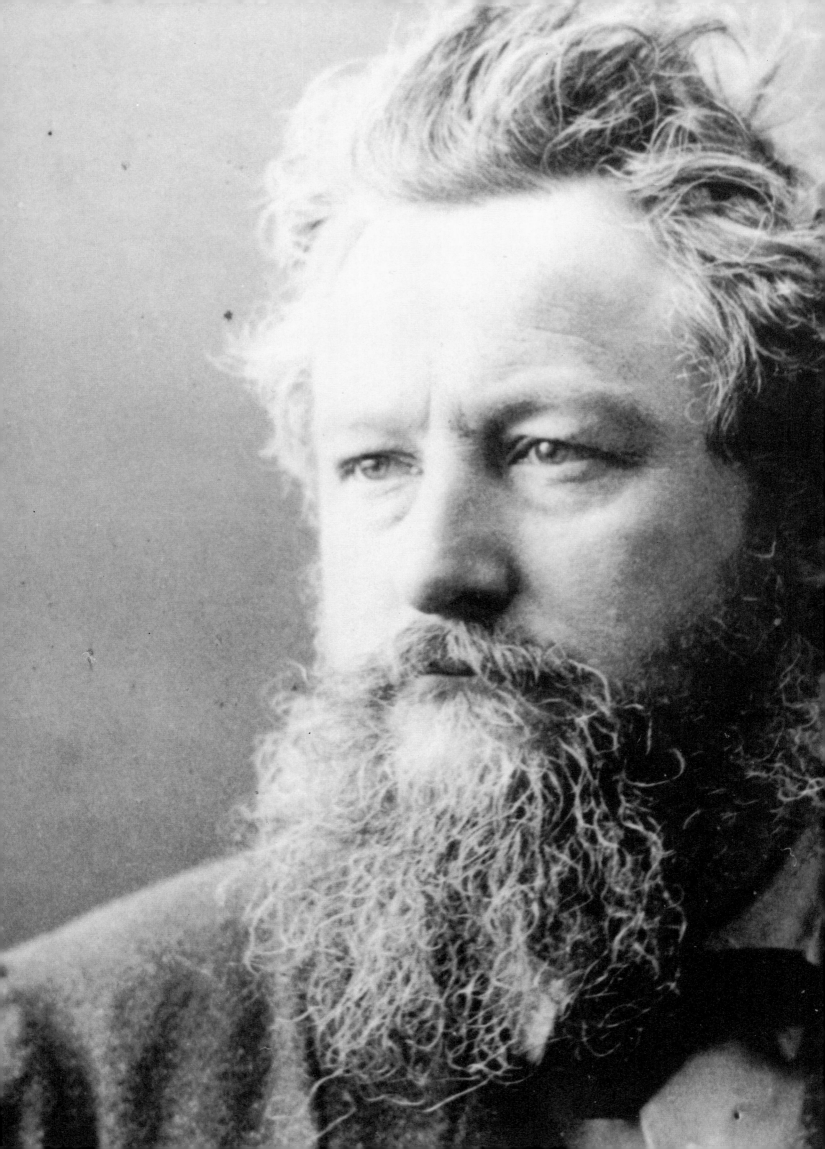

SeTTing the sTage: Europe

John Ruskin, c. 1885

William Morris, c. 1880

The arts and crafts movement began in Europe in the late nineteenth century. As industrialization threatened time-honored craft techniques with extinction, men of arts and letters throughout Europe elevated the minor arts into the realm of the fine arts. For some this was purely an aesthetic necessity; for others it symbolized the salvation of society. Although expressed differently in England than in Scotland, Austria than in France, Germany than in Italy, the movement shared similar philosophies and produced works with common characteristics.

The effort began in the birthplace of industrialization, England. English anxiety about mechanization was discernible in the 1830s in the writings of A. W. N. Pugin (England, 1812–52). He condemned the corruption of Victorian society and saw in the simple, functional design of Gothic structures evidence of a purer world. His thoughts started a chain reaction: Peter Stansky cites the "intellectual pedigree that runs from Pugin to Carlyle and Ruskin and then to William Morris."[1] In England more than anywhere else the phenomenon was inextricably linked to social and political reform.

John Ruskin (England, 1819–1900) codified the anti-industrialist philosophy of the movement, placing the ills of society firmly at the door of the factory system. As Oxford University's first art history professor, he was articulate and influential. He blamed mechanization and its division of labor for subverting workers' participation in the creative process, thereby reducing them to the level of mindless tools in a production line. Censuring the products of machinery as monotonous, uninspiring goods that disassociated their users from contact with human creativity, Ruskin crusaded for hand labor as an essential human right that preserved dignity and inventiveness in society. He suggested that the designer and craftsman should be reunited in a single individual, that "the workman ought often to be thinking, and the thinker often to be working."[2]

Ruskin was equally vehement on matters of style. He praised craft as art whose form had evolved from function, materials, and the skills of the craftsman. He accepted ornament only insofar as it affirmed the nature of the host elements and asserted natural inspiration. Like Pugin he admired Gothic architecture and condemned the subsequent neoclassical imposition of order and symmetry as artificial violations.

Ruskin saw the medieval era as the golden age of guild labor and true organic art that took its form from inherent needs. In 1871 he founded the first of the period's utopian communities, the Guild of St. George, to restore a preindustrial life-style of handcraft and joy in labor. Other communities and exhibition societies followed; the movement took its name from one such group, the Arts and Crafts Exhibition Society of London (established in 1888).

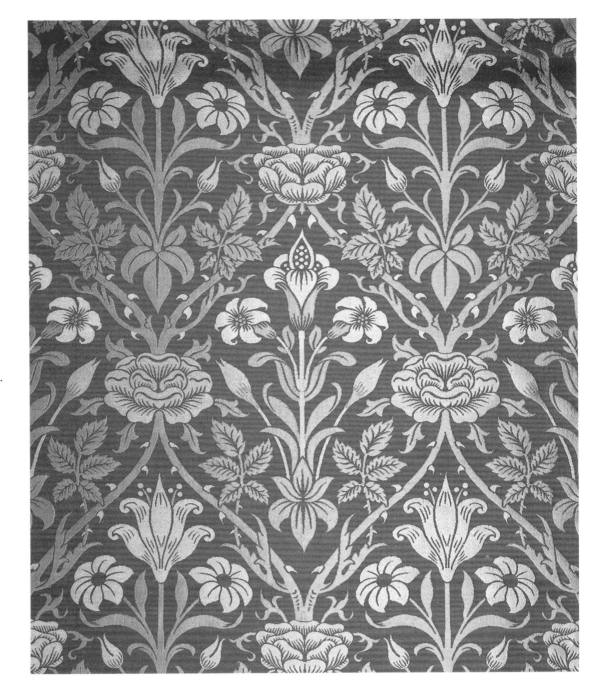

MORRIS AND COMPANY
1861–present
London and Merton Abbey,
England

.......................................

1

Rose and Lily Woven Textile,
1893

Designed by John Henry Dearle
(England, 1860–1932)
Compound wool and silk twill
144 x 27 in.
(365.8 x 68.6 cm)
62.29.3
Gift of Dr. Robert Hilpert

William Morris (England, 1834–96) strove to translate Ruskin's theories into reality and, in doing so, became the scion of the movement in both England and America. Inspired by Ruskin, Morris abandoned his plans to become a minister and devoted himself to the cause of craft and social reform. Morris, Marshall, Faulkner and Company (later Morris and Company), founded in 1861, employed craftsmen and artists to produce all manner of decorative arts, ranging from furniture, glass, ceramics, and metalwork to textiles and embroidery. While Morris included painters in his firm, he specialized in the decorative arts, the crafts threatened most by mechanization.

The Rose and Lily jacquard textile (cat. no. 1) was designed in 1893 by Morris's brilliant protégé, John Henry Dearle (England, 1860–1932). The design was based on a seventeenth-century Italian brocaded silk, but Dearle simplified it and substituted roses for the less-naturalistic crowns.[3] Morris had moved his textile workshops in 1881 to the site of an old silk-weaving mill at Merton Abbey, an ideal arts and crafts setting of assorted old buildings among willows and poplars on the River Wandle. This satisfied Ruskin's prescription for

pleasant and inspiring surroundings for workers. Morris eschewed chemical dyes and mechanized printing; his textiles were vegetable dyed and either hand printed or woven.

For Morris the loss of crafts not only threatened the dignity of the worker, it endangered the welfare of society. One of the major social effects of industrialization was the separation of home and workplace. In a rapidly urbanizing world the home took on a protective role for its occupants, sheltering them from the coal-fired urban landscape blighted by disease, poverty, and sewage and rife with crime and immorality. The home was seen as an inner sanctum for the preservation of beauty, religion, and morality. Art was deemed an essential domestic element, the inspirational evidence of human creativity in the service of beauty, a higher goal than monetary gain. In the homes of the middle and lower classes the service of art was provided by craft.

The aesthetic movement had already laid the groundwork for the redefinition of craft as art.[4] Morris invested it with an ethical as well as aesthetic justification: "So I say our furniture should be good citizen's furniture, solid and wellmade and workmanlike and in design should have nothing about it that is not easily defensible, no monstrosities or extravagances."[5] Through his writings and example Morris became the titan on whose shoulders a younger generation stood.[6]

In England that younger generation included C. F. A. Voysey (England, 1857–1941), C. R. Ashbee (England, 1863–1942), A. H. Mackmurdo (England, 1851–1941), M. H. Baillie Scott (Scotland, 1865–1945), and many others.[7] Collectively these reformers promulgated the tenets of the movement. Their criteria extended beyond objects to architecture and interiors, expressing a desire for harmony between a space and its furnishings. It was believed by extension that a structure's simple attributes would engender honest and sincere characteristics in its occupants, while discordant, fragmented design was by definition injurious.

These criteria did not dictate a particular style, but Ruskin's emphasis on organic design and preference for medieval examples established a rustic tone both in England and America. The Voysey sideboard (cat. no. 2), for instance, evokes associations with cottages and farm dwellings, not palaces or Georgian town houses. Voysey was an architect who integrated furnishings with interiors and oriented both to the arts and crafts idea of fitness for purpose. The son of a parson, he was intensely spiritual in his commitment to honest design.[8] The sideboard's aesthetic appeal lies in its proportions and materials, not in the addition of ornament. The oak is solid and unstained, a contrast with Victorian veneers and marquetry, which were spurned by arts and crafts proponents because they masked underlying materials and frequently hid shoddy construction. The decoration lies in the grain of the wood, the artistry of the hinges and heart-shaped escutcheons (which Voysey preferred unpolished), the gentle curves of the rails, the attenuation of the round posts, and the horizontal disks that cap the posts, resolving the vertical movement and containing the piece in a rectilinear spatial field. Voysey designed the piece for A. M. M. Stedman's home, Hurtmore (later called New Place), Surrey, and also had one made for his own dining room.[9]

American arts and crafts furniture was particularly influenced by Voysey and his vernacular style. His countryman C. R. Ashbee had a greater effect on American metalwork and, as a frequent visitor to the United States, did much to spread English arts and crafts philosophies and guild practices.[10] A follower of Morris, Ashbee devoted himself to social reform through craft while he was an architecture student in London. He resided in the pioneering settlement house, Toynbee Hall, where he taught art and read from Ruskin to some of London's poorest

residents. He galvanized his working-class students into forming the Guild of Handicraft in 1888, which produced furniture, metalwork, and books. Numerous American societies and communities, utopian experiments uniting craft and commerce, were founded on the example of Ashbee's guild. Some, like Hull House in Chicago, sought to improve the lives of immigrants and laborers. Others, such as Roycroft, were distinctly profit-making enterprises.

The Guild's covered bowl and spoon (cat. no. 3a–b), whose design is attributed to Ashbee, is notable for its compelling union of form, function, and ornament.[11] Like the Voysey sideboard it features simple decoration, contrasting smooth lines and surfaces with the highly chased and ornamented character of contemporary silver. The attenuated handles assert an organic vitality integral to the bowl's design. Ashbee's use of semiprecious stones

CHARLES FRANCIS
ANNESLEY VOYSEY
England, 1857–1941
London
......................................
2

*Sideboard from Hurtmore,
Surrey,* 1897

Probably executed by Frederick
Coote, London (1878–1906) or
Fredrig Christen Nielsen,
London (1897–1911)
Hardware manufactured by
Thomas Elsley and Company,
Limited, London (c. 1900–c. 1933)
Oak with brass hardware
59⅜ x 54 x 24⅝ in.
(150.8 x 137.2 x 62.5 cm)
L.87.14.3
Collection of Max Palevsky
and Jodie Evans

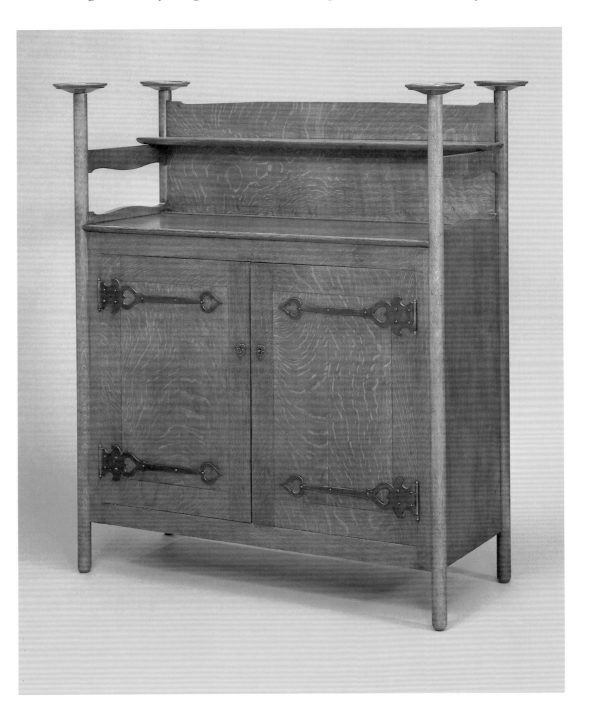

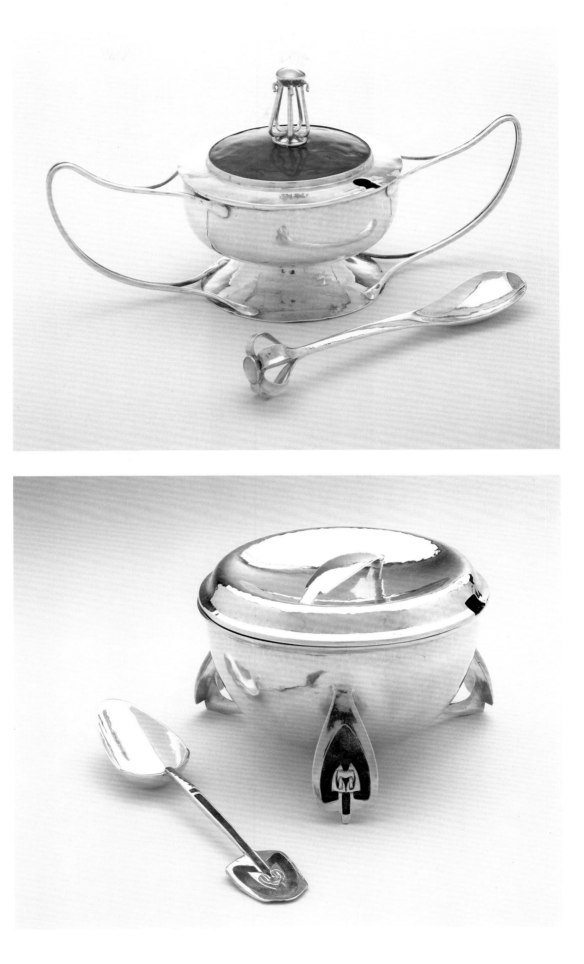

GUILD OF HANDICRAFT
1888–1907
London and Chipping Camden,
England
..
3a–b

Covered Bowl and Spoon, 1903

Design attributed to Charles
Robert Ashbee (England,
1863–1942)
Silver, enamel, and mother-of-
pearl
Bowl: 4⅛ x 9⅜ x 4⅜ (diam.) in.
(10.5 x 23.8 x 11.1 cm)
Spoon: 6⅛ x 1³⁄₁₆ x 1 in.
(15.6 x 3.0 x 2.5 cm)
Marks: near rim of bowl, on
flange of lid, and on back of
spoon, struck G. OF H LTD. in rec-
tangular surround, lion passant
in shaped surround, date letter H
in shaped surround, and leop-
ard's head in shield-shaped sur-
round; pieces assayed in London
L.88.30.42a–c
Collection of Max Palevsky
and Jodie Evans

LIBERTY AND COMPANY
1875–present
London
..
4a–b

Covered Bowl and Spoon, 1903

Designed by Archibald Knox
(Isle of Man, 1864–1933, active
England)
Silver and enamel
Bowl: 4 x 6⅜ x 6½ (diam.) in.
(10.2 x 16.2 x 16.5 cm)
Spoon: 7⅜ x 1⁹⁄₁₆ x 1 in.
(18.7 x 4.0 x 2.5 cm)
Marks: under bowl, on back of
spoon, and on flange of lid (the
latter abraded), struck L & CO
in horizontal triple-diamond
surround; anchor, lion passant,
and date letter D, all in shaped
surrounds; impressed CYMRIC
in rectangular surround with
cut corners; all over incuse 2107;
pieces assayed in Birmingham
L.88.30.52a–c
Collection of Max Palevsky
and Jodie Evans

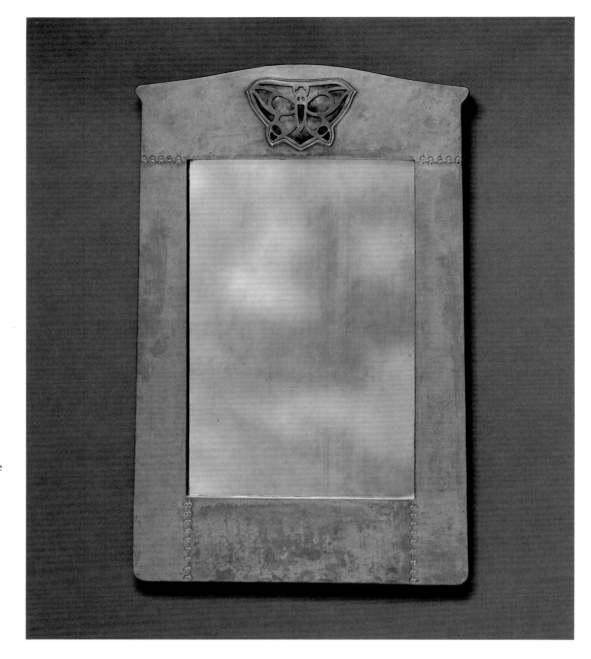

LIBERTY AND COMPANY
1875–present
London

..

5

Wall Mirror, c. 1900

Copper, pine, enamel, and glass
28 x 18 x 1 in.
(71.1 x 45.7 x 2.5 cm)
Marks: on back, printed on white
acetate tag affixed with tacks,
LIBERTY | LONDON
TR.9408.5
Collection of Max Palevsky
and Jodie Evans

was a plebeian rejection of jewel-encrusted objects, an attempt at presenting a more afford-able and democratic alternative. Beauty, argued arts and crafts reformers, was as accessible in humble materials as it was in costly mediums. Thus the bright colors of inexpensive enamel-ing frequently highlighted English arts and crafts metalwork, influencing adoption of the technique in America (by Louis Comfort Tiffany, for example). The hand-hammered surface treatment of Ashbee's silver was even more influential.

Liberty and Company imitated Ashbee's success with silver and enameling, but on a more commercial scale than the communelike Guild of Handicraft.[12] Largely indifferent to social ideals, Arthur Lasenby Liberty (England, 1843–1917) founded the firm in 1875 to capitalize on the popularity of arts and crafts. Although disdained by advocates of handwork because it combined craft with manufacturing, Liberty and Company set an economic example that later came to characterize the American approach to the movement. The business employed some of the period's best designers, among them Voysey and Archibald Knox (Isle of Man, 1864–1933, active England). It copied Ashbee's style and offered the Cymric line of silver as a less expensive alternative to his products. The covered bowl and spoon with enameled

decoration designed by Knox (cat. no. 4a–b) is such an example.[13] The copper and enamel wall mirror (cat. no. 5) subscribes to the beauty-in-humble-materials approach characteristic of the period.

The English arts and crafts movement was multifaceted in its various social and aesthetic goals. While Liberty's entrepreneurial activities were least acceptable to critics, other leaders risked criticism by actualizing design theories that paid less attention to craft. Charles Rennie Mackintosh (Scotland, 1868–1928) was such a figure. Although he championed aesthetic unity in interiors and elevated common objects to the status of art, the how and what of his forms were of less concern. Mostly ignored by his English contemporaries, Mackintosh had enormous influence on the Continent and in the United States. His interpretations of arts and crafts concepts became axioms of the modern movement.[14]

Charles Rennie Mackintosh,
c. 1903

Born and trained in Glasgow, Mackintosh subscribed to the movement's emphasis on integrated design derived from nature, however stylized, and suited to the requirements of object, user, and site. Like his English counterparts he turned to native forms for inspiration. However, this bold and creative genius abstracted shapes and motifs into spatial and visual relationships that bore little resemblance to their vernacular forebears. His sheer delight in optical drama dominated his concern for craft or construction. He was the most fantastic of British designers.

By itself the Willow Tea-Rooms side chair (cat. no. 6) speaks less of fantasy than of the architect's provincial inspiration and overwhelming concern for a graphic effect. The ladder-back design was derived from countless, indigenous slatted examples, but Mackintosh subtly refined the concept. The taller, narrower back, extension of slats to the floor, truncation of rear stiles so that they are almost flush with the top rail, and black color create an intense design of positive and negative space, a visual experience separate from the chair's role as a seating form. Indeed the seat itself stops short of the visual plane created by the back's curving slats. In context the chair was part of a design fantasy. The most elaborate of Mackintosh's tearooms, the Willow spaces were astonishing creations of stylized furniture, railings, and chandeliers based on the theme of the willow leaf.[15] The ladder-back chairs acted as spatial dividers while suggesting the tall, elegant form of the tree and its screenlike foliage.[16]

Mackintosh viewed architecture as spatial voids that defined the nature and placement of walls. He employed furnishings to enhance dimensional character while facilitating human use and comfort. His theories were of the East. According to Andrew MacMillan: "Japanese architecture revealed to him ... that beyond the Picturesque and the Arts and Crafts there could be a true non-historical style based only on space and a direct use of material."[17]

So influential were Mackintosh's designs, they affected most Glasgow stylists. One, E. A. Taylor (Scotland, 1874–1951), combined Mackintosh's motifs with English arts and crafts furniture forms.[18] For example, the desk (cat. no. 7) contains stained glass panels of the Glasgow rose and stylized, pierced leaf shapes in the corners of its skirt rail. These motifs and the crisply defined overhanging top are characteristic of Mackintosh. The overall form, in natural wood with accentuated, riveted hardware, bespeaks the influence of Voysey and his contemporaries. Taylor designed this model for the Wylie and Lochhead furniture firm, which offered it in mahogany as well as the oak seen here.

Mackintosh proved to be the bridge connecting developments in Scotland with the various arts and crafts movements on the Continent. As Roger Billcliffe writes: "Charles

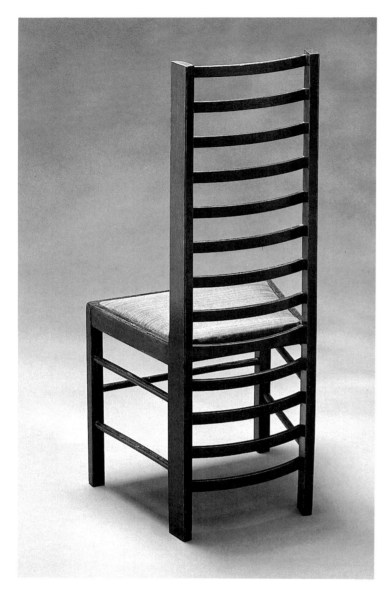

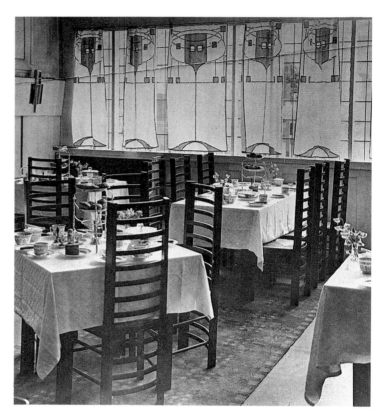

CHARLES RENNIE MACKINTOSH
Scotland, 1868–1928
Glasgow
..
6

*Side Chair from the Willow
Tea-Rooms, Glasgow*, 1905

Oak and horsehair (upholstery
replaced in the period)
41⅛ x 17¾ x 15⅝ in.
(104.5 x 45.1 x 39.7 cm)
TR.9365.11
Collection of Max Palevsky
and Jodie Evans

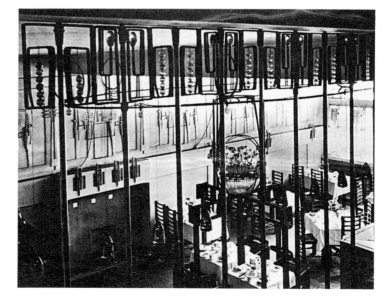

Two views of the Willow Tea-Rooms,
1903

Rennie Mackintosh's work and ideas were perhaps more widely disseminated than those of any architect before him, both through the medium of the specialist journals and magazines and by his personal visits to the centres of artistic unheaval [*sic*] in Europe. Through both these routes, Mackintosh seemed to act as a catalyst for his European contemporaries who were equally dissatisfied with the state of architecture and design in their various countries."[19] Continental interpretations distilled the movement down to a concentration on decorative arts and design reform, with little of the moral and social overtones imbuing the English example.

In Austria, Mackintosh was revered by members of the Vienna secession. Founded in 1897, this group of Austrian avant-garde designers seceded from a gentleman's art club to protest its hieratic emphasis on fine art in exhibitions and the attendant exclusion of decorative arts. Mackintosh was invited to show with them in 1900 and received great acclaim and notice in German-language journals. Like Mackintosh the secessionists were committed to function and aesthetics in an integrated scheme.

ERNEST ARCHIBALD TAYLOR
Scotland, 1874–1951
Glasgow
......................................
7

Desk, 1906

Manufactured by Wylie and Lochhead, Glasgow (1829–present)
Oak, chestnut, and leaded glass, with hardware of nickel-and-copper-plated brass with painted fabric inserts
48 x 30 x 19 $^{11}/_{16}$ in.
(121.9 x 76.2 x 50.0 cm)
Inscriptions: mounted on the drop front, engraved on small silver plaque, PRESENTED TO | MISS E. C. SHANNON | BY THE NURSING STAFF OF THE | WESTERN INFIRMARY | WITH SINCERE REGRET AT HER RESIGNATION | 14TH FEBRUARY 1906
L.88.30.84
Collection of Max Palevsky and Jodie Evans

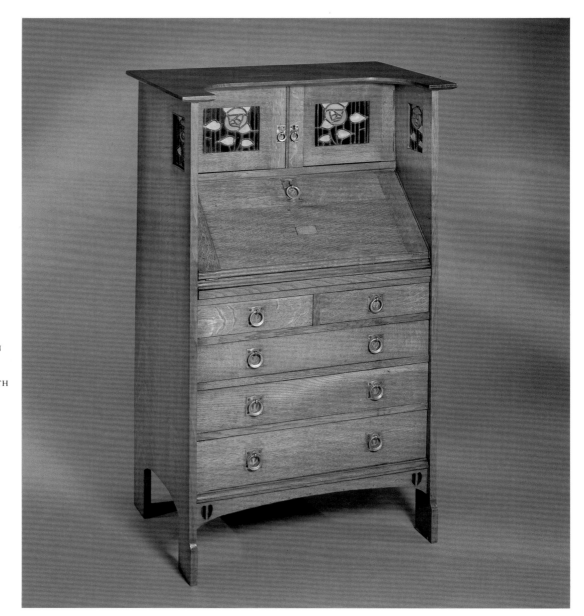

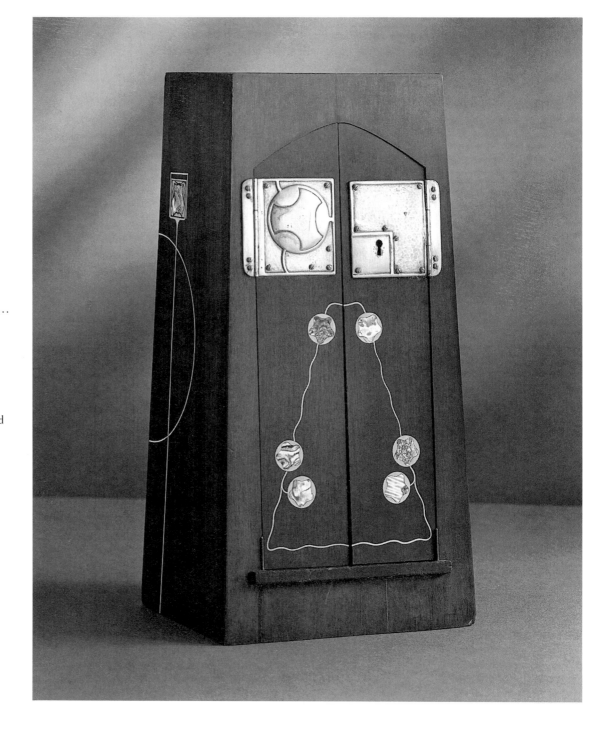

Joseph Maria Olbrich
Germany, 1867–1908
Vienna, and Darmstadt,
Germany
...
8

Jewelry Coffer, c. 1901

Executed by Robert Macco
(Germany, 1867–1951)
Ebonized sycamore, ivory, and
abalone, with silvered brass and
copper hardware
15 13/16 x 7 7/8 x 6 in.
(40.2 x 20.0 x 15.2 cm)
Marks: under base, stamped in
purple ink, two concentric
squares with illegible block
lettering and centered 4
TR.9349.1
Collection of Max Palevsky
and Jodie Evans

Joseph Maria Olbrich (Germany, 1867–1908) was a leader of the secessionists and designed their exhibition building in 1897. He exemplified the Viennese approach in his reliance on classical forms rather than vernacular examples. His jewelry coffer (cat. no. 8) is restrained in form, but its decoration consists of abstracted, geometric inlay and silvered brass and copper lock-plates that are indebted in style to the Glaswegian. Olbrich designed this form for his Darmstadt patron, the Grand Duke of Hesse, Ernst Ludwig. Several were made to this design in ebonized as well as lighter woods.

In 1903 some of the secessionists founded the Wiener Werkstätte, a group of designers who committed themselves entirely to decorative arts. Somewhat similar to English arts and crafts guilds, the Werkstätte focused on creating everyday objects of beauty and quality for mass consumption.[20] Mackintosh's influence with the set is revealed in a letter to one of its founders in its first year, as is his pragmatic approach to the movement's ideals:

From the outset your aim must be that every object which you produce is made for a certain purpose and place. Later ... you can emerge boldly into the full light of the world, attack the factory-trade on its own ground, and the greatest work that can be achieved in the century, you can achieve: namely the production of objects of use in magnificent form and at such a price that they lie within the buying range of the poorest.... But ... first the "artistic" (pardon the word) scoffers must be overcome; and those who are influenced by these scoffers must be taught ... that the modern movement is not a silly hobby-horse of a few who wish to achieve fame comfortably through eccentricity, but that the modern movement is something living, something good, the only possible art.[21]

Perhaps the best-known member of the Vienna secession was Josef Hoffmann (Austria, 1870–1956), one of the Werkstätte's founders. His barrel-shaped armchair and *Sitzmachine* (sitting machine) typify his geometric approach to design. Although the armchair (cat. no. 9) has provincial prototypes in folk furniture actually crafted from barrels, Hoffmann's use of the form is decidedly more visual than vernacular and evinces abstraction akin to Mackintosh's example.

Secessionists did not share the English movement's repudiation of new technologies and machinery. Quite the contrary, they, like Mackintosh and Frank Lloyd Wright, were intrigued with the possibilities and sought to create a new art for a new age, made available to many by the machine's abilities. Hoffmann employed new technologies to achieve his designs of steamed and bent wood.

Hoffmann's most innovative seating design was the Sitzmachine (cat. no. 10). Analogous in form to the English Morris chair, the piece, with its adjustable back and machinelike look, celebrates mechanical service to a sitter. Consisting of bent wood and plywood, it is augmented by geometric spheres and square cutouts. (Hoffmann repeatedly used groups of small squares in his designs, a motif derived from Mackintosh.) Although not uncomfortable when fitted with cushions, such a concession sacrificed design appreciation. Despite its name the sitting machine was more of an idea about sitting than an effort to provide a comfortable seat.

The visionary design concepts of the arts and crafts movement also had a French branch, art nouveau. Like outposts in Glasgow and Vienna the French movement was largely indifferent to the social and moral overtones of the English interpretation. While philosophically consistent with its British and European arts and crafts counterparts, stylistically art nouveau

JOSEF FRANZ MARIA HOFFMANN
Austria, 1870–1956
Vienna
.......................................
9

Armchair, c. 1908

Manufactured by Jacob and Josef
Kohn, Vienna (1867–1914)
Beech, brass, and (replaced)
upholstery
29½ x 31¼ x 24½ in.
(74.9 x 79.4 x 62.2 cm)
Marks: inside front seat rail,
branded J. & J. KOHN | TESCHEN
AUSTRIA; inside rear seat rail,
paper label engraved with a rec-
tangle enclosing the following:
on either side, SEMPER SURSUM
and JJK cipher within a shield;
across top, a double-headed
eagle flanked by two griffins;
across bottom, JACOB & JOSEF
KOHN. WIEN. | REGISTRIRTE
SCHUTZMARKE
TR.9349.8
Collection of Max Palevsky
and Jodie Evans

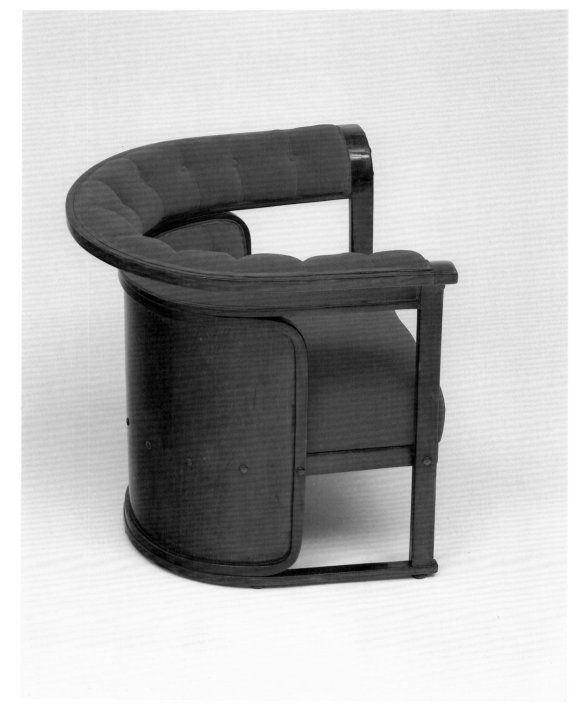

looked very different. While Scottish and Austrian designers recognized the authority of mass and space, French designers gloried in the line, relating it to the stem of the plant, a life-giving, dynamic artery. Where Mackintosh and the secessionists had abstracted by reducing and simplifying organic design sources to geometric forms, the French expanded upon the same sources. Here too there were Japanese undercurrents, specifically in asymmetry and the overt homage to nature. Unlike Hoffmann, who designed for mass production, believing in the value of design over execution, the finest art nouveau examples are individual forms, chairs or tables or vases, treated as unique works of art.

Hector Guimard (France, 1867–1942) was one of the masters of French art nouveau, an architect devoted to unified interiors. The cabinet (cat. no. 11) was part of a dining suite that also included a table and chairs. Seemingly lifelike, the form exploits the natural characteristics of wood and is carved and relieved as though to reveal musculature and tendons.

JOSEF FRANZ MARIA HOFFMANN
Austria, 1870–1956
Vienna
......................................
10

Sitzmachine, c. 1910

Manufactured by Jacob and Josef
Kohn, Vienna (1867–1914)
Beech and brass
44⅛ x 25 x 32¼ in.
(112.1 x 63.5 x 81.9 cm)
Marks: inside rear seat rail,
branded J. & J. KOHN | TESCHEN
AUSTRIA
TR.9349.7
Collection of Max Palevsky
and Jodie Evans

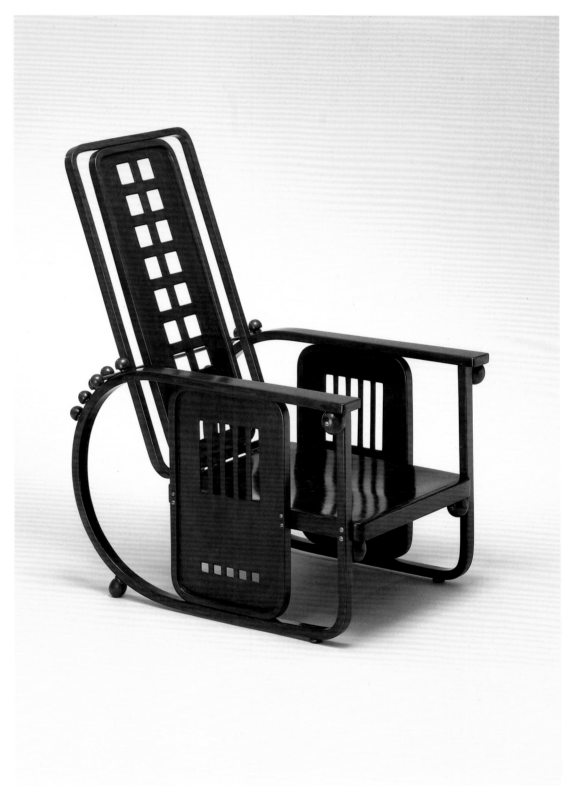

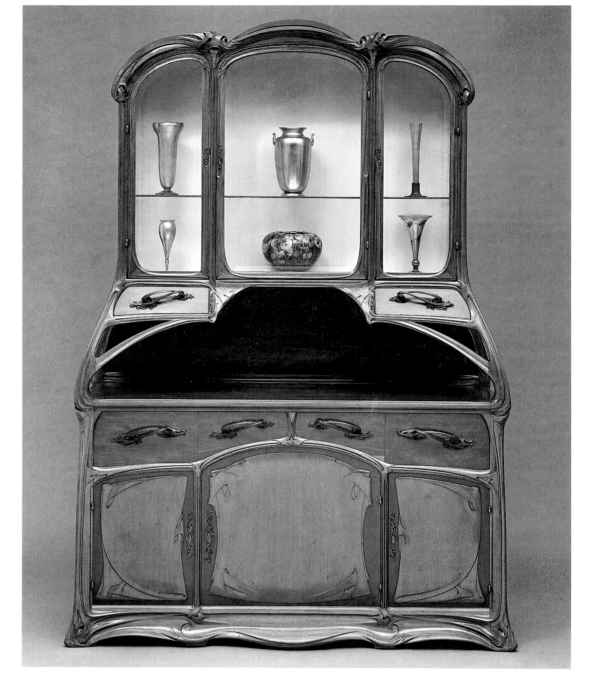

HECTOR GUIMARD
France, 1867–1942
Paris
..
11

Cabinet, c. 1905

Mahogany, poplar, bronze, and
glass
102 x 72 x 22 in.
(259.1 x 182.9 x 55.9 cm)
M.85.110
Gift of Carlyn Ring

The French art nouveau style was paralleled by similar interpretations in Belgium, Germany, and Italy.[22] The architects Victor Horta (Belgium, 1861–1946) and Henry van de Velde (Belgium, 1863–1957) were the leading proponents in Brussels. Van de Velde was also influential in the German adaptation known as *Jugendstil* (style of youth), named for the art periodical *Jugend*. Munich and Darmstadt were the centers of the German movement, with such distinguished artists as Richard Riemerschmid (Germany, 1868–1957), Otto Eckmann (Germany, 1865–1902), and Peter Behrens (Germany, 1868–1940) active there.[23] In Italy the movement was named *stile liberty* after Liberty and Company of London.[24]

All of the European design movements emphasized the value of the decorative arts and argued for design reform: simpler, more functional styles, ornament derived from nature and relevant to form and materials, with the results integrated with interior schemes. The American outpost was informed by all of them, although most strongly by that of Englan D.

NOTES

1. Stansky 1984, p. 1.

2. Ruskin 1851 (vol. 2), p. 170.

3. Parry 1983, pp. 71, 161, no. 82.

4. The aesthetic movement had chipped away at Western art hierarchies that, from the oriental viewpoint, made unnatural distinctions between the decorative and fine arts.

5. As quoted in Page 1980, p. 58.

6. Herman Muthesius, as cited in Stansky 1984, p. 8.

7. For studies of Morris and his relation to the English arts and crafts movement see Thompson 1977, Stansky 1985, and Lambourne 1980.

8. For studies of Voysey and his work see Brandon-Jones 1978 and Gebhard 1975.

9. For a photograph of the sideboard in Voysey's home see Simpson 1979, p. 121, no. 58c. The author is grateful to Duncan Simpson for his research assistance.

10. For a study of Ashbee and his work see Crawford 1985.

11. Crawford 1985, p. 337.

12. For a study of Liberty and Company see Levy 1986.

13. For a study of Knox's designs see Tilbrook and House 1976.

14. For studies of Mackintosh's influence see Howarth 1977 and Nuttgens 1988.

15. The rooms were located on Glasgow's Sauchiehall Street. "'Sauchiehall' . . . is derived from an old Scottish word signifying street, or alley of the willows." Howarth 1977, pp. 138–39.

16. For a thorough study of Mackintosh's interior designs and furniture see Billcliffe 1986.

17. MacMillan 1988, p. 30.

18. For more information on Taylor and other of the Glasgow designers see Larner and Larner 1979.

19. Billcliffe 1988, p. 6.

20. For a study of the Wiener Werkstätte see Schweiger 1984.

21. As quoted in Page 1980, p. 155.

22. For more information on the art nouveau style in Europe see Madsen 1967 and Duncan 1982.

23. For a study of Jugendstil see Hiesinger 1988.

24. For a study of Italian art nouveau see Weisberg 1988.

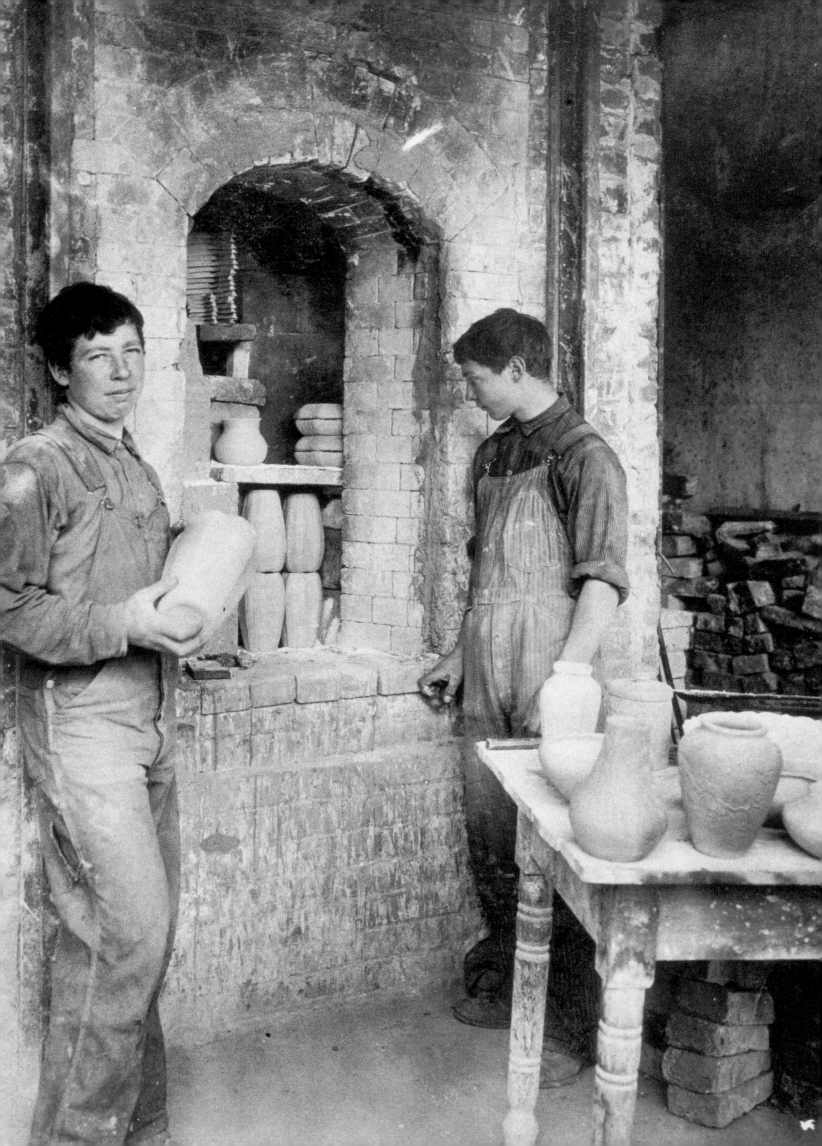

MYTHS AND REALITIES OF THE AMERICAN ARTS AND CRAFTS MOVEMENT

American craftsmen and manufacturers cultivated the myths of the arts and crafts movement, but its realities provided some ironic contrasts with those myths. The success of the movement in the United States rested on compromises that adapted it to American capitalism.

Paradoxically the crafts in America were not elevated out of industry into the fine arts, but instead were adapted to industry. Using English philosophies and rhetoric, American proponents successfully promoted the decorative arts as fine art handwrought by single craftsmen, despite the fact that most products were actually hybrids made by various hands and machines. A purist might argue that this invalidated the artistic value of the pieces; a pragmatist might respond that the middle class had never enjoyed such quality in their homes. Whether or not they produced "art," America's arts and crafts manufacturers created and supplied a thriving market for affordable, artistically conceived goods and thereby increased middle-class awareness of craft and design.

As compared with the fate of the movement in England, this was a real achievement. William Morris had become increasingly frustrated at the realities of his own company, which sustained itself with a division of labor and turned a profit due to the patronage of the wealthy. Recognizing this inconsistency, he questioned: "What business have we with art at all, unless all can share it?"[1] He gradually withdrew from the firm and became involved with socialist organizations. When C. R. Ashbee relocated the Guild of Handicraft to a small agrarian community with the hope of realizing his utopian dream, the distance from rich patrons in London strangled its success. In their purest form English arts and crafts philosophies could have been implemented only by abandoning mechanization in favor of the preindustrial economic system. Billed as art for the masses, expensive handcrafted wares could not compete with inexpensive mechanized substitutes. The movement's goals appeared to be unattainable within the free market system.

The movement spread to America through intellectual channels.[2] Charles Eliot Norton (United States, 1827–1908), the first professor of fine arts at Harvard and an art critic of enormous influence, was the American equivalent of John Ruskin. Norton was in fact a longtime friend of Ruskin and became the first president of the Boston Society of Arts and Crafts, which was founded in 1897 on the example of the London version. Oscar Lovell Triggs (United States, 1865–1930) was a professor at the University of Chicago. He founded the Chicago Arts and Crafts Society and chronicled the movement in his book, *Chapters in the History of the Arts and Crafts Movement*. Ralph Whitehead (England, 1854–1929, active United States), who studied at Oxford under Ruskin, Hervey White (United States, 1866–1944), a

Arequipa Pottery workers, c. 1915

writer, and Bolton Coit Brown (United States, 1864–1936), a Stanford University art professor, founded Byrdcliffe Colony, a utopian craft commune in Woodstock, New York. The architect Will Price (United States, 1861–1916) founded a similar venture in Rose Valley, Pennsylvania. Many other intellectuals and societies could be mentioned, but in the end they did not provide the catalyst for the American arts and crafts movement, which owed its success not to academia, but to commerce.

The reality of a free market system is a price ceiling, a level beyond which demand decreases dramatically for any given commodity. In theory competition is the self-regulating element in the system, establishing price ranges and preventing monopolies. Morris and Company, the Guild of Handicraft, Byrdcliffe (which existed on subsidies from Whitehead's fortune and produced fewer than fifty pieces of furniture), and Rose Valley (which closed when it could not maintain its ideals and meet market demand) exemplified the difficulty of supplying affordable art wares to the largest sector of the market, the middle class. Manufacturers provided the key.

American businessmen packaged arts and crafts into a consumer proposition. The best of them abided by the movement's requisite tenets of functional design, simple materials, etc., but they standardized styles and used machinery and labor division to lower costs. Their promotional materials helped to establish a market for these "handcrafted" goods. Ironically, by boosting demand with their commercial activities, the manufacturers were an enormous aid to the artists and craftsmen who worked singly or in guildlike arrangements. To a certain extent the philosophically pure arts and crafts societies in the United States benefited from the advertising hyperbole of the profit makers.

The leading promoter was Gustav Stickley (United States, 1858–1942). A veteran of the furniture business, he was converted to arts and crafts ideas while on a visit to England in the late 1890s. Already familiar with the writings of Ruskin and Morris prior to this trip, he was, upon his return, moved to found United Crafts in order "to promote and to extend the principles established by Morris, in both the artistic and the socialistic sense ... to substitute the luxury of taste for the luxury of costliness; to teach that beauty does not imply elaboration

Gustav Stickley, 1905

or ornament; to employ only those forms and materials which make for simplicity, individuality and dignity of effect."[3]

"In 1900 I stopped using the standard patterns and finishes," wrote Stickley, "and began to make all kinds of furniture after my own designs, independently of what other people were doing," forms that heeded the English dictum of vernacular origins.[4] He called his new factory "a guild of cabinet makers, metal and leather workers," and pledged to achieve "the union in one person of the designer and the workman," citing Morris's inspirational example.[5] Also reminiscent of Morris was the equation of beauty with morality: "Just as we should be truthful, real and frank ourselves, and look for these same moral qualities in those whom we select for our friends, so should the things with which we surround ourselves in our homes be truthful, real and frank. We are influenced by our surroundings more than we imagine."[6]

Stickley's designs were an extreme departure from the plethora of overdecorated styles produced for the middle-class market. He declared that his furniture must fill "its mission of usefulness as well as it possibly can; it must be well-proportioned and honestly constructed," and admitted that "massive simplicity is the leading characteristic of the style."[7] To market the products of his Morris-inspired guild, Stickley went to Grand Rapids, the center of middle-class furniture production. He launched his new line at the Grand Rapids Furniture Fair in 1900. His forms were refreshingly simple and the rhetoric appealing; his success at the fair attracted imitators almost immediately.

Stickley recognized the difficulty of persuading customers to visit craft studios and special exhibitions of arts and crafts. While he exhibited in many of those arenas, he was careful to keep his products available in mainstream establishments. He retailed his lines through conventional channels: furnishing companies in cities across America.

Stickley not only adapted his methods to the existing market, he set about influencing that market with the publication of a monthly magazine, *The Craftsman*, beginning in 1901. As editor he styled it as a how-to manual for living the arts and crafts life-style, noting that "where *The Craftsman* hopes to be of service is in suggesting how to create an environment where simple needs are met in a simple, direct way; in pointing out how a home may be built up where lives may be lived out in peace and happiness, where children may grow up in surroundings that make for good citizenship, and where good work may be done because of the silent influences of space, freedom and sincerity."[8]

By reading *The Craftsman*, the average person could learn to furnish a home, plant a garden, select healthful recreation, practice various hobbies, criticize contemporary literature, appreciate Native-American music, and explore natural wonders.[9] A contemporary publication described the magazine as "a journal advocating the influence of beautiful home surroundings as factors of the highest importance in the right development of civic and national life, and the mental and physical healthfulness that comes from the habit of spending at least a portion of each day in useful labor out of doors."[10]

Stickley's journal was the arts and crafts entry in a burgeoning realm of late nineteenth-century American publications: instruction and etiquette manuals. Such publications were monitored by middle-class readers so that they could adjust their conduct as they moved up the rungs of the social ladder.[11] Historians cite the insecurity of a large middle class only recently moneyed due to industrialization as the impetus for this type of literature. As Susan Williams writes:

During the Victorian period, a new class of Americans emerged, people with enough money to be able to live with a certain degree of comfort, often in their own homes, surrounded by an increasing selection of purchased goods and services. The constantly shifting boundaries of this new class, however, generated an unsettling degree of social uncertainty during the last half of the nineteenth century. American families eagerly adopted the rules of etiquette to proclaim and solidify their newly won position in society.[12]

Cartoon by Charles Dana Gibson, 1902

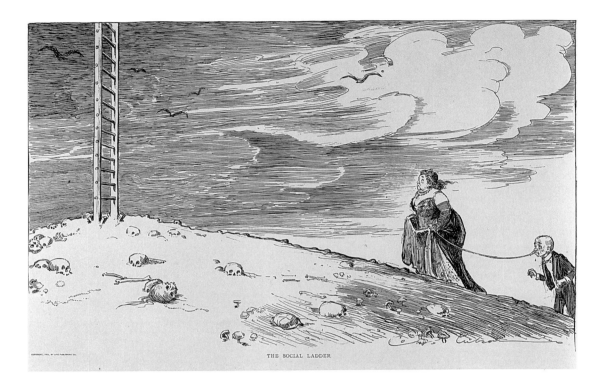

THE SOCIAL LADDER

The Craftsman was a comforting talisman in implementing new ideas of art, taste, decoration, and education. Articles by famous and influential people assured readers of the magazine's validity. As architect of both the journal and a prospering commercial empire Stickley was instrumental in establishing the predominant traits of the movement in the United States. Some of these characteristics were consistent with English ideals, others were not. Not surprisingly Stickley and his contemporaries were careful to downplay the inconsistencies, regarding them as necessary if potentially unpopular compromises. The greatest incongruity involved the employment of machinery.

Whereas Ruskin and most English leaders opposed the use of machinery, American manufacturers found it necessary to mechanize their processes. Although Ashbee was not alone among his contemporaries in accepting machinery in the cause of craft, it came to dominate American manufacturing, especially in the area of furniture.[13]

Stickley's severe styles not only met the movement's requirements for simple, functional design, they facilitated machine production. His aversion to ornament also steered him toward mechanization and away from expensive handcraftsmanship. For example, the inlaid lines designed by Harvey Ellis (United States, 1852–1904), despite their aesthetic appeal, were never put into large-scale production at Stickley's Craftsman Workshops.[14] The majority of American arts and crafts furniture pays more homage to handcraftsmanship in design than in construction.

Machinery was not so universally characteristic of American arts and crafts ceramics and metalwork, but here too it was employed. Most of the major art potteries used machine-prepared clay. Metalsmiths purchased sheet stock already rolled to a desired gauge. Many silversmiths spun their forms on models or lathe-driven chucks and added hammer marks for the finish. Maybe Gorham's carriage trade clientele could afford the hand-raised and chased Martelé line, but it was prohibitively expensive for most Americans. Copper was a favored metal not only because of its humble status but also because it was softer and could be worked faster than silver. Pewter, although just as humble, is virtually nonexistent in arts and crafts metalwork. As a harder alloy, it had to be cast, not hammered, and hammer marks connoted handwork, even if hands did not do the work.

The presence of hammer marks on arts and crafts metalwork raises the issue of craftsmanship, the raison d'être of the movement. All of the period's trade catalogues touted the practices of bygone centuries and old-world guilds, but with few exceptions the craftsmanship of the period, as compared with the finest in preindustrial times, was undistinguished. The artistic value of most arts and crafts objects lies not in technical virtuosity of any sort, but in their design. Despite its stated aim of craft preservation, the movement, for the most part, revived only rudimentary skills.

In the hierarchy of preindustrial craftsmen those who lavished ornament on surfaces were the most highly regarded and paid: the French ébénistes, who assembled the marquetry facades on furniture, the silver chasers, the ceramic decorators. Until mechanization fine craftsmen throughout history had toiled to produce a finished look that concealed evidence of an object's construction. To an eighteenth-century silversmith the hammer marks on arts and crafts metalwork would have indicated the unskilled hands of an apprentice who could not properly wield the planishing hammer. The thick boards and oversized joints of the period's furniture would have been viewed as the work of a novice incapable of shaping fine, thin boards and joining them with discreet dovetails. But just as photography altered realist traditions in painting, so machines redefined the nature of craftsmanship. Hammer marks and exposed joinery signified desirable handcraftsmanship in an age where flush, smooth surfaces indicated nothing more than machined finishes and concealed joinery hid what might not be joinery at all, but glue or dowels.

Ornament was also questioned. Stickley, with the brief exception of the unsuccessful Harvey Ellis period, spurned ornament altogether, and this viewpoint characterized many of his imitators. Moral and religious overtones are palpable in the American movement's collective mistrust of ornament. A University of Chicago sociologist explained the morality of aesthetics in 1897: "We make our houses and they turn upon us the image of our own taste and permanently fix it in our very nature. Our works and our surroundings corrupt or refine our souls." [15] This characteristic ornamental restraint effectively prevented the exercise of superlative craftsmanship.

There were exceptions to the rule, particularly in ceramics, but virtuoso craftsmen had to wrestle with a middle-class market reluctant to pay for their artistry. Adelaide Alsop Robineau (United States, 1865–1929) complained of American society: "Those who have acquired money . . . have failed to see that contemporary talent has to be encouraged by purchase of the best in native work." [16] Only in areas of upper-class patronage could top craftsmen hope for recognition and compensation. Louis Comfort Tiffany (United States, 1848–1933), Charles Sumner Greene (United States, 1868–1957), Henry Mather Greene

(United States, 1870–1954), and Frank Lloyd Wright (United States, 1867–1959) were among the few to find an affluent market for their goods and services.

Unlike Robineau and the others most of the movement's technicians were denied any role whatsoever in design. Stickley's goal of unifying designer and craftsman was not achieved. He controlled the plans and employed woodworkers and machinery to produce dictated forms. Even the eccentric and creative Charles Rohlfs (United States, 1853–1936) hired craftsmen to repeat his designs. The economics of the marketplace required it, as noted in a *House Beautiful* article of 1903 about the Van Briggle Pottery: "It is far more satisfactory to spend unlimited time and thought in carrying out an idea which may be worthy of repetition ... than to attempt ... a new design which must of necessity often be careless and hasty in thought and execution." [17]

The major art potteries furthered the craftsman myth by placing "artist" markings on the bases of their wares, but in reality these marks identified decorators who rarely had control over their work. For example, Grueby hired women art students to decorate from prescribed designs. Frederick Rhead (England, 1880–1942, active United States) hired high school girls to decorate at Roseville. Newcomb's formula was similar, although its finest decorators graduated from the school and were employed as professionals. Rookwood may have allowed its professional decorators a bit more artistic license, but here too they were handed biscuit-fired forms and instructed in the desired subject matter for application. Most pieces at Rookwood passed through some twenty-one hands. [18] One of Rookwood's finest decorators, Albert Valentien (United States, 1862–1925), complained of the response when the decorators attempted to suggest more stylized subject matter: "It was immediately turned down, and the verdict was 'Flower decorations.'" [19] Some art potteries obviated the need for expensive skilled labor by molding their designs. Gates (Teco), Tiffany, and Van Briggle were among

Frederick Rhead and actress Vivian
Rich, Rhead Pottery, c. 1917

Grueby Pottery workers, c. 1895

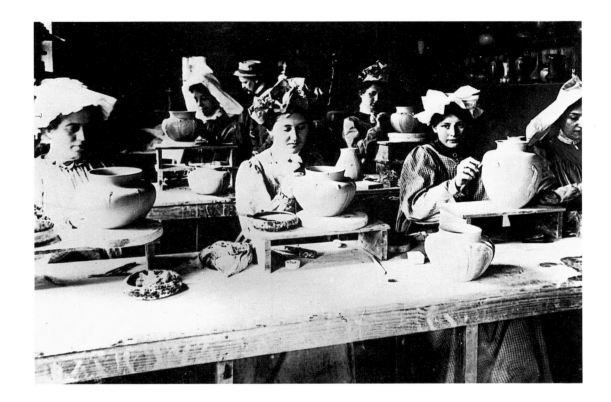

the most distinguished of this group. Whether molded, handcrafted, or machined, most arts and crafts objects in America resulted from assembly line labor division and were produced to prescribed designs.

In all fairness one must recognize that labor division was not new to craft practices. Industrialization expanded on the potential for specialization of labor, but the practice was well illustrated in Diderot's eighteenth-century *Encyclopedia*. Preindustrial artisans routinely crafted objects to preestablished designs popularized by prevailing taste and leading architects and designers. Ruskin's ideas on this issue were flawed, and in elevating the craftsman to the realm of the artist, he sought to impose criteria which had rarely been applied before.

Ruskin had defended the artist/craftsman ideal by citing the superiority of vernacular products of bygone days, provincial pieces crafted by untrained hands in the service of necessity. But by prescribing the commitment of skilled craftsmen to re-create unskilled designs, he set up a paradox. It remained for the modern movement to extract relevant axioms from Ruskin's confusion and promulgate the twentieth-century "form follows function" doctrine.

The acceptance of labor division by most American arts and crafts participants was profit-oriented, and it overrode Ruskin's concern for the plight of the worker. In the area of labor reform American arts and crafts proponents were least attentive to Ruskin's crusade. Indeed here there was less disparity between philosophy and reality, because most manufacturers stopped short of addressing the volatile issue. The labor union movement was largely a separate chapter from the arts and crafts movement. This is not to suggest that arts and crafts manufacturers tyrannized their workers. Some made a point of improving working conditions for their employees, and the nature of arts and crafts manufacturing in general was far superior to the tedious monotony of operating noisy machines for long hours in the dirty, overcrowded conditions that typified the period's mass-production factories. However, little attempt was made by arts and crafts reformers to lend their voices to the labor movement.[20]

Stickley, Elbert Hubbard (United States, 1856–1915), and Charles Limbert (United States, 1854–1923) were among the major manufacturers who were noted for providing healthful and

Elbert Hubbard and Garnet on the
Roycroft grounds, c. 1910

pleasant working conditions, Hubbard in particular. He provided playgrounds, a library, and lecture series for his workers, as well as good light, ventilation, an eight-hour day with recesses, and an honor system in place of foremen.[21] Limbert relocated his Holland Dutch factory from Grand Rapids to a scenic lakeside location in Holland, Michigan, where workers had access to recreation rooms and outdoor walks in the country. As he wrote: "We realized that to do an Italian sunset you must work in Italy—you could not get the inspiration from the Brooklyn Bridge; and to build successfully Holland Dutch Arts and Crafts, you must be stimulated by the proper temperament and environment."[22]

Arequipa Pottery workers, c. 1915

Although labor reform was not a priority of the American arts and crafts movement, philanthropic goals often accompanied craft enterprises. The moral and healthful benefits associated with handwork inspired numerous experiments that used art as therapy. For example, both Marblehead Pottery and Arequipa Pottery were founded to help rehabilitate nervous or tubercular patients. Unfortunately philanthropy was often at odds with profit: Marblehead split off as a separate business; Arequipa closed. The Paul Revere Pottery sustained its philanthropic goal of training immigrant women in marketable craft skills only because its founder subsidized it throughout its tenure. Despite the profit problem numerous arts and crafts organizations were founded to relieve the despair of the indigent. One of the earliest and best known was the Chicago establishment, Hull House, which was inspired by Ashbee and modeled after Toynbee Hall in London. Social welfare was by no means a major characteristic of the American arts and crafts movement, but the existence of such groups demonstrated a willingness to enact reform ideals.

The consumer orientation of the movement also doomed most craft communes, such as Byrdcliffe and Rose Valley, with one extraordinary exception, Hubbard's Roycroft Shops in East Aurora, New York. What started as a joke became the most successful such community in the country.[23] Hubbard's zealous and wily promotion of Roycroft was a textbook example

of salesmanship and advertising, although it led to substantial criticism of his profit motives, implying hypocrisy of the worst sort. However, his hawking of the community was analogous to Stickley's publication of *The Craftsman*; both men sought to enlarge the market for their goods, with those goods comprising not just commodities, but philosophies as well.

Roycroft may have served as a kind of arts and crafts amusement park—attracting tourists, putting them up at an inn, selling them souvenirs of their visit—but a closer examination of its products and practices reveals no greater disparity between rhetoric and reality, indeed often less, than characterized most of Hubbard's contemporaries. Although art historians may find fewer masterpieces in the Roycroft repertoire than in that of others, the works are suitably simple, derivative of English examples, and the structural, if not aesthetic, equal of those produced by the period's standard-bearer, Gustav Stickley.

The reliance on machine-assisted craftsmanship and mass marketing at Roycroft was also typical. Labor division, however, was less restrictive than elsewhere. Hubbard encouraged workers to learn different crafts from one another and alternate tasks to alleviate boredom: "When a pressman or typesetter found his work monotonous ... he felt at liberty to leave it and turn stonemason or carpenter." [24] Ashbee's axiom of joy in work was actively encouraged at Roycroft in contrast with most American factories.

Successful arts and crafts entrepreneurship did not occur in a vacuum: what made middle-class consumers buy Stickley furniture or visit the Roycroft Inn? While a thorough study of the numerous social and political factors that contributed to the movement's appeal is beyond the scope of this survey, it should be pointed out that certain arts and crafts traits touched on national characteristics: the work ethic, the common man, the simple life. [25] These concepts were particularly important to the middle class, many of whom had seized America's opportunities to gain their station and regarded the ostentatious excesses of the upper class with scorn. Middle-class consumers could not afford the expense of unique pieces created by artists, nor, one could argue, were they sufficiently knowledgeable to judge such work. The acceptance of standardized forms and subject matter assured them of tasteful, acceptable goods. All of this reflected a departure from the traditional trend of aping the rich; the middle class claimed this movement as its own. Stickley, Hubbard, and others profited from the rare confluence of art, industry, and society.

Roycroft provides yet another example of how the arts and crafts movement in the United States was a mix of myths and realities. The movement heralded craftsmanship, but produced few outstanding examples of such. Purportedly handmade by a single artist, most objects were at least partially made by molds or machines to established designs. Although codified by intellectuals, entrepreneurs masterminded the acceptance of arts and crafts products by mainstream America. While striving to elevate craft, the movement's legacy to the art world was the value of design. And finally the central irony: while the arts and crafts movement was philosophically opposed to industrialization, the markets and methods of the industrial system enabled it to flourish in America more than in the country of its birth, England.

NOTES

1. As quoted in Kaplan 1987, p. 55.

2. See Kaplan 1987, pp. 52–60, for a discussion of the movement's dissemination.

3. Stickley 1901, p. i.

4. As quoted in Gray and Edwards 1981, p. 17.

5. Stickley 1901, p. i.

6. Stickley 1905, pp. 22–23.

7. As quoted in Gray and Edwards 1981, pp. 17, 19.

8. Stickley 1905, p. 3.

9. For an anthology of articles from *The Craftsman* see Sanders 1978.

10. Wood Craft 1906, p. 71.

11. Williams 1985, p. 17.

12. Ibid., p. ix.

13. For a discussion of the use of machinery see Edwards 1987.

14. Cathers 1981, p. 49.

15. C. R. Henderson, as quoted in Boris 1986, p. 54.

16. As quoted in Weiss 1981, p. 34.

17. As quoted in Kaplan 1987, p. 154, cat. no. 40.

18. Boris 1986, p. 142.

19. As quoted in Trapp 1980, p. 28.

20. For an in-depth discussion of labor and the American arts and crafts movement see Boris 1986.

21. Boris 1986, p. 148.

22. Limbert n.d. b., p. 12.

23. Boris 1986, p. 147.

24. As quoted in Boris 1986, p. 148.

25. See Lears 1981 for a thorough and illuminating study of the social context of the movement.

FURNITURE

Cat. no. 26 (detail)

GREENE *·and·* GREENE

1893–1922

Pasadena

Charles Greene, 1906

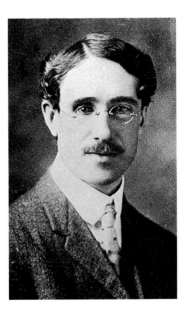

Henry Greene, 1906

After visiting Southern California in 1909, C. R. Ashbee wrote admiringly of the work of Charles Sumner Greene (United States, 1868–1957):

I think C. Sumner Greene's work beautiful; among the best there is in this country. Like [Frank] Lloyd Wright the spell of Japan is on him, he feels the beauty and makes magic out of the horizontal line, but there is in his work more tenderness, more subtlety, more self effacement than in Wright's work. It is more refined and has more repose. Perhaps it loses in strength, perhaps it is California that speaks rather than Illinois, anyway as work it is, so far as the interiors go, more sympathetic to me....

... his workshops ... [make], without exception, the best and most characteristic furniture I have seen in this country ... [with] a supreme feeling for the material, quite up to the best of our English craftsmanship.[1]

Charles and Henry Mather (United States, 1870–1954) Greene attended one of the first arts and crafts academies in America, the Manual Training High School in St. Louis, where they were exposed to concerns of design and materials. Architectural training at the Massachusetts Institute of Technology followed; they graduated in 1891. In 1893, on the way to visit their parents, who had recently retired in Pasadena, the brothers viewed the World's Columbian Exposition in Chicago. They were most impressed with the Japanese exhibit, particularly a timber-framed temple with exposed construction. They subsequently began to collect oriental art and were later to incorporate oriental design into their work. The brothers were also influenced by English arts and crafts, more directly so after Charles's 1901 honeymoon trip to England.

The Greenes remained in California and established a practice in the rich and scenic resort of Pasadena. By 1907 they had perfected their style and were attracting wealthy clients with lucrative commissions. Their "ultimate bungalows" date from this period, houses in excess of five thousand square feet where the Greenes controlled the architecture, furnishings, and landscape.[2] The earliest of these commissions was also one of the largest. For Robert R. Blacker the Greenes designed a mammoth twelve-thousand-square-foot home, a tour de force creation carefully sited in order to minimize its scale.

The Blacker House was the most oriental of their commissions. Broad, overhanging timber construction housed interiors paneled with teak and mahogany and hung with Asian-style lanterns. The architects incorporated Japanese motifs into the furniture's feet, brackets, drawer pulls, and carvings.[3] The use of inlay and stained glass contributed further to the detailed decorative effect. The furniture was constructed to the Greenes' specifications by the Peter Hall Manufacturing Company, a firm established by Peter and John Hall to cater to the Greenes' designs in 1906. The Halls used Scandinavian slotted screw techniques instead of the more common American mortise-and-tenon method and influenced the Greenes in their choice of mahogany.[4] They employed machinery extensively to fashion and finish the furniture, and the results speak resoundingly of the validity of machined construction when harnessed to sound ideals.

A distinguishing feature of furniture by the Greenes is the rounded treatment of the edges and corners, which contributes to the tenderness and subtlety cited by Ashbee. This softened effect contrasts markedly with the strong, sharp character of furniture designed by Gustav Stickley and Frank Lloyd Wright. Whereas Stickley and Wright accentuated the strength and thrust of the medium, the Greenes glorified the craftsman's ability to make it appear sensitive and pliable.

The brothers produced five more expensive bungalows for subsequent customers, but their practice slowed as the popularity of the movement waned. Clients were increasingly reluctant to pay for the Greenes' obsessive detail and time-consuming work. Charles moved north to Carmel in 1916; the joint practice ended in 1922.

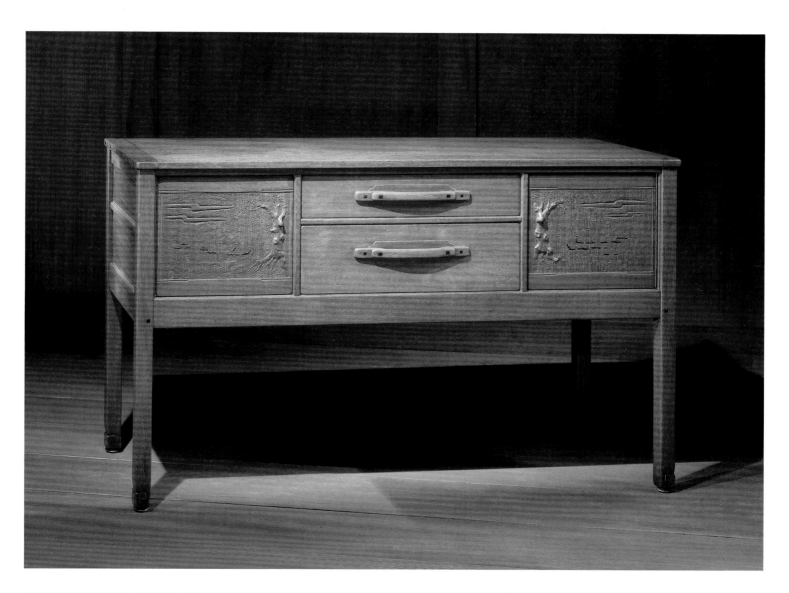

12

*Hall Cabinet from the
Robert R. Blacker House,
Pasadena*, 1907

Executed by Peter Hall Manu-
facturing Company, Pasadena
(1906–22)
Teak and ebony
36½ x 60¾ x 20¾ in.
(92.7 x 154.3 x 52.7 cm)
M.89.151.1
Gift of Max Palevsky
and Jodie Evans

Cat. no. 12 (detail)

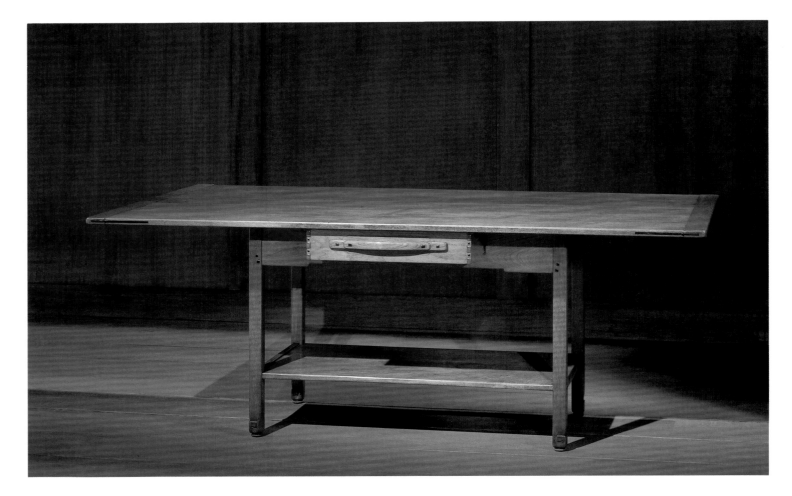

13

*Hall Table from the
Robert R. Blacker House,
Pasadena*, 1907

Executed by Peter Hall Manu-
facturing Company, Pasadena
(1906–22)
Teak and ebony
29⅜ x 76⅞ x 41¾ in.
(74.6 x 195.3 x 106.0 cm)
L.88.30.78
Collection of Max Palevsky
and Jodie Evans

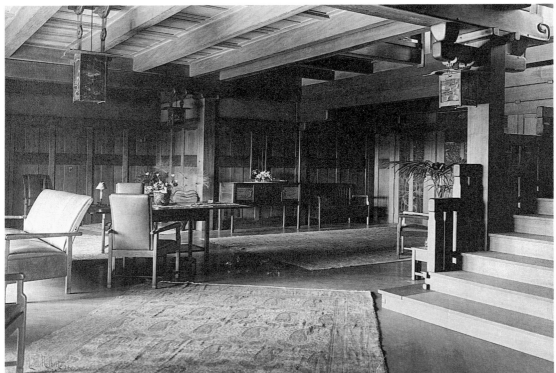

Entry hall, Robert R. Blacker House,
1907

14

*Hall Armchair from the
Robert R. Blacker House,
Pasadena*, 1907

Executed by Peter Hall Manu-
facturing Company, Pasadena
(1906–22)
Teak, oak, and (replaced) leather
40¼ x 24 x 23⅞ in.
(102.2 x 61.0 x 60.6 cm)
81.3.3
Museum Acquisition Fund

15

*Hall Mirror from the
Robert R. Blacker House,
Pasadena*, 1907

Executed by Peter Hall Manu-
facturing Company, Pasadena
(1906–22)
Teak, ebony, pine, glass, and
(replaced) leather
37¾ x 15⅞ x 1¼ in.
(95.9 x 40.3 x 3.2 cm)
81.3.5
Museum Acquisition Fund

The Greenes purposely selected
woods and design elements for
specific rooms. The entry hall
furniture was crafted in teak and
included, in addition to these
pieces (cat. nos. 12–15), a settle,
pedestal, two Morris chairs, and
another case.[5] A carved East
Asian motif appears on all the
feet of the hall furniture, in con-
trast with the recessed design on
the feet of the living room fur-
niture (see cat. no. 16). The
stepped, Japanese "cloud lift"
design appears on the apron of
the table and the handles of both
the table and cabinet. While
much of the Blacker House fur-
niture bears inlaid decoration,
the entry hall cabinet is distin-
guished by landscape scenes of
California oak trees carved by
Charles Greene. The gnarled
tree trunks serve as pulls; the
asymmetrical arrangement of the
scenes is indebted to Japanese
print sources.

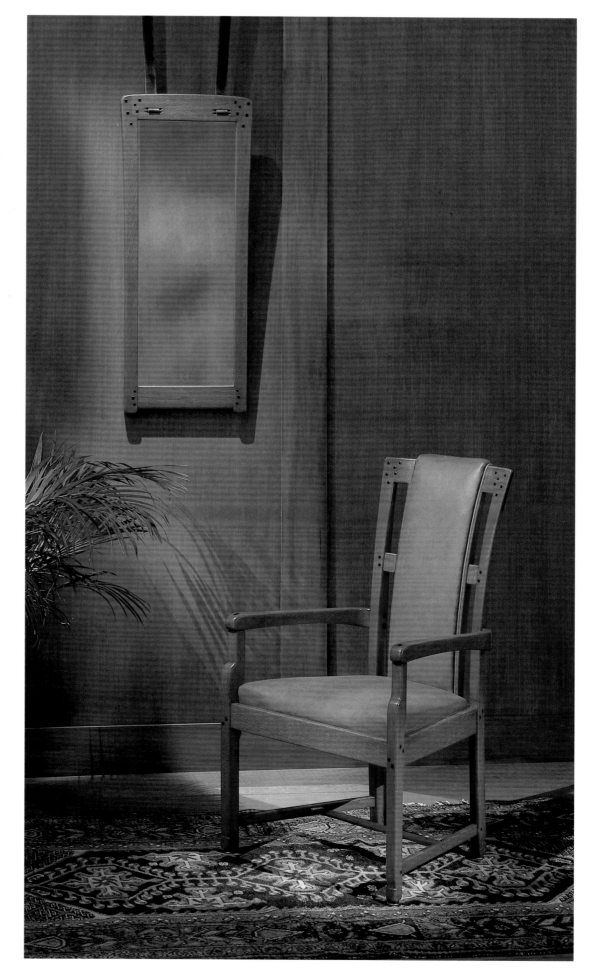

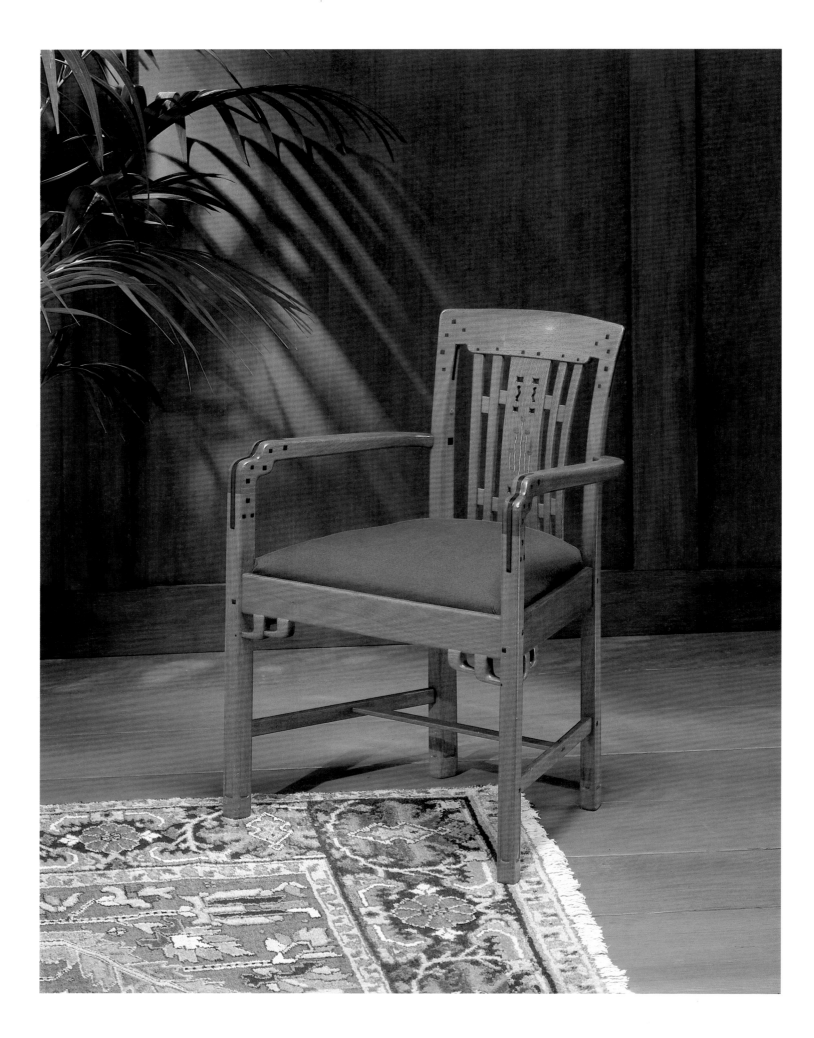

< 16

Living Room Armchair from the Robert R. Blacker House, Pasadena, 1907

Executed by Peter Hall Manufacturing Company, Pasadena (1906–22)
Mahogany, ebony, oak, and (replaced) upholstery
33⅜ x 24¼ x 21⅝ in.
(84.8 x 61.6 x 54.9 cm)
M.89.151.4
Gift of Max Palevsky
and Jodie Evans

The living room furniture, all of mahogany, graced a large salon that had leaded glass lanterns, lily pad friezes over the windows, a gold leaf ceiling, and oriental rugs. This armchair, like other of the room's furnishings, has double brackets, a stepped hand rest, and recessed carvings on the feet. The design of the chair is a complex interplay of subtly curved and tapered elements.[6]

Cat. no. 17 (detail)

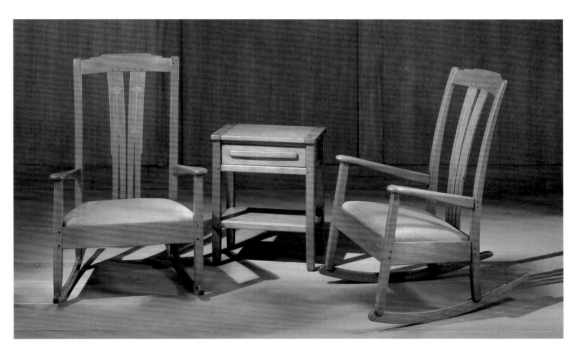

17a–b

Pair of Bedroom Rocking Chairs from the Robert R. Blacker House, Pasadena, 1907

Executed by Peter Hall Manufacturing Company, Pasadena (1906–22)
Mahogany, ebony, oak, boxwood, copper, silver-plated steel, abalone, and cotton upholstery
a: 37⅜ x 25⅞ x 31¼ in.
(94.9 x 65.7 x 79.4 cm)
b: 37⅝ x 25⅞ x 31⅛ in.
(95.6 x 65.7 x 79.1 cm)
81.3.1–2
Museum Acquisition Fund

18

Bedroom Cabinet from the Robert R. Blacker House, Pasadena, 1907

Executed by Peter Hall Manufacturing Company, Pasadena (1906–22)
Mahogany, ebony, oak, boxwood, copper, silver-plated steel, and abalone
24 x 19⅝ x 12⅜ in.
(61.0 x 49.8 x 31.4 cm)
81.3.4
Museum Acquisition Fund

For the master bedroom the Greenes provided slightly simpler pieces with inlaid abstractions of a tree-of-life design related to patterns by Charles Rennie Mackintosh. Note the

steps on the crest rails of the chairs (cat. no. 17a–b), a feature repeated in the rocker terminals, and the attenuation of rear stiles and arms, the latter expanding horizontally into hand rests as they narrow vertically. The rockers retain their original upholstery, a subtle twill diaper weave in "craftsman" colors, moss green and burnt orange. The cabinet (cat. no. 18) has the rounded corners and softened edges typical of the Greenes' furniture as well as inlays matching those on the rockers.

CHARLES P. LIMBERT COMPANY

1902–44

Grand Rapids and Holland,

Michigan

The American furniture industry was quick to capitalize on the success of Gustav Stickley's "New Furniture" at the Grand Rapids Furniture Fair of 1900.[7] Holland Dutch Arts and Crafts was the line produced by the Charles P. Limbert Company of Grand Rapids (and later Holland), Michigan. Founder Charles P. Limbert (United States, 1854–1923) chose the product name because of its quaint and clean associations and its reference to the local Dutch population.[8] Although sales literature claimed a Dutch heritage for the company's designs, many of its forms had prototypes in British and Austrian arts and crafts furniture. Limbert described the American movement as "an outgrowth of the early German and Austrian Secessionistic School."[9]

Like Stickley, Limbert maintained high quality in materials and construction while utilizing machinery to full advantage. Company catalogues predictably downplayed mechanization: "Limbert's Holland Dutch Arts and Crafts furniture is essentially the result of hand labor, machinery being used where it can be employed to the advantage of the finished article."[10] They also belied the mass production of prescribed designs, referring to company workers as a guild, craftsmen who "are allowed scope for their individual originality and genius, and in this way, in conjunction with our designers, they have evolved for us that individuality and distinction of style which has made Limbert's Holland Dutch Arts and Crafts the standard and pattern in America of this type of furniture."[11] An exaggeration, but the company was praised in local publications for its progressive attitudes: "Perhaps no factory in Michigan can boast more proudly of its craftsmanship, the general arrangement of its factory and its equipment for the comfort of its employees."[12] This extended even to the factory's resettlement in 1906 to Holland, Michigan, a village with "attractive summer cottages and quaint houses with fertile gardens and well kept lawns."[13]

The oval table (cat. no. 19) is one of the company's superlative designs, notable for its parallel planes and pierced rectangles in the cross braces. The firm incorporated such cutouts in a number of its pieces, copying the motif, reminiscent of Vienna secessionist design, from Mackintosh.[14]

Hall chairs were traditionally inexpensive pieces used for seating lowly visitors not accorded the honor of the parlor. They lacked expensive upholstery and any attention to the comfort of the guest. As such they gave arts and crafts designers license to focus on purely visual effects. The form provided a vehicle for some of the most interesting chair designs of the period (see cat. nos. 20, 24, 26, 38). The social context of the form emphasized utilitarian, vernacular design; hall chairs are nearly always of simple plank construction. The Limbert example (cat. no. 20) presents an interplay of trapezoidal planes and cutouts repeated even in the canted sides. Limbert's use of angled supports in this and other works is also derived from Mackintosh and contrasts with Stickley's starkly rectilinear forms.

The table lamp (cat. no. 21) is a rare example of Limbert's design number seven, an "Electric Lamp" with "Hand-Beaten Copper Shade."[15] The hipped roof and architectonic base are indebted to prairie school designs, while the meandering vine on the shade is Japanese inspired. The copper work may have been subcontracted to the Stickley Brothers firm.[16] The lamp descended in the family of its original owners, who lived in Hamilton, Ohio, and bought it in 1913 for thirty-five dollars, probably from Robert Mitchell Company, a department store.[17]

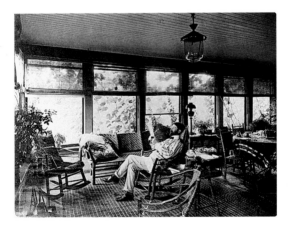

Charles P. Limbert, c. 1902–4

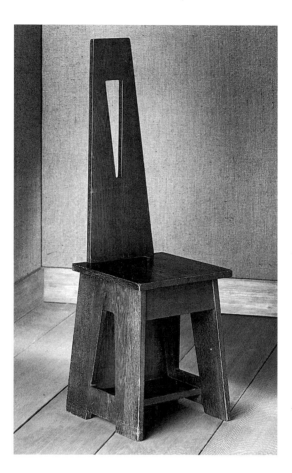

20

Hall Chair, c. 1910

Oak
45½ x 14 x 16⅛ in.
(115.6 x 35.6 x 41.0 cm)
Marks: under center bottom
stretcher, branded outline of
craftsman planing wood on
workbench superimposed
on LIMBERTS | ARTS CRAFTS |
FURNITURE | TRADE MARK |
MADE IN | GRAND RAPIDS |
AND HOLLAND, all enclosed
within a rectangle
L.88.30.67
Collection of Max Palevsky
and Jodie Evans

19

Table, c. 1910

Oak
29 x 47⅞ x 36¼ in.
(73.7 x 121.6 x 92.1 cm)
Marks: under top, branded out-
line of craftsman planing wood
on workbench superimposed
on LIMBERTS | ARTS CRAFTS |
FURNITURE | TRADE MARK |
MADE IN | GRAND RAPIDS |
AND HOLLAND, all enclosed
within a rectangle
M.89.151.24
Gift of Max Palevsky
and Jodie Evans

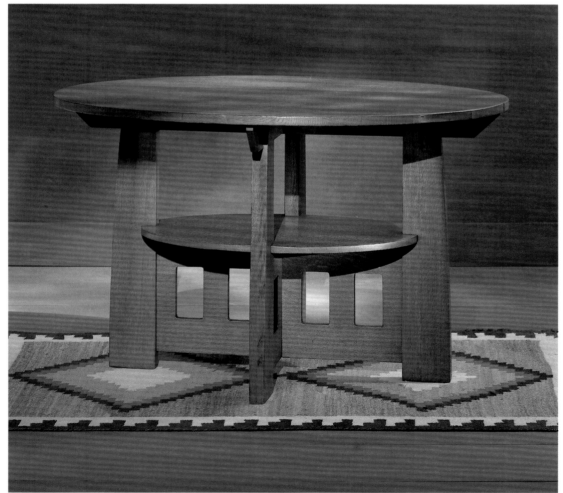

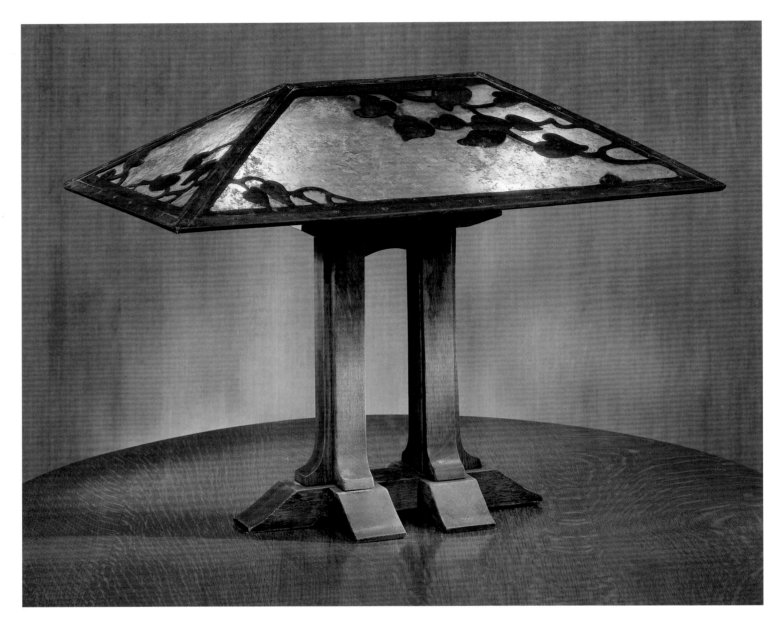

21

Electric Lamp, c. 1910

Oak, copper, and mica
18½ x 24 x 15⅝ in.
(47.0 x 61.0 x 39.7 cm)
Marks: under base, branded out-
line of craftsman planing wood
on workbench superimposed
on LIMBERTS | ARTS CRAFTS |
FURNITURE | TRADE MARK |
MADE IN | GRAND RAPIDS |
AND HOLLAND, all enclosed
within a rectangle
TR.9533
Collection of Max Palevsky
and Jodie Evans

ARTHUR *and* LUCIA MATHEWS'S FURNITURE SHOP

1906–20

San Francisco

The Furniture Shop is best known for its colorful carved and painted works in the so-called California decorative style.[18] However, the shop also supplied furnishings in a more sober arts and crafts vein, such as the center table (cat. no. 22), as well as in Chinese and Vienna secessionist styles.[19]

Arthur Frank Mathews (United States, 1860–1945) was a French-trained painter in the classical tradition. While director of the California School of Design he met and married his student, Lucia Kleinhans (United States, 1870–1955). After the San Francisco earthquake of 1906 the couple established the Furniture Shop with a part-

ner, John Zeile, to supply furniture, frames, and decorative wood objects to wealthy San Franciscans who were rebuilding.

The center table was designed for one of the Mathewses' most important commissions, the Masonic Temple of San Francisco. They collaborated on the complete interior design and furnishings scheme in 1913. The solemn appearance of the piece is consistent with its use in a fraternal edifice. Its simple design and oak construction relate it to Gustav Stickley's Craftsman furniture, but evidence of Arthur Mathews's beaux-arts training can be seen in the legs, which are treated as fluted columns.

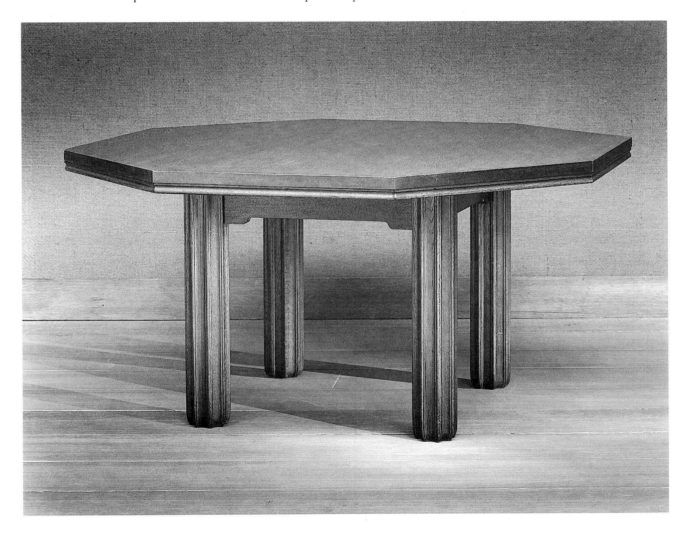

22

Center Table from the Masonic Temple, San Francisco, 1913

Oak
29 3/8 x 59 7/8 x 57 1/4 in.
(74.6 x 152.1 x 145.4 cm)

Marks: outside apron, near leg, branded FURNITURE | SHOP superimposed on a flower
L.88.30.76
Collection of Max Palevsky and Jodie Evans

BERNARD RALPH
MAYBECK

United States, 1862–1957

Berkeley

Bernard Maybeck, the most famous arts and crafts architect of Northern California, is best remembered for his timber-framed, shingled California chalets in the hills of Berkeley. He integrated his buildings with their sites in design and materials and imbued them with a particular atmosphere: "His empathic response to materials, color, and space helped him create buildings always notable in their power to evoke mood."[20] He did not as a rule design entire interiors in the manner of Frank Lloyd Wright or Greene and Greene, so his furniture is quite rare.

Maybeck studied architecture at the École des Beaux-Arts in Paris in the 1880s. He was employed by the New York firm of Carrère and Hastings before moving to the San Francisco area in 1890. While with the architectural office of A. Page Brown, Maybeck worked on the Swedenborgian Church commission with another young architect, A. C. Schweinfurth.[21] The design was regional and vernacular, drawing on the Spanish missions for inspiration: "The church is extremely simple, massive and its heavy tile covered roof supported by simple trusses of madrone trees with the bark on."[22] For

seating the architects designed what was to become the prototype for the period's ubiquitous "mission chairs" (cat. no. 23). Of broad profile with stocky frames and tule-grass seats, the chairs epitomized California's Spanish heritage. Despite their humble aspects they had subtle refinements in their shaped legs, flared feet, and angled back rails.

Brown, the supervising architect, sent one of the chairs to New York furniture manufacturer Joseph P. McHugh, who responded with a line of mission furniture.[23] McHugh's version of the chair lacked the commanding proportions and character of the original. Hundreds of copies by Stickley and other manufacturers varied the basic theme of straight stiles, perimeter stretchers, ladder back, and rush seat.

The hall chair (cat. no. 24) is attributed to Maybeck on the basis of its similarity to dining room chairs designed by the architect for Phoebe Hearst's country retreat, Wyntoon, built in 1902. The moody mountain castle was heavy and medieval, well matched to its site on a rushing river amidst immense redwood trees. The last line of Maybeck's description of the living room speaks

Bernard Maybeck, 1930

Swedenborgian Church,
San Francisco, 1896

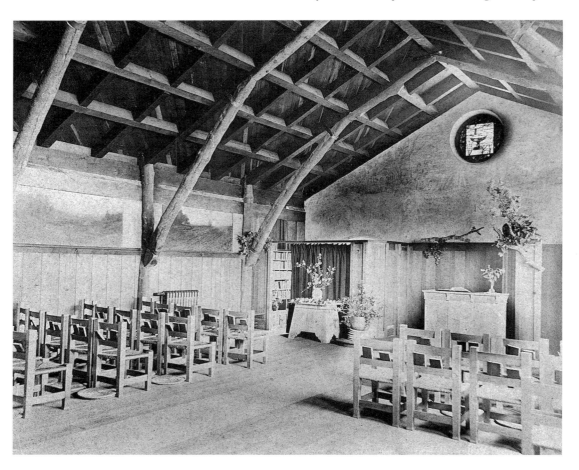

volumes about his philosophy of architecture: "The dark height of the room, the unobstructed archways, the deep blues, reds, and yellows of the cathedral window … the tapestries, the little flicker of fire, and the roaring of the river outside; and you, satiated, tired, and inspired by the day's trip among hazel, dogwood, great aged pines, rocks, cascades, great trunks of trees fallen years ago,—a dishevelled harmony,—here you can reach all that is within you." [24]

Similar chairs of plank construction with "keyhole" backs appear in contemporary photographs of the dining room, lined up alongside a massive trestle table.[25] Derived from medieval examples, the proportions have been exaggerated to accentuate the chair's visual effect. The pierced "handle" in the back is vestigial and decorative, the front leg repeats the shape of the crest rail, and a protruding mortise with key corresponds decoratively to the "hand hole" above. Completing the design is the intersection of angled planes, from which identical trapezoids form lower back and seat. The proportions were artfully conceived to integrate structural integrity with design.

23

Side Chair from the Swedenborgian Church, San Francisco, 1894

Oak and (replaced) tule grass
36¼ x 21 x 19¾ in.
(92.1 x 53.3 x 50.2 cm)
M.89.52
Purchased with funds provided by the Decorative Arts Council in honor of Patricia M. Fletcher in recognition of her dedicated service

24 ∧

Hall Chair, c. 1902

Oak
42 x 11¾ x 20⅛ in.
(106.7 x 29.8 x 51.1 cm)
TR.9349.3
Collection of Max Palevsky and Jodie Evans

CHARLES ROHLFS WORKSHOP

1898–1928

Buffalo

Charles Rohlfs (United States, 1853–1936) was among the most creative of American arts and crafts furniture manufacturers. His eccentric variations on the oaken-plank theme were a refreshing departure from line after commercial line of slat-sided rectangles that paid homage to Gustav Stickley's innovative forms. Rohlfs imbued his pieces with vitality and movement, celebrating structure and hardware with animated carvings. Most American designers subscribed to the Stickley school of restraint, mistrusting both Victorian ornamental abuse and art nouveau's unfettered wanderings. Rohlfs, however, delighted in using decorative motifs from other cultures, incorporating in his works styles as varied as medieval, art nouveau, prairie school, Moorish, Chinese, and Norwegian.[26]

Rohlfs turned to woodworking after abandoning a theatrical career as a condition of marriage—his first efforts motivated by the need for furnishings in his home—sometime in the 1880s.[27] His distinctive designs won wide recognition, and he opened a commercial workshop in 1898. Marshall Field and Company sponsored an exhibition of his pieces in 1900, and his exhibits at international expositions were well received. After one held in Turin in 1902 (as the only American woodworker invited), Rohlfs was made a fellow of the Royal Society of Arts in London and commissioned to provide a set of chairs for Buckingham Palace. His popularity in Europe is explained by the relationship of his designs to those of Liberty and Company, Charles Rennie Mackintosh, C. F. A. Voysey, and Italy's Carlo Bugatti. Rohlfs employed as many as eight assistants to produce his styles and aid him with the custom commissions he favored. A sales packet from 1907 leaves no doubt that he produced standard forms to order, with the warning that delivery for Christmas could not be guaranteed unless orders were placed early.[28]

Like Mackintosh, Rohlfs conceived of furniture as intensely visual utilitarian constructions. The planar quality of his designs balances the curves and whimsies of his carvings, asserting a dominant rectilinear structure that visually contains the decoration and distinguishes it from mature French art nouveau (see cat. no. 11).

Despite its highly decorative character Rohlfs's furniture is characteristically arts and crafts in its use of quarter-sawn oak, emphatic joinery, and vernacular design. Although less rhetorical than Stickley, Rohlfs sympathized with the movement as evidenced by his philosophy of design: "Does it enhance the appearance of the piece as a whole? Is it the natural outgrowth of the main idea? Is it suitable to the use to which the piece is put? All nature answers these questions for its own handiwork. My effort was to follow the guiding spirit of the manifestations of nature—I could do no more, if as much."[29]

Rohlfs's raison d'être for ornament was based on unity with his medium: "My feeling was to treat my wood well, caress it perhaps, and that desire led to the idea that I must embellish it to evidence my profound regard for a beautiful thing in nature. This embellishment consisted of line, proportion, and carving."[30]

Charles Rohlfs, 1920s

25

Desk, c. 1900

Oak with iron hardware
56⅛ x 25¾ x 24¾ in.
(142.6 x 65.4 x 62.9 cm)
Marks: inside desk, proper right
side, branded R within a bow saw
M.89.151.6
Gift of Max Palevsky
and Jodie Evans

This piece, with its swiveling
base, is probably based on the
English Davenport desk from
the late-Victorian and Edwardian
periods. In a *House Beautiful*
article of 1900 it was illustrated
as a "Swinging Writing Desk"
and described as "a very marvel
of complexity, with endless
delights in the way of doors,
pigeon-holes, shelves, and
drawers ... like nothing so much
as a miniature Swiss cottage." [31]
It was also illustrated in a Ger-
man journal, *Dekorative Kunst*,
the same year. [32] Of special note
is the complementary relation-
ship between the vigorous quar-
ter-sawn oak grain and the
carved designs. A few other
examples are known, all with
variations in the carvings. [33]

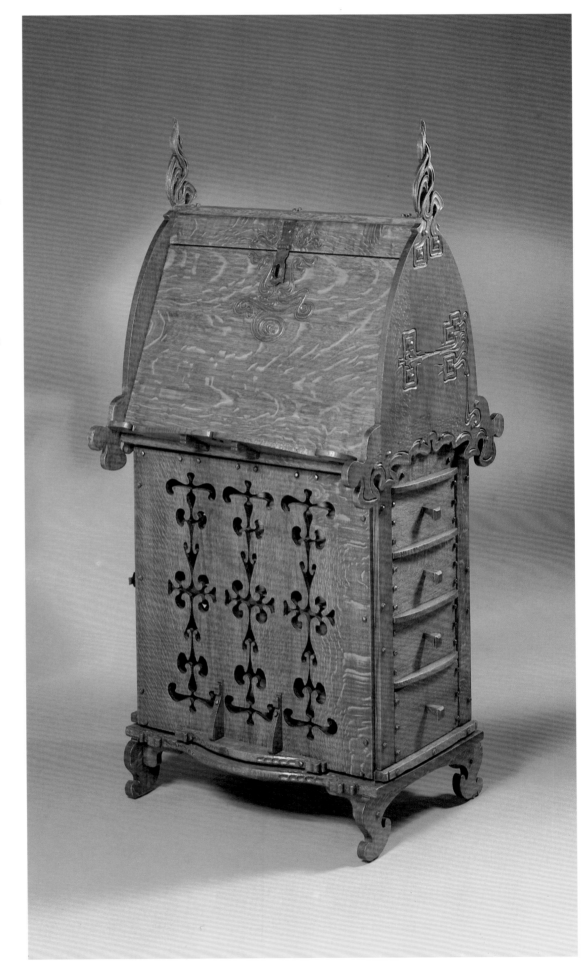

26

Hall Chair, c. 1900

Oak
56¾ x 19 x 15 in.
(144.1 x 48.3 x 38.1 cm)
Marks: under seat, branded R
within a bow saw
M.89.151.2
Gift of Max Palevsky
and Jodie Evans

Three examples, two privately
owned, of this classic Rohlfs
design are known, with minor
variations in the carving. Called
a "Hall Chair" in an article of
1900, it is the most visually
arresting of Rohlfs's pieces.[34] As
with certain seating designs of
Mackintosh visual effect is the
paramount consideration here,
a luxury permitted hall chairs.

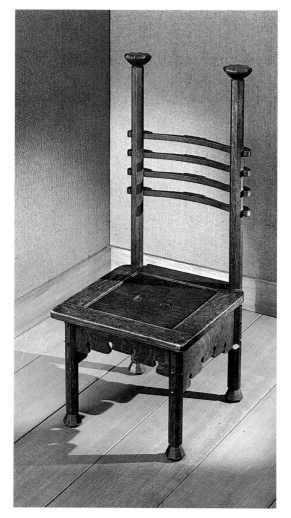

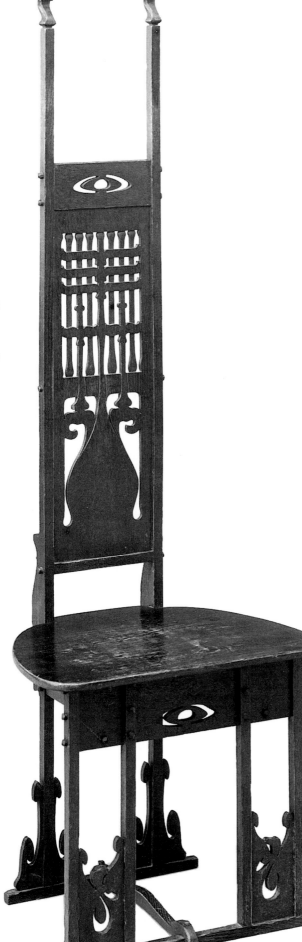

◄ 27

Side Chair, 1901

Oak
47 x 20 x 22⅝ in.
(119.4 x 50.8 x 57.5 cm)
Marks: outside rear seat rail,
proper left side, branded ʀ
within a bow saw | 1901, all high-
lighted in red
TR.9349.4
Collection of Max Palevsky
and Jodie Evans

Rohlfs supplied patron Darwin
Martin of Buffalo (see also cat.
nos. 230–31) with furniture that
included an example of this
chair.[35] The mushroom finials
relate to works by C. F. A. Voy-
sey (see cat. no. 2), while the
ladder back and pierced "hand-
hole" seat are vernacular refer-
ences. The placement of the
shaped rails and the contrast
between the low, heavy seat and
the tall back were carefully
orchestrated by Rohlfs, belying
the supposed folk effect.

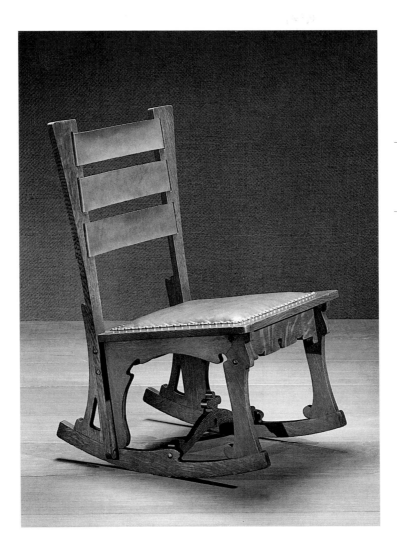

29

Rocking Chair, 1903

Oak, pine, and (partially
replaced) leather
33⅞ x 23¼ x 24⅜ in.
(86.0 x 59.1 x 61.9 cm)
Marks: outside rear seat rail,
proper left side, branded and
carved ʀ within a bow saw |
19 | 03
L.87.14.8
Collection of Max Palevsky
and Jodie Evans

One of Rohlfs's more common
seating forms, the rocking chair
(cat. no. 29) displays the curved
and notched carving typical of
his furniture. A much rarer seat-
ing design, the armchair (cat.
no. 28) is far more craftsmanlike.
Its heavy, geometric, planar
design and exposed tenons with
locking keys are indebted to
Gustav Stickley's Craftsman
furniture. Rohlfs infused his own
eccentric style in the arms and
arm supports and the oriental
carving on the back.

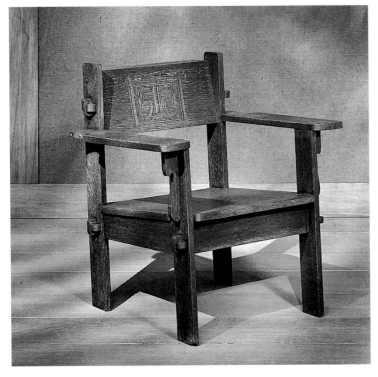

28

Armchair, 1902

Oak
32⅛ x 30⅛ x 26⅝ in.
(81.6 x 76.5 x 67.6 cm)
Marks: outside rear seat rail,
proper left side, branded ʀ
within a bow saw | 1902
L.87.14.7
Collection of Max Palevsky
and Jodie Evans

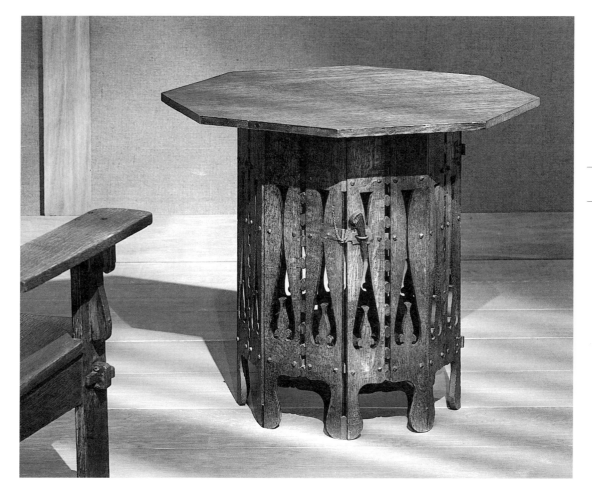

30

Octagon Table, c. 1905

Oak with iron hardware
29¼ x 34⅝ x 32 in.
(74.3 x 87.9 x 81.3 cm)
Marks: inside door, branded R
within a bow saw
L.87.14.12
Collection of Max Palevsky
and Jodie Evans

Rohlfs's 1907 sales catalogue
illustrates similar tables with
copper hinges and interior
shelves. A version more simply
carved than this example retailed
for twenty-seven dollars in oak,
while a more elaborately carved
piece was priced at one hundred
dollars.[36]

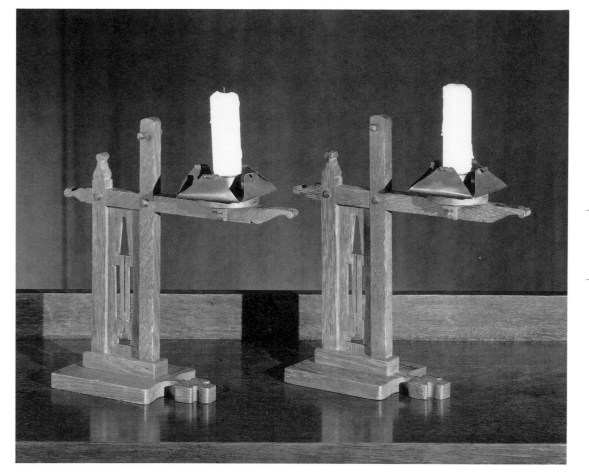

32a–b

Pair of Cresset Candlesticks,
1904 and 1905

Oak and copper
a: 13½ x 4½ x 13⅛ in.
(34.3 x 11.4 x 33.3 cm)
b: 13½ x 4½ x 13½ in.
(34.3 x 11.4 x 34.3 cm)
Marks: a) under base, branded R
within a bow saw beside 19 | 05;
b) under base, branded R within
a bow saw beside 19 | 04
TR.9349.2a–b
Collection of Max Palevsky
and Jodie Evans

31

Cathedral Sconce, 1905

Oak and copper, with copper-
plated brass nails and copper-
plated iron chain
38½ x 6⅞ x 6½ in.
(97.8 x 17.5 x 16.5 cm)
Marks: on back, branded R
within a bow saw beside 19 | 05
L.88.30.71
Collection of Max Palevsky
and Jodie Evans

More than half of the objects in
the 1907 sales catalogue are
candlesticks or small wooden
accessories, perhaps because of
the publication's Christmas ori-
entation. The Cathedral wall
sconce (cat. no. 31) was priced at
six dollars and included a "rich
red" candle. The repetition of
square rivets on the copper face-
plate relates to Vienna secession-
ist design, an unusual reference
in Rohlfs's work. Rohlfs may
have been introduced to Vien-
nese design at the nearby
Roycroft community, where he
lectured.[37] The copper was pati-
nated with a "Japanese bronze
finish." The Cresset candlesticks
(cat. no. 32a–b) retailed for two
dollars and fifty cents apiece.
Rohlfs illustrated some of
his candle holders with shell
shades that could be purchased
separately.[38] The varying dates
on the two candlesticks suggest
that Rohlfs kept a ready supply
and assembled pairs for his
clients.

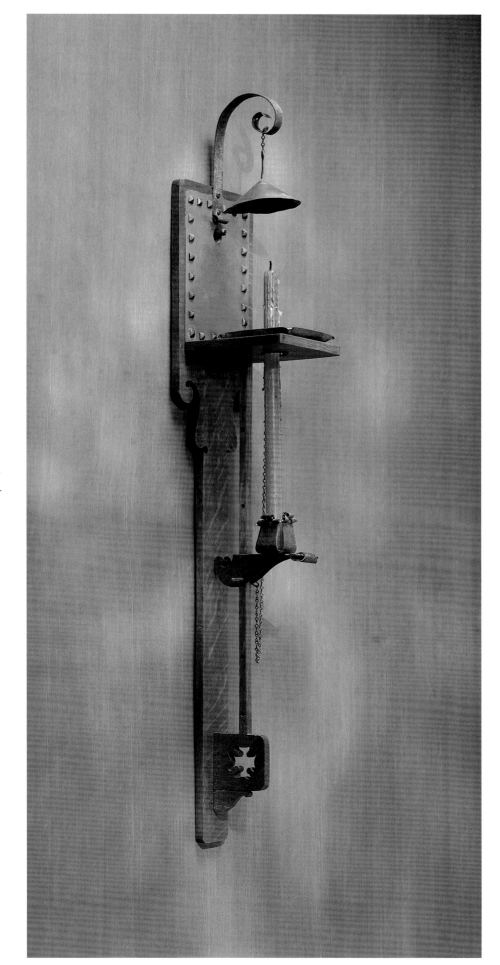

THE FURNITURE SHOP OF THE ROYCROFTERS

1895–1938

East Aurora, New York

The Roycroft community was founded by one of the movement's great proselytizers, Elbert Green Hubbard (United States, 1856–1915).[39] Like the other American crusader, Gustav Stickley, Hubbard was inspired by a trip to England, specifically by a visit he paid to William Morris at Merton Abbey. Hubbard devoted himself to his newfound passion for the arts and crafts with the same zeal that had made him a successful soap promoter for the Larkin Company in Buffalo. Already a budding author, Hubbard established his own version of Morris's Kelmscott Press in 1895, calling it the Roycroft Press after the seventeenth-century bookbinding partners, Samuel and Thomas Roycroft. Hubbard also appreciated the name's literal translation, "king's craft," with its appropriate guild connotations. The press begat a bindery, which in turn begat a leather shop, giving substance to Hubbard's dream of a craft community.

Furniture was produced as early as 1896 for internal use, offered in mail order catalogues by 1901, and distributed to hundreds of retailers nationally between 1915 and 1938.[40] Roycroft pieces were available in mahogany and ash, although dark, fumed oak was the most popular choice. Hubbard's symbol, a double-barred cross enclosing an R, identified most Roycroft creations. This symbol appeared not only on the community's handcrafts but also on less-enduring marketing ploys such as mousetraps and candy boxes, often with a moralistic axiom attached.

The need for suitable furniture hardware spawned a metalworking component, which became the Copper Shop in about 1903. Collectively the Roycroft craftsmen were known as Roycrofters, and Hubbard marketed the community as well as its products, opening an inn in 1903 to serve the lucrative tourist trade. He also

invited important personages to lecture for the benefit of the community and its visitors. Such celebrities included Gutzon Borglum, Clarence Darrow, Eugene Debs, Henry Ford, Margaret Sanger, and Booker T. Washington, among others.[41]

Keenly aware of the power of the pen, Hubbard published two periodicals, appropriately titled *The Fra* and *The Philistine*, as philosophical mouthpieces for his arts and crafts ideas and their embodiment at Roycroft. Fra Elbertus was a charismatic secular evangelist with an acute sense of marketing and psychology. Using his name as a title reflected the fraternal concept of the community and referred to the chief "brother," Hubbard himself. The title of *The Philistine* suggested the unconventional, avant-garde philosophies of the community.

Hubbard and his wife perished aboard the *Lusitania* in 1915. Their son, Elbert Hubbard, Jr., assumed directorship of the Roycrofters until the community closed in 1938.[42]

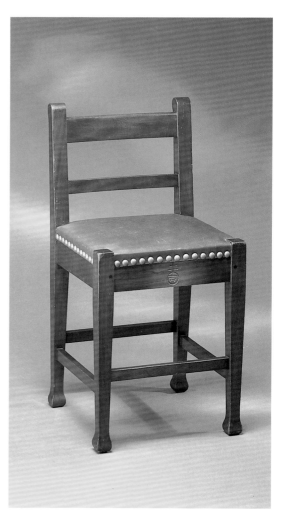

From left: Historian George Wharton James, humorist Marshall P. Wilder, and Elbert Hubbard, c. 1912

33

Marshall P. Wilder Chair,
c. 1906–c. 1912

Mahogany, oak, (replaced)
leather, and brass
35 1/16 x 17 x 17 1/4 in.
(89.1 x 43.2 x 43.8 cm)
Marks: on front seat rail, carved
orb and double-barred cross
enclosing R
M.89.151.28
Gift of Max Palevsky
and Jodie Evans

Pictured as the "Marshall P.
Wilder Chair," this piece was
offered in a 1912 catalogue "as
an intermediate between baby's
high-chair and an ordinary
dining-chair." [43] It was originally
designed and named for Wilder,
a dwarf who frequented Roy-
croft. The distinctive feet, copied
from the works of A. H. Mack-
murdo, appear on a number of
Roycroft pieces.[44]

34

Magazine Pedestal,
c. 1906–c. 1912

Oak
63 3/4 x 21 1/8 x 17 7/8 in.
(161.9 x 53.7 x 45.4 cm)
Marks: on both sides, carved orb
and double-barred cross enclos-
ing R
L.88.30.82
Collection of Max Palevsky
and Jodie Evans

As with much American arts and
crafts furniture the primary dec-
oration on this piece consists of
construction details: canted sides
for stability and carved keys
locking through tenons. While
this example is carved with a
fleur-de-lis design on the side,
examples are also known with
leaf designs.[45]

35

Motto Plaque, c. 1912

Oak
9 x 52 1/4 x 1 in.
(22.9 x 132.7 x 2.5 cm)
Inscriptions: IN RECOGNITION OF
THE BLESSINGS | OF GOD THIS
HOME IS DEDICATED TO | FAITH
HOPE AND LOVE
Marks: on front, at both lower
corners, carved orb and double-
barred cross enclosing R
TR.9349.9
Collection of Max Palevsky
and Jodie Evans

Roycroft mottoes were ubiqui-
tous in the community and its
literature. They adorned door-
ways, gift cards, and such
objects as this wooden plaque.
Customers could have their own
sayings inscribed, but the phrase
on this example is typical of
Roycroft and refers to 1 Corin-
thians 13:13: "And now abideth
faith, hope, love, these three; but
the greatest of these is love." In
designing his mark, Hubbard
sectioned the orb into three
parts, symbolizing faith, hope,
and love.

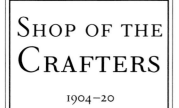

SHOP OF THE CRAFTERS

1904–20

Cincinnati

The Shop of the Crafters in Cincinnati was founded by Oscar Onken (United States, 1858–1948) in about 1904.[46] Onken was impressed with the Austro-Hungarian exhibits at the 1904 Louisiana Purchase Exposition in St. Louis, exhibits that composed the most complete display of Vienna secessionist design in America. He subsequently hired the person responsible for the works, design professor Paul Horti (Hungary, 1865–1907, active United States). A 1906 trade catalogue credited Horti with introducing "a touch of inlay work of colored woods or metal, that enlivens the strong simple lines of Mission furniture."[47] The most progressive designs in the catalogue, however, were found in the suggestions for interiors, which included forms not offered for sale. Perhaps Onken believed mature secessionist design was too sophisticated for American consumers.

The pattern on the armchair (cat. no. 36)—geometric stylizations of floral motifs—is typical of the firm's inlay designs and was repeated on a number of pieces. The square and rectangular lattice sides relate to Viennese examples.

The desk and its chair (cat. no. 37a–b) contrast with the armchair in structure and materials; they are perhaps the finest pieces produced by the firm. Kenneth Trapp has noted: "The elegant proportions and subtle grace ... separate them from other furniture produced by The Shop."[48] The desk is a one-piece version of a seventeenth-century form, the desk-on-frame. Its arched trestle feet and general lightness of design suggest derivation from similar British arts and crafts examples, also revived cabinet-on-frame forms. The art nouveau peacock feather inlay contrasts with the geometric styling seen on the armchair. Indeed the curving stiles and stretcher of the desk chair relate to Jugendstil, the German version of art nouveau. The lighter design of the chair and desk called for a less ponderous material than quarter-sawn oak, so both pieces were offered in "Dull or Polished Mahogany."[49]

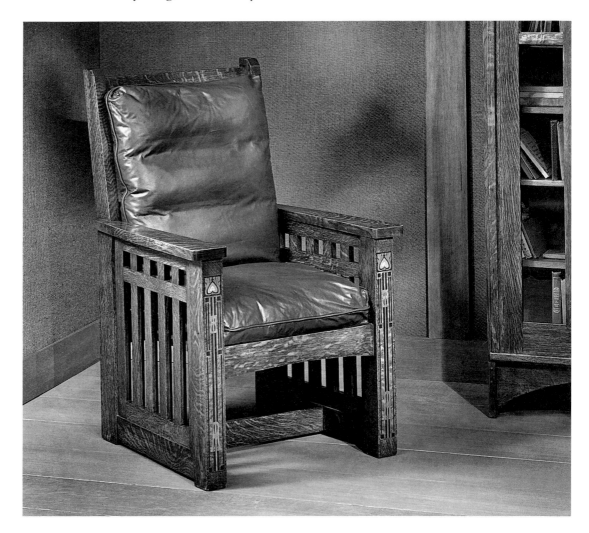

36

Armchair, c. 1910

Probably designed by Paul Horti
(Hungary, 1865–1907, active
United States)
Oak, burled birch, tulipwood,
ebony, boxwood, and (replaced)
leather
44 ⅜ x 28 ¼ x 29 ½ in.
(112.7 x 71.8 x 74.9 cm)
Marks: on seat, under cushion,
printed on paper label, SHOP OF
THE | CRAFTERS | TRADE MARK
(flanking lantern) | AT CINCINNATI |
OSCAR ONKEN CO. SOLE OWNERS,
all enclosed within a rectangle
L.88.30.68
Collection of Max Palevsky
and Jodie Evans

37a–b

Desk and Chair, c. 1910

Probably designed by Paul Horti
(Hungary, 1865–1907, active
United States)
Mahogany, boxwood, pearwood,
mansonia, sycamore, lacewood,
leather, and brass
Desk: 48 ⅛ x 39 ¼ x 18 ¼ in.
(122.2 x 99.7 x 46.4 cm)
Chair: 33 x 15 ⅜ x 18 ⅛ in.
(83.8 x 39.1 x 46.0 cm)
Marks: on back of desk, printed
on paper label, SHOP OF THE |
CRAFTERS | TRADE MARK (flanking
lantern) | AT CINCINNATI | OSCAR
ONKEN CO. SOLE OWNERS, all
enclosed within a rectangle
M.89.151.25a–b
Gift of Max Palevsky and
Jodie Evans

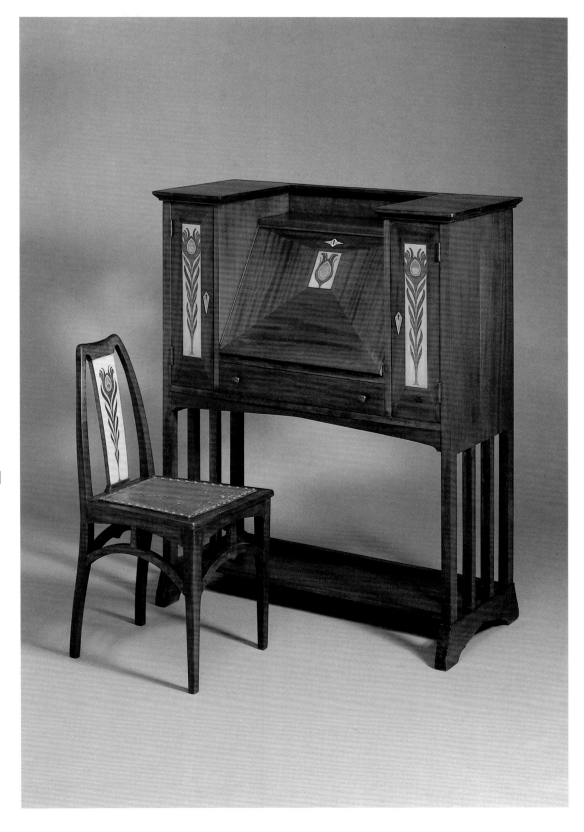

STICKLEY BROTHERS COMPANY

1891–1954

Grand Rapids

The Stickley Brothers Company was founded by Gustav Stickley's brothers Albert (United States, 1863–1928) and John George (United States, 1871–1921) in Michigan in 1891 (see the Gustav Stickley entry for the early history of the Stickley brothers).[50] John George later returned to New York to join another brother, Leopold, in establishing the L. and J. G. Stickley Company in 1902 (see separate entry). By the turn of the century Grand Rapids had become a major furniture production center, holding an annual furniture trade fair. The city's preeminent position in the industry must have motivated the brothers to relocate from New York. The company did not immediately market arts and crafts lines, however, and followed the lead of their brother Gustav's firm, Craftsman Workshops, in introducing their Quaint furniture line around 1900.

A pervasive English influence characterizes the firm's Quaint pieces. Indeed the company operated a factory and showrooms in London from 1897 to 1902, providing ample exposure to contemporary English arts and crafts, even before Gustav made his seminal trip in 1898. The side chair (cat no. 39) is decidedly English in character, with its tapered stiles and elegant proportions.[51]

Stickley Brothers introduced their line of inlaid furniture in 1901, two years before Harvey Ellis so influenced production at Gustav Stickley's establishment. The brothers subcontracted their inlay orders to another Grand Rapids firm, T. A. Conti and Company, which advertised itself as "designers and manufacturers of fancy inlaid work."[52] The senior member of the firm, Timothy A. Conti, had earned gold medals for his products at world expositions in Malta, Florence, and London.[53] City directories for Grand Rapids record Conti independently from 1895 to 1899, as an employee of Stickley Brothers from 1900 to 1903, and thereafter with his own firms. If the chairs date earlier than 1904, then he may have done the inlay while at Stickley Brothers.

The hall chair (cat. no. 38) is an eloquent example of the company's finest work and curiously combines British and Japanese design. Both the cutout in the lower back and the stretcher arrangement have British arts and crafts antecedents, as does the plank form itself. The asymmetrical and naturalized rendering of the floral inlay is indebted to the popularity of Japanese art in late nineteenth-century America.[54] Of special note is the manner in which the

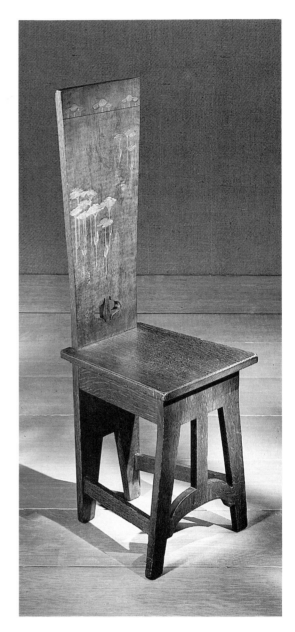

inlay meanders off the edges, in contrast with the side chair's inlay and the rigidly contained, stylized, symmetrical work of Harvey Ellis, the Shop of the Crafters, the Charles P. Limbert Company, or on other English-derived American examples. The only comparable inlay style, found in the works of Greene and Greene, was also influenced by oriental art.[55]

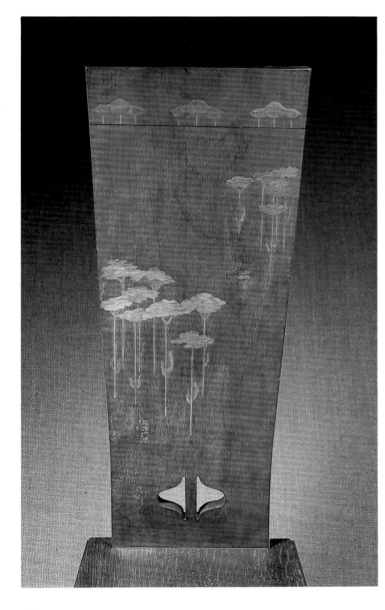

< Cat. no. 38 (detail)

< 38

Hall Chair, c. 1905–10

Inlay by Timothy A. Conti
(before 1904), T. A. Conti and
Company (1904–7), or T. A.
Conti and Son (1907–37),
Grand Rapids
Oak, walnut, tulipwood, and
beech
44⅛ x 13¼ x 16 in.
(112.1 x 33.7 x 40.6 cm)
Marks: inside back, below seat,
printed on oval paper label
affixed with tacks, MADE BY |
STICKLEY BROS. CO. | GRAND
RAPIDS, MICH., all enclosed
within an oval
M.89.151.13
Gift of Max Palevsky
and Jodie Evans

39 >

Side Chair, c. 1905–10

Inlay by Timothy A. Conti
(before 1904), T. A. Conti and
Company (1904–7), or T. A.
Conti and Son (1907–37),
Grand Rapids
Mahogany, ebony, and pewter,
with cotton upholstery
39¾ x 17⅝ x 17⅞ in.
(101.0 x 44.8 x 45.4 cm)
M.90.36
Gift of D. J. Puffert in honor of
Tiffany K. Puffert

Cat. no. 39 (detail) >

GUSTAV STICKLEY'S CRAFTSMAN WORKSHOPS

1899–1916

Eastwood and New York,

New York

Gustav Stickley (United States, 1858–1942) was born Gustave Stoeckel in Wisconsin to German immigrant parents who Americanized their name to Stickley. A stonemason's son, he left school after the eighth grade to help support his family; as the eldest son, he shouldered much of the burden when his father left home. His unhappy reminiscences of stonemasonry may explain in part his attitudes toward machinery in the arts and crafts movement. In contrast with English intellectuals, Stickley knew firsthand the joys and toils of handwork: "It was heavy and tedious labor, much too hard for a boy of my age, and being put to it so early gave me an intense dislike for it. Had I been older and stronger, I might not have realized so keenly its disagreeable features, but as it was ... the toil itself meant the utmost physical strain and fatigue."[56]

In the mid-1870s the Stickley family moved east to Brandt, Pennsylvania, into the care of Gustav's uncle, Jacob Schlaeger. The Stickley boys went to work in his chair factory. In woodworking Gustav found a favorable alternative to stonemasonry: "It was the most common-place of stereotyped work, yet from it, I can date my love for working in wood."[57] He left the factory in 1884 to start a furniture business with his two younger brothers, Charles and Albert, in Binghamton, New York. When in 1899 he established United Crafts, the forerunner of Craftsman Workshops, Stickley had been associated with a number of family furniture concerns, logging twenty-five years in the furniture industry.

Stickley turned to simpler, more vernacular design as early as the late 1880s, when, lacking capital for sophisticated machinery, he produced crude chairs. His full conversion to arts and crafts design occurred after a trip to England in 1898, from which he returned to found the United Crafts.

Although Stickley is often credited as being the father of the American arts and crafts movement, he is better designated its chief promoter. When he founded his workshops, the movement was already known in the United States through domestic and international journals such as *The House Beautiful*, *International Studio*, and *Deutsche Kunst und Dekoration*. The Roycroft community was already producing furniture, as was Charles Rohlfs. Arts and crafts societies had been formed in Boston and other cities. Stickley was joining a small tide of sentiment that sided

with English philosophies of art and labor. What he contributed was mass marketing, publicity, and a unique American style.

Stickley sited his United Crafts near Syracuse, New York. Modeling it on Morris and Company, he assembled woodsmen, metalsmiths, and leather workers to "produce ... articles which shall justify their own creation; which shall serve some actual and important end in the household ... by ... providing agreeable, restful and invigorating effects of form and color, upon which the eye shall habitually fall, as the problems of daily existence present themselves for solution. Thus, it is hoped to ... create ... an art developed by the people, for the people, as a reciprocal joy for the artist and the layman."[58]

Stickley used a joiner's compass as the firm's trademark, accompanied by the motto *Als ik kan*, the Flemish version of William Morris's motto, *Si je puis*, meaning "as I can," or in a broader reading, "to the best of my abilities." Stickley's signature was stamped below the trademark, connoting his (unlikely) inspection of every piece.

In contrast with the practices of his arts and crafts contemporaries, Stickley launched his furniture at the Grand Rapids Furniture Fair in 1900, far from the artistic exposition arenas and sympathetic halls of arts and crafts societies. A seasoned manufacturer, he courted the retailers that would make or break him. His successful debut and subsequent exhibitions not only sold his new style, they also inspired numerous imitators, his brothers Leopold and John George among them. They closely modeled their firm, L. and J. G. Stickley, on the example of Gustav's company.

As Stickley's business prospered, he expanded it to include metalwork accessories, lighting, and textiles. In 1904 he changed the name to Craftsman Workshops, a humble moniker for a thriving factory. While Stickley's metalwork and embroidery were largely handcrafted, he could not afford to meet the needs of his demanding middle-class furniture market without using machinery to speed tedious tasks and free the craftsmen for carving and finish work. Although his promotional literature furthered the handmade creed, Stickley acknowledged the valuable role of machinery in a 1906 article, "The Use and Abuse of Machinery, and Its Relation to the Arts and Crafts," in which he clarified his attitudes:

NEW FVRNITVRE

FROM THE WORK SHOP

GVSTAVE STICKLEY
CABINET MAKER
SYRACVSE NY VSA

no 1

As a matter of fact, given the real need for production and the fundamental desire for honest self-expression, the machine can be put to all its legitimate uses as an aid to, and a preparation for, the work of the hand, and the result be quite as vital and satisfying as the best work of the hand alone.... The modern trouble lies not with the use of machinery, but with the abuse of it, and the hope of reform would seem to be in the direction of a return to the spirit which animated the workers of a more primitive age, and not merely to an imitation of their method of working.[59]

In 1901 Stickley commenced publication of *The Craftsman*, a monthly journal that became the mouthpiece of the American movement. As editor, he included philosophical and practical treatises on the meaning and implementation of the arts and crafts life-style in middle-class America. *The Craftsman* was amply illustrated with suitable suggestions for interiors, offered Craftsman house plans to subscribers through a special club, and published instructions on how to make Craftsman furniture. The success of Craftsman lines and publications established a generic meaning for the term, connoting the American style that grew out of Stickley's example.

Stickley consolidated his retail and publishing empire in a New York City office building in 1913, but the move proved financially unsound, coinciding with a wane in popular sentiment for his oft-copied stark and simple styles. After Stickley's declaration of bankruptcy in 1915 and a later abortive reorganization attempt, Craftsman Workshops was taken over in 1918 by L. and J. G. Stickley of Syracuse. The last issue of *The Craftsman* appeared in 1916.

Craftsman furniture is characterized by thick boards of quarter-sawn white oak, visible mortise-and-tenon joinery, and heavy, cast and hammered hardware. White oak, a native wood, was suitable for Stickley's new American style. It was also among the strongest and most enduring of woods. Preindustrial carpenters had found oak easier to rive than saw, because it split naturally along medullary rays, revealing a unique ribboned grain. Riven oak was also less susceptible to shrinkage and expansion. Quarter-sawn oak, sawn parallel to its radial structure in imitation of riving, appealed to Stickley for these reasons. He

used panel-and-frame construction and mortise-and-tenon joinery because these techniques also had preindustrial associations and permitted expansion and shrinkage with minimal damage. Eighteenth-century cabinetmakers had abandoned these techniques because they resulted in heavy mass, limited height, and design inflexibility, but these qualities were assets to Stickley, who sought to produce solid furniture suitable for middle-class homes.

Although hailed now as a forerunner of modernism, Stickley relied upon historical antecedents for many of his methods and designs. The arts and crafts movement's emphasis on integration of form and function without superfluous ornament presaged modern concepts, but Stickley and designers such as M. H. Baillie Scott and C. F. A. Voysey derived most of their inspiration from preindustrial, vernacular examples conceived of with little or no regard for design. Stretchers, gatelegs, trestle bases, and brass-tacked leather—all had seventeenth-century origins. Stickley's designs for leather dining chairs, gateleg tables, solid-backed settles, corner cupboards, and taborets were indebted to colonial American works. His sideboards, low settles, strap hinges, and trestle-footed tables had obvious English counterparts.[60] Stickley moved beyond English styles by deliberately over-constructing his pieces, emphasizing their solidity and endurance.

There is a larger distinction than American versus English sources that should be mentioned when discussing Stickley's work. His oeuvre can be divided into two groups: one consisting of designs associated with the tradesman himself; the other consisting of works designed or influenced by Harvey Ellis.[61]

Stickley was mistrustful of design for its own sake; his forms rarely attain the graphic impact of pieces by Rohlfs or Mackintosh. He adhered strictly to his utilitarian creed of comfort and solidity and spurned ornament entirely. He described his forms as being expressive of "*the primitive structural idea*: that is, the form which would naturally suggest itself to a workman, were he called upon to express frankly and in the proper materials, the bare essential qualities of a bed, chair, table, or any object of this class."[62] Stickley was in fact not a designer, but a craftsman, and his works reflect an expert's preoccupation with structure and materials. All the

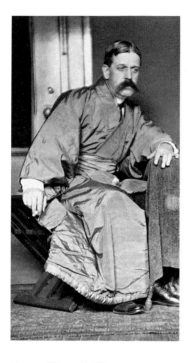

Harvey Ellis, c. 1885

40

Divan, 1901–3

Oak and (replaced) leather
40¼ x 61¼ x 27⅜ in.
(102.2 x 155.6 x 69.5 cm)
Marks: outside rear seat rail, red
decal of compass enclosing ALS |
IK | KAN over script signature
STICKLEY enclosed within a
rectangle
M.89.151.9
Gift of Max Palevsky
and Jodie Evans

This early piece has subtle
arches in the splat design,
tapered stiles, and a relieved
seat rail. Stickley abandoned
this style almost immediately in
favor of plainer forms, but Ellis
reintroduced such touches in
1903. Remnants of the divan's
original, laced, green leather
upholstery assisted in the fab-
rication of the present version.

same, he came closer to Ruskin's ideal of the
united craftsman/designer than Ruskin's own
countrymen.

The second Stickley style was introduced by
an architect, Harvey Ellis (United States, 1852–
1904), who was hired in 1903 to provide designs
for *The Craftsman*. His influence on Stickley's
furniture was palpable and immediate. He was a
brilliant designer with a sensitive and sophisti-
cated command of British arts and crafts styles.
His motifs and interiors reveal a strong alle-
giance to the works of Mackintosh.

Ellis refined Stickley's style, introducing an
alluring sensitivity. He elongated and lightened
the pieces with taller proportions, thinner
boards, broad overhangs, and arching skirts. He
maintained the direct integrity of Stickley's look,
but dispensed with oversized joints and hardware
in favor of line and form. He used ornament—
dramatic attenuated inlays of stylized floral pat-
terns in pewter, copper, and colored woods—to
effect a unique balance of European sophistica-
tion with American simplicity. For example,
compare the Ellis library table (cat. no. 54), a
straightforward, trestle-footed generic form of
dark, textural oak accented with dramatic inlaid
patterns, with the Olbrich jewelry coffer (cat. no.
8), a small ebonized cabinet with beguiling pro-

portions and asymmetrical ivory and abalone in-
lay. Both employ Mackintosh-style motifs, but to
different aesthetic purposes.

Stickley must have swallowed hard to permit
Ellis's inlay. Ornament without structural pur-
pose was anathema to him, a "parasite ... [ab-
sorbing] the strength of the organism on which it
feeds."[63] He went to great lengths to rationalize
the plantlike forms as organic elements that
"seem to pierce the surface of the wood from
beneath."[64] Yet he admitted the beauty of the
designs, advertising them as "Lighter in Effect
and More Subtle in Form than any former pro-
ductions ... [with] an added Color-Element in-
troduced by means of wood-inlay, in designs of
great delicacy, founded upon plant forms which
are obscured and highly conventionalized."[65]

However elegant, Ellis's labor-intensive de-
signs were expensive, and production never ex-
ceeded the promotional needs of retailers and
expositions.[66] Evidently the furniture was over-
priced for Stickley's middle-class market, and he
discontinued most of it shortly after Ellis's death
in 1904. With or without inlay Craftsman furni-
ture continued to show Ellis's influence. In at
least one instance Stickley reintroduced the inlay
on a line of maple furniture offered after the
architect's death (see cat. nos. 57–58).

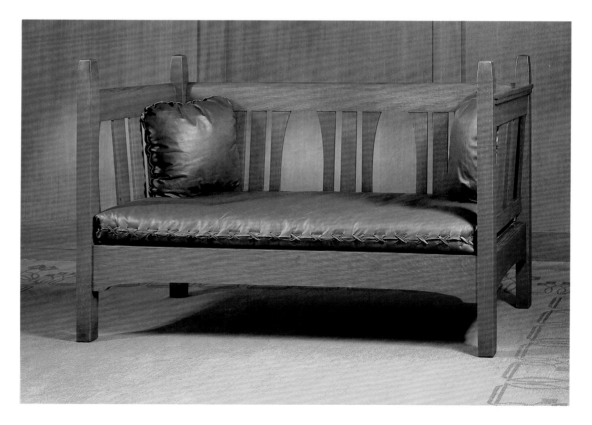

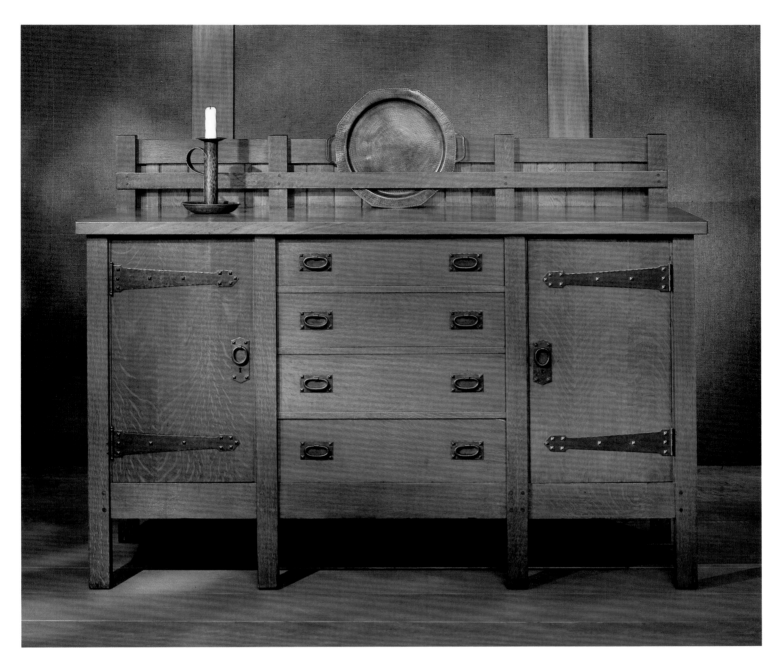

41

Sideboard, 1912–16

Oak and mahogany, with iron
hardware
50⅛ x 70 x 25¼ in.
(127.3 x 177.8 x 64.1 cm)

Marks: on proper right side of
top drawer, branded compass
enclosing ALS | IK | KAN over
script signature STICKLEY; under
top drawer, printed on paper
label, CRAFTSMAN | compass
enclosing ALS | IK | KAN over
script signature STICKLEY flanked
by TRADE | MARKS | REG'D and IN
U.S. | PATENT | OFFICE, all over
THIS PASTER TOGETHER WITH
MY DE- | VICE AND SIGNATURE
(BRANDED) ON A | PIECE OF FUR-
NITURE STANDS AS MY | GUARANTEE
TO THE PURCHASER THAT | THE
PIECE IS MADE WITH THE SAME |
CARE AND EARNESTNESS THAT HAS |
CHARACTERIZED ALL MY EFFORTS |
FROM THE BEGINNING, AND IS
MEANT | TO IMPLY THAT I HOLD
MYSELF RE- | SPONSIBLE FOR ANY
DEFECTS IN MATE- | RIAL, WORK-
MANSHIP OR FINISH THAT | MAY
BE DISCOVERED BY THE PUR- |
CHASER EVEN AFTER THE PIECE
HAS | BEEN IN USE FOR A REASON-
ABLE | LENGTH OF TIME, AND THAT
I WILL | EITHER MAKE GOOD ANY
DEFECTS OR | TAKE BACK THE
PIECE AND REFUND | THE PUR-
CHASE PRICE. | THIS PIECE WAS
MADE IN MY | CABINET SHOPS
AT EASTWOOD, N.Y. | GUSTAV
STICKLEY, all enclosed within
a rectangle

L.89.20
Collection of Max Palevsky
and Jodie Evans

Although this sideboard dates
from 1912–16, Stickley introduced
the design late in 1901 and main-
tained it with minor variations
throughout his career.[67] One of
his pre-Ellis forms, it embodies
the "primitive structural idea,"
relying upon the bold frame-
work, quarter-sawn grain pat-
tern, batten-board gallery, and
iron hardware for decorative
effect. The horizontal mass
could be overpowering, but visu-
ally it is relieved by the center
bay of drawers, to which the eye
is drawn by strap hinges on
flanking cabinet doors that point
to the central section. Also
arresting the horizontal move-
ment are eight legs, two of
which define the drawer area.
These correspond to two in the
rear that extend above the body
of the work to intersect with the
horizontal plate rail.

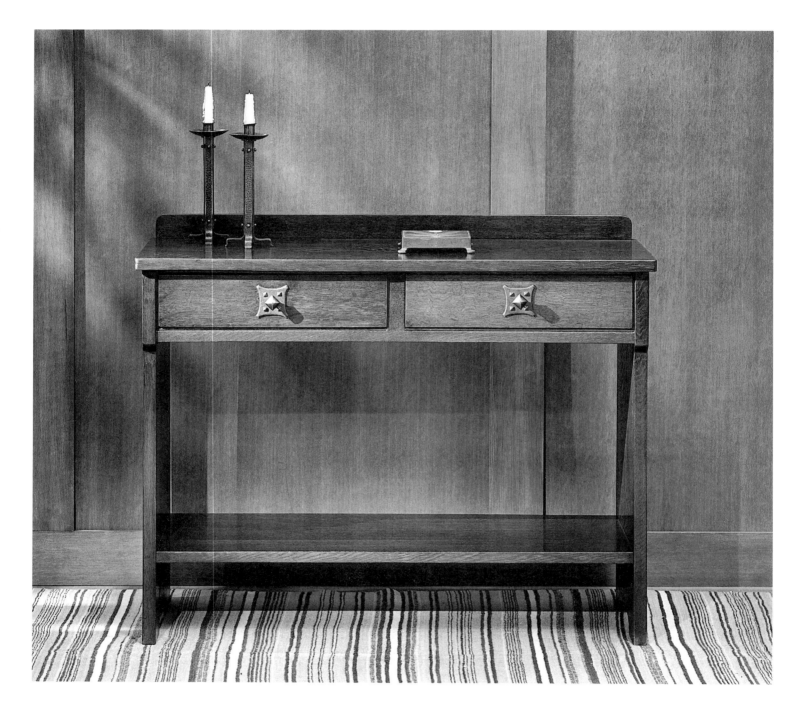

42

Serving Table, c. 1902

Oak with iron hardware
38¼ x 48 x 19¾ in.
(97.2 x 121.9 x 50.2 cm)
TR.9408.7
Collection of Max Palevsky
and Jodie Evans

This early serving table, illus-
trated in a 1902 catalogue, was
probably discontinued by 1904.[68]
The form is a satisfying balance
of strong horizontals contained
within broad plank sides that are
punctuated with exposed flush
tenons. The hardware design is
one of the earliest hand-forged
types used on Stickley's pieces.

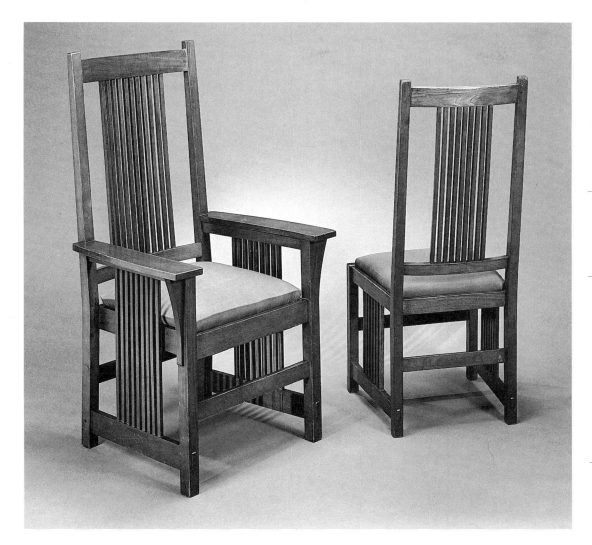

43

Armchair, 1905–9

Mahogany and (replaced) upholstery
47¼ x 27½ x 25 in.
(120.0 x 69.9 x 63.5 cm)
Marks: outside rear stretcher, proper right side, red decal of compass enclosing ALS | IK | KAN over script signature GUSTAV STICKLEY
M.89.151.12
Gift of Max Palevsky and Jodie Evans

44

Side Chair, 1905–9

Mahogany and (replaced) upholstery
47⅞ x 19⅛ x 21⅜ in.
(121.6 x 48.6 x 54.3 cm)
Marks: outside rear stretcher, proper right side, red decal of compass enclosing ALS | IK | KAN over script signature GUSTAV STICKLEY
TR.9349.12
Collection of Max Palevsky and Jodie Evans

45

Round Table, 1905–9

Oak
30⅛ x 29¾ (diam.) in.
(76.5 x 75.6 cm)
TR.9349.13
Collection of Max Palevsky and Jodie Evans

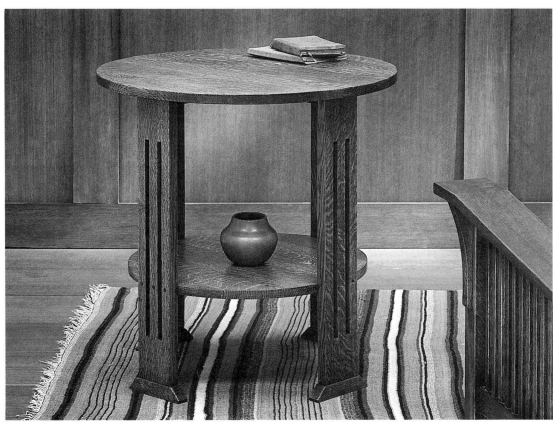

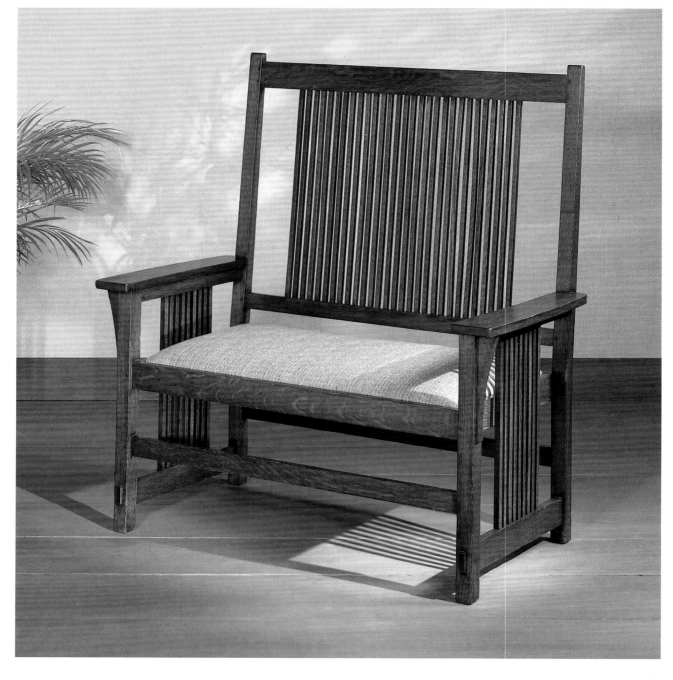

46

Settle, 1905–9

Oak and (replaced) upholstery
48⅞ x 47½ x 25⅛ in.
(124.1 x 120.7 x 63.8 cm)
Marks: outside rear stretcher,
proper right side, red decal of
compass enclosing ALS | IK | KAN
over script signature GUSTAV
STICKLEY
L.88.30.85
Collection of Max Palevsky
and Jodie Evans

47

Library Table, 1905–9

Oak

28⅝ x 48¼ x 29¾ in.
(72.7 x 122.6 x 75.6 cm)
Marks: on underside of table,
on fragments of paper label,
PATENTED [? 1]905. | [NO... FIN...
UPH...] | circular seal with THE
CRAFTSMAN WORKSHOPS | GUSTAV
STICKLEY in circular formation
surrounding compass enclosing
ALS | IK | KAN, the seal flanked by
TRADE MARK, all over DESIGNED
AND MADE BY | script signature
GUSTAV STICKLE]Y | [EASTWOOD,
N.]Y., all enclosed within a
rectangle
TR.9365.13
Collection of Max Palevsky
and Jodie Evans

Stickley introduced his spindle
furniture in 1905, producing
it until about 1909. A 1906
advertisement noted that the
spindle pattern "was designed
for use where the more solid and
massive type was not suitable." [69]
Variations of the round table,
library table, and reclining chair
(cat. nos. 45, 47–48) are illus-
trated in the ad. With the excep-
tion of Ellis's chair designs, the
tall-backed seating forms (cat.
nos. 43–44, 46) are Stickley's
only references to the high-
backed examples of Mackintosh
and Wright. Indeed the use
of spindles was undoubtedly
derived from Wright, who had
introduced them in furniture
and interiors in the late 1890s.

Craftsman catalogues offered
most designs in a choice of
woods. Although fumed oak
was the most popular selection,
mahogany, as seen in the arm-
chair and side chair (cat. nos. 43–
44), was a more expensive
alternative.

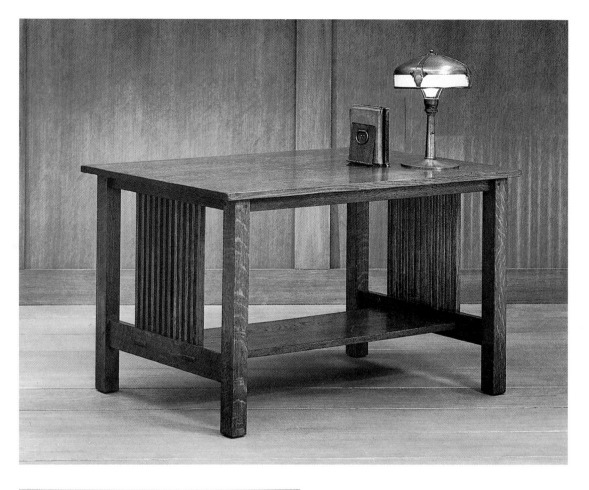

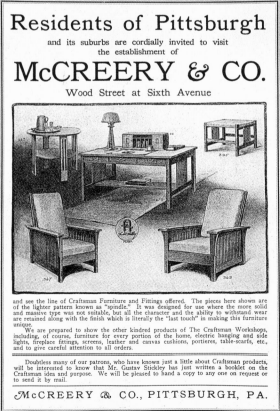

48

Reclining Chair, 1906–7

Oak and (replaced) upholstery
39⅝ x 32¾ x 41 in.
(100.6 x 83.2 x 104.1 cm)
Marks: inside rear seat rail,
printed on paper label, [NO]…369
(numbers handwritten in pencil)
FIN… UPH… | circular seal with
THE CRAFTSMAN WORKSHOPS |
| GUSTAV STICKLEY | in circular for-
mation surrounding compass
enclosing | ALS | IK | KAN], the seal
flanked by TRADE MARK, all over
DESIGNE|D AND| MADE BY | script
signature GUSTAV STICKLEY |
| EASTW|OOD, N.Y., all enclosed
within a rectangle

TR.9349.14
Collection of Max Palevsky
and Jodie Evans

William Morris's company pro-
duced the first Morris chairs,
adjustable-back armchairs for
leisure sitting, in the 1860s.
Stickley introduced his version
in 1901 and adapted it to spin-
dles in 1905. His first design fea-
tured straight horizontal arms,
but he refined it by balancing the
angled back with the thrusting
canted arms seen here. The seat
is also angled, although less
sharply than the arms. Note the
exposed tenons at the hand rests
and legs.[70]

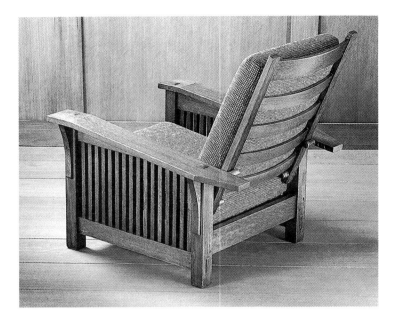

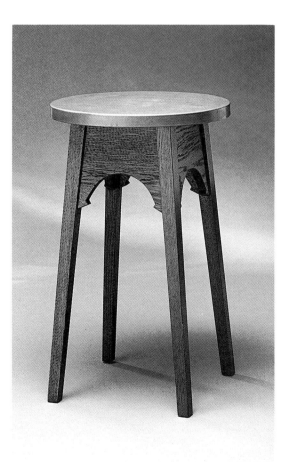

50

Table, 1907–12

Oak and copper
28 x 18 (diam.) in.
(71.1 x 45.7 cm)
Marks: under top, printed on
paper label, THE NAME "CRAFTS-
MAN" IS OUR | REGISTERED TRADE
MARK AND | IDENTIFIES ALL OUR
FURNITURE, all enclosed within a
rectangle | "CRAFTSMAN" | TABLE
(handwritten in pencil on line) |
NO…8615 (numbers handwritten
in pencil) | FIN… COV… | com-
pass enclosing ALS | IK | KAN
flanked by SHOP MARK over MADE
BY script signature GUSTAV STICK-
LEY IN THE | CRAFTSMAN WORK-
SHOPS | EASTWOOD NEW YORK |
NEW YORK CITY SHOW-ROOMS | 29
WEST THIRTY-FOURTH STREET, all
enclosed within a rectangle
TR.9349.15
Collection of Max Palevsky
and Jodie Evans

While Stickley usually origi-
nated designs, which were then
copied by numerous other firms,
the plans for this copper-top café
table may have originated in
Grand Rapids with the Stickley
Brothers Company. Stickley
Brothers produced a nearly iden-
tical table from about 1905 to
about 1915.[72] Indeed the canted
legs and arched skirt suggest
that firm's preference for more
decorative British design.

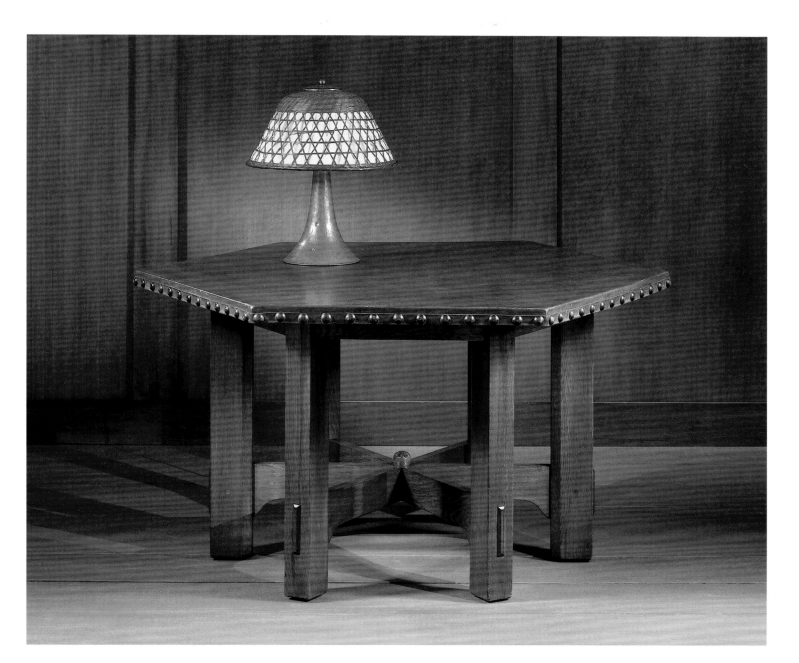

49

Library Table, 1910–12

Oak, leather, and brass
29⅞ x 55½ x 49 in.
(75.9 x 141.0 x 124.5 cm)
Marks: inside leg near top, red
decal of compass enclosing ALS |
IK | KAN over script signature
GUSTAV STICKLEY
M.89.151.14
Gift of Max Palevsky
and Jodie Evans

Stickley first introduced a hexagonal library table with heavy stacked stretchers and exposed tenon-and-key joinery in 1900. He modified the design in 1910 to the form seen here, a less ponderous version with smaller, converging stretchers and exposed tenons without keys. Both designs convey Stickley's signature penchant for overconstruction. Describing his style in 1903, Stickley noted: "the structural lines should be obtrusive rather than obscured.... Furthermore, these same lines must contribute to the decoration of the piece, which should result principally from such modification of the constructive features as will not impair their validity." [71] The large brass tacks provide additional decorative interest and relate to similar work on American seating forms of the seventeenth century.

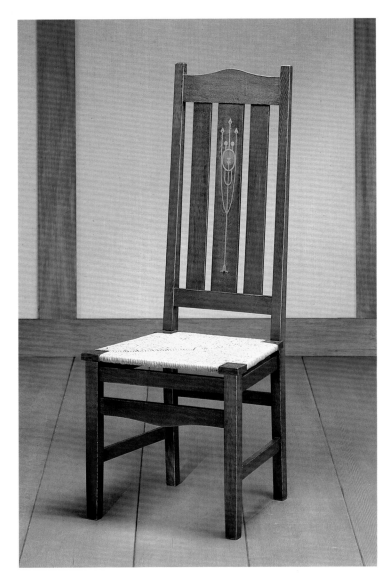

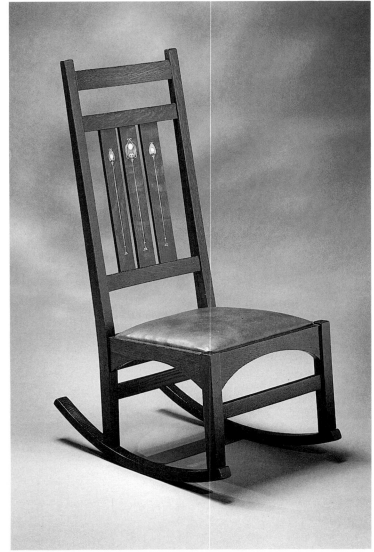

51

Side Chair, 1903

Design attributed to Harvey
Ellis (United States, 1852–1904)
Oak, mahogany, copper, pewter,
and (replaced) rush
47⅞ x 18⅜ x 18⅞ in.
(121.6 x 46.7 x 47.9 cm)
TR.9349.6
Collection of Max Palevsky
and Jodie Evans

Perhaps one of Ellis's earliest
chair designs, this example is
attributed on the basis of a 1903
Ellis drawing for *The Craftsman*,
which illustrates a similar form.[73]
The attenuated design and curv-
ing crest rail and stretcher relate
to chairs by C. F. A. Voysey.

Drawing by Harvey Ellis, *The
Craftsman*, 1903

52

Rocking Chair, c. 1903–4

Designed by Harvey Ellis
(United States, 1852–1904)
Oak, beech, copper, pewter, and
(replaced) leather
37½ x 16¾ x 26⅜ in.
(95.3 x 42.5 x 67.0 cm)
Marks: inside rear leg, proper
right side, red decal of compass
enclosing ALS | IK | KAN over
script signature STICKLEY
enclosed within a rectangle, all
enclosed within a rectangle
TR.9349.5
Collection of Max Palevsky
and Jodie Evans

This piece is more typical of
Ellis's seating forms than the
side chair (cat. no. 51). The dark,
fumed oak, triple slat back,
straight crest rail, and arching
seat rail are characteristic of his
chair designs.

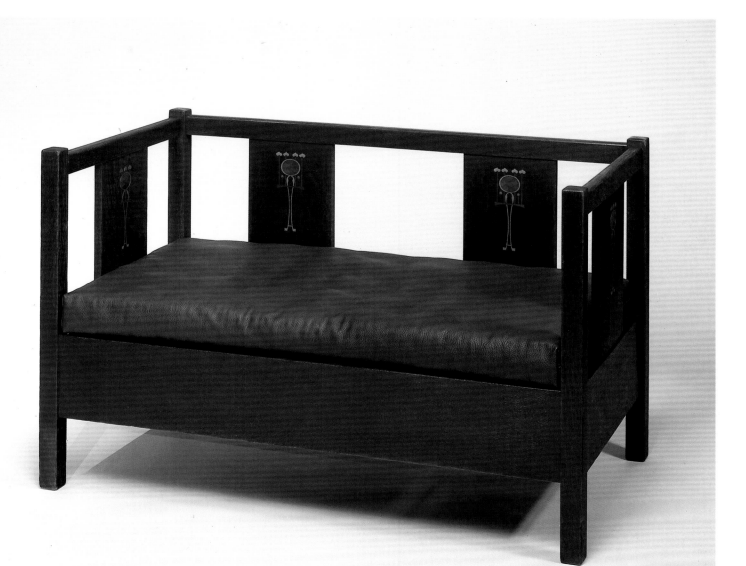

Cat. no. 53 (detail)

53

Settle, 1903

Designed by Harvey Ellis
(United States, 1852–1904)
Oak, beech, copper, pewter, and
(replaced) leather
30½ x 50⅛ x 26⅞ in.
(77.5 x 127.3 x 68.3 cm)
Marks: outside rear seat rail, at
center, red decal of compass
enclosing ALS | IK | KAN over
script signature STICKLEY
enclosed within a rectangle
M.89.151.7
Gift of Max Palevsky
and Jodie Evans

Ellis copied the style of this
settle from one by M. H. Baillie
Scott.[74] The inlay appears on
both sides of the vertical planks.
The same design without inlay
was offered in a two- and three-
back version as well as in an
armchair model in a 1904
Craftsman Workshops cata-
logue.[75] An armchair version
with identical inlay is also
known.[76]

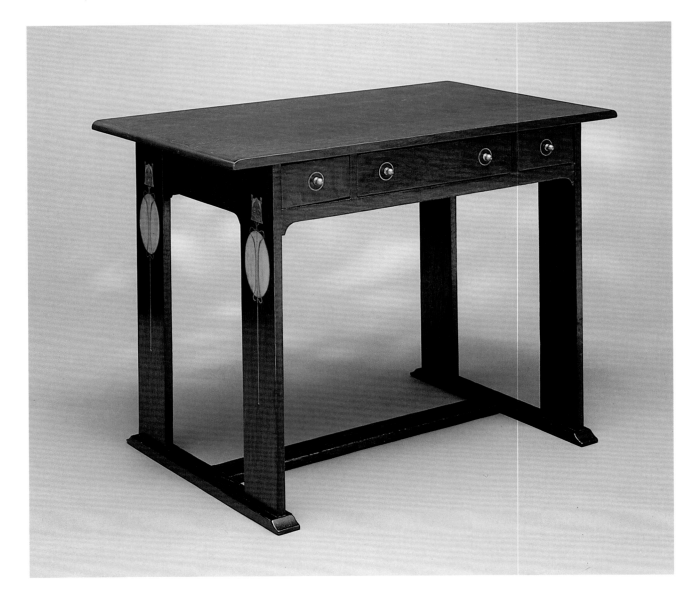

54

Library Table, 1903–4

Designed by Harvey Ellis
(United States, 1852–1904)
Oak, lemon wood, sycamore,
exotic woods, copper, and pew-
ter, with brass hardware
29⅞ x 41⅞ x 25⅛ in.
(75.9 x 106.4 x 63.8 cm)
M.89.151.3
Gift of Max Palevsky
and Jodie Evans

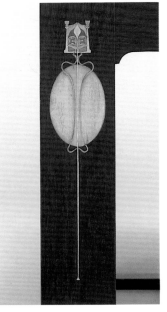

Ellis introduced trestle feet into
Stickley's line, inspired by ver-
nacular designs by Morris and
British stylists.[77] The same feet
can be found on inlaid Ellis
chairs. The pattern on this table
is among the most elaborate of
his designs. The table was also
produced in a smaller, single-
drawer version, and a similar
piece with two drawers is illus-
trated in an Ellis drawing for
The Craftsman.[78]

Cat. no. 54 (detail)

55

Double-Door Bookcase, 1903

Designed by Harvey Ellis
(United States, 1852–1904)
Oak, lacewood, sycamore,
beech, mahogany, padauk, and
glass, with copper hardware
55⅝ x 55⅝ x 12⅝ in.
(141.3 x 141.3 x 32.1 cm)
Marks: on back, at top center,
red decal of compass enclosing
ALS | IK | KAN over script signa-
ture STICKLEY enclosed within a
rectangle
M.89.151.5
Gift of Max Palevsky
and Jodie Evans

Overhanging tops and arching
skirts are characteristic of Ellis's
work for Stickley. The same ele-
ments are found in designs by
Mackintosh and his followers.
For instance, compare this piece
with the desk by E. A. Taylor
(cat. no. 7). One of only two
known inlaid examples (the
other is privately owned), this
design evidently inspired the
more common bookcase asso-
ciated with Ellis (cat. no. 56).[79]

56

Double-Door Bookcase, 1907–9

Design attributed to Harvey Ellis (United States, 1852–1904) Oak and glass, with brass hardware
57⅞ x 45⅝ x 14⁵⁄₁₆ in. (147.0 x 115.9 x 36.4 cm)
Marks: inside, at back, red decal of compass enclosing ALS | IK | KAN over script signature GUSTAV STICKLEY; on back, printed on paper label, THE NAME "CRAFTS-MAN" IS OUR | REGISTERED TRADE MARK AND | IDENTIFIES ALL OUR FURNITURE, all enclosed within a rectangle | "CRAFTSMAN" | [BOOK] CASE (handwritten in pencil on line) | NO…701 (numbers hand-written in pencil) | FIN… COV… | compass enclosing ALS | IK | KAN flanked by SHOP MARK over MADE BY script signature GUSTAV STICK-LEY IN THE | CRAFTSMAN WORK-SHOPS | EASTWOOD NEW YORK | NEW YORK CITY SHOW-ROOMS | 29 WEST THIRTY-FOURTH STREET, all enclosed within a rectangle
L.88.30.88
Collection of Max Palevsky and Jodie Evans

Comparison of this design with the rarer piece (cat. no. 55) con-firms Ellis's responsibility for its curved skirt and broad top. The distinctive pilasters on both works are described in a 1903 *Craftsman* article as "quarter-inch strip[s] of wood, ending in … small block[s] resembling … Tuscan capital[s]."[80] The design, introduced in 1903, was available in a single-door model as well as wider two-door versions.[81]

Drawing of farmhouse interior, *The Craftsman,* 1906

57

Chest of Drawers, 1912–16

Curly maple, beech, oak,
avodire, and pewter
51⅜ x 36⅛ x 20¼ in.
(130.5 x 91.8 x 51.4 cm)
Marks: on side of proper right
top drawer, branded compass
enclosing ALS | IK | KAN over
script signature STICKLEY; on
back, proper right side, printed
on paper label, CRAFTSMAN |
compass enclosing ALS | IK | KAN
over script signature STICKLEY
flanked by TRADE | MARKS | REG'D
and IN U.S. | PATENT | OFFICE, all
over (for text see cat. no. 41) |
THIS PIECE WAS MADE IN MY |
CABINET SHOPS AT EASTWOOD,
N.Y. | GUSTAV STICKLEY, all
enclosed within a rectangle
L.88.30.75
Collection of Max Palevsky
and Jodie Evans

Cat. no. 57 (detail from top of
chest)

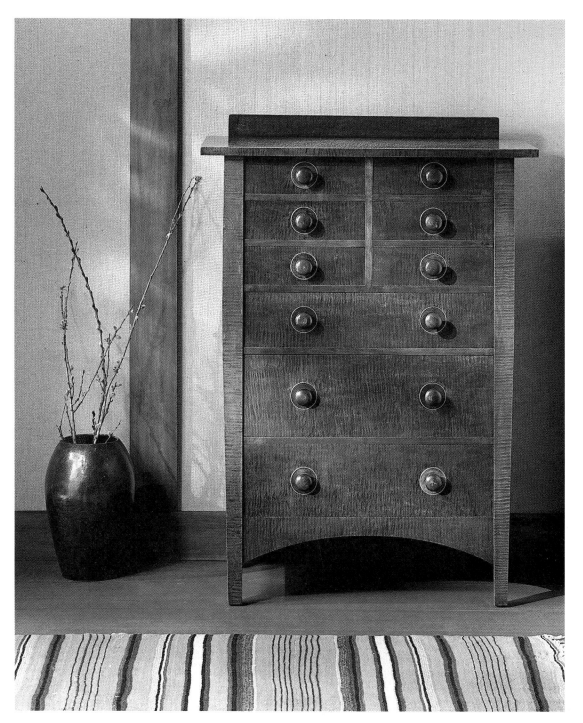

58

Tea Table, 1907–12

Curly maple, beech, oak, and pewter
29⅜ x 24 (diam.) in.
(74.6 x 61.0 cm)
Marks: under top, printed on paper label, THE NAME "CRAFTS-MAN" IS OUR | REGISTERED TRADE MARK AND | IDENTIFIES ALL OUR FURNITURE, all enclosed within a rectangle | "CRAFTSMAN" | TABLE (handwritten in pencil on line) | NO...654 (numbers handwritten in pencil) | FIN...GRAY (hand-written in pencil) COV...MAPLE (handwritten in pencil) | com-pass enclosing ALS | IK | KAN flanked by SHOP MARK over MADE BY script signature GUSTAV STICK-LEY IN THE | CRAFTSMAN WORK-SHOPS | EASTWOOD NEW YORK | NEW YORK CITY SHOW-ROOMS | 29 WEST THIRTY-FOURTH STREET, all enclosed within a rectangle
L.88.30.74
Collection of Max Palevsky and Jodie Evans

"Silver Gray Maple" was offered as an option on a number of forms in Stickley's catalogues.[82] The nine-drawer chest (cat. no. 57) was introduced in 1906, and while an inlaid version could conceivably have been offered at that time, the brand on the piece lends evidence to a later date. Evidently a line of forms was offered in curly maple with disk-and-spade inlay. Besides the chest and tea table (cat. no. 58), a costumer, dresser, and dressing table are known. This group appears to be the only inlaid fur-niture offered after Ellis's death. Similar inlay patterns appear on furniture designed by him, as seen, for example, on the rocking chair (cat. no. 52).

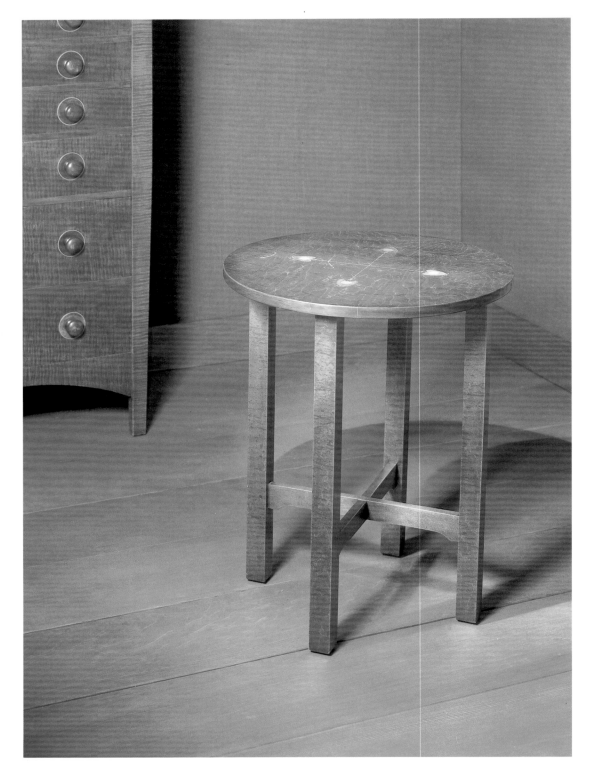

59

Chest of Drawers, 1910–12

Oak and beech, with copper
hardware and iron studs
50⅜ x 36 x 20 in.
(128.0 x 91.4 x 50.8 cm)
Marks: inside proper right top
drawer, at center, red decal of
compass enclosing ALS | IK | KAN
over script signature GUSTAV
STICKLEY
TR.9365.16
Collection of Max Palevsky
and Jodie Evans

This chest was introduced after
Ellis's death in 1904, but the
architect's influence can be seen
in the flat, projecting, rooflike
top, arched skirt, and bowed
stiles that create entasis. The
nine-drawer chest appeared with
other hardware (see cat. no. 57),
but this is the most successful
version, its distinctive hammered
drawer pulls reinforcing the
vertical thrust. Stickley copied
many of his hardware designs
from British examples. For
instance, compare this hardware
with that on the Taylor desk
(cat. no. 7).

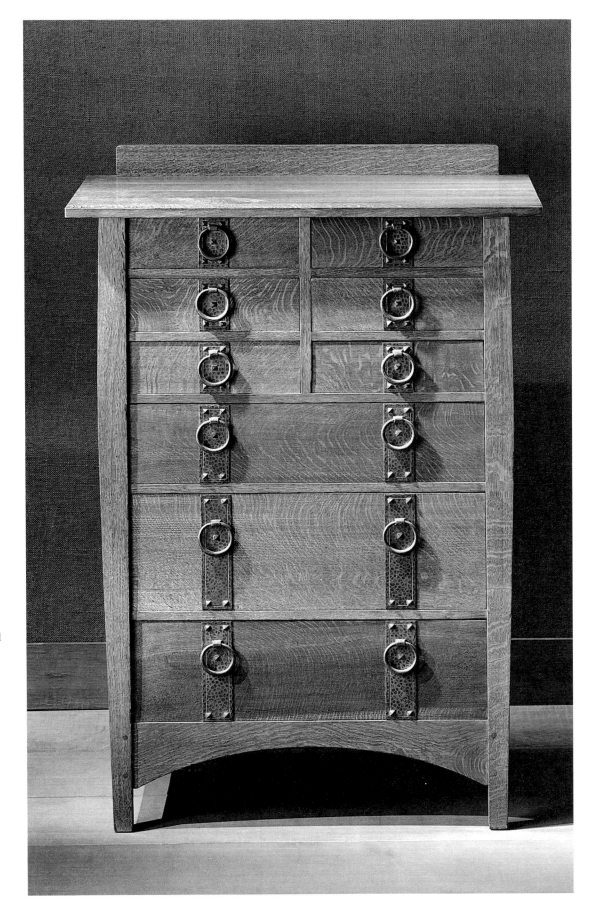

L. and J. G. STICKLEY

1902–present

Fayetteville, New York

Leopold (United States, 1869–1957) and John George (United States, 1871–1921) Stickley modeled their company and its products after their brother Gustav's successful Craftsman Workshops in nearby Eastwood, New York. Leopold had worked as foreman for Craftsman Workshops and was therefore well acquainted with that company's designs and business practices. Known as the Onondaga Shops until about 1910, L. and J. G. Stickley styled its rhetoric, designs, construction methods, marketing, and trademark after those of Gustav's precedent-setting firm.[83]

When the popularity of arts and crafts furniture began to wane in the mid-teens, L. and J. G. Stickley introduced alternative styles. It absorbed the bankrupt Craftsman Workshops in 1918 and suspended the Craftsman style in favor of colonial revival lines. It has recently reintroduced a line of arts and crafts reproductions based on original L. and J. G. Stickley and Gustav Stickley designs.

Cat. no. 60 (detail)

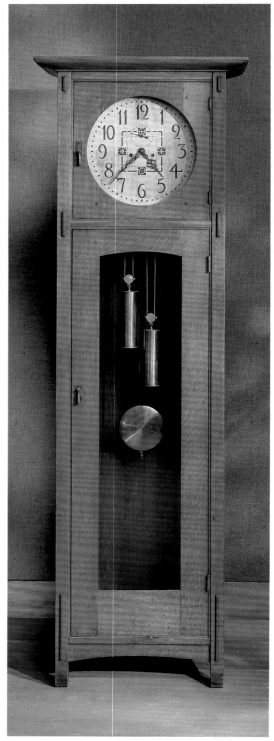

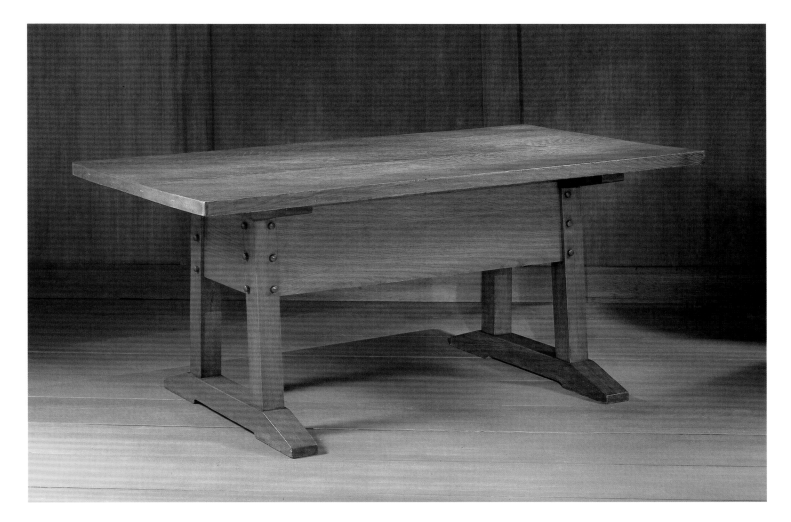

60

Tall Case Clock, c. 1906–12

Clockworks attributed to Seth Thomas, Thomaston, Connecticut (1809–present)
Oak, pine, copper, brass, lead, and steel, with copper and copper-plated steel hardware
80¼ x 27 x 16 in.
(203.8 x 68.6 x 40.6 cm)
Marks: at bottom of face, acid-etched and stained black, L & J. G. STICKLEY FAYETTEVILLE, N.Y. | HANDCRAFT; inside, on back, red decal of hand screw on which is printed L & J. G. STICKLEY | HANDCRAFT; on back, painted in black, #86
L.89.36
Collection of Max Palevsky and Jodie Evans

Recorded in a trade catalogue as model number eighty-six, this tall case clock is among the most aesthetically successful of such arts and crafts designs.[84] The vertical thrust is punctuated by exposed tenons (where the framing members of the side panels are joined to the front stiles), is balanced by an arching skirt and door frame, and is resolved with a projecting cornice. The copper-finished dial is decorated with a secessionist-style design.

By this period the tall case clock was an arcane form, long since made obsolete by technical advances in clockworks. Such timepieces were revived because of their romantic, preindustrial, colonial associations. *The Old Clock on the Stairs*, a poem by Henry Wadsworth Longfellow published in 1845, was a major factor in the popularization of the "grandfather clock."[85]

61

Table, 1906–12

Oak
30 x 71½ x 36 in.
(76.2 x 181.6 x 91.4 cm)
Marks: inside top of leg, on fragments of red decal of hand screw, L | & J. G. STICKLEY | HANDCRA | FT
L.88.30.79
Collection of Max Palevsky and Jodie Evans

This piece was copied from Gustav Stickley's trestle table of about 1904, which was in turn based on a contemporary English table designed in 1901 by M. H. Baillie Scott, who adapted his design from medieval English prototypes.[86]

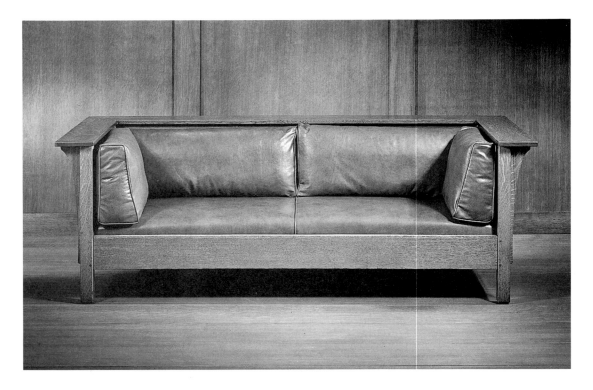

62

Book Table, 1912–17

Oak
29 x 27 x 27 in.
(73.7 x 68.6 x 68.6 cm)
Marks: inside slat of upper shelf,
gold-and-white rectangular decal
on which is printed THE WORK
OF | L. & J. G. STICKLEY
L.88.30.80
Collection of Max Palevsky
and Jodie Evans

This book table was also based
on a Gustav Stickley prototype,
a "combination table and ency-
clopedia bookcase" of 1909.[87]
The L. and J. G. Stickley book
table was offered in an undated
trade catalogue issued around
1914.[88]

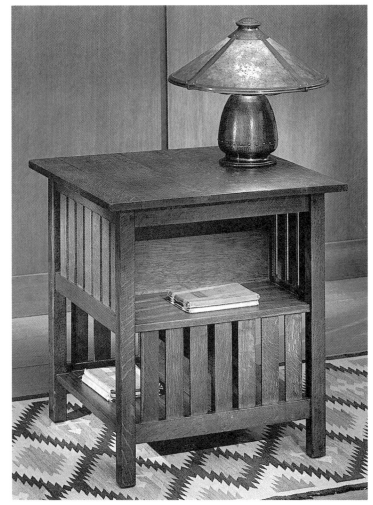

63

Settle, 1912–17

Oak and (replaced) leather
29 x 84⅝ x 36¾ in.
(73.7 x 214.9 x 93.3 cm)
Marks: on back, proper left side,
gold-and-white rectangular decal
on which is printed THE WORK OF |
L. & J. G. STICKLEY
L.89.17.1
Promised gift of Max Palevsky
and Jodie Evans

One of the firm's classic pieces,
this settle does not imitate a
Craftsman Workshops model,
but refers instead to both a Voy-
sey design with broad planar
arms and a Baillie Scott form
with level back and arms.[89] Also
produced with spindled sides and
back, the design is distinguished
by the broad continuous shelf,
which is eminently useful as well
as visually satisfying.[90] The long,
low, overhanging silhouette
accounts for its modern nick-
name, prairie settle, despite its
English heritage. The paneling
harks back to seventeenth-
century colonial joinery and is
another example of construction
doubling as ornament.

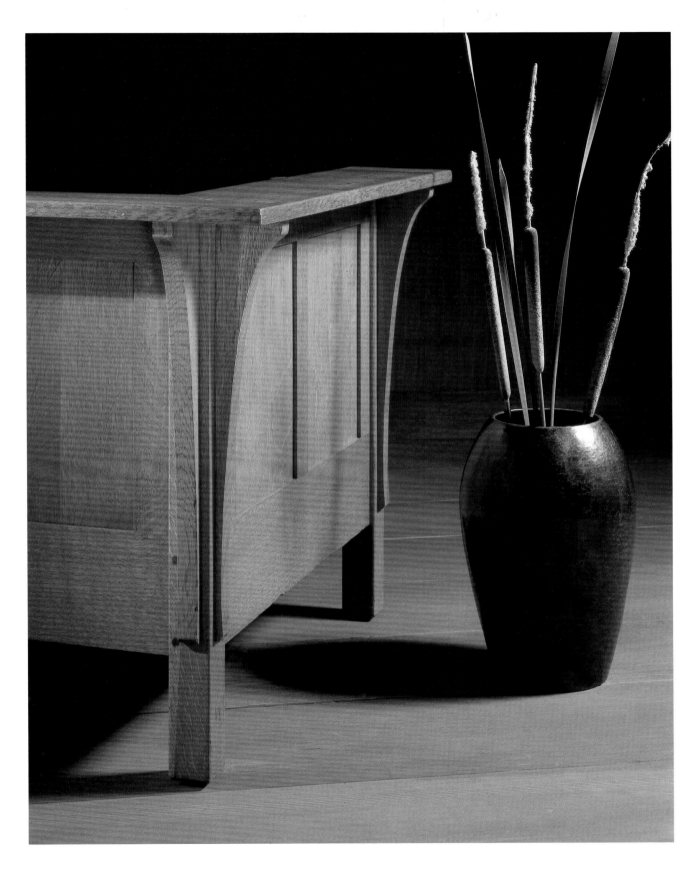

Cat. no. 63 (detail)

FRANK LLOYD WRIGHT

United States, 1867–1959

Oak Park, Illinois

The most influential architect to emerge from the American arts and crafts movement was Frank Lloyd Wright. A seminal member of Chicago's greatest contribution to the style, the prairie school, Wright advocated architecture and furnishings consistent with site and function, constructed of natural materials, relieved of unnecessary ornament, and derived from nature. Prairie school buildings were largely domestic and characterized by long, ground-hugging profiles with protective, overhanging eaves and open, light-filled interiors of clean, geometric lines (see cat. nos. 238–39). Wright described the inspiration for the style: "We of the Middle West are living on the prairie. The prairie has a beauty of its own and we should recognize and accentuate this natural beauty, its quiet level. Hence, gently sloping roofs, low proportions, quiet sky lines, suppressed heavy-set chimneys, and sheltering overhangs, low terraces and out-reaching walls sequestering private gardens." [91]

Like other prairie school architects Wright had worked in the Chicago office of Louis Sullivan. He left Sullivan's employ to establish his own practice in 1893. From his Oak Park home and studio he developed his own distinctive style of domestic architecture. He conceived of decorative arts as interior architecture, forms that contributed to a unified design scheme: "The 'grammar' of the house, is its manifest articulation of all its parts—the 'speech' it uses.... When the chosen grammar is finally adopted (you go almost indefinitely with it into everything you do) walls, ceilings, furniture, etc. become inspired by it. Everything has a related articulation in relation to the whole and all belongs together because all are speaking the same language." [92]

Wright repeatedly stressed the organic conception of his designs, which "emphasized the geometric relationships underlying all structures" (see cat. nos. 229a–b, 230–31), in marked contrast with Sullivan, who "sought the abstraction of ornament through the understanding of natural evolution" (see cat. nos. 94–95). [93] Wright was strongly influenced in this by Japanese art and architecture. He visited Japan in 1905, frequently praised Japanese design, and considered the Japanese the only people who understood the beauty of wood, who had not "universally abused and maltreated" it. [94] He followed their lead in his conception of architecture as interior spaces that determined the nature of exterior structure. A sentence quoted by Wright from *The Book of Tea* by Okakura Kakuzo sums up his ideas: "The reality of a room was to be found in the space enclosed by the roof and walls, not in the roof and walls themselves." [95]

Wright helped to found the Chicago Arts and Crafts Society in 1897 and was a philosophical follower of the movement. C. R. Ashbee admired his work and wrote the introduction to a German publication by Wright. [96] Wright's views on machinery, however, contrasted with those of Ashbee and with the rationalizations that characterized American arts and crafts doctrine. Whereas most reformers passively accepted the view put forth by the Chicago Arts and Crafts Society, which allowed the use of machinery "in so far as it relieves the workman from drudgery," Wright reveled in the new possibilities machinery provided and hailed "the metamorphosis of ancient art and craft." [97] In 1901 he delivered his views in a landmark lecture, "The Art and Craft of the Machine," to the Chicago Arts and Crafts Society, in which he proclaimed that "the machine is capable of carrying to fruition high ideals in art—higher than the world has yet seen!" [98] He went on to praise machinery for enabling the designer to produce art inexpensively, affordable for the poor as well as the rich.

Wright openly designed for machinery and dispensed with arcane allusions to handcrafted construction that characterized most of the period's furniture. He appreciated the machine's ability to produce smooth, finished boards that showed the true nature of the material without the distraction of plane or saw marks.

All of the chairs seen here (cat. nos. 64a–b, 65–66) were designed to maximize the use of machinery. Comfort was less important to Wright than visual effect and integration with surrounding design. Like Mackintosh, who also drew inspiration from the Japanese, he designed chairs that are visual statements. The tall backs of his early examples were influenced by British arts and crafts prototypes.

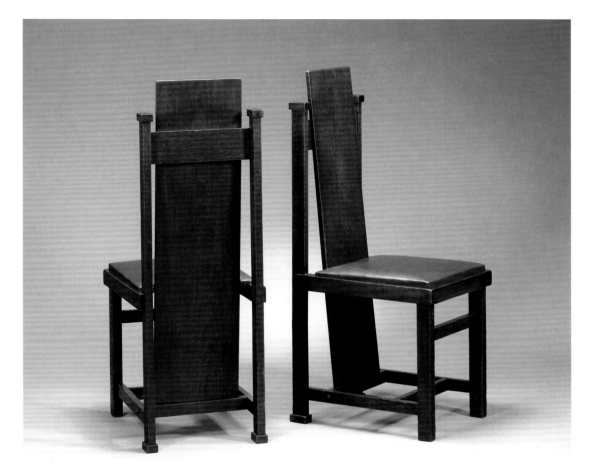

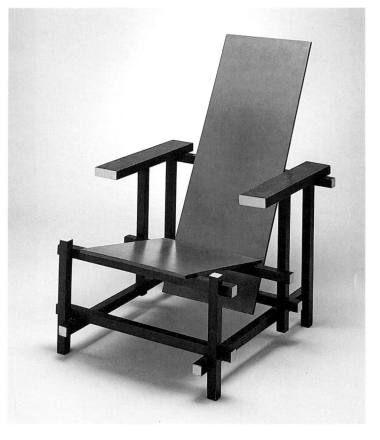

Gerrit Rietveld (Netherlands, 1888–1964), *Red-Blue Chair,* designed 1918, manufactured c. 1950, painted wood, 23⅝ x 33¹/₁₆ x 33¹/₁₆ in. (60.0 x 84.0 x 84.0 cm), M.86.258, purchased with funds provided by Merle Oberon

64a–b

Pair of Side Chairs from the Frank Lloyd Wright Studio, Oak Park, Illinois, 1898–1902

Probably executed by
John W. Ayers Company,
Chicago (1887–1913)
Oak, pine, and (replaced) leather
Each: 40⅛ x 15 x 18⅞ in.
(101.9 x 38.1 x 47.9 cm)
M.89.71.1 –2
Gift of Elma Shoemaker, Daisy and Daniel Belin, and Susan and Robert F. Maguire III, through the 1989 Collectors Committee

In the late 1890s Wright added a studio to his home in Oak Park, Illinois, for which he designed these chairs. He first ordered four, of which these are the only survivors, and added six more in 1904. This pair came from the family of Wright's first wife, Catherine Tobin Wright.

The earliest examples of a seminal design, these chairs are also part of the first flowering of Wright's mature, rectilinear, prairie school style in furniture.[99] With characteristic emphasis on visual and spatial effects he masterfully orchestrated angles and proportions to produce a geometric composition about sitting. Gerrit Rietveld's classic *Red-Blue Chair* of 1918 relates to this design.

65

*Side Chair from the
Ward W. Willits House,
Highland Park, Illinois*, 1902

Probably executed by
John W. Ayers Company,
Chicago (1887–1913)
Oak and (replaced) upholstery
45⅛ x 17 x 18½ in.
(114.6 x 43.2 x 47.0 cm)
TR.9349.10
Collection of Max Palevsky
and Jodie Evans

Another classic furniture design
by Wright, this side chair is dis-
tinguished by the tall spindle
back that extends nearly to the
floor. Wright first used spindles
on dining chairs for his own
home and repeated the motif in
other commissions. The tall
backs functioned as screens in
the dining room, symbolically
sheltering the family during the
meal, a sacred ritual of family
life.[100] The verticality of such
chairs also balanced the horizon-
tal lines of the architecture.
Gustav Stickley and other arts
and crafts manufacturers copied
the spindle design, recognizing
in it an admirable unity of struc-
ture and style that needed no
additional ornament (see cat.
nos. 43–48).

The Willits House is consid-
ered Wright's first mature prairie
school home.[101] This piece is one
of five children's dining chairs
that could be elevated to the
same height as the adult chairs
when installed on specially
designed dollies.[102]

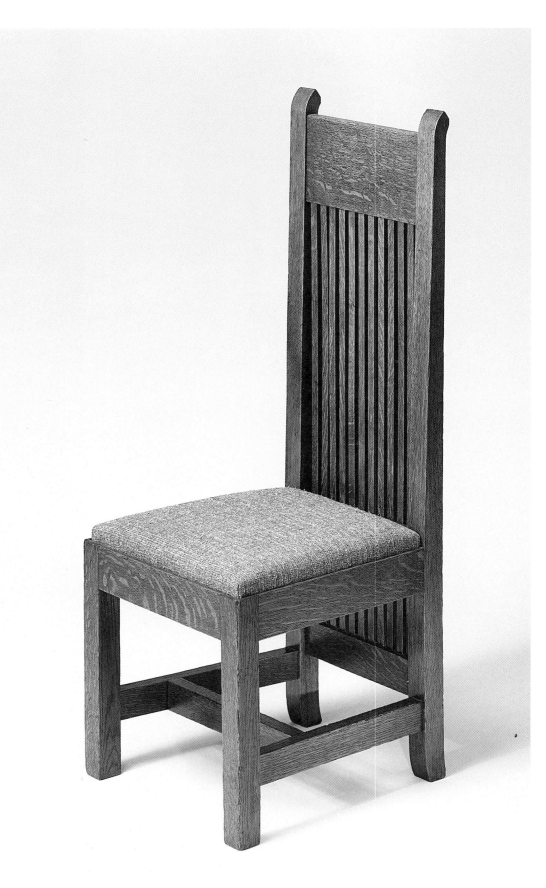

66

*Side Chair from the
Francis W. Little House,
Peoria, Illinois*, 1902–3

Oak, pine, and (replaced)
upholstery
40¹/₁₆ x 16¹/₄ x 18 in.
(101.8 x 41.3 x 45.7 cm)
TR.9349.11
Collection of Max Palevsky
and Jodie Evans

Wright's appreciation for natural
materials is evident in this de-
sign. He admired the machine's
ability to show off the beauty of
wood grain with smooth straight
cuts, a feature evident in this
quarter-sawn oak form from the
Little House (see also cat. nos.
238–39).

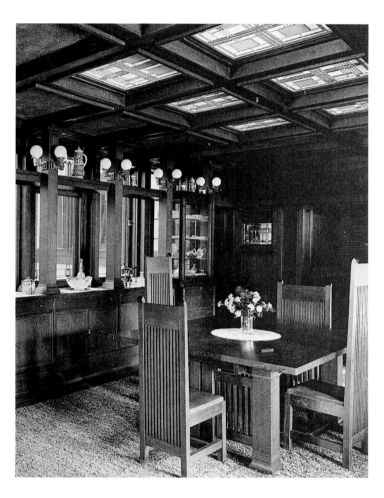

Dining room, Ward W. Willits House,
1902

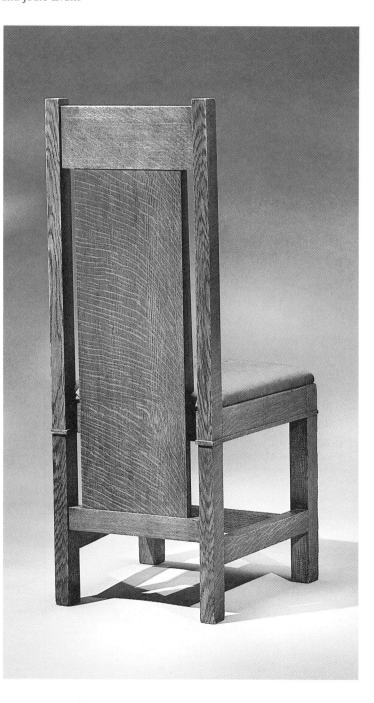

NOTES

1. As quoted in Makinson 1979, p. 150.

2. Makinson 1977, p. 150. This book provides an in-depth study of Greene and Greene architecture.

3. See Makinson 1979, pp. 58–67, for an examination of Blacker House furniture. This companion volume to Makinson 1977 examines the Greenes' designs for interior furnishings.

4. Kaplan 1987, p. 404, cat. no. 222, and Makinson 1979, pp. 34–35, 56–62.

5. Makinson 1979, pp. 61, 65.

6. For an illustration of the armchair in situ see Makinson 1979, p. 59.

7. Zusy 1987, p. 243.

8. Edwards introduction to Limbert n.d. a., p. [5]. An increasing awareness of hygiene resulted in manufacturers promoting removable cushions and easily cleaned surfaces, like the straight lines of the period's furniture.

9. As quoted in Kaplan 1987, p. 167, cat. nos. 51–52, n. 4.

10. Limbert n.d. b., p. 13.

11. Limbert n.d. a., p. 6.

12. Dearborn Corporation booklet, as quoted in Marek 1987, p. 46. For a full account of Limbert's designs and practices see pp. 37–49.

13. Limbert n.d. b., p. 11.

14. Kaplan 1987, p. 165, cat. no. 51.

15. Limbert n.d. c., p. 58.

16. Marek, Don. Telephone conversation with author, 27 October 1989. Marek has found no listings for coppersmiths in Holland city directories and has noted a marked similarity between certain Limbert metalwork designs and Stickley Brothers examples.

17. Skinner 1989b, lot 89.

18. See Jones 1972.

19. Kaplan 1987, p. 193, cat. nos. 79–80, n. 3.

20. Cardwell 1977, p. 54.

21. Wilson 1987, p. 125.

22. The Reverend Joseph Worcester, as quoted in Cardwell 1977, p. 32.

23. Cathers 1981, pp. 14–15, and Kaplan 1987, p. 185, cat. no. 71.

24. As quoted in Cardwell 1977, p. 53.

25. Cardwell 1977, p. 55.

26. For an example of Rohlfs's work in the prairie school style see Skinner 1989a, lot 142.

27. Clark 1972, p. 28.

28. Rohlfs 1907, unpaginated. The author is grateful to Catherine Zusy for providing a photocopy of this document. An original can be found in the Department of Prints and Drawings at the Metropolitan Museum of Art, New York.

29. As quoted in James 1987, p. 16.

30. Ibid.

31. Moffitt 1900, p. 83.

32. Dekorative Kunst 1900, p. 75. The author is grateful to Catherine Zusy for providing information about this article.

33. See Brandt 1985, pp. 72–73, cat. no. 16, and Skinner 1989b, lot 164. The author is grateful to Michael James for his assistance with all of the Rohlfs entries.

34. Moffitt 1900, p. 85.

35. Christie's 1987, lot 38.

36. Rohlfs 1907, unpaginated (Octagon Table, Wild Honey-Suckle Octagon Table).

37. James, Michael. Telephone conversation with author, 8 September 1989.

38. Rohlfs 1907, unpaginated (Cathedral, no. 19; Cresset, no. 2.)

39. For an account of the colorful Hubbard see Champney 1968.

40. Hamilton 1980, pp. 63–67.

41. Champney 1968, p. 183.

42. The author is grateful to Robert Rust and Kitty Turgeon for their assistance with all of the Roycroft entries throughout this catalogue.

43. Roycrofters 1912, p. 22.

44. For examples by Mackmurdo see Anscombe and Gere 1978, p. 110, no. 126; p. 123, no. 142.

45. Hanks 1985, p. 20, fig. 1.19.

46. Trapp introduction to Shop of the Crafters 1906, p. 3.

47. Shop of the Crafters 1906, p. 4.

48. Trapp 1986, p. 15.

49. Shop of the Crafters 1906, p. 36, nos. 285, 285½.

50. See Marek 1987, pp. 26–28, 50–55, for information on the Stickley Brothers Company.

51. This side chair is attributed to Stickley Brothers on the basis of design and construction similarities to marked examples.

52. Grand Rapids 1903, p. 222.

53. Altenbrandt 1909, p. 95. The author is grateful to Don Marek for sharing his expertise and research on Stickley Brothers and Conti.

54. See Burke 1986 for a comprehensive study of the Japanese influence on design in nineteenth-century America.

55. See the Greenes' design for the Pratt House desk in Christie's 1985, lot 136.

56. As quoted in Smith 1983, p. 1.

57. Ibid., p. 2.

58. Stickley 1901, p. i.

59. Sanders 1978, pp. 187–88.

60. See Clark and Kaplan 1987 for information on European influences in American arts and crafts furniture.

61. The Stickley entries have been organized to separate these two groups, with the works by Stickley preceding the works designed or influenced by Ellis. Within the first group the order is chronological by date of design (if known); where unknown, the object's date determines its placement.

62. Stickley 1904, p. 18.

63. Stickley 1903, p. 21.

64. Craftsman 1904a, p. 396.

65. The advertisement is reproduced in Cathers 1981, p. 48.

66. Cathers 1981, p. 49.

67. Ibid., p. 204.

68. Gray 1987, p. 110, no. 970.

69. Craftsman 1906, p. xxiv.

70. For a discussion of the Morris chair's social context see Boris 1986, pp. 58–60.

71. Stickley 1903, p. 21.

72. Stickley Brothers n.d., pp. 22–23, no. 2615.

73. See Cathers 1981, pp. 46–47, for a reproduction of the drawing and another version of the design.

74. Cathers 1981, p. 29.

75. Gray and Edwards 1981, pp. 60–61, nos. 213–14, 328.

76. Cathers 1981, p. 126.

77. For examples see Anscombe and Gere 1978, pp. 78–79.

78. Craftsman 1904b, p. 289.

79. Skinner 1988b, lot 35.

80. Craftsman 1903a, p. 390.

81. Gray and Edwards 1981, pp. 92–93, nos. 700–701.

82. For examples see the reprint of a 1904 catalogue in Gray and Edwards 1981, pp. 57–116.

83. Cathers 1981, p. 76, and Kaplan 1987, pp. 246–47, cat. no. 104.

84. Gray 1983, p. 135, no. 86.

85. Monkhouse and Michie 1986, p. 13. The author is grateful to Christopher Monkhouse for sharing his expertise on the colonial revival and its influence.

86. Clark and Kaplan 1987, pp. 83–84, fig. 12.

87. Gustav Stickley, *Craftsman Homes*, as quoted in Kaplan 1987, p. 383, cat. no. 206.

88. L. and J. G. Stickley n.d., p. 38, no. 516, and Cathers introduction, p. vii.

89. Brandon-Jones 1978, pp. 94–95, no. C66 (Voysey), and Cathers 1981, p. 29 (Baillie Scott).

90. Gray 1983, p. 148, no. 234.

91. As quoted in Hanks 1979, p. 73.

92. As quoted in Darling 1984, p. 257.

93. Cooke 1987, p. 391.

94. As quoted in Kaufmann and Raeburn 1960, p. 66.

95. Ibid., p. 300.

96. Wilson 1987, p. 101.

97. As quoted in Darling 1977, p. 37 (Chicago Arts and Crafts Society), and Kaufmann and Raeburn 1960, p. 55 (Wright).

98. As quoted in Kaufmann and Raeburn 1960, p. 55.

99. Wright repeated this design at the Hillside Home School, the Unity Temple, and the Larkin Building. For a thorough discussion of Wright's furnishings and decorative arts see Hanks 1979.

100. For a discussion of Wright's spindle furniture see Hanks 1979, pp. 37–39.

101. Kalec 1988, p. 84.

102. Eifler, John. Telephone conversation with author, 30 May 1989. The author is grateful to Mr. Eifler for this information and for other assistance with this entry.

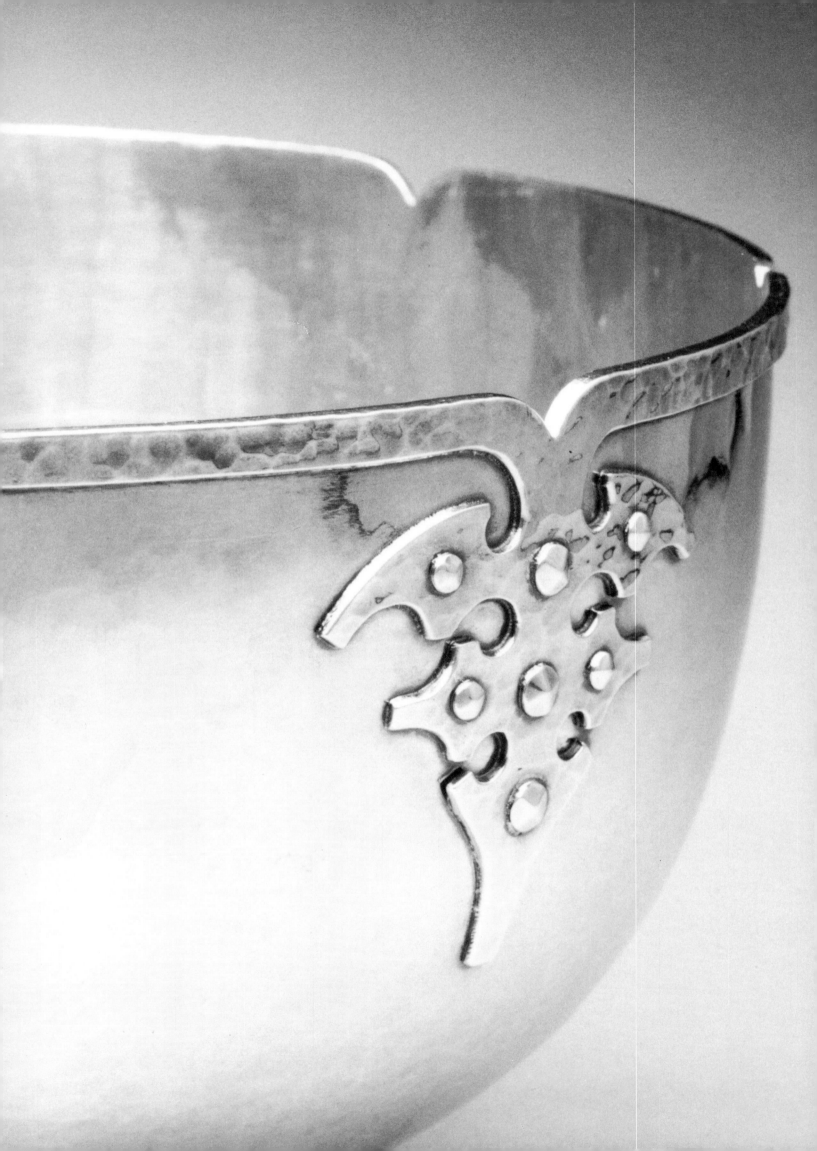

METALWORK

Cat. no. 88 (detail)

JOHN O. BELLIS

United States, d. 1943

San Francisco

67

Cake Plate, c. 1910

Silver

1 x 11⅛ (diam.) in.
(2.5 x 28.3 cm)

Inscriptions: on surface in center, engraved script cipher TS

Marks: on back, struck incuse JOHN O BELLIS. | STERLING

L.88.30.43

Collection of Max Palevsky and Jodie Evans

John O. Bellis was among the silversmiths trained at Shreve and Company to craft their hand-wrought arts and crafts lines. He established his own shop in San Francisco after the earthquake of 1906. This cake plate, like many of his pieces, was spun on a lathe and finished by hand with a strapwork-and-rivet border. He copied the design from Shreve's patterns (see cat. nos. 87a–d, 88), which he undoubtedly learned while employed there.[1]

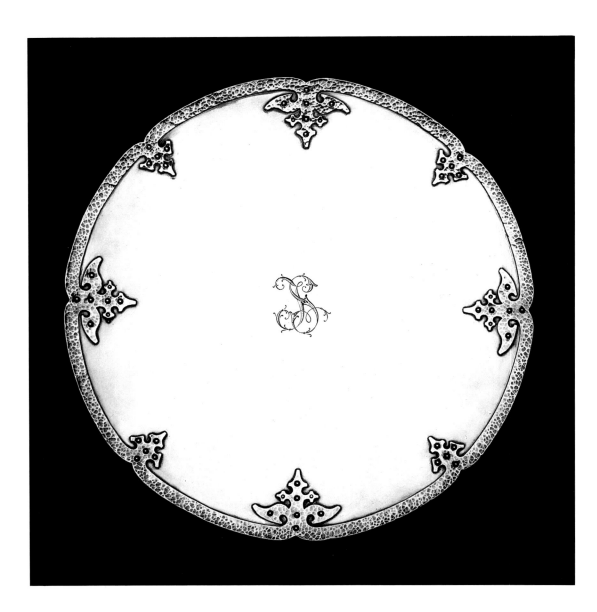

PORTER GEORGE BLANCHARD

United States, 1886–1973

Burbank, Los Angeles, and Calabasas, California

Porter George Blanchard was trained in the family flatware business by his father, Boston silversmith George Porter Blanchard. The son was already a member of Boston's Society of Arts and Crafts and the Detroit Society of Arts and Crafts, where he exhibited in 1912, when he moved to California in 1923. He became the first president of the Arts and Crafts Society of Southern California, which was founded in 1924. Blanchard operated a business bearing his name and, with several assistants, produced hollowware and flatware at various Southern California locations until his death in 1973. The firm, using the same mark, continues today.

Shortly after his arrival in California, Blanchard augmented his colonial revival repertoire with more progressive European-inspired designs like the coffee service in the Common-wealth pattern (cat. no. 68a–c). As with most of his silver this set is of a heavy gauge, is minimally ornamented, and bears the period's requisite hammered finish. He cited "Ruskin and his followers" for initiating "simpler, finer lines and plainer surfaces," qualities Blanchard lauded and practiced.[2]

Blanchard was a great hammersmith and enjoyed raising vessels. However, his commercial success necessitated faster production. Flatware was hammered by hand, but vessels were often spun on a lathe and finished by hand. Like Stickley and many of his contemporaries Blanchard freely admitted machinery, provided it was used in the service of arts and crafts principles, easing the task of the craftsman without compromising quality.

68a–c

Commonwealth Coffee Service,
c. 1930

Silver
Coffee pot: 8¾ x 9¼ x 4 in.
(22.2 x 23.5 x 10.2 cm)
Sugar bowl: 3 x 3⅝ x 2⅝ in.
(7.6 x 9.2 x 6.7 cm)
Creamer: 3⅝ x 5⅝ x 2⅜ in.
(9.2 x 14.3 x 6.0 cm)
Marks: under base of each, struck incuse STERLING | man hammering within a rectangle | PORTER BLANCHARD
M.89.22.1–3a–b
Purchased with funds provided by the Decorative Arts Council

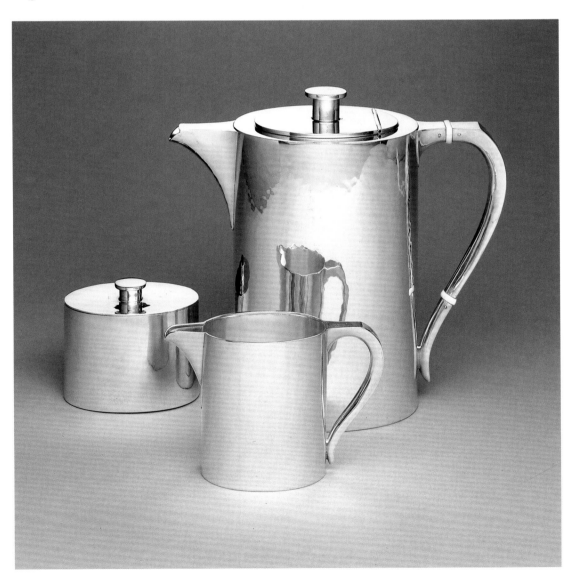

Porter Blanchard, late 1930s

HAROLD LUKENS DOOLITTLE

United States, 1883–1974

Pasadena

69

Plaque, c. 1915

Brass

11¼ x 8¾ in.
(28.6 x 22.2 cm)

Inscriptions: FROM WHERE TO WHERE | WHO KNOWS, BUT AS | YOU PASS, PAUSE | WHERE A FLOWER | GROWS, AND WITH | FORM, COLOR, TEXTURE, | SCENT, DEEPEN YOUR | SOUL'S CONTENT. | ANON.

Marks: on front, at lower proper left corner, handwritten in black ink, script signature HAROLD L. DOOLITTLE

M.90.25.8

Art Museum Council Fund

Harold Doolittle studied manual arts at Throop Polytechnic Institute in Pasadena, a bastion of arts and crafts education. An engineer by profession, he was also an amateur craftsman in various areas, including carving, cabinetmaking, printing, and lettering. Several of his brass plaques survive; their calligraphic designs were cut out so that the lines were contiguous.[3] He is one of many Americans who responded to the movement's call for amateur participation, a call that promised increased health and happiness as a result of practicing crafts.

CLEMENS FRIEDELL

United States, 1872–1963

Pasadena

Clemens Friedell was one of the movement's virtuoso craftsmen, a chaser of extraordinary skill.[4] Although American-born, he trained as a silversmith in Vienna before returning to the United States in 1892. From 1901 to 1908 he worked for Gorham on their Martelé line (see Gorham entry). Like many of the era's craftsmen he was wooed by the California dream and came to Los Angeles in 1910. Within the year he moved north to Pasadena.

Friedell designed all his work but, even as a solo craftsman, stopped short of Ruskin's concept of creating a piece from start to finish. Whenever possible he saved his own involvement for the highly skilled chasing and hired an assistant to raise the forms for him. His clientele was distinctly upper class and could afford the expense of custom-made, handwrought silver.

Friedell favored the art nouveau style he had practiced at Gorham. Visible hammermarks were characteristic of his work, as was the intentional oxidation that patinated his elaborate chasing, also a method used at Gorham. Exceptions to the Gorham style were his trophy plaques, which were decidedly vernacular in concept, often of mixed metals, and riveted to oaken shields.

The plaque in the collection (cat. no. 70) was commissioned by the Baldwin family of Pasadena and depicts their horse Missouri King. A photograph was undoubtedly used as a model for the chasing. For unknown reasons the Baldwins did not take possession of the plaque, and the horse's name was never added. The piece remained in the Friedell family until its donation.[5]

Friedell was highly regarded for his skills and won a gold medal at the Panama-California Exhibition in San Diego in 1915. His entries included a punch bowl, coffee set, and several portrait plaques such as this one. He frequently decorated his silver with regional flora, reflecting an arts and crafts emphasis on local motifs; California poppies, citrus flowers, and pine cones frame the horse's portrait. He decorated his most famous work, a 107-piece hollowware dinner service for Los Angeles brewing millionaire Eddie Maier, with California orange blossoms.[6]

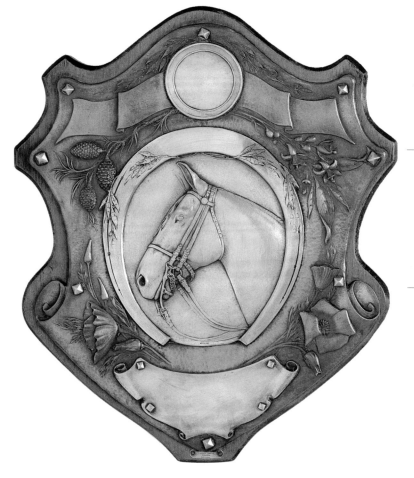

70

Plaque, c. 1915

Silver, copper, and oak
20⅝ x 17¼ x 1⅜ in.
(52.4 x 43.8 x 3.5 cm)
Marks: on front, at base of copper, chased HAND CHASED BY
C. FRIEDELL-PASADENA; on silver tag affixed with screws to lower edge of wood, struck incuse
CLEMENS FRIEDELL | PASADENA |
HAND WROUGHT; below horseshoe, struck incuse STERLING
M.89.9
Gift of Clemens Friedell, Jr.

Clemens Friedell, 1912

GORHAM MANUFACTURING COMPANY

1863–present

Providence

Gorham cost slip,
December 14, 1899

Gorham's Martelé silver is startling testimony to the pervasive commercial influence of the arts and crafts movement in America. Rivaled only by Tiffany and Company, Gorham was among the largest silver firms in the world by the end of the nineteenth century. The company was fully mechanized, so its decision to introduce the handwrought Martelé line was an expensive venture, necessitating the hiring and training of traditional craftsmen like Clemens Friedell. However, while most arts and crafts silversmiths or silver companies worked in preindustrial medieval and colonial styles, Gorham chose a progressive look, art nouveau. Horace Townsend, in a Gorham publication, described the firm's decision:

> The hammer, they determined, should reign supreme. Secondly, they laid it down as an axiom that the designer and the craftsman, if they could not actually be united in the same individual, should be … brought into such close connection that the resultant effect should be practically the same.
>
> There was yet a third guiding principle to be borne in mind. The work they produced should be of its own century. Beautiful as is the work of the "Little Masters" of the past it yet speaks in a dead and forgotten tongue. The designer of today, if he is a true artist, must create and not copy.[7]

Gorham's principles for Martelé design and construction followed standard period doctrine. Although entirely handcrafted, Martelé pieces were not made by a single artisan. Raisers hammered the basic forms; chasers, who were paid more, added prescribed decorations. Such separation of labor was typical of most American arts and crafts production. Like decorators at Rookwood Pottery the chasers may have enjoyed some artistic license in interpreting designs.

Gorham's choice of the art nouveau style was also linked to arts and crafts precepts. The fluid organic shapes were consistent with the emphasis on form being derived from nature; the ornament, although more decorative than that on most American objects, was integral. In comparison with contemporary late-Victorian styles, art nouveau was viewed as reformist and simple.

Gorham prided itself on quality and high fashion, and the latest French style was undoubtedly appealing. (The new line was even named after the French word for hammered, *martelé*.) It also showcased superb handcraftsmanship. The meandering ornament required highly skilled chasing, a level of metalworking not seen in basic hammered forms.

Of the nearly forty-eight hundred Martelé objects recorded in company archives, only twelve mirrors are listed. Most of these were the smaller, hand-held type. Indeed a search through the archives suggests that this piece (cat. no. 71) is the only example of a dressing table mirror or one of very few. The only other similar work known was part of a suite with dressing table and stool produced for the Paris Exposition of 1900. The archives contain both a photograph of and a manufacturing cost slip for the museum's mirror. The latter, dated December 14, 1899, reveals that a total of 327¼ hours were required to make the piece, including 80 by the initial silversmith and 240 by the chaser (the equivalent of four weeks work when work weeks were 60 hours). The slip also records that the mirror was made for the New York silver firm Theodore B. Starr. The archival photograph shows the mirror without the engraved cipher, which must have been added by Starr for the purchasing client or by a subsequent owner. The original price of the mirror was $500; a 10 percent discount to Starr brought the price down to $450.[8]

71

Martelé Mirror, 1899

Silver and glass
23¼ x 16 x 14⅜ in.
(59.1 x 40.6 x 36.5 cm)
Inscriptions: on upper front in
cartouche, engraved cipher SML
Marks: struck on back, lion pas-
sant in shaped surround, eagle
perched on shield displaying
anchor, gothic letter G in shaped
surround | incuse 950–1000 FINE |
THEODORE B. STARR | NEW YORK;
on support, struck incuse 950–
1000 FINE
M.86.293
Decorative Arts Acquisition
Fund

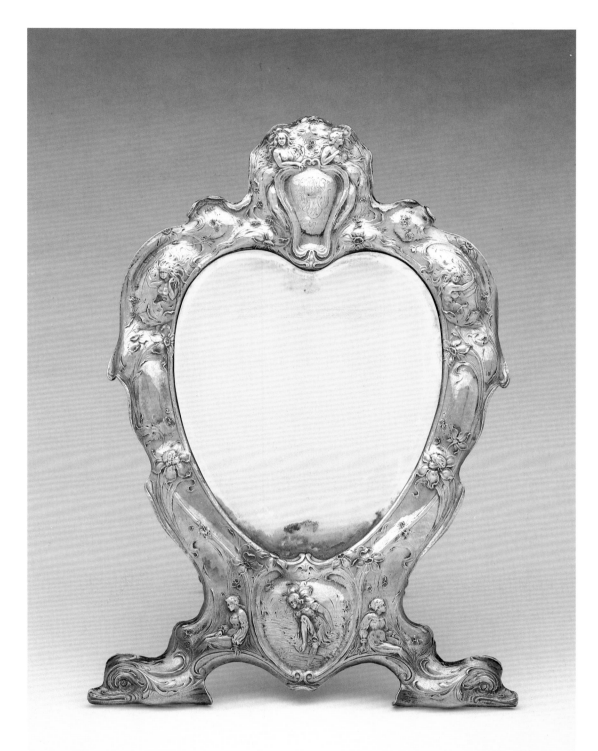

GREENE *and* GREENE

1893–1922

Pasadena

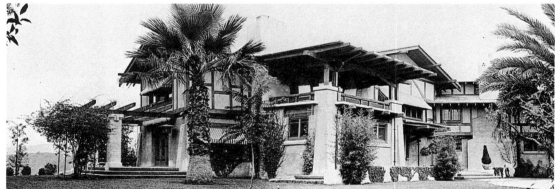

Henry M. Robinson House, 1906
(note lantern on left porch)

72

*Lantern from the
Henry M. Robinson House,
Pasadena*, 1906

Executed by Emil Lange,
Los Angeles (in business
independently by 1910)
Steel and slag glass
24¼ x 32¾ x 33⅛ in.
(61.6 x 83.2 x 84.1 cm)

L.88.30.48
Collection of Max Palevsky
and Jodie Evans

The Robinson House was
the first commission in which
Charles and Henry Greene
began to refine their early style
with oriental motifs.[9] This exte-
rior porch lantern expresses such
an influence, with its broad, low-

hipped "roof" that echoes the
lines of the home's gently sloped,
overhanging housetop. The cut-
out on the sides is derived from
a similar motif by Charles Ren-
nie Mackintosh (see cat. no. 7 for
an example of its use by E. A.
Taylor). The lantern was painted
to simulate copper.

ROBERT RIDDLE
JARVIE
United States, 1865–1941

Chicago

Like San Francisco metalworker Dirk van Erp, Robert Jarvie began his arts and crafts career as a hobbyist. He exhibited some of his wares at the Chicago Arts and Crafts Society in 1900 and later began advertising himself as "The Candlestick Maker."[10] In 1903 he was the subject of an article in *The Craftsman*, which noted that "the possessor of one of the Jarvie candlesticks must feel that nothing tawdry or frivolous can be placed by its side," and that the "motive in all Mr. Jarvie's work is utility and simple beauty rather than a striving for striking effects."[11] The following year he was praised in *The International Studio*: "Most of Mr. Jarvie's candlesticks are of cast brass, or copper, brush polished—a process which leaves the metal with a dull glow. Some pieces are cast in bronze; others, again, are in spun brass. Through them all runs the exquisite line of design which has given Mr. Jarvie an en-

viable reputation."[12]

Jarvie left his job as a Chicago city clerk to open an art metal shop in 1905. He produced a variety of household accessories in addition to more than sixteen designs of candlesticks, all named with Greek letters. He was evidently influenced by candle holders produced by Tiffany Studios, as at least two of his designs are quite similar to Tiffany works. The Beta pieces seen here (cat. no. 73a–b) have obvious connections with the Tiffany candlesticks in the collection (cat. no. 99a–b). His well-known Theta style is nearly identical to another Tiffany design. The Beta model was illustrated in the two articles cited above and exhibited at the Louisiana Purchase Exposition in St. Louis in 1904. The silver-plated Alpha candlesticks (cat. no. 75a–b) are much rarer than the brass versions (cat. no. 74a–b).

R. R. JARVIE
THE CANDLESTICK MAKER
Makes all kinds of
Candlesticks and Lanterns
608 W. Congress St.
Chicago

Send for Catalogue of New Candlesticks

Mr. Jarvie's work may be
seen at

The Kalo Shop
916 Fine Arts Building

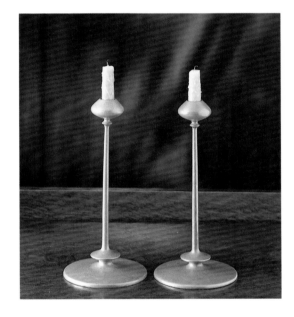

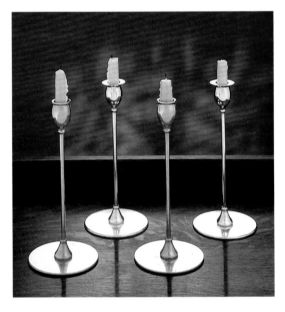

73a–b

Pair of Beta Candlesticks, c. 1905

Copper
Each: 12¼ x 5⅞ (diam.) in.
(31.1 x 14.9 cm)
Marks: a) under base, cast incised script signature JARVIE | B; b) under base, cast incised JARVIE
M.89.151.20a–b
Gift of Max Palevsky and Jodie Evans

74a–b

Pair of Alpha Candlesticks, c. 1905

Brass
Each: 11⅛ x 5 (diam.) in.
(28.3 x 12.7 cm)
Marks: under base of each, cast incised script signature JARVIE
TR.9365.5a–b
Collection of Max Palevsky and Jodie Evans

75a–b

Pair of Alpha Candlesticks, c. 1910

Silver-plated brass
Each: 10⅞ x 5 (diam.) in.
(27.6 x 12.7 cm)
Inscriptions: on each candle cup, engraved cipher GPC
Marks: under base of each, cast incised script signature JARVIE
TR.9408.4a–b
Collection of Max Palevsky and Jodie Evans

OLD MISSION KOPPER KRAFT

1922–c. 1925

San Jose and San Francisco

The name Old Mission Kopper Kraft was only one of several given to art metal shops owned individually and jointly by Hans W. Jauchen (Germany, 1863–1970, active United States) and Fred T. Brosi (Italy, d. 1935, active United States).[13] Jauchen came to California from Hamburg about 1911.[14] City directories indicate a partnership with Brosi from 1915 to 1918, after which each maintained separate shops until the formation of Old Mission Kopper Kraft. This business had a manufacturing plant in San Jose but retailed goods in San Francisco. Many of the wares were decorated with eucalyptus pods picked from San Francisco's Golden Gate Park, in keeping with the arts and crafts emphasis on vernacular motifs (the pods were picked, treated, and metallized). The mark was a line drawing of the city's Mission Dolores. City directories record Brosi as president of the firm in 1923 and 1924; after 1925 he was listed as a public school teacher. Whether he continued a sideline partnership with Jauchen during this period is unclear.[15]

The design of the lamp seen here (cat. no. 76) was copied from those sold by Dirk van Erp's studio. However, just as Grand Rapids furniture manufacturers borrowed Gustav Stickley's ideas without concern for construction, Old Mission Kopper Kraft transcribed van Erp's designs for mechanization. The establishment was stocked with various machines and molds that were employed to stamp out hammer patterns on copper and die-press parts for assemblage. This lamp was made from three manufactured segments and is held together with a central rod that is bolted under the base. The rivets are entirely decorative; the surface bears no hand-hammering. So popular had the arts and crafts movement become that machines paid craftsmen the ultimate compliment of imitation. It hardly needs to be pointed out that machine-made substitutes were far less expensive than handmade goods.

76

Table Lamp, 1922–c. 1925

Copper, steel, and mica
16½ x 18¼ (diam. of shade)
x 6¾ (diam. of base) in.
(41.9 x 46.4 x 17.1 cm)
Marks: under base, struck incuse
OLD MISSION KOPPERKRAFT |
outline of mission | SAN
FRANCISCO
L.88.30.50
Collection of Max Palevsky
and Jodie Evans

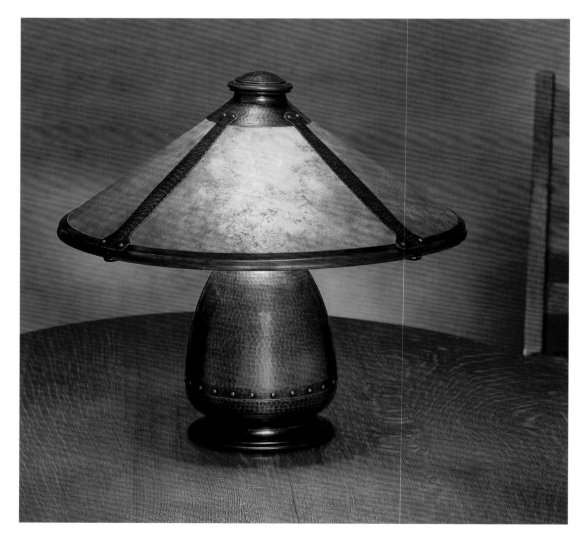

THE PALMER COPPER SHOP

1910–c. 1918

San Francisco

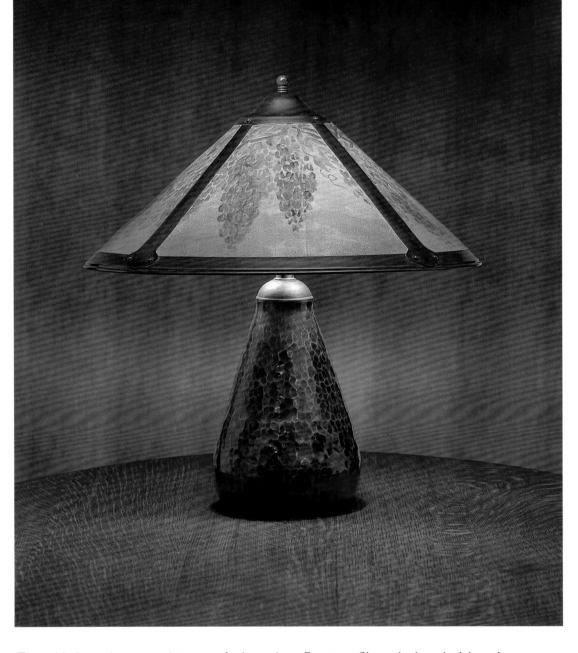

77

Table Lamp, c. 1913

Copper and wire mesh
21 x 19½ (diam. of shade)
x 7¼ (diam. of base) in.
(53.3 x 49.5 x 18.4 cm)
M.89.151.23
Gift of Max Palevsky
and Jodie Evans

This table lamp (cat. no. 77) is one of a limited number produced by Lillian MacNeill Palmer (United States, 1871–1961), probably while in collaboration with Harry St. John Dixon (United States, 1890–1967). Palmer, cousin of painter James Abbott McNeill Whistler, was president of the Palmer Copper Shop from 1910 until about 1918. She continued to work as a solo artisan until about 1928. For Gumps, the San Francisco department store, she adapted oriental vases into lamps, supplying various styles of shades.[16] She was particularly noted for shades of hand-painted wire mesh. A 1917 notice in the *San Francisco Chronicle* described her shop as specializing in "designing fixtures which not only attain the desired lighting effects in a given room, but also conform to the style and contour of the room and the usage to which it is to be put."[17] Dixon, who had worked in Dirk van Erp's shop, joined with Palmer to produce a line of lamps after he left van Erp in 1912. It is likely that he hammered the base of this example. The unusually large indentations harmonize with the pattern of the wisteria blossoms on Palmer's shade.

THE PETTERSON STUDIO

c. 1912–19

Chicago

78

Covered Standing Cup,
c. 1912–14

Silver with garnet
12½ x 4⅞ (diam.) in.
(31.8 x 12.4 cm)
Marks: under base, struck incuse
THE PETTERSON STUDIO | CHICAGO
M.89.151.19
Gift of Max Palevsky
and Jodie Evans

John Pontus Petterson (Norway,
1884–1949, active United States)
trained as a silversmith in his
native country before immigrat-
ing to America in 1905. He
worked for Tiffany and Com-
pany and Robert Jarvie before
founding his own shop in Chi-
cago. The Petterson Studio pro-
duced a variety of handwrought
goods as well as special commis-
sion flatware and hollowware.[18]

The style of this standing cup
is indebted to English arts and
crafts silver by C. R. Ashbee's
Guild of Handicraft. The finial,
with its semiprecious stone set
in a filigree mounting, is com-
parable with that on Ashbee's
covered bowl (see cat. no.
3a–b). The organic elongation
of the stem is analogous to the
exaggerated handles of the
Ashbee piece.

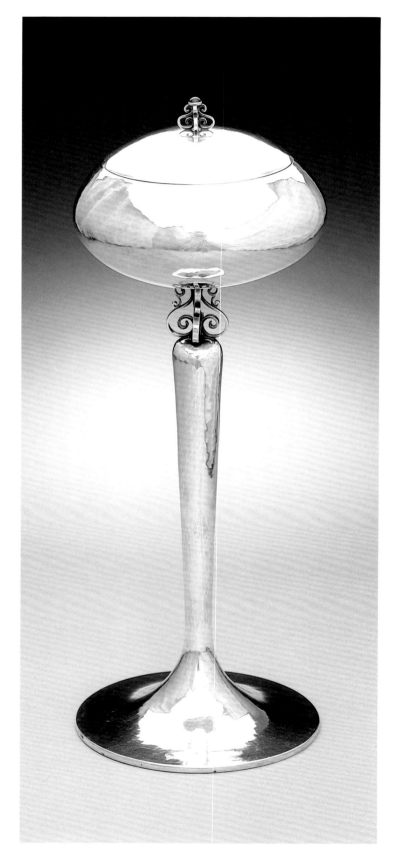

THE RANDAHL SHOP

1911–50

Chicago

79

Bowl, 1911–c. 1920

Silver

4½ x 10¾ (diam.) in.
(11.4 x 27.3 cm)

Marks: under base, struck incuse
JOR superimposed on a hammer |
HAND WROUGHT | STERLING | 1191

M.84.99

Gift of Phyllis and Lawrence
Margolies in memory of Rose
and Alex Margolies

Julius Olaf Randahl (Sweden, 1880–1972, active United States) was associated with Chicago's Kalo Shop before he founded his own business in 1911, retailing his products through Marshall Field and Company and other department stores. His design for this handwrought bowl is indebted to both his Scandinavian background and his association with Kalo.[19]

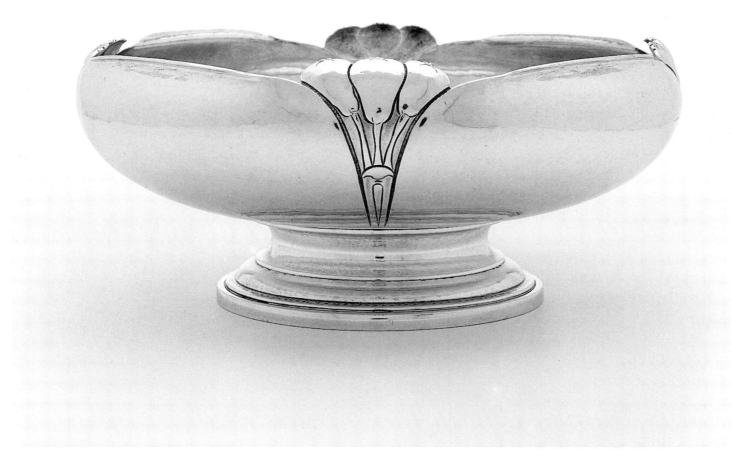

The Copper Shop of the Roycrofters

c. 1903–38

East Aurora, New York

Copper was a favored metal in the arts and crafts movement, because it was removed from the elitist associations of silver. Indeed a 1919 Roycroft catalogue, referring to the company's "copper craft," noted: "Beautiful objects should be owned by the people. They should be available as home embellishments and placed within the reach of all."[20]

Elbert Hubbard's dream of a commercially viable craft community was being realized at Roycroft when, about 1903, he established an art copper department, the Copper Shop. In 1908 he placed Karl E. Kipp (United States, 1882–1954) in charge. Kipp, from the bookbinding area, organized the section and planned most of the prototypes, delegating production of the designs to assistants. Roycroft's art copper was marketed nationally along with its other products and was quite popular with middle-class customers.

Kipp left Roycroft in 1911 to found his own firm, the Tookay (or "two K") Shop, but returned in 1915.[21] The Copper Shop, which employed as many as thirty-five workers, continued uninterrupted production from about 1903 to 1938, making "hand-hammered copper vases, trays, bowls, candlesticks, lighting fixtures and a hundred and one other objets d'art—individual pieces of craftsmanship that were lasting, beautiful and worthwhile."[22]

Kipp's previous work in the bindery is evident in many Roycroft copper ware designs, which have stamped borders that emulate the stitching of leather. A Viennese secessionist influence is also evident, gained from contemporary journals as well as the firsthand experience of Dard Hunter (United States, 1883–1966), a Roycroft craftsman who studied in Vienna from 1908 to 1909 and worked closely with Kipp before the coppersmith left in 1911 (see also cat. no. 236).

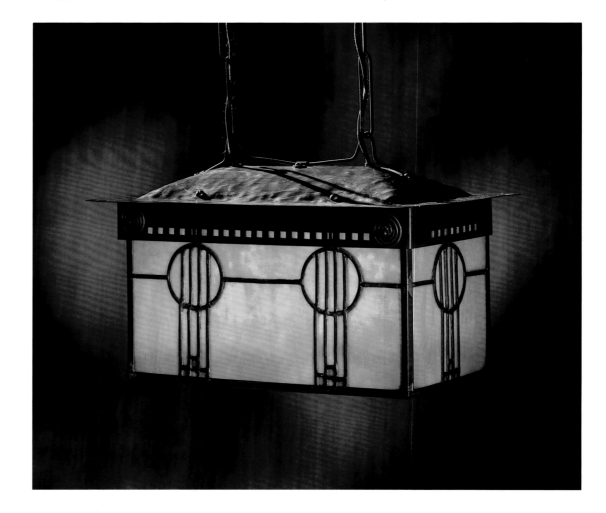

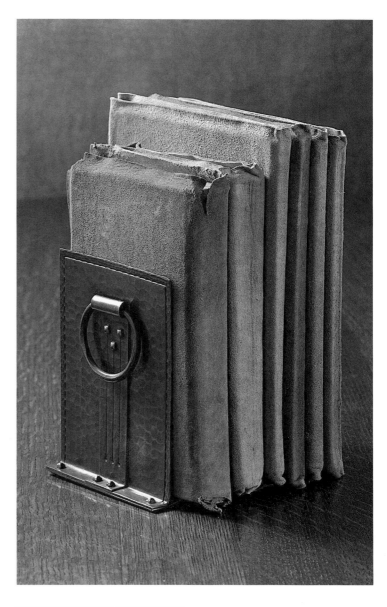

80

Hanging Lantern from the Roycroft Chapel, East Aurora, New York, c. 1908–10

Design attributed to Karl E. Kipp (United States, 1882–1954) and/or Dard Hunter (United States, 1883–1966)
Copper, leaded glass, and (replaced) copper chains and beam straps
8½ x 14¾ x 8¾ in.
(21.6 x 37.5 x 22.2 cm)
M.89.151.10
Gift of Max Palevsky and Jodie Evans

Never in production, this lantern originally hung with nine others in the Roycroft Chapel. Custom-made around 1908–10, the lanterns were strapped to the open beams of the roof trusses. Because of modifications necessary for a later ceiling installation, the chains and beam straps are restorations. Roycroft did not use the term "chapel" in a religious sense, but rather in its archaic meaning as a meeting house for printers. The Roycroft Chapel served as the community's auditorium, as noted in a contemporary journal: "The building is devoted more to recreation uses than anything else. It contains a lecture hall and a number of parlors."[23] The design of the lantern suggests a collaboration between Kipp and Hunter. The latter may have designed it before his trip to Vienna in 1908 or Kipp from other of Hunter's lighting fixtures.[24] In either case, the style is indebted to Glasgow and Vienna.

81a–b

Pair of Bookends, c. 1910–c. 1926

Design attributed to Karl E. Kipp (United States, 1882–1954)
Copper
Each: 5⅜ x 4⅛ x 3⅛ in.
(13.7 x 10.5 x 7.9 cm)
Marks: on top of each base, struck incuse orb and double-barred cross enclosing R
L.88.30.56a–b
Collection of Max Palevsky and Jodie Evans

Offered in a 1919 catalogue for five dollars, these bookends were probably designed by Kipp before he left Roycroft in 1911.[25] The rivets are both functional and decorative, as is common with arts and crafts metalwork. The bold, vertical strapwork-and-ring design, accentuated by the rivets, relates to the geometric abstractions of the Vienna secessionists. A variant of the design can be found in the leaded glass of the Roycroft Chapel lantern (cat. no. 80).

Karl Kipp, c. 1905

82a–b

Pair of Princess Candlesticks,
1915–c. 1926

Designed by Karl E. Kipp
(United States, 1882–1954)
Copper
a: 7¾ x 3¼ x 3¼ in.
(19.7 x 8.3 x 8.3 cm)
b: 7⁹⁄₁₆ x 3⁵⁄₁₆ x 3⁵⁄₁₆ in.
(19.2 x 8.4 x 8.4 cm)
Marks: on top of each base,
struck incuse orb and double-
barred cross enclosing R
L.88.30.58a–b
Collection of Max Palevsky
and Jodie Evans

"The Princess Candlesticks" sold
for three dollars and fifty cents a
pair in an undated Roycroft cata-
logue issued before 1919, proba-
bly between 1915 and 1918.[26] They
were originally designed and
made by Kipp at the Tookay
Shop and were adopted by
Roycroft after his return. The
hipped bases and attenuated
"spindle" shafts relate to Vienna
secessionist design and such
American interpretations as the
spindle-back seating forms of
Gustav Stickley and Frank Lloyd
Wright (see cat. nos. 43–44, 46, 65).

83a–b

Pair of Candlesticks,
c. 1915–c. 1926

Copper
a: 11⁷⁄₈ x 4⁵⁄₈ x 4½ in.
(30.2 x 11.7 x 11.4 cm)
b: 11¾ x 4¼ x 4¼ in.
(29.8 x 10.8 x 10.8 cm)
Marks: on side of each shaft,
struck incuse orb and double-
barred cross enclosing R
TR.9365.9a–b
Collection of Max Palevsky
and Jodie Evans

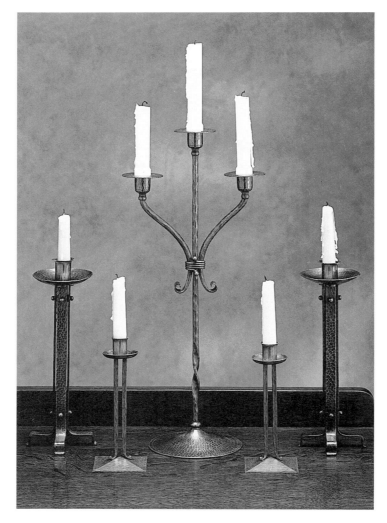

84

Candelabrum, c. 1915–c. 1926

Copper
20 x 9⅛ x 6⅛ (diam.) in.
(50.8 x 23.2 x 15.6 cm)
Marks: under base, struck incuse
orb and double-barred cross
enclosing R
L.88.30.60
Collection of Max Palevsky
and Jodie Evans

Candle holders were a popular
product of the Copper Shop.
The candlesticks (cat. no. 83a–b)
retailed for fifteen dollars a pair
in a 1926 Roycrofters catalogue;
the candelabrum (cat. no. 84),
for twelve dollars and fifty
cents.[27]

Cat. nos. 83a–b (outer pair),
82a–b (inner pair), 84 (at center)

85 ➤

*Vase from the Grove Park Inn,
Asheville, North Carolina,*
1912–13

Copper
22⅝ x 8¼ (diam.) in.
(57.5 x 21.0 cm)
Marks: under base, struck incuse
THE G.P.I. AMERICAN BEAUTY VASE |
MADE EXCLUSIVELY FOR | GROVE
PARK INN | BY THE ROYCROFTERS
TR.9408.6
Collection of Max Palevsky and
Jodie Evans

In 1912 Roycroft was commis-
sioned to supply furnishings for
a 152-room resort hotel in the
Blue Ridge Mountains of North
Carolina, the Grove Park Inn in
Asheville, built by Edwin Wiley
Grove. Among the objects sup-
plied was a special version of
Roycroft's American Beauty
Vase. The regular model was
sold to the public in seven-,
twelve-, and nineteen-inch sizes.
For the inn Roycroft produced
this monumental twenty-two-
inch piece, which was marked as
being made exclusively for the
hotel. Meant for installation in
the six ladies' parlors, probably
no more than two dozen were
made. The inn opened to the
public in 1913 and remains in
operation today.[28]

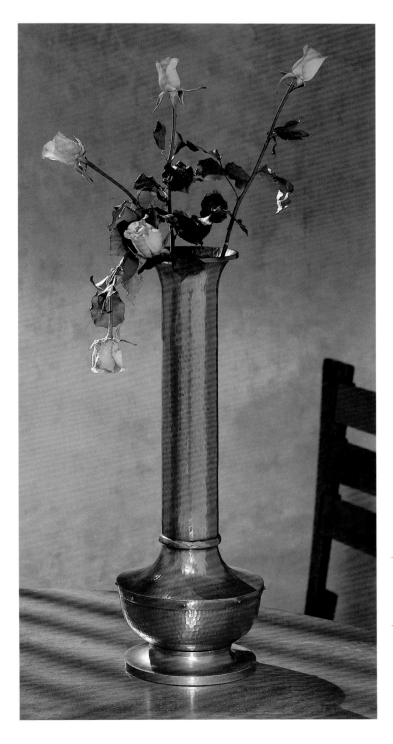

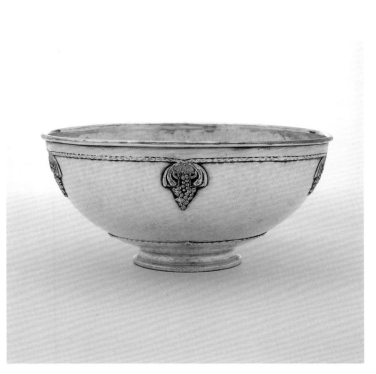

86

Nut or Fruit Bowl, 1915–20

Designed by Karl E. Kipp
(United States, 1882–1954)
Silver-plated copper
4¼ x 9¼ (diam.) in.
(10.8 x 23.5 cm)
Marks: under base, struck incuse
orb and double-barred cross
enclosing R | ROYCROFT |
SHEFFIELD
M.87.156
Purchased with funds provided
by Laurence and Terry Sterling

Silver was electroplated to se-
lected Roycroft designs in the
late teens.[29] The grape clusters
on this bowl are part of a
machine-stamped border applied
around the rim of the piece.
After the bowl was electroplated,
the silver was removed from
the grape design to reveal the
copper. Although the bowl is
marked Sheffield, the electro-
plating procedure used to create
it was quite different from the
original Sheffield process.[30] The
term was undoubtedly chosen
for its antique associations. In
solid copper this form, called a
"Nut or Fruit Bowl," retailed for
eighteen dollars in the undated
catalogue of about 1915–18.[31]

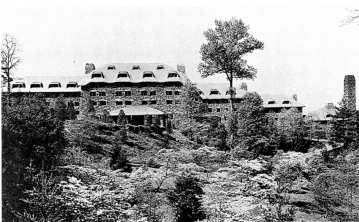

Grove Park Inn, c. 1920

SHREVE
and
COMPANY

1852–present

San Francisco

Shreve and Company, founded in 1852, was a well-established and fully mechanized silver manufacturer by the late nineteenth century. Like Gorham it responded to the arts and crafts movement with special "handcrafted" designs. This meant that the hammermarks on most of the wares were added by hand after the form had been spun on a lathe, a typical mechanized compromise in arts and crafts silver.[32]

Introduced late in the 1890s, Shreve and Company's most distinctive craftsman line was styled after medieval ironwork, with applied strapwork and rivets (see cat. nos. 87a–d, 88). In silver these techniques were purely decorative but evoked the construction-as-ornament philosophy of the movement. Rivets in arts and crafts metalwork are analogous to wooden pegs in the period's furniture, connoting strong, enduring construction, even when used decoratively. This theme is particularly evident in the breakfast set (cat. no. 87a–d). Shreve entitled such designs Fourteenth Century in both its flatware and hollowware lines, although they are commonly called Shreve Strap today. They were produced by the firm until about 1920.[33]

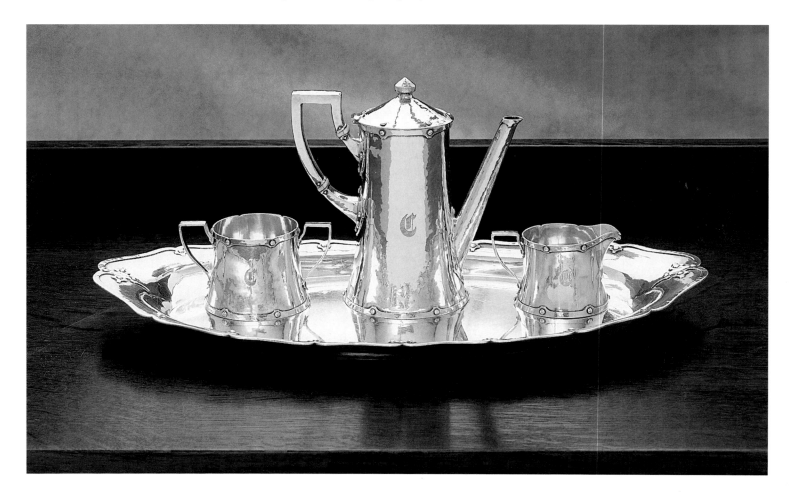

87a–d

Breakfast Set, c. 1910

Silver and ivory
Coffee pot: 6½ x 6⅝ x
3¾ (diam.) in.
(16.5 x 16.8 x 9.5 cm)
Sugar bowl: 2⅜ x 4⅜ x
3⅛ (diam.) in.
(6.0 x 11.1 x 7.9 cm)

Creamer: 2¼ x 3¾ x
2¾ (diam.) in.
(5.7 x 9.5 x 7.0 cm)
Tray: 1⅜ x 17¼ x 9 in.
(3.5 x 43.8 x 22.9 cm)
Inscriptions: on body of each,
engraved C

Marks: under base of each,
struck incuse SHREVE & CO | SAN
FRANCISCO | STERLING; on coffee
pot, struck incuse 1 PINT
L.88.30.62a–d
Collection of Max Palevsky
and Jodie Evans

88

Punch Bowl, c. 1910

Silver
4⅞ x 9½ (diam.) in.
(12.4 x 24.1 cm)
Marks: under base, struck incuse
SHREVE & CO | SAN FRANCISCO |
STERLING
M.89.151.26
Gift of Max Palevsky
and Jodie Evans

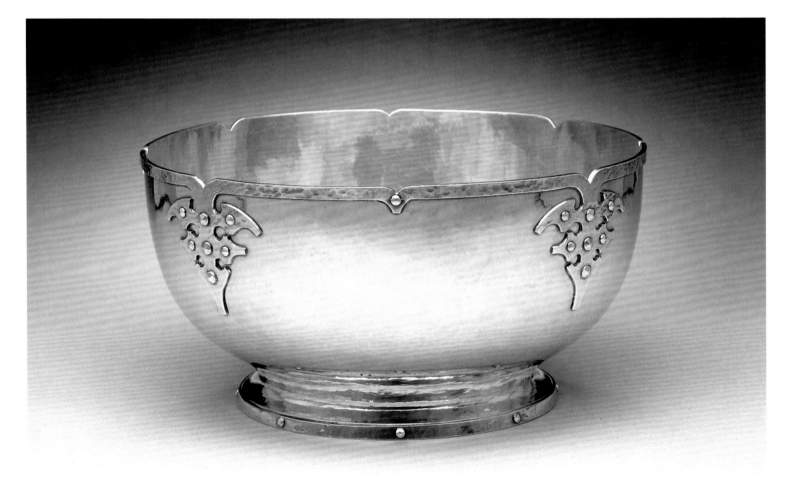

GUSTAV STICKLEY'S CRAFTSMAN WORKSHOPS

1899–1916

Eastwood and New York,

New York

Describing a master metalsmith from his Craftsman Workshops, Gustav Stickley wrote in a metalwork trade catalogue of about 1905: "Projected against the firelight of the flaming forge, his sinewy frame satisfies the spectator with a sense of fitness, as he moves with quick, decisive gesture, directing the processes of the men who are shaping a large number of objects, widely differing in size and use: such as Lamps, Lanterns, Electroliers, Candlesticks, Umbrella Stands, Jardinieres, Wine Coolers, Cigar Boxes, Serving Trays, Wall Plaques, Hinges, Drawer Pulls, Knockers and Escutcheons." [34]

Stickley recognized early on the need for hardware comparable in quality with the furniture it fitted. Dissatisfied with commercially available products, he founded a metalworking shop sometime before 1905. He noted in a publication of that year:

The Craftsman Metal Work is the direct outgrowth of a need developed by the strong individuality of The Craftsman furniture, and possesses the same structural and simple quality. This department of the Workshops was established when it was found impossible to procure metal accessories to the furniture, such as drawer and door pulls, hinges and escutcheons, that harmonized with its character. Only handwrought metal in simple, rugged designs would do, and the only way to get this was to make it ourselves. [35]

From hardware it was a natural step to the production of household accessories in copper and wrought iron. Some designs for these wares were copied from English pieces Stickley had previously imported and sold.[36] Stickley metalwork is characteristically handwrought, with obvious hammermarks and repoussé designs that are often of simple and stylized floral patterns.

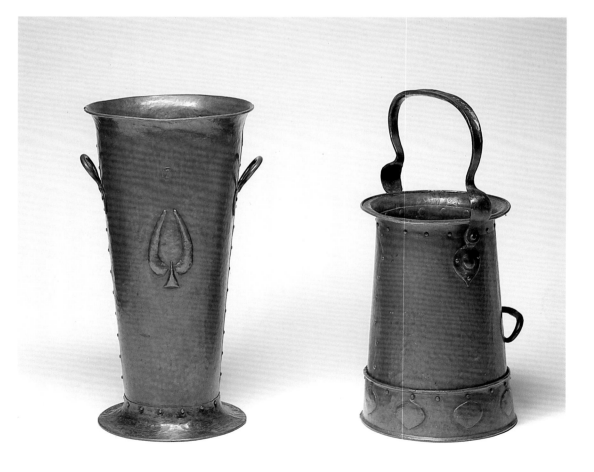

Cat. nos. 90, 89

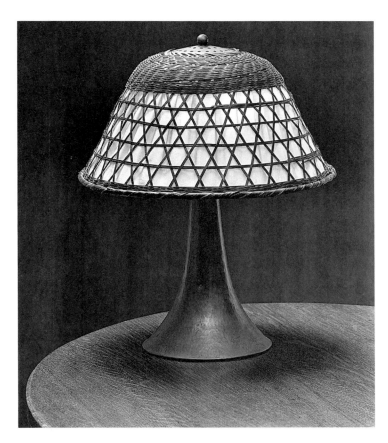

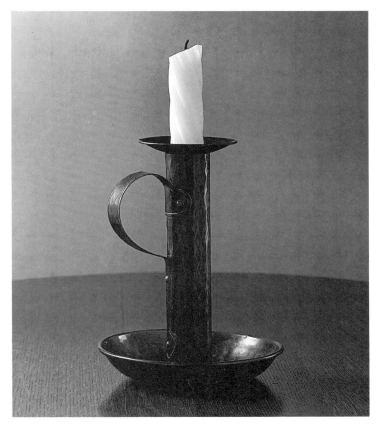

< 89

Coal Bucket, 1905–c. 1910

Copper and iron
25 x 14⅝ x 12½ in.
(63.5 x 37.1 x 31.8 cm)
TR.9408.3
Collection of Max Palevsky
and Jodie Evans

< 90

Umbrella Stand, 1905–c. 1910

Copper and copper-plated steel
23¾ x 13¾ x 12⁷⁄₁₆ (diam.) in.
(60.3 x 34.9 x 31.6 cm)
Marks: on side, struck incuse
THE CRAFTSMAN WORKSHOPS |
GUSTAV STICKLEY within two con-
centric circles enclosing compass
enclosing ALS | IK | KAN
L.89.17.2
Collection of Max Palevsky
and Jodie Evans

The coal bucket (cat. no. 89) and
umbrella stand (cat. no. 90) were
illustrated in a 1905 catalogue,
the former as being available in
copper or brass.[37]

91

Table Lamp, 1905–c. 1910

Copper, steel, willow, and silk
18¾ x 16⅜ (diam. of shade)
x 8⅛ (diam. of base) in.
(47.6 x 41.6 x 20.6 cm)
Marks: under base, struck incuse
compass enclosing ALS | IK | KAN
L.88.30.47
Collection of Max Palevsky
and Jodie Evans

Lamps with hammered copper
bases and wicker-and-silk shades
were offered by about 1905.
Whether achieved with mica,
parchment, art glass, or silk,
arts and crafts lighting was
consistently muted and warm,
illuminating the immediate
sphere. Electric lighting was
considered glaring when intro-
duced; this type of lamp helped
to approximate the softer glow
of candles and gaslights.[38]

92

Candlestick, 1913–15

Copper
9 x 7⅛ (diam.) in.
(22.9 x 18.1 cm)
Marks: under base, struck incuse
compass enclosing ALS | IK | KAN
L.88.30.46
Collection of Max Palevsky
and Jodie Evans

An oversized, vernacular version
of a chamberstick, this candle-
stick was first offered in a
1913 Craftsman catalogue.[39] It
was later promoted in *Craftsman*
Christmas advertisements as
a solution to the problem of
"choosing something beautiful
and inexpensive for men."[40]

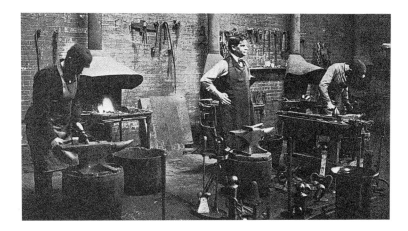

Craftsman metalworking shop,
c. 1904 (note Gustav Stickley
at center)

L. *and* J. G. STICKLEY

1902–present

Fayetteville, New York

93

Serving Tray, c. 1912

Copper

1⅛ x 18⅞ (diam.) in.
(2.9 x 47.9 cm)

Marks: on back, struck incuse triangle with clipped lower corners enclosing conjoined LJGS

L.88.30.51

Collection of Max Palevsky and Jodie Evans

Little is known about metalwork production at L. and J. G. Stickley. Except for the mark, this tray is identical to a Craftsman Workshops model, number 347, which was advertised in *The Craftsman* in 1904 as well as in a 1905 Craftsman Workshops catalogue. It was probably made for L. and J. G. Stickley by a subcontractor, possibly Benedict Studios of Syracuse, that also supplied wares to Gustav Stickley. The stylized repoussé design was characteristic of Craftsman Workshops metalwork and was derived from English prototypes.[41]

94

Baluster from the Schlesinger and Mayer Department Store, Chicago, 1898–99

Manufactured by Winslow Brothers Company, Chicago (1887–1921)
Cast iron
34½ x 9¾ x 1⅞ in.
(87.6 x 24.8 x 4.8 cm)
L.88.30.65
Collection of Max Palevsky and Jodie Evans

The Schlesinger and Mayer (later Carson Pirie Scott) Department Store is one of Sullivan's classic buildings, its frothy ornament on the lower, pedestrian-oriented floors contrasting with the stark, modern appearance of the upper floors. This baluster was one of many in the building's iron staircases. It was probably removed from the structure in the late 1960s when open staircases were altered and enclosed following a serious fire.[44]

As tutor to the three most prominent prairie school architects—Frank Lloyd Wright, George Grant Elmslie, and George Washington Maher—Louis Sullivan is considered the father of the school. His own greatest contributions were commercial buildings, on which he practiced his distinctive and influential theories of integrated structure, form, and ornament—theories that were transcribed for domestic buildings by prairie school proponents. Sullivan believed that ornament should be an organic outgrowth of form and structure; the motifs themselves should be derived from nature. Art nouveau influences are recognizable in his work, but that movement's loose, meandering asymmetry is absent. By imposing a geometric order on the active motifs of the French style, he set up an underlying tension that rhythmically tightened and subsided.

Sullivan was fascinated by plants and cell growth, recommending books on both in his treatises. He found inspiration in their underlying energy. According to William Jordy: "It was not the visible surface of plant life that stirred Sullivan, but its anatomy and growth. So what he came to call the idea of 'suppressed functions' is variously manifest in Sullivan's life and career. 'Suppressed functions' of the human body, of plant life, of buildings—the theme of suppressed energies for Sullivan was all-embracing.... To Sullivan these energies could only be fully embodied in architecture through ornament."[42]

George Grant Elmslie (United States, 1871–1952), a brilliant designer who succeeded Frank Lloyd Wright in Sullivan's office, was chief draftsman from 1893 to 1909. It frequently fell to him to execute Sullivan's distinctive theories of ornament on specific commissions. He is believed to have contributed substantially to the Schlesinger and Mayer and Babson projects.[43] He left Sullivan in 1909 to establish his own practice in the firm of Purcell, Feick, and Elmslie.

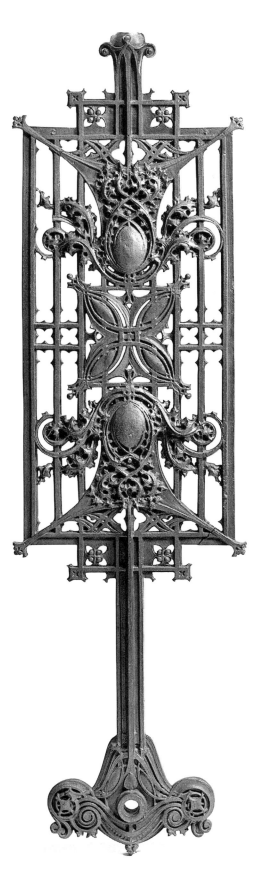

Staircase, Schlesinger and Mayer Department Store, c. 1955

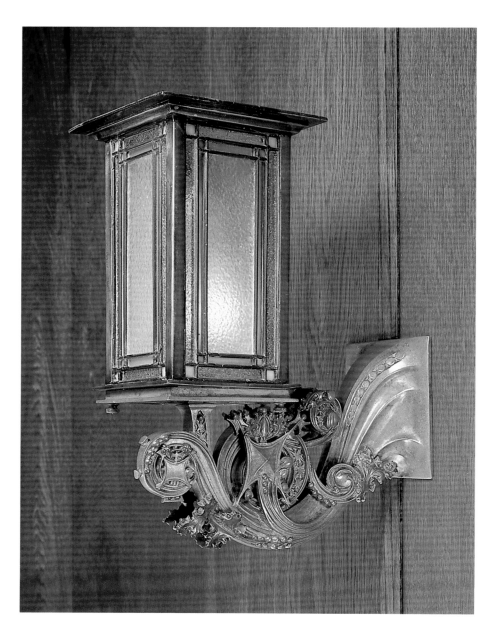

95

*Wall Sconce from the
Henry B. Babson House,
Riverside, Illinois*, 1907

Probably manufactured by
Winslow Brothers Company,
Chicago (1887–1921)
Brass and leaded glass
12⅜ x 5⅜ x 9¾ in.
(31.4 x 13.7 x 24.8 cm)
M.89.151.21
Gift of Max Palevsky
and Jodie Evans

The Babson House was among
the most outstanding of Sulli-
van's infrequent residential com-
missions. Elmslie contributed
many of the plans for furnishings
and accessories for this expan-
sive suburban home. This wall
sconce was one of a number
custom-made for the residence
and illustrates Sullivan's theories
of geometry integrated with
nature.[45]

Entry hall, Henry B. Babson House,
1907

ARTHUR THUMLER

United States, 1886–1969

San Francisco

A native San Franciscan, Arthur Thumler went to work for Shreve and Company at the age of seventeen. In 1906 he traveled east to the employ of the Towle Company in Newburyport, Massachusetts, but returned to Shreve in 1911. He established his own shop in San Francisco after serving in World War I. Restoration and repair work formed a large part of the business; Thumler silver was usually made to order and is rare. He continued to work in the style and methods of the arts and crafts movement until his retirement in 1968. His silver is characteristically heavy, handwrought, and simply designed.[46]

This teapot of stylized colonial form (cat. no. 96) is typical of Thumler's reinterpreted Early American designs. His favoring of such styles was in common with many arts and crafts silversmiths.[47] The shape is derived from nineteenth-century neoclassical silver teapots; the monogram is in a lettering style popularized by Chicago arts and crafts silversmiths.[48] The initials are those of William James Lindenberger; Mrs. Lindenberger commissioned the piece for her husband around 1950. Although dating some twenty years after the decline of the arts and crafts movement in America, the teapot is distinctively of that period in philosophy and construction and illustrates the isolated survival of the style in the careers of some artisans. Lindenberger's widow willed the piece to Thumler's apprentice, Dr. Howard Hammond, about 1969.

96

Teapot, c. 1950

Silver and fruitwood
5 ⅜ x 9 ⅛ x 5 ⅛ in.
(13.7 x 23.2 x 13.0 cm)
Inscriptions: on body, applied
WJL
Marks: under base, struck incuse
THUMLER | cipher AT in square
surround | incuse STERLING
M.88.198
Purchased with funds provided by the Decorative Arts Council in honor of Timothy Schroder

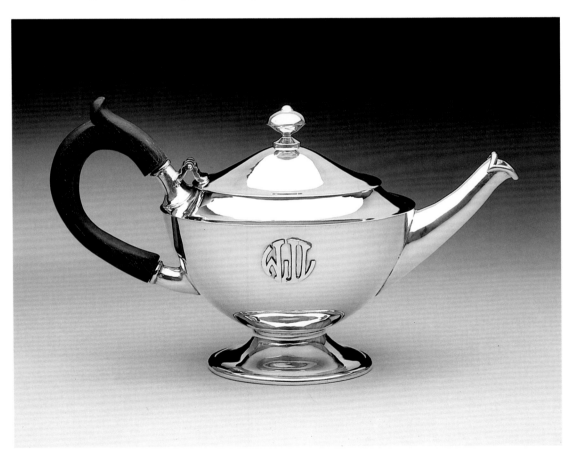

Arthur Thumler (second from right), 1903–6

LOUIS COMFORT TIFFANY

United States, 1848–1933

Corona and New York,

New York

97a–c

Tea Set, 1902–4

Probably executed by Julia Munson (United States, 1875–1971)
Silver and ivory
Teapot: 6¼ x 7⅞ x 5⅞ (diam.) in. (15.9 x 20.0 x 14.9 cm)
Sugar bowl: 3¼ x 5⅜ (diam.) in. (8.3 x 13.7 cm)
Creamer: 4 x 5⅛ x 4⅛ (diam.) in. (10.2 x 13.0 x 10.5 cm)
Marks: under base of each, struck incuse TIFFANY STUDIOS | NEW YORK | STERLING | ⁹²⁵⁄₁₀₀₀ | 6646
M.85.3a–c
Purchased with funds provided by the Director's Roundtable

Louis Comfort Tiffany, the son of Charles Tiffany, owner of New York's Tiffany and Company, was the acknowledged master of the art nouveau style in America. Not surprisingly, his philosophies about decorative arts were mainstream arts and crafts. After a budding career as a painter Tiffany concentrated on the so-called applied arts in the 1870s. He studied medieval stained glass techniques and tested the artistic possibilities of the medium from the 1870s to the early 1900s. In his various companies he encouraged craftsmen to experiment and assist in the design process.[49] In comparison with Gustav Stickley and other arts and crafts manufacturers, Tiffany came closer to implementing what Ruskin proposed, that the worker should think and the thinker should work. According to Gertrude Speenburgh: "Mr. Tiffany liked to employ artists with genuine talent, unspoiled by too much previous training. He gave them every facility to develop along lines of their own abilities or limitations, but in accordance with his requirements. He never hampered his workers by being dictatorial as to technique, but he would criticize sharply if results showed lack of precision or application."[50]

Tiffany Studios (Corona, New York, 1902–38) was an outgrowth of his glass company, which had required bronze fittings and bases. It produced metalwares, enamels, and pottery in addition to art glass.

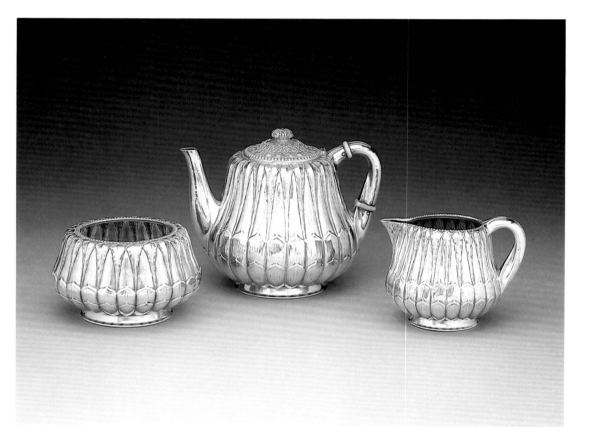

Fewer than two dozen examples of silver survive that are attributable to Louis C. Tiffany or his businesses. Undoubtedly reluctant to compete with his father's well-known silver firm, Louis distinguished himself in the realms of art glass, bronze, and enamelwork. This silver tea set was made for Tiffany's own use at Laurelton Hall, his estate at Oyster Bay, New York. Along with a hot water kettle on a stand and a hammered copper tray it decorated a sideboard until sold with the contents of the house in 1946. The whereabouts of the kettle and tray are unknown.[51]

Tiffany is the assumed designer of these compact shapes. The lid, spout, and handles appear as organic appendages emerging from lotuslike forms. The likely craftsman was Julia Munson, studio supervisor and accomplished metalworker. All three pieces are raised and retain their hammermarks, as is typical of arts and crafts silver.

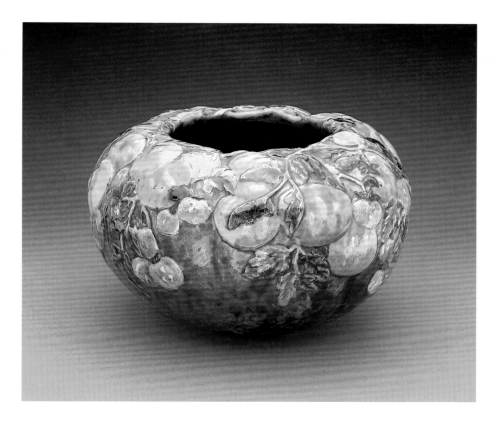

98

Bowl, 1902–5

Copper, gold foil, and enamel
6⅜ x 10¼ (diam.) in.
(16.2 x 26.0 cm)
Marks: under base, struck incuse
SG 61 | engraved script signature
LOUIS C. TIFFANY
46.41.5
Gift of Mr. H. E. Rose

Tiffany began experimenting
with enamels in the 1890s, a
natural outgrowth of his essays
in glass. He produced enamel-
work from 1898 to about 1910 on
a variety of wares, including
lamps, plaques, and desk sets.
This bowl, decorated with
tomato vines, is one of his more
elaborate productions, illustrat-
ing accomplished repoussé work
as well as subtle and complex
shadings of enamel. The irides-
cent metallic effect was achieved
by underlying the enamels with
gold foil, a technique he also
employed in glass mosaics. Tif-
fany also produced a larger ver-
sion of this design in earthenware.

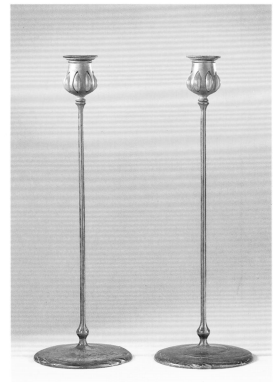

99a–b

Pair of Candlesticks, c. 1905

Bronze and glass
Each: 17⅝ x 5¾ (diam.) in.
(44.8 x 14.6 cm)
Marks: under base of each,
struck incuse TIFFANY STUDIOS |
NEW YORK | 1300
M.58.26a–b
Gift of Mrs. James H. McCarthy

With their elongated shafts, bud-
formed sockets, and swirling,
rippled bases, these candlesticks
are art nouveau in style, sug-
gesting plants growing out of
water. The "seed pods" are
formed of green glass inserts.
They were probably the basis for
Robert Jarvie's Beta candlestick
design (cat. no. 73a–b).

DIRK VAN ERP COPPER SHOP

1908–77

Oakland and San Francisco

Dirk Koperslager van Erp (Netherlands, 1860–1933, active United States) was apparently trained in the family hardware business before immigrating to America in 1885. A commercial coppersmith in the shipyards of San Francisco, he also hammered brass shell casings into art wares on the side, a hobby that became increasingly lucrative. He left the shipyards and opened the Copper Shop in Oakland in 1908, moving it to San Francisco in 1910 when he went into partnership with craftsman and designer Elizabeth Eleanor D'Arcy Gaw (Canada, 1868–1944, active United States). Gaw left the business after a year, but van Erp continued until his retirement in 1929, at which point his son assumed control. The studio produced all manner of handwrought metalwork, including lamps, vases, candlesticks, bookends, and desk and table accessories, primarily in copper, van Erp's favorite metal, but also in brass and iron. Silver seems to have been used very rarely during the senior van Erp's direction.

Lamps were second only to special commissions in being the most sophisticated products of the shop, comprising approximately 25 percent of the firm's output. Most retailed at twenty to a hundred and fifty dollars. Van Erp appears to have popularized the use of mica in the shades of arts and crafts period lamps, and his products are among the most important contributions to lighting of the period.

Van Erp's studio operated much like pre-industrial metalworking shops. He eschewed machinery but admitted machined sheet stock, from which he hammered his products. At the peak of the firm's prosperity he employed five craftsmen, either journeymen or apprentices, who worked from templates to produce established designs. Certainly in more complex pieces, like lamps, a division of labor was utilized. Van Erp's daughter, Agatha (United States, 1895–1978), and designer Thomas Arnold McGlynn (United States, 1878–1966) formed the decorating department, where nonhammered decoration such as piercing or stenciling was done.

The partnership with Gaw is credited with introducing more sophisticated designs into van Erp's repertoire. Gaw had trained at the Art Institute of Chicago and C. R. Ashbee's Guild of Handicraft. She returned to the interior design business sometime in 1911. Since the studio produced pieces from patterns, her influence persisted after her departure.

Van Erp's expertise lay not in design, but in metalworking; he was skilled in hammering as well as in applying subtle patinas, which accentuated his hammermarks. Patination processes utilized oak chips, brick dusts, and even driftwood powder to achieve tones ranging from browns to golds to reds. Lamps of such bases, paired with luminous mica shades, provided a soft amber glow with electric lighting that approximated the warmth of earlier forms of illumination such as candles and oil lanterns.

From left: Agatha van Erp, Auguste Tiesselinck, and Dirk van Erp, c. 1911

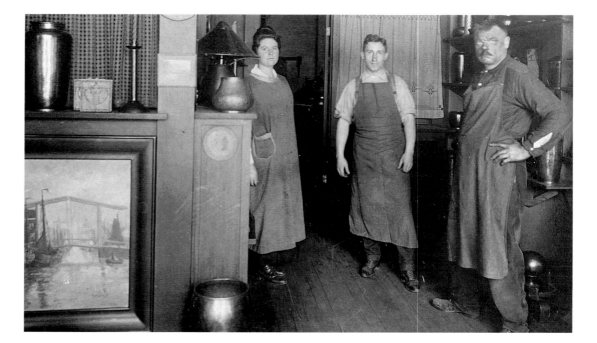

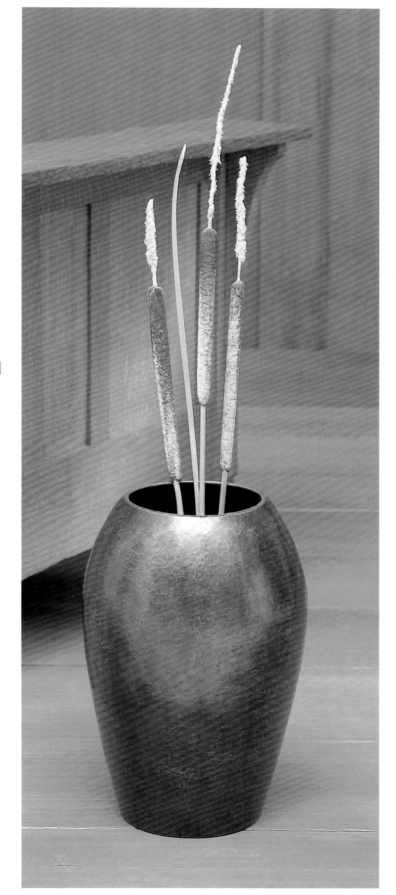

100

Vase, 1911

Copper
15⅛ x 10⅛ (diam.) in.
(38.4 x 25.7 cm)
Marks: under base, struck incuse
outline of windmill | rectangle
enclosing obliterated D'ARCY GAW |
DIRK VAN ERP
L.88.30.66
Collection of Max Palevsky
and Jodie Evans

The simple, graceful form of
this vase serves as a foil for the
tactile hammermarks and varie-
gated patina of blackened brown.
The results suggest the fire and
forging of the metalsmith. In
its union of form and finish it
is the metalworker's answer
to oriental-inspired art pottery.
The piece dates from imme-
diately after Gaw's brief
association with the studio.

DIRK VAN ERP
COPPER SHOP
1104 SUTTER ST., SAN FRANCISCO
ARTISTIC DESIGNERS AND WORKERS OF
HAND WROUGHT COPPER AND BRASS
Gifts of a Superior Quality
A visit to our shop will certainly please you Lessons given

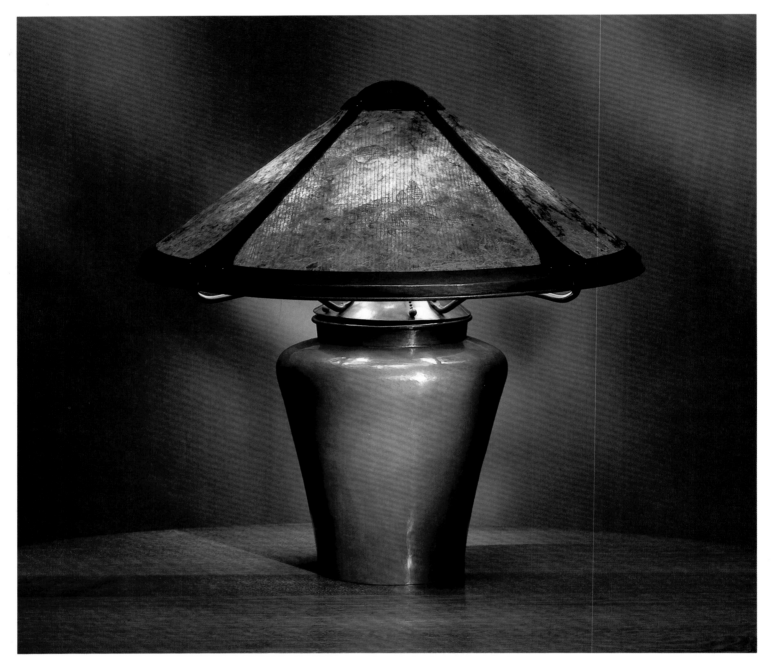

101

Table Lamp, 1911–c. 1912

Shade designed and executed by
Violet Agatha van Erp (United
States, 1895–1978)
Copper, mica, and paper
22¾ x 24 (diam. of shade)
x 10½ (diam. of base) in.
(57.8 x 61.0 x 26.7 cm)
Marks: under base, struck incuse
outline of windmill | rectangle
enclosing obliterated D'ARCY
GAW | DIRK VAN ERP
TR.9365.18
Promised gift of Max Palevsky
and Jodie Evans

This table lamp, one of the
largest produced in van Erp's
repertoire, is particularly rare
because of the floral decoration
in the mica shade. Agatha van
Erp worked in the shop intermit-
tently between 1910 and 1951 and
made such shades between 1910
and 1914. She sandwiched cut,
paper patterns between layers
of mica to achieve the subtle
effect.[52] The extra decoration
and large size accounted for the
lamp's high price, about three
hundred dollars.[53]

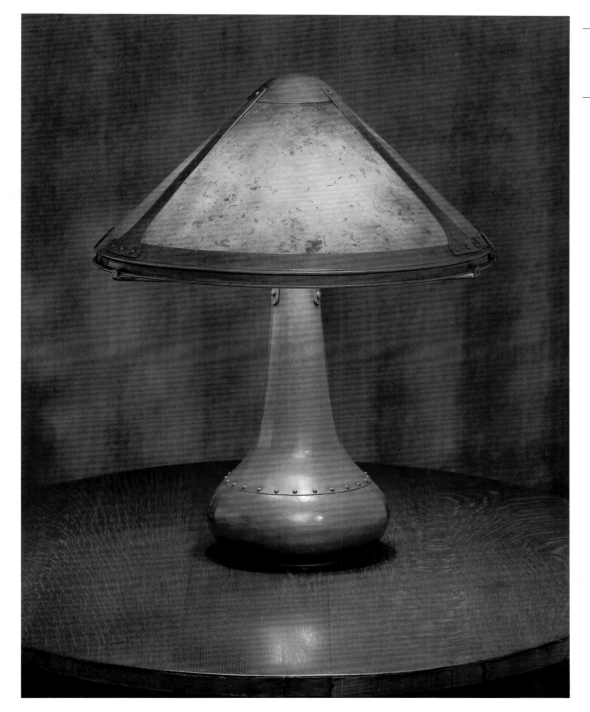

102

Table Lamp, 1915–c. 1920

Copper and mica
24 x 19⅜ (diam. of shade)
x 9 (diam. of base) in.
(61.0 x 49.2 x 22.9 cm)
Marks: under base, struck incuse
outline of windmill | open rec-
tangle enclosing DIRK VAN ERP
over SAN FRANCISCO
TR.9365.19
Collection of Max Palevsky
and Jodie Evans

The design of this lamp was a
popular one in van Erp's produc-
tion, and it showcases his fine
technique. Composed of a
trumpet shape joined to a bowl-
like base, the lamp was harder to
construct and rivet properly than
many of the other designs. Both
segments had to be perfectly
round, and the rivets are util-
itarian as well as decorative.
A preindustrial craftsman
would undoubtedly have de-
emphasized the seam, hiding
it with clever soldering and
finishing. This lamp cost its
original owner about ninety
dollars when new.

NOTES

1. For more information on Bellis see Morse 1986, pp. 20–22. The author is grateful to Edgar Morse and Mike Weller for their assistance with this entry.

2. As quoted in Bowman 1986, p. 49. For a more thorough discussion of Blanchard see pp. 46, 48–55.

3. For a similar example see Andersen, Moore, and Winter 1974, p. 121.

4. Chasing involves decorating the surface of metal by hammering a design without cutting or removing any material. When done from the reverse side, it is called repoussé.

5. Friedell, Clemens, Jr. Interview with author, spring 1986.

6. For more information on Friedell see Bowman 1986, pp. 41–46.

7. As quoted in Carpenter 1982, p. 224. For a study of Martelé silver see pp. 221–52.

8. Carpenter 1982, pp. 241–42, fig. 256; pp. 249, 251, no. 30. The author is grateful to Samuel Hough for researching this piece in the Gorham archives. The mirror is listed as number A8765.

9. Makinson 1977, p. 121.

10. House Beautiful 1903, p. xxiv.

11. Craftsman 1903b, pp. 273–74, 276.

12. International Studio 1904, p. 366.

13. From about 1915 to 1918 their partnership was called Ye Olde Copper Shop and was located at 474 Sutter Street in San Francisco. Brosi continued at that site, but in 1918, Jauchen established Jauchen's Olde Copper Shop at 1391 Sutter, where he operated during the tenure of Old Mission Kopper Kraft and until 1935 and possibly later.

14. Seares 1931, p. 13.

15. The author is grateful to D. J. Puffert for his assistance with this entry.

16. The author is grateful to D. J. Puffert for supplying the information on Gumps.

17. Chronicle 1917, p. 51, col. 7.

18. For more information see Darling 1977, pp. 91–93.

19. The firm is still in existence, under the name of Randahl Jewelers. For more information on Randahl and his companies see Darling 1977, pp. 84–88.

20. Roycrofters 1919, p. 10.

21. Kaplan 1987, pp. 385–86, cat. no. 209.

22. Roycrofters 1919, p. 10.

23. Wood Craft 1905, p. 15.

24. Rust, Robert. Telephone conversation with author, April 1989. The style of the lantern is closely related to a wall sconce designed by Hunter for the Roycroft Inn.

25. Roycrofters 1919, pp. 14, 53, no. 309.

26. Roycrofters n.d., p. 30, no. C-403. The price was raised to five dollars a pair in the 1919 catalogue (Roycrofters 1919, pp. 16, 53). The price discrepancy between the undated and 1919 catalogues suggests at least a few years difference in publication dates. The author is grateful to Boice Lydell and Robert Rust for their assistance with this and all the Roycroft metalwork entries.

27. Roycrofters 1926, pp. 71, 80, nos. 412, 419.

28. In addition to Roycroft goods the inn also commissioned furniture from Gustav Stickley and L. and J. G. Stickley. The author is grateful to Bruce Johnson for sharing his research for this entry.

29. Rust, Robert. Interview with author, October 1988. Also, Groll introduction to Roycroft n.d., p. 5.

30. The Sheffield process, developed in England in the 1730s, was a fused plating procedure in which a sheet of copper was fused between two thin sheets of silver. The resulting plate was then fashioned into wares. The electroplating process, developed in England in the nineteenth century, was much less expensive and permitted the object to be silvered in an electrolytic bath after it was fashioned.

31. Roycrofters n.d., p. 50, no. C-803. This work, like the Princess candlesticks, was originally designed by Kipp at the Tookay Shop.

32. It should be noted that lathe-spinning silver is not a fully mechanized operation, but requires a skilled technician, a situation similar to that of a potter at a wheel. The silversmith uses tools to shape the metal around a chuck that rotates on a mechanized axis. Although not exercising creative control over the form, the smith must maintain the balance and thickness of the silver as it is manipulated over the chuck. A good "spinner" can work much faster than a "raiser," who forges the piece by hammering, and thus spinning speeds production and lowers costs.

33. For more information on Shreve and Company see Morse 1986, pp. 16–23, and Kaplan 1987, p. 283, cat. no. 146. The author is grateful to Edgar Morse and Mike Weller for their assistance with this entry.

34. As quoted in Gray and Edwards 1981, p. 141.

35. Stickley 1905, p. [ii].

36. Clark 1972, p. 43, cat. no. 46. Although Stickley maintained his own metalwork shop, evidence suggests that he continued to use subcontractors as well (see cat. no. 93).

37. Gray and Edwards 1981, p. 144, no. 351 (coal bucket); p. 156, no. 382 (umbrella stand).

38. See House Beautiful 1899a for a period article on domestic lighting.

39. Clark 1972, p. 43, no. 47.

40. Craftsman 1915, p. 42a.

41. Craftsman 1904c, p. xxi, and Gray and Edwards 1981, p. 159. The author is grateful to Dr. Donald Davidoff for his assistance with this entry. Dr. Davidoff has only found one reference to L. and J. G. Stickley metalwork and speculates that the company subcontracted such work to firms like Benedict Studios.

42. Jordy 1986, p. 125.

43. Gebhard 1960, p. 64.

44. Samuelson, Tim. Letter to author, 19 April 1989.

45. The author is grateful to Crombie Taylor and Tim Samuelson for their assistance with the Sullivan/Elmslie entries.

46. For more information on Thumler see Morse 1986, pp. 20, 22–23.

47. For other examples see the work of Arthur Stone (Skinner 1988a, lot 145), George Gebelein (Kaplan 1987, pp. 178–79, cat. no. 65), and Porter Blanchard (Bowman 1986, pp. 50–51).

48. Such lettering appears on Kalo silver and other contemporary Chicago silver. See Darling 1977, pp. 52, 95, 99, for illustrations of this style.

49. For more information on the Tiffany companies see Kaplan 1987, pp. 152–53, cat. no. 38.

50. As quoted in Carpenter 1980, p. 392.

51. For an illustration of the complete service and more information see Carpenter 1980, pp. 391–92, fig. 1.

52. Japanese stencils would have been easy to procure in San Francisco. If Agatha did not use Japanese examples, she could have cut her own imitations of them. A 1910 article on Japanese stencils in the arts and crafts journal *Handicraft* attests to the popularity of the style and technique. See Pearce 1910.

53. The author is grateful to D. J. Puffert for his assistance in preparing the van Erp entries. Much of the information is based on his extensive research and interviews with the van Erp family. See also Andersen, Moore, and Winter 1974, pp. 78–81, 87; Kaplan 1987, pp. 28, 275–76, cat. no. 137; and Lamoureux 1989.

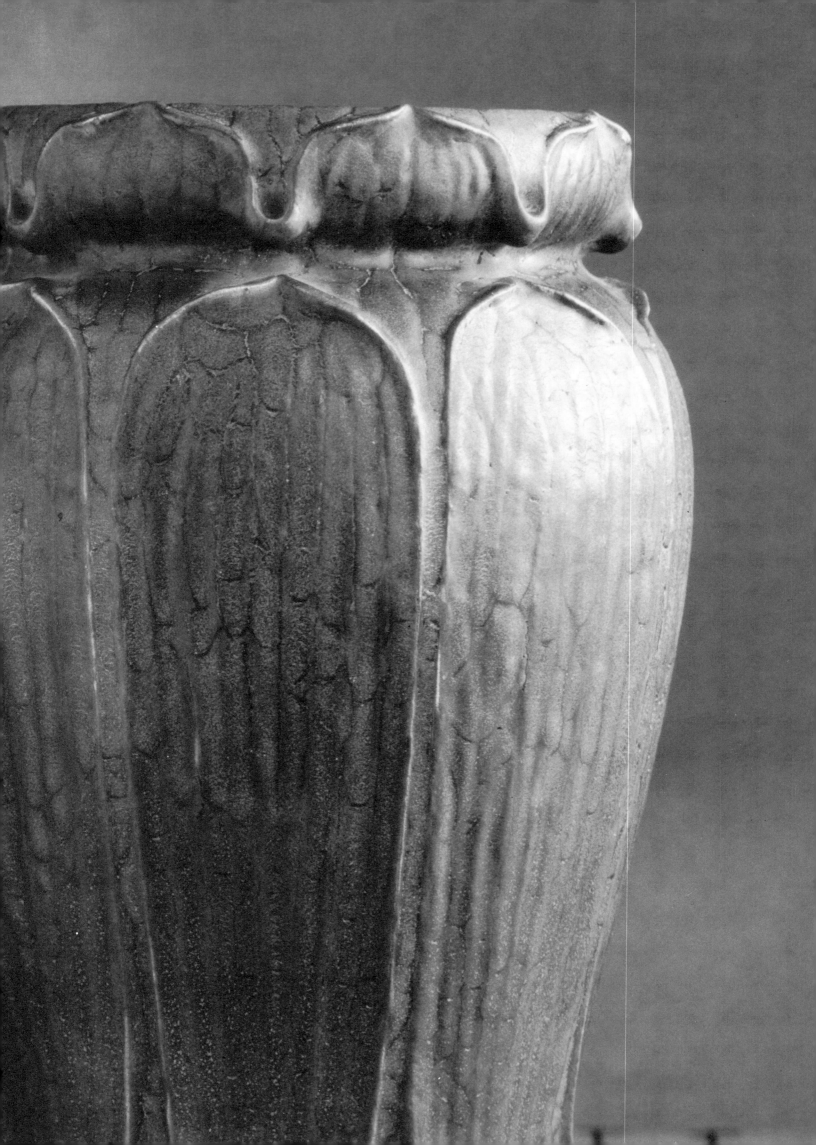

CERAMICS

Cat. no. 137 (detail)

Art pottery was the most prolific product of the American arts and crafts movement. Clay was an everyday material, familiar, inexpensive, and less daunting than other arts and crafts mediums. Ceramics was particularly attractive to Victorian women seeking respectable work. The art pottery movement actually began in the preceding aesthetic period, when a fascination with Japanese styles resulted in a new appreciation for this traditional oriental art form. International expositions in Philadelphia in 1876 and Chicago in 1893 provided inspiration for potters in the United States. Impressive exhibits of oriental and European ceramics contrasted with a paucity of native work. The arts and crafts movement galvanized American efforts and supported enormous developments in art ceramics between 1880 and 1930. As a *House Beautiful* article of 1899 stated:

> *In nearly all American manufactures in which taste performs a part, it is possible to find individuals and companies conducting their work in a spirit that demands first of all that results shall be honest and beautiful....*
>
> *In the manufacture of pottery, oftener perhaps than in other crafts, one meets with this renascent spirit; possibly because its subtle chemistry offers an opportunity to the scientist as well as to the artist. It is a fascinating and absorbing art, claiming the utmost devotion, but lavishly rewarding the man who can discover its secrets.*[1]

The remarkable achievements of Americans within this short period are exemplified by the results of the 1910 Turin International Exposition, in which a New Yorker, Adelaide Alsop Robineau, took the coveted grand prize.

Three different approaches are discernible in American art pottery. The first, European in nature, is characterized by pictorial and decorative applications to forms, in which the ceramic is treated as a canvas for embellishment. This approach characterizes most of Rookwood's production (cat. nos. 201–11) as well as that of Batchelder (cat. nos. 103–8), John Bennett (cat. no. 109), Marblehead (cat. nos. 141–47), Newcomb (cat. nos. 149–50, 152–56), and Frederick H. Rhead (cat. nos. 171–75, 176a–c, 177–79).

In the second approach, also influenced by European examples, the sculptural possibilities of the form itself are emphasized. Such works have no applied decoration; their decorative appeal rests on the manipulation of form. The Grueby scarab (cat. no. 138) is an example of this, as are works by George Ohr (cat. nos. 158–60) and Artus Van Briggle (cat. nos. 215–18).

In the third approach the unity of form and glaze is extolled, to the exclusion of any additional decoration. This oriental philosophy was favored and taught by Charles Binns at the New York School of Clayworking and Ceramics. The technique characterizes works by Binns (cat. nos. 110–12), California Faience and California Porcelain (cat. nos. 117a–b, 118–19, 121–23), Fulper (cat. nos. 126–31), Grand Feu (cat. nos. 133–36), and both Fred and Hugh Robertson (cat. nos. 186–92). Certain pieces by Newcomb (cat. no. 151), Robineau (cat. nos. 194–96, 198–99), and Rookwood (cat. no. 212) also illustrate this approach. Unglazed wares without applied decoration, like the bisque vase and mug by Alexander W. Robertson (cat. nos. 180–81), also fit into this category.

Many of the body and glaze formulas and firing procedures had to be devised by Americans through tedious experimentation. Oriental and European examples provided precedents, but it is important to realize that ceramics artisans and firms closely guarded their methods. The success of art potters in the United States is one of the most important chapters in the history of ceramics, and it paved the way for the subsequent development of studio ceramic S.

BATCHELDER TILE COMPANY

1909–32

Pasadena and Los Angeles

Ernest Allan Batchelder (United States, 1875–1957) was a leading designer of the American arts and crafts movement, already well known when he founded his own tile company in Pasadena in 1909. After studying at the School of Arts and Crafts in Birmingham, England, he taught at the Harvard Summer School of Design, organized the Handicraft Guild in Minneapolis, where he taught summer courses, and directed the department of arts and crafts at Throop Polytechnic Institute in Pasadena. He published *Principles of Design* in 1904, and his numerous articles for *The Craftsman* were compiled as the book *Design in Theory and Practice* in 1910. Ever a proponent of putting theory into practice, Batchelder built a kiln behind his bungalow when he left Throop in 1909. There, with the help of former students, he began making decorative tiles of his own design. This enterprise was timely; Southern California's booming construction industry called for architectural tiles, and his products were much in demand. He moved twice due to expansion, with his largest business site occupying six acres in Los Angeles.

Batchelder's products earned a gold medal at the 1915 San Diego Exposition. His marketing samples (such as cat. nos. 107–8) were used in company display rooms in Chicago, San Francisco, and New York as well as Los Angeles. Like many arts and crafts enterprises the firm was put out of business by the Depression; all of its assets were sold in 1932. Batchelder reverted to a home operation, later moved to a small shop in Pasadena, and continued to make pottery until the early 1950s.

103 ∧

Tile, 1912–15

Earthenware

4 x 3 ⅜ x ⅜ in.

(10.2 x 8.6 x 1.0 cm)

Inscriptions: on front, molded in relief, BATCHELDER | TILES

Marks: on back, incised 13400, impressed 5

M.90.25.2

Art Museum Council Fund

104 ∧

Tile, 1912–15

Earthenware

3 ⅞ x 3 ⅜ x ⁷⁄₁₆ in.

(9.8 x 8.6 x 1.1 cm)

Inscriptions: on front, molded in relief, BATCHELDER | TILES

Marks: on back, incised 13400, impressed 5

M.89.119.5

Art Museum Council Fund

105

Paver Tiles (28), 1916–32

Earthenware

Square tiles: 3 ¾ x 3 ¾ x ½ (approx.) in.

(9.5 x 9.5 x 1.3 cm)

Hexagonal tiles: 3 ¾ x 4 ¼ x ½ (approx.) in.

(9.5 x 10.8 x 1.3 cm)

Marks: on back, impressed BATCHELDER | LOS ANGELES; most impressed 4

M.87.157.1–28

Purchased with funds provided by Patricia M. Fletcher

Cat. no. 105 (continued)

The two hexagonal advertising tiles—one with a stylized floral design (cat. no. 103), the other with a peacock (cat. no. 104)—were probably produced at Batchelder's Pasadena tile works on Broadway between 1912 and 1915. The remaining works (cat. nos. 105–6) were most likely produced at the Los Angeles site on Artesian Street between 1916 and 1932. Batchelder abided by his own precepts of ordered design through harmony, balance, and rhythm. He favored medieval motifs for his English look and Mediterranean and Mayan subjects for his Spanish style. Of his admiration for Gothic design he wrote: "The Mediæval carvers found suggestions from many sources about them,—from constructive forms ... from nature ... from chivalry and its varied heraldic devices ... from the rich symbolism of their faith." [2] Accordingly, animals, hunters, and crosses figure among the tile designs illustrated here. [3]

Most of the museum's tiles are modeled pavers, approximately four inches wide, that were intended for installation "in a connected border treatment or as inserts to furnish points of interest in either border or field." [4] The Mayan designs appeared in a 1923 catalogue, undoubtedly in response to the growing popularity of the Spanish colonial style in domestic architecture. [5]

106 ∧

Tile, 1916–32

Earthenware
2¾ x 2¾ x ⅝ in.
(7.0 x 7.0 x 1.6 cm)
Inscriptions: on front, molded in relief, BATCHELDER TILE | LOS ANGELES
Marks: on back, impressed BATCHELDER | LOS ANGELES; impressed 5
M.90.25.1
Art Museum Council Fund

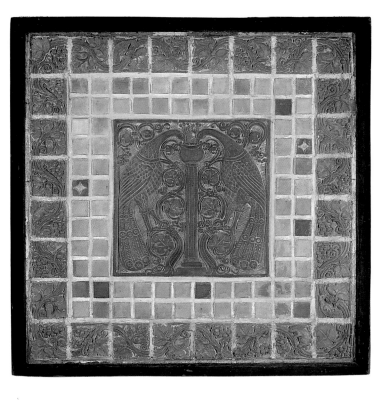

107

Tile Panel, c. 1915 – c. 1920

Earthenware
24½ x 24¼ x ⅞ (approx.) in.
(62.2 x 61.6 x 2.2 cm)
Framed: 26⅝ x 26½ x 2⅞ in.
(67.6 x 67.3 x 7.3 cm)
M.85.18
Gift of Theodore C. Coleman

Peacocks and their feathers were favorite motifs in American arts and crafts and French art nouveau design (for other makers' versions see cat. nos. 37a–b, 132a–b, 173, 205–6, 209). They were a personal favorite of Batchelder and appeared again and again in his works (see cat. no. 104). This plaque was used as a display piece for marketing and includes pavers as well as smaller units that "form interesting accents of color, glaze and texture … [and] add a sparkle of enrichment to a pavement design."[6] It remained in Batchelder's family until its donation.

108

Sample Fireplace, c. 1920 – c. 1930

Earthenware
21 x 28 x 11 in.
(53.3 x 71.1 x 27.9 cm)
L.89.5.1
Collection of Max Palevsky and Jodie Evans

Fireplaces were central to arts and crafts interiors, a belief echoed in Batchelder's 1923 catalogue: "A fireplace, in a peculiarly intimate sense, is the center of the home."[7] This two-piece example functioned as a salesman's sample; the actual design was recorded as number 278 in a 1927 mantel catalogue.[8]

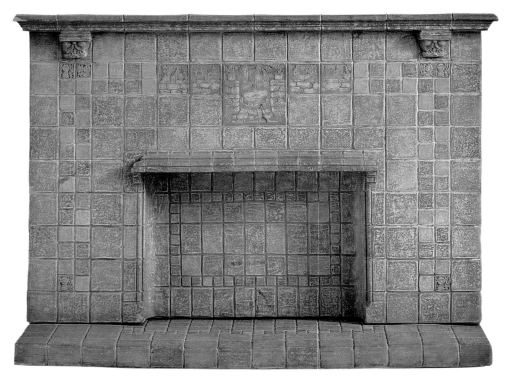

JOHN BENNETT'S AMERICAN POTTERY

1877–83

New York

109

Charger, 1877

Earthenware
1⅞ x 17⅞ (diam.) in.
(4.8 x 45.4 cm)
Marks: on back, painted in
brown, J conjoined with
BENNETT. | 101 LEX AVE N.Y. |
1877.; impressed 9 | [7]7
L.88.30.1
Collection of Max Palevsky
and Jodie Evans

The revival of the potter's craft for art wares began in France and England in the 1870s. *Faïence*, the French term for brightly colored, tin-glazed earthenwares produced in Europe since the fourteenth century, was applied to the new French and English interpretations of the technique.

John Bennett's American Pottery was the only workshop in the United States that produced the English style of faience, as practiced at Doulton and Company in Lambeth, England.

Indeed Bennett (England, 1840–1907, active United States) had developed the technique for Doulton before immigrating to America in 1877. His draftsman-like style and translucent palette contrasted with the heavy impasto slip decoration of contemporary French faience.[9] While the vivid coloring of this charger is dramatic, the calla lilies are sensitively depicted and characteristically outlined in black, a style derived from Japanese print sources.[10]

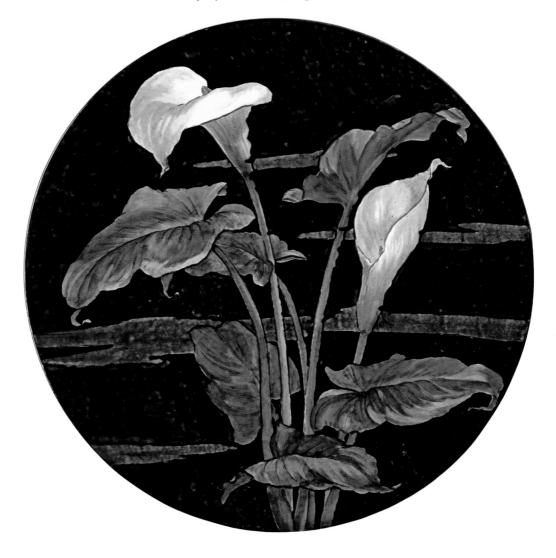

CHARLES FERGUS BINNS

England, 1857–1934,

active United States

Alfred, New York

Charles Fergus Binns was already an accomplished ceramist when he left Worcester's Royal Porcelain Works to come to the United States in 1899. Shortly after immigrating, he became the first director of the New York School of Clay-working and Ceramics in Alfred, New York. Considered the father of studio ceramics, Binns established in Alfred one of the first comprehensive training facilities for clay artists in America. Students of his who made their own contributions to the movement included Arthur Baggs (Marblehead Pottery), William Victor Bragdon (California Faience), Paul Cox (Newcomb Pottery), Elizabeth Overbeck (Overbeck Pottery), Mary Chase Perry (Pewabic Pottery), Adelaide Alsop Robineau (Robineau Pottery), and Frederick Walrath (Walrath Pottery).

Binns advocated the oriental approach to ceramics, striving for a unity of form and glaze that obviated the need for additional decoration. To this end he pioneered the use of flowing mat glazes, as seen on the three vases (cat. nos. 110 – 12). Such glazes were unknown in America prior to the art pottery movement. Binns wrote what might be considered his credo in 1903: "To endow either porcelain or pottery with brilliant color, pulsing with life and radiance, or with tender texture, soft and caressing . . . which owe their existence and their quality to the fire,—this is art." [11]

Charles Binns, c. 1925

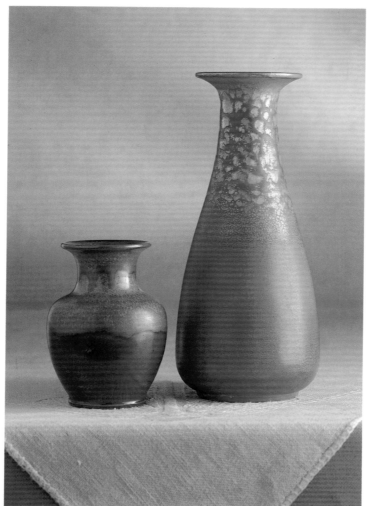

Cat. nos. 111, 110

110

Vase, 1920

Stoneware

11 7/16 x 5 1/16 (diam.) in.

(29.1 x 12.9 cm)

Marks: under base, incised

C. F. B. | 1920, all within a circle

M.90.25.3

Art Museum Council Fund

111

Vase, 1920

Stoneware

5 1/2 x 4 1/4 (diam.) in.

(14.0 x 10.8 cm)

Marks: under base, incised

C. F. B. | 1920, all within a circle

89.2.5

Purchased with funds provided by the William Randolph Hearst Collection

BUFFALO POTTERY

1901–present

Buffalo

112

Vase, 1923

Stoneware

10 x 9⅝ (diam.) in.

(25.4 x 24.4 cm)

Marks: under base, incised

C. F. B. | 1923, all within a circle

L.89.37.1

Promised gift of Max Palevsky
and Jodie Evans

113a–b

Coffee Cup and Saucer, 1925

Designed by the Roycrofters,
East Aurora, New York
(1895–1938)

Earthenware

Cup: 2¼ x 3½ x 2⅝ (diam.) in.

(5.7 x 8.9 x 6.7 cm)

Saucer: ⅝ x 5 (diam.) in.

(1.6 x 12.7 cm)

Marks: under base of cup,
printed in green, BUFFALO |
POTTERY | 1925 | ROYCROFT.

M.84.118.3a–b

Gift of the Jordan-Volpe Gallery,
New York, New York

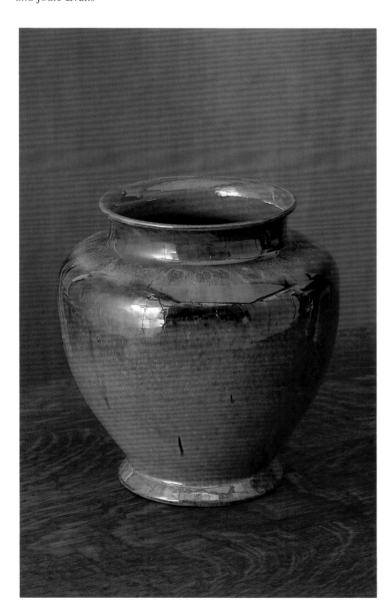

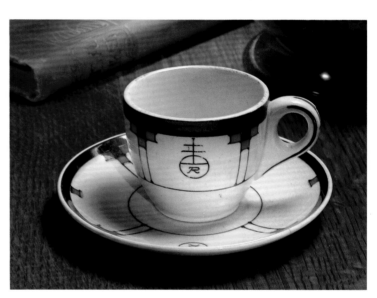

The Roycrofters contracted with
the Buffalo Pottery to produce
custom dinnerware with transfer-
printed decoration adapted
from designs by Dard Hunter.
The china, decorated with the
ubiquitous Roycroft orb-and-
cross symbol, was used at the
Roycroft Inn; it was never sold
to the public.

Elbert Hubbard had pre-
vious ties to the Buffalo Pottery
through his former business
partners at the Larkin Soap
Company, who had founded the
pottery to produce dishes as pre-
miums for soap certificates.

CALIFORNIA
FAIENCE

1915–30

Berkeley

■ ■ ■

CALIFORNIA
PORCELAIN

c. 1925

Millbrae, California

California Faience was founded by William Victor Bragdon (United States, 1884–1959) and Chauncey R. Thomas (United States, 1877–1950). Bragdon was a well-schooled ceramist; he had trained with Charles Binns, worked with Taxile Doat at University City in St. Louis, and taught ceramics at the University of Chicago and the California School of Arts and Crafts in Berkeley.[12] Not much is known about Thomas. Although the partnership is traditionally dated from 1916, the 1915 Panama-Pacific International Exposition in San Francisco exhibited "a California *faïence* made at Berkeley," suggesting an earlier founding.[13]

The firm did not formally adopt the name California Faience until 1924, but products were so marked from the beginning. Despite the use of the moniker the Tile Shop from 1922 to 1924 (see cat. no. 114), the company produced both tiles and vessels throughout its operation. One of the more prolific and successful of California art potteries, California Faience made economical use of molds and, with few exceptions (the two polychrome mat vases with highly decorative molding being examples [cat. nos. 115–16]), limited decoration on vessels to a wide variety of glazes, ranging from brilliant high-gloss hues (cat. no. 117a–b) to subtle mat textures (cat. nos. 118–19), some decidedly vegetal in the Grueby style. The reliance on form and glaze for aesthetic appeal eliminated the need for expensive hand decoration and can be credited to Binns's influence. Tiles were usually mold decorated and vividly glazed in bright, glossy colors. The trivet (cat. no. 120) and tiles mounted as bookends document the collaboration between California Faience and San Francisco metalworker Dirk van Erp.

The California Porcelain line dates from a brief association of California Faience with the West Coast Porcelain Manufacturers of Millbrae, California, around 1925. The latter firm contracted with California Faience staff to produce a line of art porcelain. The technical challenges of this high-fired material required different glazes, and one assumes that the brilliant mirror (cat. nos. 121–22) and mat crystalline (cat. nos. 123–25) varieties are indebted to Bragdon's training with Binns and Doat. The association lasted little more than a year.

114

Tile Sign, c. 1920

Earthenware
6¾ x 9⅛ x ⅞ in.
(17.1 x 23.2 x 2.2 cm)
Inscriptions: on front, molded in relief, CALIFORNIA | FAIENCE | MADE AT | THE TILE SHOP | BERKELEY, CAL.
Marks: on back, incised CALIFORNIA | FAIENCE
M.89.10.3
Gift of Bryce and Elaine Bannatyne

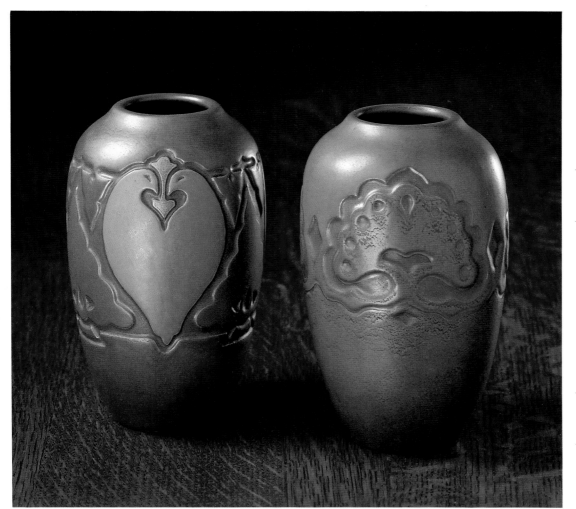

Cat. nos. 115–16

115

Vase, c. 1920

Earthenware
6⅜ x 4⅛ (diam.) in.
(16.2 x 10.5 cm)
Marks: under base, incised
CALIFORNIA | FAIENCE in circular
formation
TR.9349.17
Promised gift of Max Palevsky
and Jodie Evans

116

Vase, c. 1920

Earthenware
6⅜ x 4⅛ (diam.) in.
(16.2 x 10.5 cm)
Marks: under base, incised and
rubbed in blue, CALIFORNIA |
FAIENCE
89.2.9
Purchased with funds provided
by the William Randolph Hearst
Collection

117a–b

Pair of Covered Jars,
c. 1920

Earthenware
a: 9⅝ x 4½ (diam.) in.
(24.4 x 11.4 cm)
b: 9½ x 4⅝ (diam.) in.
(24.1 x 11.7 cm)
Marks: under base of each,
incised and rubbed in pink,
CALIFORNIA | FAIENCE
M.90.25.7a–d
Art Museum Council Fund

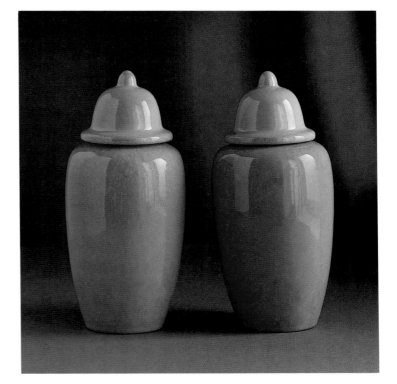

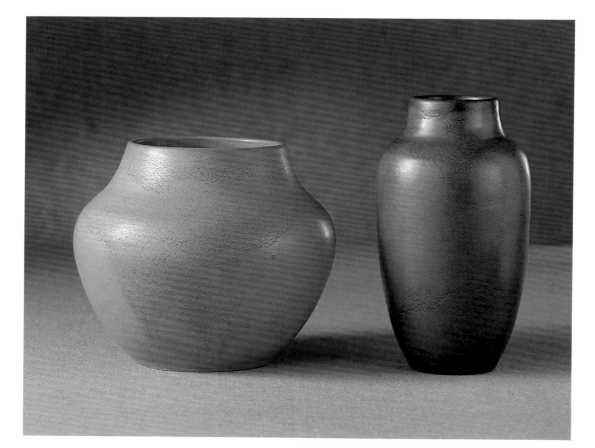

Cat. nos. 119, 118

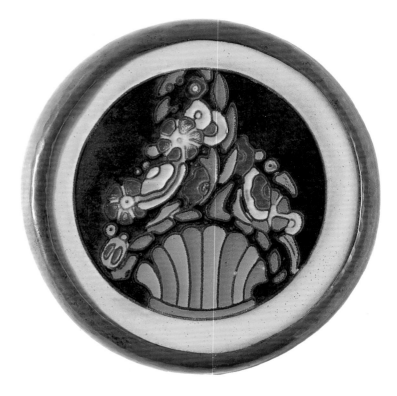

118

Vase, c. 1920

Earthenware
6 x 3½ (diam.) in.
(15.2 x 8.9 cm)
Marks: under base, incised
CALIFORNIA | FAIENCE
89.2.7
Purchased with funds provided
by Arthur Hornblow, Jr.

119

Vase, c. 1920

Earthenware
5 x 5⅞ (diam.) in.
(12.7 x 14.9 cm)
Marks: under base, incised
CALIFORNIA | FAIENCE
89.2.8
Purchased with funds provided
by Mrs. Leonard Martin, the Los
Angeles County, Mrs. Charles
Otis, Emma Gillman in memory
of Edith O. Bechtel, Mrs. Edwin
Greble, and Edwin C. Vogel

120

Trivet, c. 1920

Copper mount by Dirk
Koperslager van Erp (Nether-
lands, 1860–1933, active United
States)
Earthenware and copper
¾ x 5½ (diam.) in.
(1.9 x 14.0 cm)
Marks: on back, struck incuse
outline of windmill | rectangle
enclosing obliterated D['ARCY
GAW] | DIRK VAN ERP over SAN
FRANCISCO
M.88.194.10
Decorative Arts Council Fund

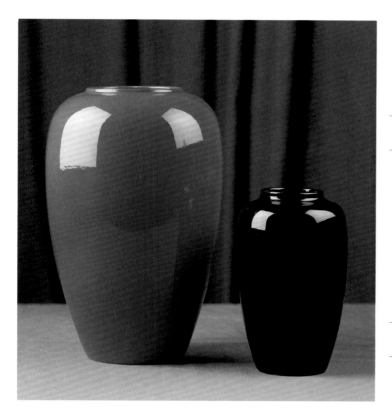

∧ Cat. nos. 122, 121

123

Vase, c. 1925

Porcelain
10⅜ x 8¼ (diam.) in.
(26.4 x 21.0 cm)
Marks: under base, incised
CALIFORNIA | FAIENCE
L.88.30.3
Collection of Max Palevsky
and Jodie Evans

124

Vase, c. 1925

Porcelain
12 x 8 (diam.) in.
(30.5 x 20.3 cm)
Marks: under base, incised
CALIFORNIA | PORCELAIN
L.88.31.24
Promised gift of Max Palevsky
and Jodie Evans

125

Vase, c. 1925

Porcelain
5½ x 7⅝ (diam.) in.
(14.0 x 19.4 cm)
Marks: under base, incised
CALIFORNIA | FAIENCE
M.85.31
Purchased with funds provided
by Mr. and Mrs. Mortimer Kline
and Decorative Arts Council
Curatorial Discretionary Fund

121

Vase, c. 1925

Porcelain
8 x 4⅞ (diam.) in.
(20.3 x 12.4 cm)
Marks: under base, incised
CALIFORNIA | FAIENCE
M.90.25.5
Art Museum Council Fund

122

Vase, c. 1925

Porcelain
12¼ x 8⅛ (diam.) in.
(31.1 x 20.6 cm)
Marks: under base, incised
CALIFORNIA | PORCELAIN
L.88.30.2
Collection of Max Palevsky
and Jodie Evans

∨ Cat. nos. 125, 124, 123

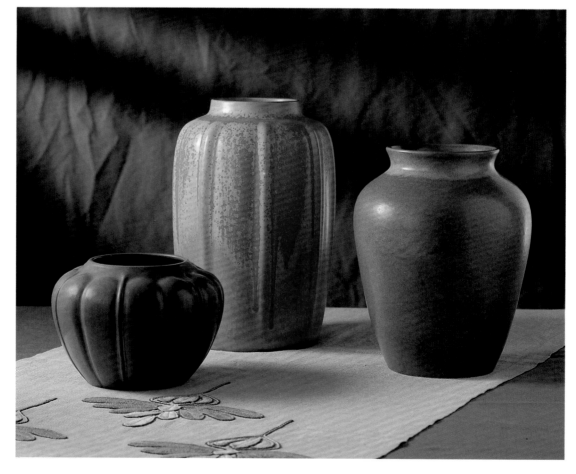

FULPER POTTERY COMPANY

1860–c. 1935

Flemington, New Jersey

126

Vasekraft Table Lamp, 1909–14

Stoneware and slag glass
21½ x 18¼ (diam. of shade)
x 8½ (diam. of base) in.
(54.6 x 46.4 x 21.6 cm)
Marks: under base, printed in
brown, VASEKRAFT | FULPER 1805
within two concentric circles
enclosing potter at wheel; 3
printed twice in brown; under
shade, 23 and 59 printed in
brown
TR.9408.8
Collection of Max Palevsky
and Jodie Evans

Vasekraft lamps, introduced for
the Christmas market in 1910,
were Fulper's crowning achieve-
ment and among the most
expensive pieces sold. This
example is typically oriental
in design, with a soft, mat,
café au lait glaze.[16]

Of all the potteries subscribing to the oriental approach of excluding applied decoration in favor of form and glaze, Fulper was the most prolific and commercially successful. Already thriving, Fulper introduced Vasekraft in 1909, an art line that became almost instantly profitable since it was fired alongside utilitarian wares and required no new kilns or other facilities. Molds were used for most of the shapes; glazing was the primary decoration. Renowned for its splendid glazes, Fulper produced both glossy and mat styles that included mirrored, luster, flambé, and crystalline variations. A Fulper catalogue described some of the latter as "clear crystals like the starry Heavens; surface crystals like hoar frost on window panes and still others like the surface effect of galvanized iron."[14]

With the exception of those with the most exotic glazes, Fulper's wares were priced at an affordable level for middle-class customers. The shapes of the vases were intentionally simple; suitable surfaces for the marvelous glazes. Interpreted in stoneware, the works have an almost monumental quality.[15]

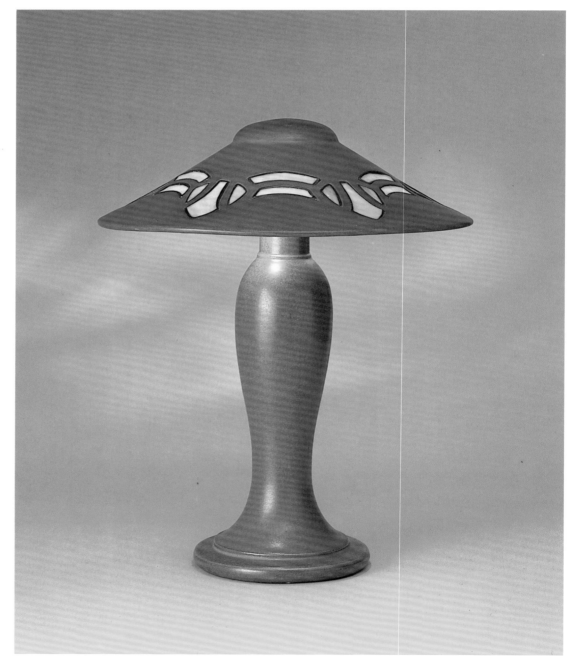

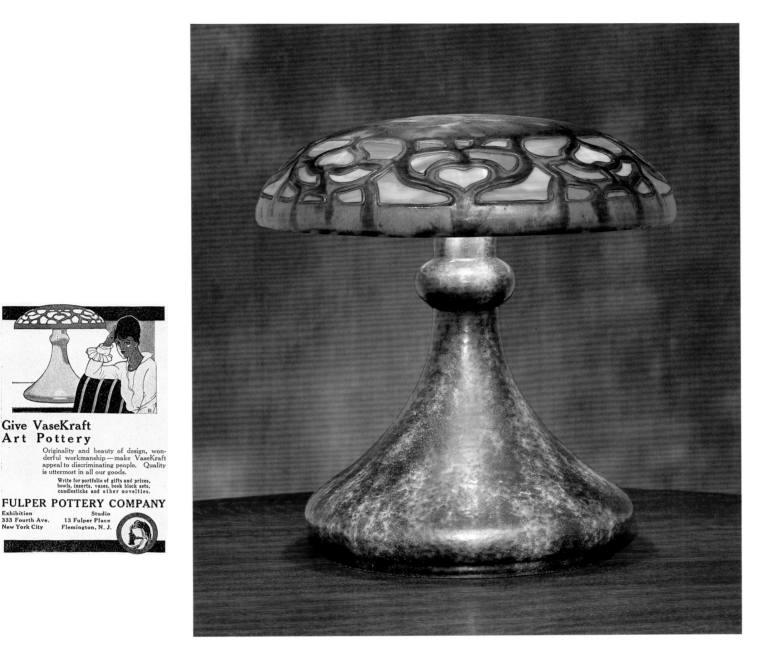

127

Vasekraft Table Lamp, 1915–18

Stoneware and slag glass
17 x 16¾ (diam. of shade)
x 13¼ (diam. of base) in.
(43.2 x 42.5 x 33.7 cm)
Marks: under base, printed in
black, vertical FULPER within a
rectangle
M.89.151.11a–b
Gift of Max Palevsky
and Jodie Evans

A 1913 *Vogue* advertisement
noted: " 'Vase Kraft' Lamps and
Pottery are much admired for
their rich subdued colorings.
They lend an air of refined ele-
gance to the surroundings in
which they are displayed." [17]
This model sold for thirty-five
dollars in 1913 and seventy-five
dollars by 1918.[18] The glaze is
cucumber crystalline.

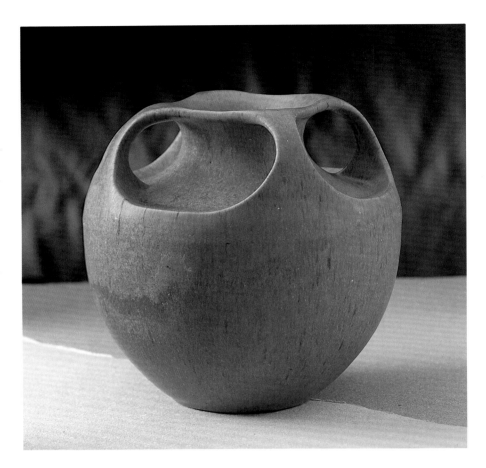

131 >

Vasekraft Vase, 1915 – c. 1920

Stoneware
6⅞ x 4⅞ (diam.) in.
(17.5 x 12.4 cm)
Marks: under base, molded in
relief, vertical FULPER within
an oval
M.83.141.1
Gift of Bryce R. Bannatyne, Jr.

The green flambé glaze on this
piece is distinguished by a metal-
lic luster that flowed in striations
from the rim.

128

Vasekraft Vase, 1915 – c. 1920

Stoneware
8⅜ x 8⅞ (diam.) in.
(21.3 x 22.5 cm)
Marks: under base, molded in
relief, vertical FULPER within
an oval
TR.9349.19
Collection of Max Palevsky
and Jodie Evans

This vase illustrates Fulper's
blue mat glaze.[19] Characteristic
of Fulper pottery, there is a com-
plementary relationship between
the speckled glaze and the egg-
like form. The design may have
been inspired by a Teco vase
created by Fritz Wilhelm Albert
(Alsace-Lorraine, 1865 –1940,
active United States) that was
offered in a 1906 Gates Potteries
catalogue.[20]

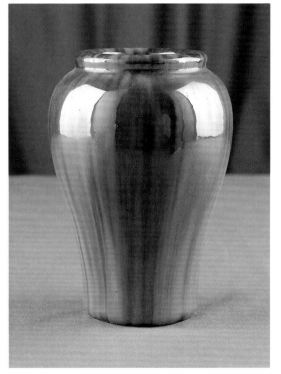

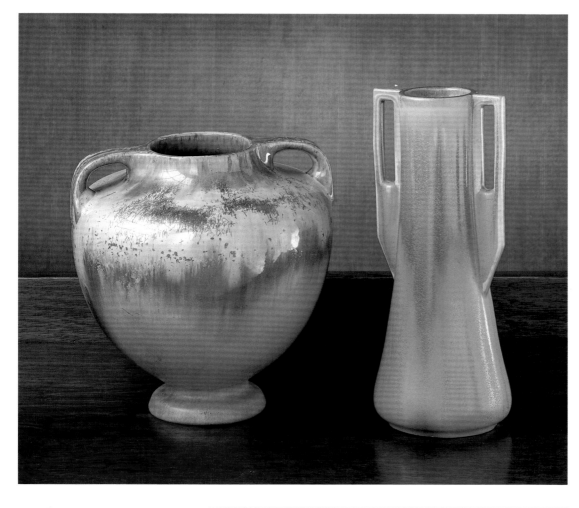

129

Vasekraft Vase, 1915–c. 1920

Stoneware
9 x 8¾ (diam.) in.
(22.9 x 22.2 cm)
Marks: under base, molded in
relief, vertical FULPER within
an oval
L.88.30.5
Collection of Max Palevsky
and Jodie Evans

130

Vasekraft Vase, c. 1912–15

Stoneware
11 x 4¾ x 4⅝ (diam.) in.
(27.9 x 12.1 x 11.7 cm)
Marks: under base, printed in
black, vertical FULPER within
an oval
M.86.169.1
Gift of Mr. Joel Silver

These two vases illustrate
Fulper's combination of mat and
crystalline glazes. The first piece
(cat. no. 129) has an overlay of
blue crystalline flambé, with
crystals "like hoar frost," on a
rose mat. The second vase (cat.
no. 130) has a more unusual color
combination of green crystalline
and rose mat glazes. Both vases
have classical forms derived
from antique prototypes and are
typical of Fulper's repertoire.

132a–b

Pair of Vasekraft Bookends,
c. 1912–15

Stoneware
a: 5⅞ x 4⅞ x 3¾ in.
(14.9 x 12.4 x 9.5 cm)
b: 5⅞ x 4⅞ x 3¼ in.
(14.9 x 12.4 x 8.3 cm)
Marks: under base of each,
printed in black, vertical FULPER
within an oval
M.84.26a–b
Gift of Mr. and Mrs. Lawrence
Margolies in memory of
Florence S. Deutsch

The common arts and crafts mo-
tif of the peacock is seen sculp-
turally on these bookends. They
were naturalistically glazed in
flambé colors.

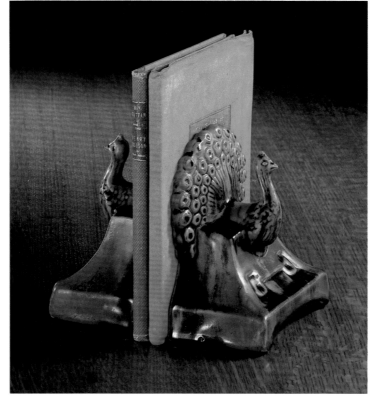

GRAND FEU ART POTTERY

c. 1913–c. 1916

Los Angeles

133

Vase, c. 1913–c. 1916

Stoneware
10⅛ x 8⅛ (diam.) in.
(25.7 x 20.6 cm)
Marks: under base, impressed
GRAND FEU | POTTERY | L.A., CAL.;
impressed TT; incised 101730, all
rubbed in blue
L.88.31.32
Promised gift of Max Palevsky
and Jodie Evans

This vase is among the most
spectacular examples of the Sun
Rays glaze.

The title of Cornelius Walter Brauckman's Los Angeles pottery suggests his familiarity with the writings and work of Taxile Doat, author of *Grand Feu Ceramics* and instructor at University City Pottery in St. Louis from 1909 to 1915. Indeed Brauckman (United States, 1864–1952) was a Missouri native who studied in St. Louis in 1880 at Washington University's newly established School of Fine Arts. Although this was well before Doat's tenure at University City, it is conceivable that Brauckman was still in St. Louis in 1904 and that he saw Doat's work for Sèvres in the French exhibit at the Louisiana Purchase Exposition. The speculation that Brauckman worked or was connected with Robert Bringhurst at Ozark Pottery in St. Louis is strength- ened by the fact that Bringhurst was a fellow student at Washington University.[21]

Brauckman established the Cornelius Brauckman Pottery on West 96th Street in Los Angeles in about 1912.[22] By April of 1913 he wrote to the Library of Congress on Grand Feu Art Pottery letterhead, with a Mountain View Avenue address.[23] His pottery won a gold medal at the 1915 Panama-California Exposition in San Diego and was exhibited in 1916 at the First Annual Arts and Crafts Salon held at the Museum of History, Science, and Art in Los Angeles.[24]

Brauckman produced grès at Grand Feu, a porcelainlike "ceramic ware fired at a high temperature which can mature body and glaze simultaneously … [and which] differs from it

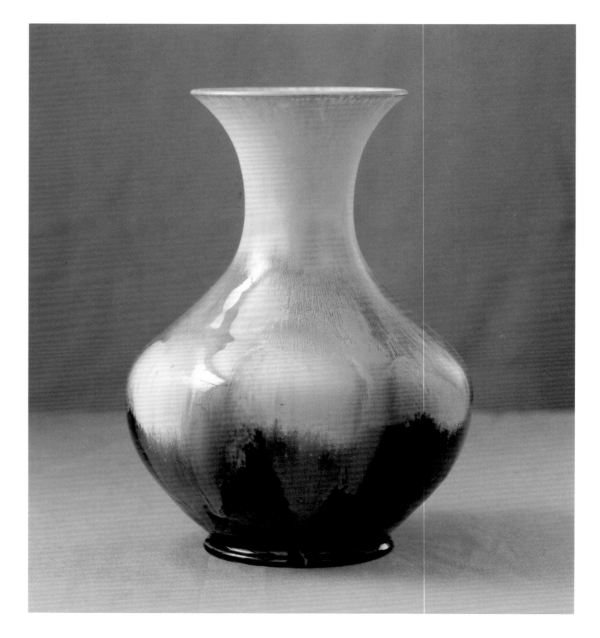

[porcelain] by being neither pure white nor translucent."[25] His glazes were superb accomplishments that showed his great technical skill with high-fired wares. A Grand Feu Art Pottery brochure stated: "Grand Feu uses no applied or painted decorations. The wonderful play of colors blending harmoniously one with the other are created by the firing effects and various glazes as in the Turquois, Mission, Tiger Eyes, Blue, Yellow, Green, Red and Moss Crystals, Green and Blue Ramose, Moss, Agate, Multoradii, Venetian Green and Sun Rays."[26] Brauckman claimed that his pottery was "not to be classed with the common Art Pottery (Faiance) [*sic*], known and made everywhere."[27]

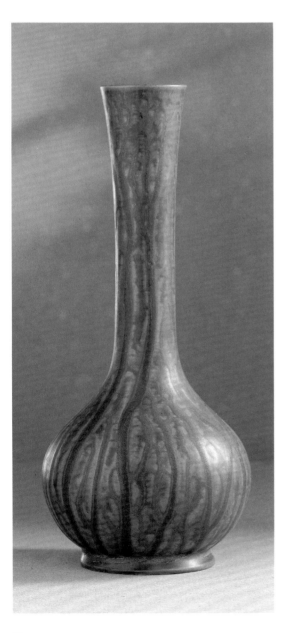

Cat. no. 134

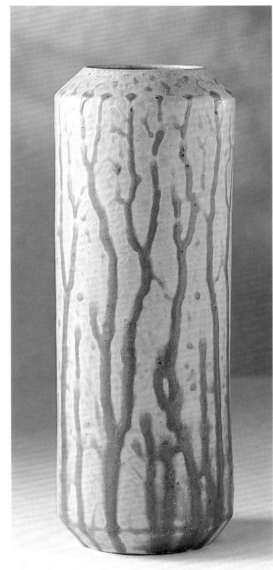

Cat. no. 135

134

Vase, c. 1913–c. 1916

Stoneware
10⅝ x 4⅝ (diam.) in.
(27.0 x 11.7 cm)
Marks: under base, impressed
GRAND FEU | POTTERY | L.A., CAL.;
incised 75 | script GA
89.2.12
Purchased with funds provided by the William Randolph Hearst Collection and the Los Angeles County

135

Vase, c. 1913–c. 1916

Stoneware
11⅛ x 4⅛ (diam.) in.
(28.3 x 10.5 cm)
Marks: under base, impressed
GRAND FEU | POTTERY | L.A., CAL.;
incised 8013
L.88.31.35
Promised gift of Max Palevsky and Jodie Evans

These two vases (cat. nos. 134–35) show Grand Feu's Green and Blue Ramose glazes. *Ramose*, derived from the Latin word for branches, refers to the distinctive drip design.

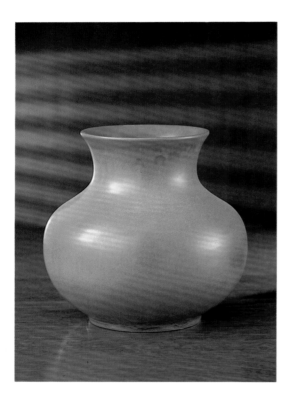

136

Vase, c. 1913 – c. 1916

Stoneware
7⅜ x 7⅞ (diam.) in.
(18.7 x 20.0 cm)
Marks: under base, impressed
GRAND FEU | POTTERY | L.A., CAL.;
impressed TT; incised 71, all
rubbed in brown

89.2.13
Purchased with funds provided
by the Los Angeles County

The tight, skinlike luster glaze
on this vase is unparalleled until
later studio pottery. The name
of the glaze was Mission. The
incised numbers on this work
and the other Grand Feu pieces
seem to refer not to specific
shapes, but to glazes.[28]

GRUEBY POTTERY

1894–1920

Boston

William Henry Grueby (United States, 1867–1925) at age twenty-six was already a thirteen-year veteran of the ceramics business when he was sent by the Boston firm of Fiske, Coleman and Company to the 1893 World's Columbian Exposition in Chicago. The so-called dead (mat) glazes of the French pottery exhibit inspired him to commence his own glaze experiments.[29]

Grueby founded his own business in 1894, the Grueby Faience Company, which produced architectural brick and tile. By 1897 the designer George Prentiss Kendrick (United States, 1850–1919) had joined the firm and assumed responsibility for the company's burgeoning art wares. Predictably Grueby remained in charge of glazes.

Mat glazes were unknown in American ceramics until various art potters devised them at the turn of the century. This type of finish was previously achieved by abrading the surface of the glaze after firing. A mat glaze perfected by Grueby in 1898 was perhaps the most influential of the newly developed coverings.

Thick, vegetative, and often green, the Grueby glaze was well suited to the heavy earthenware bodies of Kendrick's organic designs. A 1904 company brochure described the pottery's "peculiar texture" as being comparable "to the smooth surface of a melon or the bloom of a leaf, avoiding the extreme brilliancy of high glazes as well as the dull monotony of the mat finish."[30] Referring to the inspiration for the ceramics, the brochure explained that the "motives by which the Grueby Pottery is recognized are taken from certain common forms in plant life, such as the mullen leaf, the slender marsh grasses, the lotus or tulip, treated in a formal or conventional way."[31] Grueby's works won international acclaim almost immediately, earning medals at the 1900 International Exposition in Paris, the 1901 Pan-American Exposition in Buffalo, and the 1904 Louisiana Purchase Exposition in St. Louis. Their fame inspired hundreds of imitations of the famous "Grueby green."

Among American art potteries, the Grueby Faience Company was one of the largest producers, along with Rookwood, Newcomb, and Fulper. The adaptation of handcraft techniques to large-scale production necessitated philosophical compromises. Like most of the commercially successful arts and crafts manufacturers Grueby standardized patterns, removing creative decision making from technicians. Hired men con-

structed the vessels; semiskilled female art students decorated the works with established designs.

In addition to the famous rindlike green glaze Grueby developed variations in cream, ocher, blue, mauve, and brown. The late Victorian pre-occupation with bringing nature inside the home, a predictable reaction to urbanization and industrialization, must have contributed to the popularity of Grueby's plantlike products.

Kendrick left the firm in 1901, but his designs were continued long afterwards. The business went through further changes in 1907 with the creation of the Grueby Pottery Company. Although incorporated separately, the faience and pottery companies shared factory space and kilns, so their division was largely a bookkeeping convenience. However, Grueby tile proved to be the bread and butter of the operation; the pottery encountered financial difficulties. The Grueby Faience Company reorganized as the Grueby Faience and Tile Company in 1909. After a fire in 1913 the tile company was rebuilt and continued successful operation until 1920, when Grueby sold the company. The Grueby Pottery Company ceased production after the fire.

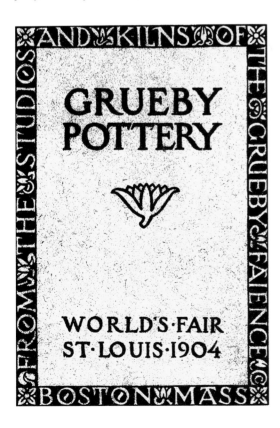

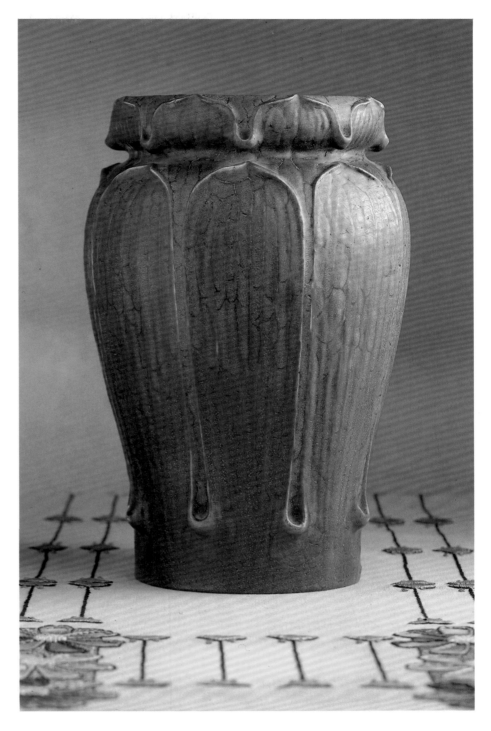

137

Vase, 1897–1902

Design attributed to George Prentiss Kendrick (United States, 1850–1919)
Earthenware
12⅞ x 8¾ (diam.) in.
(32.7 x 22.2 cm)
Marks: under base, impressed GRUEBY POTTERY | BOSTON USA in circular formation enclosing lotus blossom

L.88.31.37
Promised gift of Max Palevsky and Jodie Evans

Among the most monumental of Grueby's vases, this example summarizes the finest attributes of the company's products: a dense, rindlike, veined glaze appearing as the ripened surface of an organic form. This vase was also offered in smaller sizes and with appended handles.[32]

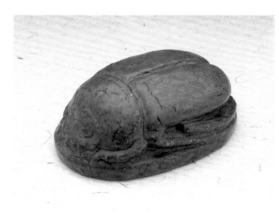

138

Scarab Letter Weight, 1904–13

Earthenware
1½ x 3⅞ x 2¾ in.
(3.8 x 9.8 x 7.0 cm)
Marks: under base, impressed
GRUEBY POTTERY | BOSTON USA
in circular formation enclosing
lotus blossom
M.88.195.5
Art Museum Council Fund

Grueby introduced "scarab letter weights" as a novelty at the Louisiana Purchase Exposition in 1904.[33] The motif was inspired by the contemporary fashion for Egyptian artifacts; the scarab symbolized immortality in ancient times.

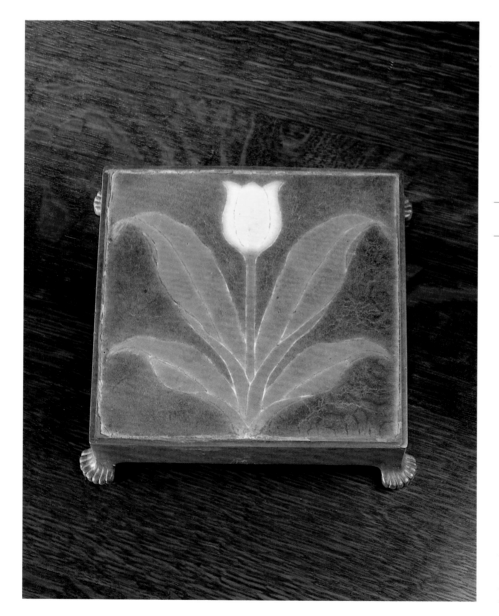

139

Tile Trivet, c. 1905

Bronze mount attributed to Tiffany Studios, Corona, New York (1902–38)
Decorated by unknown artist, E. R.
Earthenware and bronze
1⅜ x 6½ x 6½ in.
(3.5 x 16.5 x 16.5 cm)
Marks: on back, painted in green slip, E. R.
L.88.30.7
Collection of Max Palevsky and Jodie Evans

Grueby's new mat glazes significantly enhanced tiles as well as vessels. The velvety, dense glazes on the former were a refreshing departure from the standard high-glazed surfaces on his competitors' wares. As with the pottery the glazes assisted in the presentation of naturalistic subject matter, such as this tulip. The cloisonné effect was achieved by press molding the tile before applying different colored glazes to the recessions. Although unmarked, the trivet base is attributed to Tiffany Studios because of its similarity to marked examples.

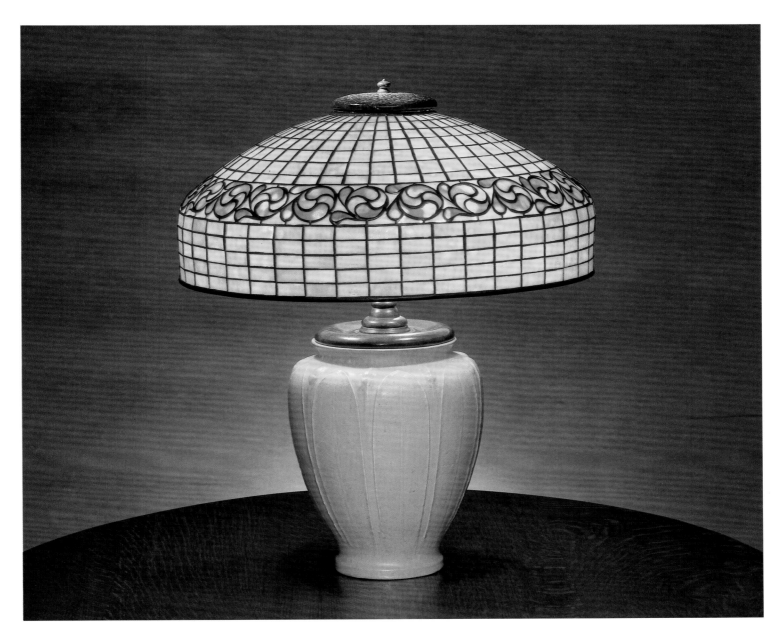

140

Table Lamp, c. 1905

Shade made by Tiffany Studios, Corona, New York (1902–38)
Base decorated by Marie A. Seaman (active c. 1907)
Earthenware, leaded glass, and bronze
22 x 18¾ (diam. of shade) x 8½ (diam. of base) in.
(55.9 x 47.6 x 21.6 cm)
Marks: under base, impressed
GRUEBY POTTERY | BOSTON USA in circular formation enclosing lotus blossom; incised MS;

impressed 100; on shade, on applied metal tag, struck incuse TIFFANY STUDIOS NEW YORK 1470
TR.9365.22
Collection of Max Palevsky and Jodie Evans

Tiffany Studios not only mounted Grueby tiles as trivets (see cat. no. 139), it also used wide-mouthed Grueby vases to house fuel canisters for lamps. Most examples known, like this one, feature shades of relatively simple design that harmonize with the heavy earthenware

bases. The product of the collaboration was described in a 1904 Grueby brochure:

A fine piece of pottery is essentially an object of utility as well as of decoration. In no way does the Grueby ware fulfil these two purposes more completely than in its lamp forms, whether for oil or electricity. The Grueby-Tiffany lamp combines two recent products of the Applied Arts, the support for the bronze fitting being a Grueby jar made for that special purpose, completed by a leaded or blown-

glass shade of Tiffany design and workmanship.[34]

When Tiffany began electrifying its lamps around 1906, it no longer needed bases capable of concealing fuel canisters, so the successful collaboration ended.[35]

MARBLEHEAD POTTERY

1904–36

Marblehead, Massachusetts

Named for the scenic New England coastal town where it operated, the Marblehead Pottery produced works that reflected "something of the gay little gardens and the gray old streets, something of the rocks and the sea." [36] The pottery was conceived in 1904 as part of the Handcraft Shops, a craft therapy program for convalescing patients, but within a year it became an independent commercial enterprise. [37] The firm's director, Arthur Eugene Baggs (United States, 1886–1947), had studied with Charles Binns at the New York School of Clayworking and Ceramics. Following in the tradition of Grueby, the company specialized in soft mat glazes and stylized naturalistic designs, which were either incised or painted. A 1919 Marblehead sales brochure stated: "Marblehead Pottery has always been distinguished for the simplicity and restraint of its forms. Its designers have tried to avoid the bizarre both in form and decoration. The shapes are by no means commonplace but their distinctive style is

attained through subtle refinement of line rather than by attempting the strikingly unusual." [38] In contrast with Grueby, however, Marblehead abstracted natural motifs instead of imitating them. Grapevines, blossoms, parrots, and other flora and fauna bedecked its pieces in careful symmetry (see cat. nos. 143–47). Sometimes nature was reduced to geometric translations in the manner of Frank Lloyd Wright and Scottish and Viennese designers (see cat. nos. 141–42). The 1919 brochure explained Marblehead's style: "In decorating Marblehead pottery its designers have tried to keep in mind the same principles of dignity, simplicity and harmonious color which distinguish the ware in general. The aim has been to make the decoration a part of the form, not merely a pretty ornament stuck on at haphazard. Naturalistic representation has been avoided in favor of a broad, flat, semi-conventionalized treatment." [39] The colors were "a beautiful old blue known as Marblehead blue, a warm gray, wis-

141

Vase, c. 1910 – c. 1920

Decorated by unknown artist, M. T.
Earthenware
6⅛ x 5¼ (diam.) in.
(15.6 x 13.3 cm)
Marks: under base, impressed sailing ship flanked by M P, all within a circle; incised M | T
L.89.37.2
Collection of Max Palevsky and Jodie Evans

142

Vase, c. 1910 – c. 1920

Decorated by Hannah Tutt (United States, 1860–1952)
Earthenware
9½ x 5¼ (diam.) in.
(24.1 x 13.3 cm)
Marks: under base, impressed sailing ship flanked by M P, all within a circle; incised HT
TR.9349.21
Collection of Max Palevsky and Jodie Evans

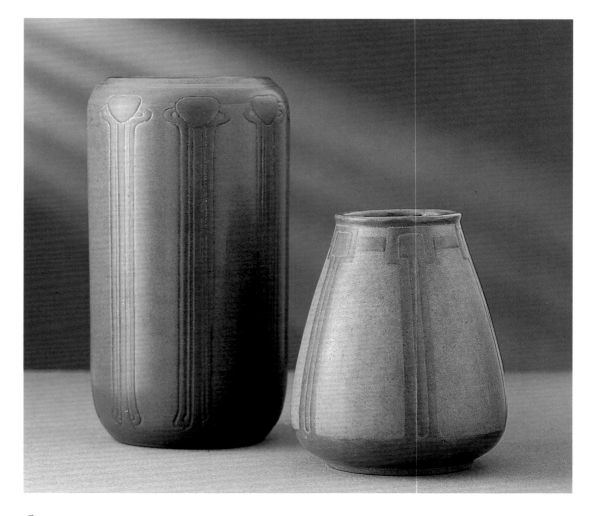

Cat. nos. 142, 141

taria, rose, yellow, green and tobacco brown. All are soft, harmonious tones which lend themselves well to the display of flowers." [40]

A mixture of earthenware and stoneware clays, Marblehead pieces are dense and heavy, well suited to their lapidarylike glazes. They have the appearance of polished stone, being grainy in appearance but smooth to the touch. The vessels were thrown by John Swallow (England, 1856–1920, active United States) and decorated by women to designs by Baggs and others. Chief decorator was Hannah Tutt (United States, 1860–1952), whose initials appear on the bases of a number of pieces. Marblehead marketed its wares both locally and through a catalogue, from which customers selected designs and background colors.[41] Undecorated, mat-glazed wares were considerably less expensive and produced in far greater numbers than the labor-intensive decorated pieces.

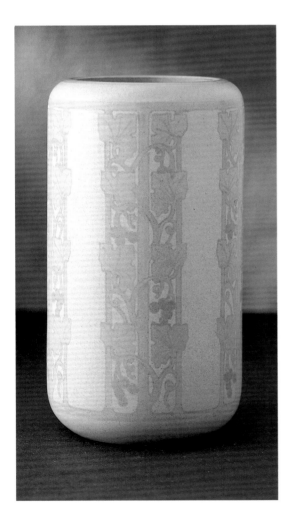

Cat. no. 143

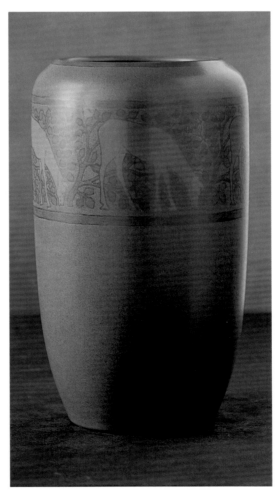

Cat. no. 144

143

Vase, c. 1910 – c. 1920

Decorated by Hannah Tutt
(United States, 1860 –1952)
Earthenware
9¼ x 5⅛ (diam.) in.
(23.5 x 13.0 cm)
Marks: under base, impressed
sailing ship flanked by M P, all
within a circle; H | T painted
in gray
L.89.38.2
Collection of Max Palevsky
and Jodie Evans

144

Vase, c. 1910 – c. 1920

Earthenware
11½ x 7 (diam.) in.
(29.2 x 17.8 cm)
Marks: under base, impressed
sailing ship flanked by M P, all
within a circle
M.89.151.22
Gift of Max Palevsky
and Jodie Evans

145

Vase, c. 1910 – c. 1920

Earthenware
6³⁄₁₆ x 5³⁄₁₆ (diam.) in.
(15.7 x 13.2 cm)
Marks: under base, impressed
sailing ship flanked by M P, all
within a circle
M.89.151.27
Gift of Max Palevsky
and Jodie Evans

146

Vase, c. 1910 – c. 1920

Decorated by Hannah Tutt
(United States, 1860 –1952)
Earthenware
10³⁄₈ x 5⁷⁄₈ (diam.) in.
(26.4 x 14.9 cm)
Marks: under base, impressed
sailing ship flanked by M P, all
within a circle; H | T painted
in gray
L.89.37.3
Promised gift of Max Palevsky
and Jodie Evans

Cat. nos. 146, 145

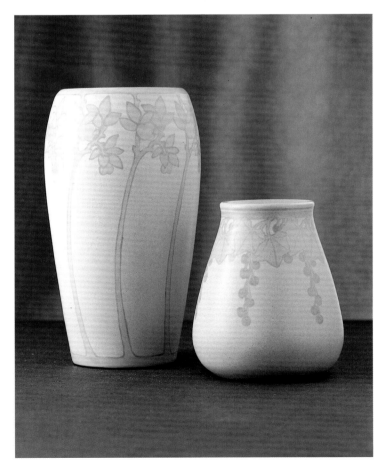

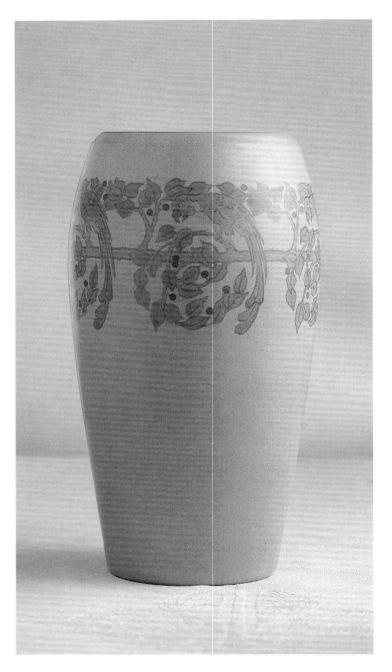

147

Vase, c. 1910 – c. 1920

Earthenware
13¹⁄₄ x 7¹⁄₂ (diam.) in.
(33.7 x 19.1 cm)
Marks: under base, impressed
sailing ship flanked by M P, all
within a circle
L.88.31.42
Promised gift of Max Palevsky
and Jodie Evans

MARKHAM POTTERY

1905–21

Ann Arbor, Michigan,

and

National City,

California

Herman C. Markham (United States, 1849–1922) began his involvement with ceramics while employed in the archaeology department at the University of Michigan. Another of the movement's amateurs, he conducted experiments with both forms and surface treatments in order to make vessels that would preserve the coolness of water so as to better display the roses from his garden. With the help of his son, Kenneth, he developed two unique glazes for his simple forms: *reseau* and *arabesque*. Archaeologically inspired, these mat finishes resembled the exteriors of fossils or other unearthed objects. Their partially porous surfaces kept water cooler by permitting evaporation. Reseau, seen here (cat. no. 148), has tones varying from brown to red with a burnt and weblike acidic finish suggestive of erosion. Arabesque is more evenly brown with a design approximating the imprint of fossils. A period publication described Markham's unique glazes: "The first thought upon looking at the pottery is of its peculiar beauty; then of its appearance of age—as if the vases had been excavated from some long-buried ancient atelier; and then an impression—widely different—of the open, of the forest, of sunlight filtering through bare branches or autumn tinted leaves."[42]

By 1905 the self-taught Markhams had perfected their products sufficiently to operate commercially from their backyard setup. Their vessels were slip cast in molds, decorated and completed in a single firing. Attracted by California clays and possibly the California dream, they relocated the pottery from Ann Arbor, Michigan, to National City, California, near San Diego, in 1913. They continued their practice of numbering individual pieces, with those marked higher than six thousand indicating a National City origin.[43] Although technically inferior to the products of more professional potters, Markham works earned medals, popular success, and art-historical significance because of their distinctive and mysterious surfaces.

148

Vase, 1913–21

Earthenware
7⅛ x 5⅝ (diam.) in.
(18.1 x 14.3 cm)
Marks: under base, incised script MARKHAM; incised 7202, all rubbed in brown
M.89.119.7
Art Museum Council Fund

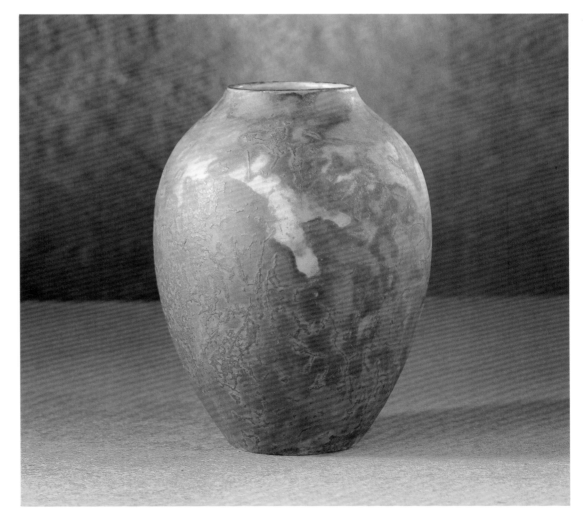

NEWCOMB POTTERY

1895–1940

New Orleans

149

Vase, 1902

Thrown by Joseph Fortune
Meyer (Alsace-Lorraine, 1848–
1931, active United States)
Decorated by Erin (Effie)
Shepard (d. 1917)
Earthenware
8⅝ x 3⅞ (diam.) in.
(21.9 x 9.8 cm)
Marks: under base, impressed
conjoined NC rubbed in blue;
incised script SHEPARD; ES
painted in black; impressed con-
joined JM; registration number
P91 painted in blue; impressed
clay code Q
M.88.167
Purchased with funds provided
by the Robert and Nancy Daly
Foundation

This vase is unusual in its use of
a yellow palette with a silvery-
black luster glaze outlining the
flowers in the Japanese print-
making style. The glaze was
probably among those perfected
by chief potter Joseph Meyer
(see cat. no. 151).

Founded in 1895, Newcomb Pottery was an edu-
cational enterprise associated with Sophie New-
comb Memorial College, the sister school of
Tulane University. Newcomb aimed to be com-
mercially viable, training young women in a
marketable and respectable skill and hiring grad-
uates to produce salable goods. "The whole
thing was to be a southern product, made of
southern clays, by southern artists, decorated
with southern subjects," wrote founding director
Mary Sheerer.[44] Like Arequipa, Marblehead, and
most of the commercial potteries Newcomb em-
ployed men to throw pots, reserving the less
arduous decorating for women.

Sheerer instructed students in ceramic paint-
ing and decoration, employing the more accom-
plished graduate students as decorators. Despite
proclaiming that "the decorator should be given
full rein to his fancy," she dictated a consistent
look at Newcomb based on the abstracted Jap-
anese style of American printmaker Arthur
Wesley Dow (United States, 1857–1922).[45] New-
comb's early works featured boldly defined ab-
stractions of natural forms—usually in blues and
greens, occasionally in blacks and yellows—
under a high-gloss glaze, an appearance indebted
to Dow and contemporary English designers.[46]
After about 1910 mat-glazed decoration domi-
nated, an imitation of Rookwood's revolutionary
Vellum glaze. Paul Cox, a former student of
Charles Binns, joined Newcomb that year and
developed the translucent glaze, winning great
praise for his work. In contrast with the wheel-
thrown vessels of the early decoration period,
many of the mat-glazed wares were molded. The
palette and subject matter, typically flora and
fauna of the South, remained the same.

Joseph Meyer, c. 1920

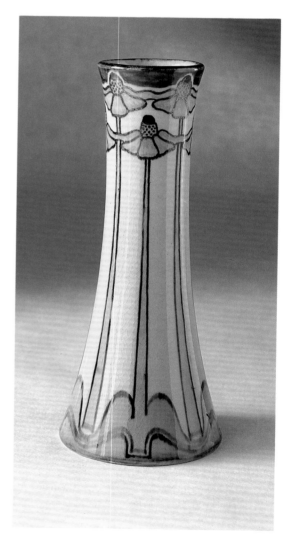

150 >

Vase, 1906

Thrown by Joseph Fortune
Meyer (Alsace-Lorraine, 1848–
1931, active United States)
Decorated by Mazie Teresa Ryan
(United States, 1880–1946)
Earthenware
12⅞ x 8⅛ (diam.) in.
(32.7 x 20.6 cm)
Marks: under base, impressed
conjoined NC rubbed in blue;
M. T. RYAN. painted in blue;
impressed conjoined JM; regis-
tration number BH82 painted
in blue; impressed clay code Q
L.88.31.48
Promised gift of Max Palevsky
and Jodie Evans

This vase, with its stylized
geraniums and broad expanses
of color, illustrates the early,
abstracted, high-gloss period at
Newcomb. The decorator, Mazie
Teresa Ryan, also worked in
other crafts taught at Newcomb:
embroidery, beadwork, metal-
work, and leaded glass.

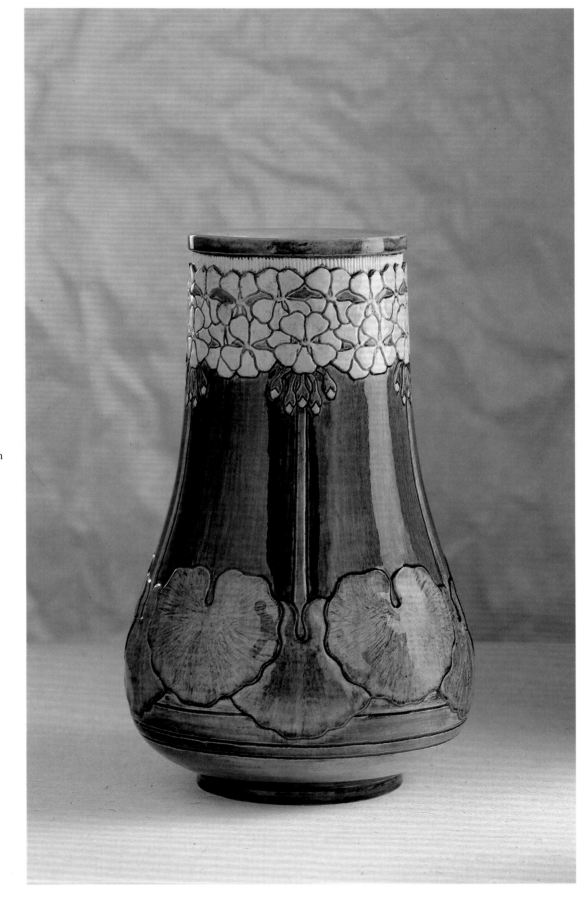

151

Vase, c. 1910

Thrown by Joseph Fortune
Meyer (Alsace-Lorraine, 1848–
1931, active United States)
Earthenware
3¼ x 3⅝ (diam.) in.
(8.3 x 9.2 cm)
Marks: under base, impressed
conjoined NC; impressed con-
joined JM; impressed glaze
code G
89.2.16
Purchased with funds provided
by the William Randolph Hearst
Collection

A departure from Newcomb's
standard palette were the experi-
mental luster glazes occasionally
produced by Joseph Meyer in the
period from 1895 to 1910. This
example illustrates the appeal
of the elusive Chinese oxblood
glaze to American potters of the
period (see also cat. nos. 188, 192,
196). A nearly identical vase was
purchased by the Newark
Museum in 1911.[47]

152

Plate, 1913

Thrown by Joseph Fortune
Meyer (Alsace-Lorraine, 1848–
1931, active United States)
Decorated by Anna Frances
Connor Simpson (United States,
1880–1930)
Earthenware
1¼ x 8⅞ (diam.) in.
(3.2 x 22.5 cm)
Marks: under base, impressed
conjoined NC rubbed in blue;
incised conjoined AFS; impressed
conjoined JM; registration num-
ber FZ81 painted in blue; im-
pressed clay code B within a
circle
M.84.118.4
Gift of the Jordan-Volpe Gallery,
New York, New York

Although Newcomb, in its
commitment to unique hand-
craftsmanship, claimed no two
pieces were alike, at least one
other plate survives that is iden-
tical to this one.[48] Perhaps the
anomaly is explained by New-
comb decorator Sadie Irvine's
recollection regarding motifs:
"No Newcomb pot was ever
duplicated unless the purchaser
asked for it."[49]

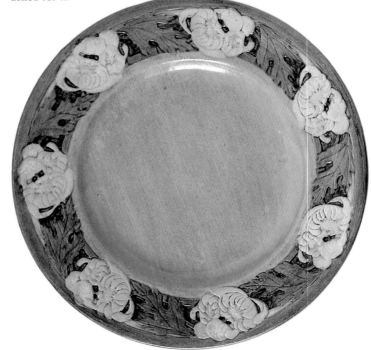

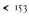 153

Plaque, 1915

Decorated by Anna Frances
Connor Simpson (United States,
1880–1930)
Earthenware
9⅞ x 6 x ½ in.
(25.1 x 15.2 x 1.3 cm)
Marks: on front, at lower proper
left corner, impressed conjoined
NC painted in blue; on back,
incised conjoined AFS rubbed in
blue; incised shape number 258;
registration number HL1 painted
in blue
L.88.30.13
Collection of Max Palevsky
and Jodie Evans

This plaque depicting Southern
cypress trees is typical of New-
comb's landscapes, "finely
wrought designs of moss draped
live oaks and cypresses growing
along the banks of the bayous."[50]
These romantic, often moonlit
landscapes were the ceramic
equivalent of tonalism in early
twentieth-century American
painting and were paralleled
at Rookwood (see cat. nos.
207–8).[51] The decorator, Anna
Frances Connor Simpson, was
one of Newcomb's most prolific
artists.

154

Vase, 1915

Decorated by Cynthia Pugh
Littlejohn (United States,
1890–1959)
Earthenware
12 x 5¾ (diam.) in.
(30.5 x 14.6 cm)

Marks: under base, impressed
conjoined NC rubbed in blue;
incised conjoined CL rubbed in
blue; impressed shape number
165; registration number
HF49 painted in blue; impressed
clay code C within a circle
TR.9349.24
Collection of Max Palevsky
and Jodie Evans

This vase, like the plaque deco-
rated by Simpson (cat. no. 153),
dates from Newcomb's middle
period of mat-glazed, natu-
ralistically decorated wares.
Cynthia Pugh Littlejohn un-
doubtedly followed the proce-
dures recalled by Sadie Irvine:

*Each decorator had her own port-
folio, pencil studies of various
plant forms, trees, etc., that she
knew well and probably grew in
her own garden.... The chosen
plant or tree was sketched with
a soft drawing pencil.... Next,
with tools each had made to suit
her own needs, the design was
carved in low relief....*

*... A very thin wash of blue
(cobalt oxide) was applied with
a wide, soft brush to every piece
biscuited. The piece was set aside
for the water to evaporate, leaving
a light tone all over the surface.
This tone was carefully evened
by using bristle brushes of various
sizes. Darker tones were added ...
as required.... Before firing, the
cobalt that made the lovely misted
effect we strove for was a soft
lavender.*[52]

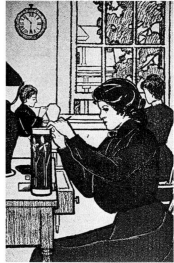

Woodcut of Newcomb decorators,
1902

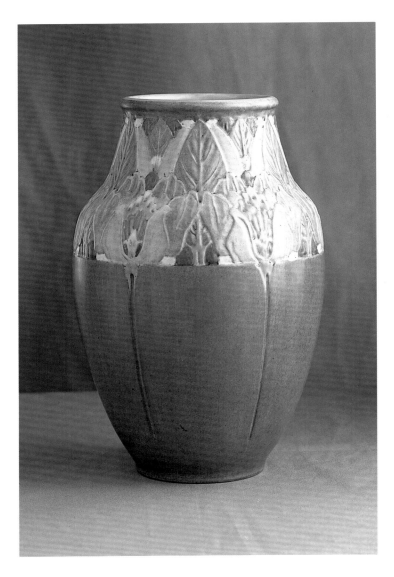

155

Vase, 1925

Thrown by Joseph Fortune
Meyer (Alsace-Lorraine, 1848–
1931, active United States)
Decorated by Corinne Marie
Chalaron (United States,
1900–1977)
Earthenware
14⁹/₁₆ x 9¾ (diam.) in.
(37.0 x 24.8 cm)
Marks: under base, impressed
conjoined NC; incised conjoined
CMC; impressed conjoined JM;
impressed shape number 322;
impressed registration number
PC26
L.88.30.12
Collection of Max Palevsky
and Jodie Evans

This vase reflects the increas-
ingly stylized character of New-
comb's designs in the mid-to-late
1920s. Mary Sheerer attended the
International Exposition of Dec-
orative Arts in Paris in 1925,
where art deco was introduced,
and brought the new style back
to Newcomb.

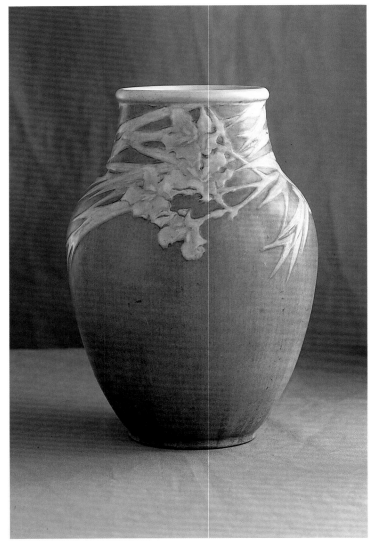

<div style="border: 2px solid black; display: inline-block; padding: 1em;">

NORTHWESTERN TERRA COTTA COMPANY

1888–1956

Chicago

</div>

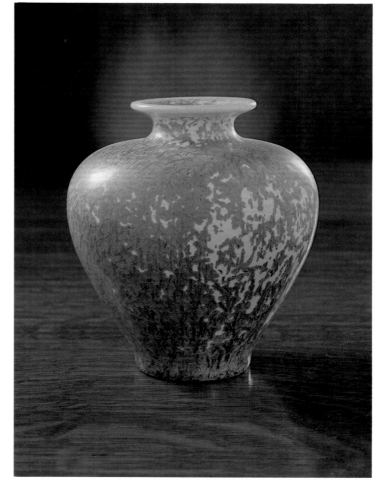

‹ 156

Vase, 1927

Thrown by Joseph Fortune
Meyer (Alsace-Lorraine, 1848–
1931, active United States)
Decorated by Sarah Agnes
Estelle (Sadie) Irvine (United
States, 1887–1970)
Earthenware
14 x 10⅛ (diam.) in.
(35.6 x 25.7 cm)
Marks: under base, impressed
conjoined NC; incised conjoined
SI; impressed conjoined JM;
impressed shape number 322;
impressed registration number
QM65
M.89.151.15
Gift of Max Palevsky
and Jodie Evans

Although this piece has the same
shape as the stylized vase (cat.
no. 155), the more naturalistic
floral decoration changes the
pot's appearance entirely.

157

Norweta Vase, c. 1907–20

Earthenware
4⅞ x 4⅝ (diam.) in.
(12.4 x 11.7 cm)
Marks: under base, incised
NORWETA
M.88.194.5
Decorative Arts Council Fund

Inspired by the success of the
crosstown Gates Potteries
(makers of Teco), the North-
western Terra Cotta Company
produced a limited line of
crystalline-glazed art ceramics as
a sideline to its major production
of architectural terra-cotta.
(Crystalline glazes, like mat
glazes, were an innovation of the
period.) Norweta was the name
given to this line, which was
produced from about 1907 to 1920.
In 1920 the firm acquired the
Chicago Crucible Company and
discontinued Norweta in favor of
new items with the Chicago
Crucible mark.[53]

GEORGE EDGAR OHR

United States, 1857–1918

Biloxi, Mississippi

George Edgar Ohr created the most radical art pottery of the period while remaining truer to arts and crafts ideals than most of his contemporaries. At his Biloxi Art Pottery in Biloxi, Mississippi (c. 1880–c. 1910), the maverick Ohr, using local clays, designed and crafted each unique piece without assistance. A thrower of extraordinary skill, he would construct earthenware vessels with walls as thin as eggshell porcelain, after which he twisted, crinkled, folded, or crushed them before applying one of his bizarre glazes (see cat. nos. 158–60). A contemporary critic noted: "While much of Mr. Ohr's work will not meet the requirements of accepted standards, his one aim is to not have it in any way like what people have been accustomed to. There is art—real art—in the Biloxian's pottery, albeit at times he has a way of torturing the clay into such grotesque shapes that one can well believe it to cry out in anger and anguish against the desecration."[54]

Ohr cultivated his image as the "mad potter of Biloxi" and declared himself the "Second Palissy," referring to the legendary sixteenth-century potter, Bernard Palissy (France, c. 1510–c. 1590). He evidently sold enough utilitarian wares to provide for his family, but stockpiled thousands of unsold pieces, which he prophesied would someday be worth their weight in gold.[55]

George Ohr, c. 1900

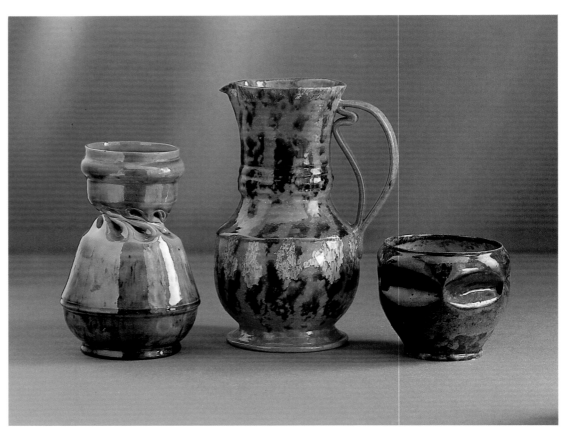

158	159	160
Vase, c. 1888–94	*Pitcher*, c. 1895–1900	*Bowl*, c. 1898–1910
Earthenware	Earthenware	Earthenware
7¼ x 4⅞ (diam.) in.	9⁵⁄₁₆ x 6¾ x 5¼ (diam.) in.	4 x 5 (diam.) in.
(18.4 x 12.4 cm)	(23.7 x 17.1 x 13.3 cm)	(10.2 x 12.7 cm)
Marks: under base, impressed	Marks: under base, impressed	Marks: under base, incised circle
BILOXI, MISS. \| GEO. E. OHR.	G E OHR \| BILOXI, MISS.	enclosing script G E OHR
M.89.151.17	L.88.30.16	L.88.30.15
Gift of Max Palevsky	Collection of Max Palevsky	Collection of Max Palevsky
and Jodie Evans	and Jodie Evans	and Jodie Evans

OVERBECK POTTERY

1911–55

Cambridge City, Indiana

Large commercial potteries operated with a division of labor, separating the creation of vessels into distinct categories. One set of workers designed pots, another set threw them, still another set decorated them. The Overbeck Pottery of Cambridge City, Indiana, also had a division of labor, but with a major difference: four sisters did all the work.

Margaret (United States, 1863–1911), Hannah Borger (United States, 1870–1931), Elizabeth Gray (United States, 1875–1936), and Mary Frances (United States, 1878–1955) Overbeck established their business in 1911. All four had previously been china painters and had varying artistic backgrounds. Elizabeth, for example, had studied with Charles Binns at the New York School of Clayworking and Ceramics; Mary and Margaret were both students of Arthur Wesley Dow.[56]

Logically Elizabeth handled the technical aspects of the pottery, including clay and glaze development and building the wares. Margaret's influence was chiefly in establishing the firm, as she died the year of its formation. Mary and Hannah both designed and applied decoration, although Hannah, an invalid, did more designing and less decorating than Mary. Most of the wares were wheel thrown or hand built and decorated with glaze inlay and/or carving. Like Marblehead and early Newcomb works Overbeck pieces were characterized by stylized renderings of natural subjects. The tones ranged from soft, mat colors to bright, high-gloss glazes.

The trophy cup (cat. no. 161) was specially commissioned for the General Federation of Women's Clubs, as proudly noted in the *Cambridge City Tribune*:

The Misses Overbeck have just completed a vase which is to be awarded as a trophy cup at the biennial meeting of the General Federation of Woman's [sic] Clubs to be held in Chicago next week. A feature of one of the sessions will be the presentation of this vase to the State Federation president, who has been responsible for the greatest increase in subscriptions to the Federation magazine. The vase is about twelve inches high, with two handles, gray with blue design, and bears the letters G. F. W. C., the initials of the Federation, and the words, "Honor for Service." The order was received through Mrs. M. F. Johnston of Richmond, who

is chairman of the art committee of the General Federation. This is a commission that any potter in the United States would have been glad of the opportunity to fill, and the honor is rather an exceptional one to have been bestown in this locality.[57]

The aforementioned Mrs. Johnston described the commission in the Federation's magazine:

I took the first car out to the little town of Cambridge City, to see some potters, whom I knew very well. I wish I could make you see their pleasant old house among the apple trees, and introduce you to the four sisters who live there....

When I told them that we wanted a pottery cup for this prize they were delighted ... and at once began to see visions of cups of many designs, and made various suggestions of what we might have. They welcomed the conditions of a gray and blue color scheme and the lettering I proposed....

So they went to work with enthusiasm, starting four cups, that we might be sure of one perfect piece. They did there, in their own studio, all the work of mixing and lawning the clay, throwing and turning on the wheel, building by hand, carving, designing, painting, grinding, mixing and applying glaze, and the firing of four cups—two of which were perfect, and we have them here.

The taller one was thrown and turned on the wheel, and decorated with applied design in glaze inlay, in a conventional floral design.

The broader one is hand built, and has a carved design with hydrangea motif.[58]

The broader cup was awarded to Mrs. L. J. Haley, president of the Alabama delegation, the state federation with the greatest number of subscription sales. The taller cup, the one in the collection, was presented to Mrs. Percy V. Pennybacker of Texas, president of the General Federation.

The related watercolor sketch (cat. no. 163j) is from the Overbeck sketchbook (see cat. no. 163a–k).

161

Trophy Cup, 1914

Probably designed by Hannah
Borger Overbeck (United States,
1870–1931)
Made by Elizabeth Gray Over-
beck (United States, 1875–1936)
Decorated by Mary Frances
Overbeck (United States,
1878–1955)
Stoneware
14 x 6 ⅞ (diam.) in.
(35.6 x 17.5 cm)
Inscriptions: around top rim,
incised HONOR FOR SERVICE;
around body, GFWC; under base,
on foot rim, BIENNIAL JUNE 1914
Marks: under base, incised con-
joined OBK | E F
M.89.151.16
Gift of Max Palevsky
and Jodie Evans

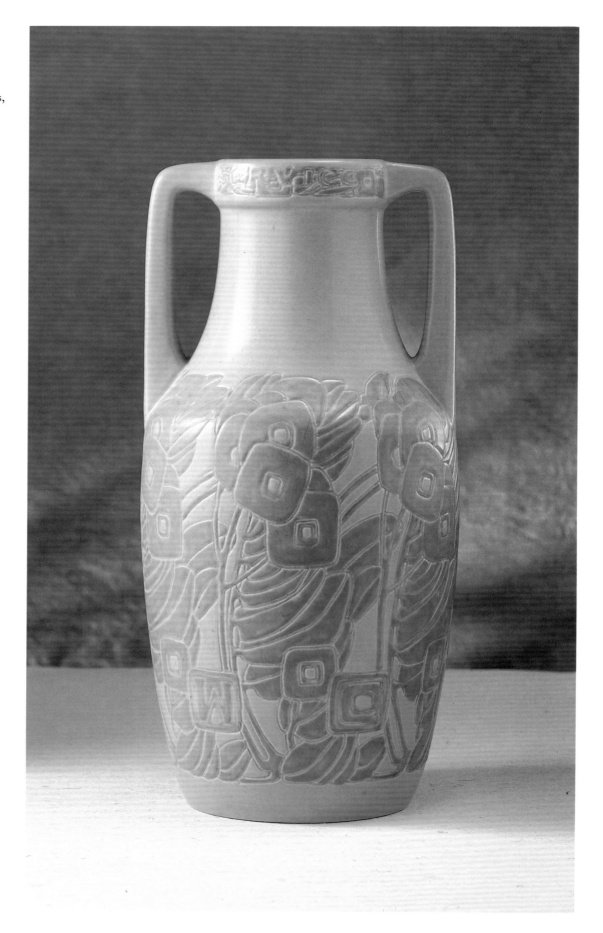

From left: Hannah, Mary, Harriet (another sister), and Elizabeth Overbeck in 1914 with the two trophy cups made for the General Federation of Women's Clubs. Cat. no. 161 is shown at right.

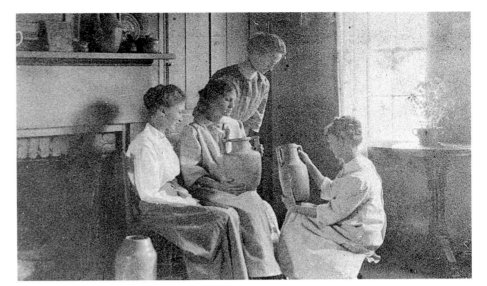

∧ Cat. no. 163j

162

Tile Sign, c. 1915

Earthenware
5½ x 8⅝ x ⅞ in.
(14.0 x 21.9 x 2.2 cm)
Inscriptions: on front, impressed and incised conjoined OBK and script OVERBECK | POTTERY | CAMBRIDGE CITY | INDIANA
Marks: on back, incised conjoined OBK
M.88.194.6
Decorative Arts Council Fund

Various potteries made advertising tiles like this one for use in the shop or at exhibitions (for a similar example see cat. no. 114).

163a–k

Sketchbook, c. 1915

Painted by Hannah Borger
Overbeck (United States, 1870–
1931) and Mary Frances Over-
beck (United States, 1878–1955)
Watercolor and pastel on paper,
mounted in scrapbook
Each (approx.): 11 x 8 in.
(27.9 x 20.3 cm)
M.88.35.3.1–41, M.89.10.5,
M.88.35.3.43–52
Museum Acquisition Fund

These works are taken from an
untitled sketchbook containing
fifty-two watercolor and pastel
drawings, one of which is signed
by Mary, thirty-two by Hannah.
Nineteen have no signature but
appear to represent Hannah's
hand. Two of the abstracted
drawings (cat. no. 163j, k) relate
to and are shown with known
Overbeck pieces (cat. nos. 161,
164). Two others were among the
many Overbeck sketches pub-
lished in *Keramic Studio* between
1903 and 1916 with instructions
on how to execute them on
ceramics. A period article men-
tioned the sketchbook, stating
that "Hannah has managed for
many years to keep a record in
pencil and water color drawings
of the flora of … [the] vicinity—
a library of motifs for designs
which are used in decorating the
pottery, and many of which have
been published in the Keramic
Studio."[59]

a

b

c

d

e

f

g

h

i

Cat. no. 163k

164

Saucer, c. 1915

Decorated by Hannah Borger Overbeck (United States, 1870–1931)
Porcelain (made in Limoges, France)
¾ x 7⅜ (diam.) in.
(1.9 x 18.7 cm)
Marks: under base, printed in green, flagpole with bird and two flags, LIMOGES on upper flag, FRANCE on lower flag; HANNAH B. OVERBECK painted in red
M.89.10.4a
Gift of Bryce and Elaine Bannatyne

This saucer and a matching bowl (in the collection but not included in the catalogue) relate to a sketch from the Overbeck scrapbook (cat. no. 163k) and were painted on French porcelain blanks.

PAUL REVERE POTTERY OF THE SATURDAY EVENING GIRLS' CLUB

1907–42

Boston and Brighton,

Massachusetts

Like Marblehead and Arequipa the Paul Revere Pottery was founded with social as well as commercial aims. These divergent goals were no more congruent at Paul Revere than at the other two establishments. Unlike the first two, however, Paul Revere sacrificed profit for social experimentation.

The Saturday Evening Girls' Club provided cultural activities for poor immigrants of the Jewish and Italian neighborhoods of North Boston. On Saturday evenings the girls met at a local public library to participate in lectures, music, dancing, crafts, and readings. Through the patronage of Mrs. James J. Storrow a pottery was begun in 1907 to train the girls in a respectable craft that would provide them with additional income. Never profitable, the pottery was subsidized by Storrow until it closed in 1942.[60]

The operation took its name from the prox-imity of its Boston location to the Old North Church. In 1915 new quarters were built in Brighton. Subscribing to the arts and crafts conviction that beautiful surroundings contributed to creative work, the new pottery was designed in the style of an English country house, surrounding gardens and all.

The participants glazed and decorated wares thrown by a hired male potter. The vase (cat. no. 165) illustrates the pottery's incised style; the trivet (cat. no. 166) shows the use of polychrome glazing. Sarah Galner (United States, 1894–1982), the vase's decorator, specialized in flower designs of this nature.[61] Art wares were outnumbered in production by utilitarian tablewares that had simpler, more repetitive decoration in the manner of Walter Crane (England, 1845–1915) and other English designers.

165

Vase, 1916

Decorated by Sarah Galner
(United States, 1894–1982)
Earthenware
10⁹⁄₁₆ x 5¾ (diam.) in.
(26.8 x 14.6 cm)
Marks: under base, painted in
black slip, s e g | 6–16 and s | g
within a circle
M.89.151.29
Gift of Max Palevsky
and Jodie Evans

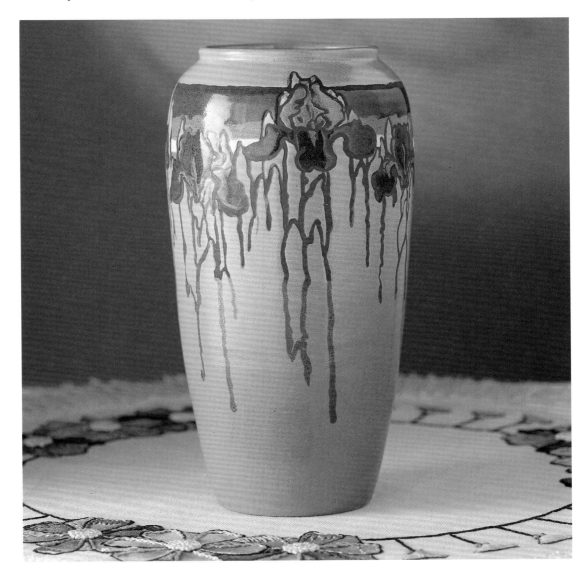

166

Trivet, c. 1915 – c. 1920

Earthenware
¼ x 5⅛ (diam.) in.
(0.6 x 13.0 cm)
Marks: on back, painted in black
slip, conjoined SEG
M.89.10.2
Gift of Bryce and Elaine
Bannatyne

REDLANDS POTTERY

c. 1904 – c. 1909

Redlands, California

"About three years ago, while looking for a damp place where some tadpoles, that had served science and amused a group of children, might continue their evolution and in course of time reach frogs' estate ... W. H. Trippett of Redlands happened upon a surface bed of damp clay. This discovery at once suggested to Mr. Trippett the possibilities of such material,—modeling, pottery, Redlands Pottery,—why not? He acted upon the suggestion." [62] Wesley H. Trippett (United States, 1862–1913) had moved to California from New York about 1895 for health reasons. He established the Redlands Pottery about 1904 after three years of experimenting with ceramics. While self trained, he was not entirely ignorant of clay processes, having designed and modeled the material for "architectural and decorative metal work." [63] Trippett established his business in his home, apparently as a one-man operation. Between 1902 and 1908 city directories list him first as a sculptor, then as an artist, and finally as a pottery proprietor (in the years 1907 and 1908).[64] However, a tile dated 1904 in a Redlands Pottery sales brochure suggests he was in business by that date, and a 1905 trade catalogue shows that Trippett's wares were retailed that year in San Francisco.[65] Redlands probably closed before 1909; Trippett died of tuberculosis in 1913.

Trippett's wares are usually molded with "subjects peculiar to this [the California] coast." [66] In decoration and finish they are similar to works by Alexander W. Robertson, particularly those he made at Halcyon and Alberhill (see cat. nos. 183–85), although no connection can be established between the two men. Both used red and white ceramic bodies and preferred a bisque finish that revealed the quality and color of California clays. Trippett's rustic decoration of local fauna parallels a style Robertson adopted after working with Linna Irelan at Roblin. Irelan and Trippett may have been independently influenced by the Victorian fascination with Bernard Palissy, whose wares were decorated with reptiles and other natural elements cast from life.

167 (top left)

Flower Bowl, c. 1904–c. 1909

Earthenware
3½ x 5⅛ (diam.) in.
(8.9 x 13.0 cm)
Marks: under base, molded in
relief, REDLANDS | POTTERY in
circular formation around a
circle enclosing tadpole
M.89.119.10
Art Museum Council Fund

168 (top right)

Flower Bowl, c. 1904–c. 1909

Earthenware
3 x 3½ (diam.) in.
(7.6 x 8.9 cm)
Marks: under base, molded in
relief, REDLANDS | POTTERY in
circular formation around a
circle enclosing tadpole
M.89.119.12
Art Museum Council Fund

The Paul Elder Company of San
Francisco sold "Flower Bowls"
among its other Redlands Pot-
tery offerings in a 1905 trade cat-
alogue.[67] They were described as
being of "various sizes, nearly
round in shape, with figures of
crabs and frogs in relief, charm-
ingly executed." Sizes were
two to three-and-a-half inches
in height; prices were three to
four dollars. There are two such
bowls in the collection (cat.
nos. 167–68), one with a sandy,
encrusted texture that befits its
crustacean subject matter (cat.
no. 167).

169 (bottom left)

Bonbon Box, c. 1904–c. 1909

Earthenware
2 x 3¼ (diam.) in.
(5.1 x 8.3 cm)
Marks: under base, molded in
relief, REDLANDS (N is back-
wards) | POTTERY in circular for-
mation around a circle enclosing
tadpole
M.89.119.11
Art Museum Council Fund

The Elder catalogue illustrated
a piece similar to this box and
noted that "a variety of designs"
were available with "covers
ornamented with figures in relief
of horn-toads, crabs, frogs, liz-
ards, and rabbits." The 1905 price
was two dollars.

170 (bottom right)

Covered Bowl, c. 1904–c. 1909

Earthenware
3⅜ x 5⅝ (diam.) in.
(8.6 x 14.3 cm)
Marks: under base, molded in
relief, REDLANDS | POTTERY in
circular formation around a
circle enclosing tadpole
M.88.195.2
Art Museum Council Fund

In shape and color this bowl is
well suited to its decoration of
sharks gliding through a surg-
ing, green sea. It is one of the
largest forms extant from the
pottery, although the 1904 Red-
lands sales brochure pictured a
vase that stood eight-and-a-half-
inches tall.[68]

FREDERICK HURTEN RHEAD

England, 1880–1942,

active United States

■ ■

ROSEVILLE POTTERY

1892–1954

Zanesville, Ohio

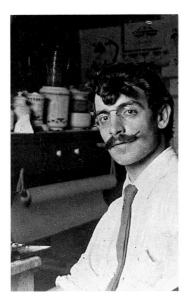

Frederick Rhead, 1904–8

Frederick H. Rhead was one of America's most talented and influential art potters. He emigrated from England in 1902 and was associated with two other American potteries before becoming the art director of Roseville in 1904.[69] While at Roseville he introduced the sgraffito process, which is seen on the vases shown here (cat. nos. 171–72). He had learned the technique in England; indeed the line is named for the English art pottery that popularized it, Della Robbia. Rhead described the procedure this way: "The sgraffito process consisted in the application of the design by means of a copying ink stencil, or by drawing by freehand, in incising the outline by means of specially ground darning needles set in handles; the incised clay coming out through the eye of the needle; chiseling out the background to the second layer of color, and then painting in colored slips where additional color was needed."[70]

He continued to use variations of this technique throughout his career (see cat. nos. 173–74, 176a–c, 178) and admitted in 1909: "I like all types of clay work but perhaps prefer incising and carving to the other kinds."[71] The process was labor intensive, however, so Rhead adapted it to the production line by employing high school girls to scratch out the basic designs. The vessels themselves were cast in two layers of clay, the inner one, of a different color, being revealed in the sgraffito process. From a practical standpoint this prevented the girls from carving too deeply.

Rhead's style at Roseville was English in other ways as well. The daffodil (cat. no. 171) and lotus (cat. no. 172) designs employed here are tightly controlled and stylized in the manner prescribed by English arts and crafts designers Walter Crane, Owen Jones, and Lewis Day: nature abstracted but ordered. While Rhead maintained the stylized approach to decoration throughout his career, some of his later designs (see cat. nos. 174, 176a–c) show a relaxation of the tight order seen here.

Roseville was another example of a commercial pottery that introduced art ceramics as a sideline. Collectively Roseville's art pottery wares were called Rozane.[72] In a 1906 company catalogue the daffodil vase was listed for sixteen dollars, reflecting its time-consuming decoration.[73]

171

Della Robbia Vase, 1906–8

Decorated by Helen Smith
(active c. 1906)
Earthenware
10⅞ x 5⅜ (diam.) in.
(27.6 x 13.7 cm)
Marks: under base, applied blue disk with ROZANE | WARE molded in relief; on side, incised H. SMITH
L.88.30.30
Collection of Max Palevsky and Jodie Evans

172

Della Robbia Vase, 1906–8

Decorated by unknown artist, G. B.
Earthenware
15⅛ x 4½ (diam.) in.
(38.4 x 11.4 cm)
Marks: on side, at foot, incised G. B.
M.88.35.2
Museum Acquisition Fund

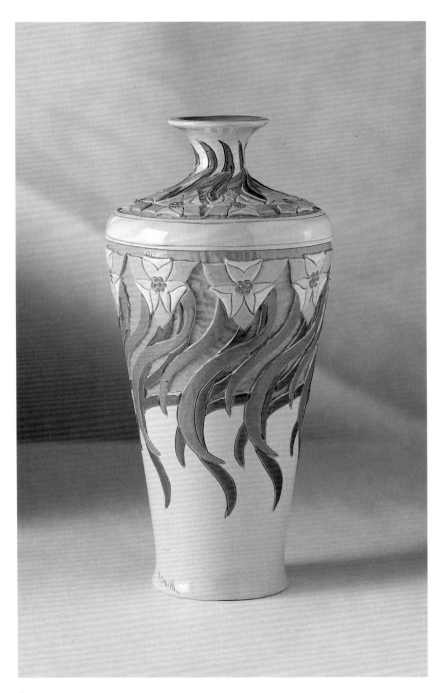

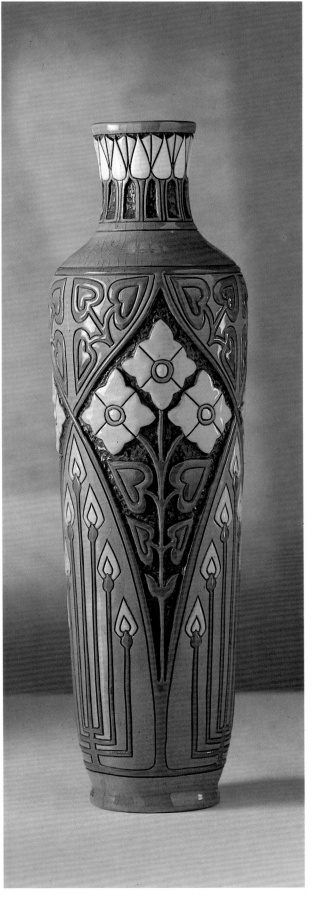

Cat. no. 171

Cat. no. 172

FREDERICK HURTEN RHEAD

England, 1880–1942,

active United States

■ ■

UNIVERSITY CITY POTTERY

1909–15

University City, Missouri

173

Tile Plaque, 1910–12

Made by Frederick Hurten Rhead (England, 1880–1942, active United States) and Agnes Rhead (England, b. 1877, active United States)
Earthenware
19¾ x 19¾ x 1 in.
(50.2 x 50.2 x 2.5 cm)
Marks: on front, at lower proper right corner, incised within a rectangle, AGNES | AND | FREDERICK | RHEAD.
M.89.119.16
Decorative Arts Council Fund

Rhead produced at least two of these peacock tile plaques while at University City. He sent one example, along with another tile peacock design, to a friend in Zanesville, Ohio, who installed them in his home.[74] This one, judging from the mark, was at least partially executed by Rhead's first wife, Agnes. He employed his favorite technique, carving and incising, to produce one of the most spectacular examples of this genre.

The University City Pottery was the brainchild of Edward Gardner Lewis (United States, 1869–1950), part of his American Woman's League educational program. He intended this Missouri establishment to be a center for experimentation and teaching—a laboratory—not a commercial operation. Lewis was able to persuade the premier French potter, Taxile Doat (France, 1851–1938, active United States), to leave his personal studio at the French National Porcelain Manufactory at Sèvres, perhaps because Lewis offered him the opportunity to build a state-of-the-art pottery. Lewis also invited Adelaide Alsop Robineau and her husband, Samuel; Frederick Rhead, who had left Roseville in 1908 and was working for Jervis Pottery; and Kathryn E. Cherry (United States, 1870–1931), a distinguished china painter and former Robineau student.

Doat and Robineau (see cat. no. 195) worked in porcelain, while Rhead made lower-fired pottery. Amidst such distinguished colleagues, with modern equipment and the absence of commercial pressures, it is not surprising that the three produced some of their finest work despite the brief tenure of the project. Financial difficulties closed the venture after only a few years.

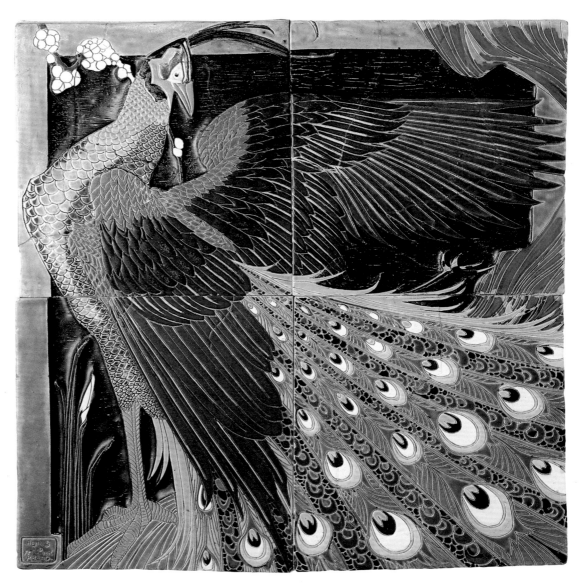

174

Vase, 1911

Earthenware
17¼ x 5⅛ (diam.) in.
(43.8 x 13.0 cm)
Marks: under base, incised
conjoined FHR and AWL within
conjoined UC; incised 1911;
incised 1020
L.88.31.74
Promised gift of Max Palevsky
and Jodie Evans

A virtuoso example of Rhead's
incised technique, this vase pro-
vides a contrast with his earlier
carved vessels in the Della Rob-
bia line (cat. nos. 171–72). The
tight geometry of his English
style has loosened; the stylized
landscape is lyrical and sinuous.
The AWL mark stands for the
American Woman's League, the
parent organization of Univer-
sity City Pottery.[75]

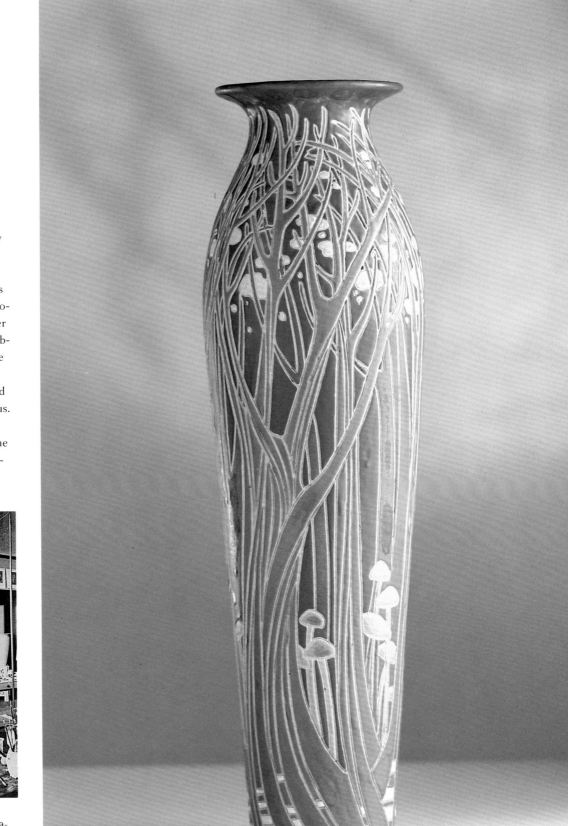

Frederick Rhead, 1911 (note pea-
cock plaque in left background)

FREDERICK HURTEN RHEAD

England, 1880–1942,

active United States

∎ ∎

AREQUIPA POTTERY

1911–18

Fairfax, California

While in California on a promotional tour for University City, Rhead met Dr. Philip King Brown, founder of a new sanatorium for working-class tubercular women, Arequipa ("Peruvian for 'place of rest'").[76] Impressed with California's climate and beauty and aware that University City was experiencing difficulties, Rhead accepted Brown's offer to organize a pottery at the establishment. Arequipa numbered among many period experiments that incorporated craft as therapy.[77] The sanatorium was established, in Rhead's words, "to help people who were nervous and who needed rest"; the ceramics workshop, "to give these people interesting work."[78] Sale of the goods also defrayed expenses.

Rhead hired men to throw or mold vessels and trained patients in the less arduous skills of decorating and glazing. The vase in the collection (cat. no. 175) illustrates a design process he called "the raised line," in which slip was trailed onto vessels in decorative patterns, accentuated by glazes.[79] The process was much simpler than techniques he had used at Roseville and University City and was easily grasped by amateurs. The stylized organic design of meandering leaves evinces his English arts and crafts training; he heeded countryman Walter Crane's advice: "A spiral curve is a harmonious line … repeat it, reversed, and you prolong the harmony; repeat it again, with variations, and you complete the harmony."[80] In 1909 Rhead perfected the rindlike mat glaze seen here, undoubtedly a response to the popularity of the famous Grueby green.

Ultimately Rhead's emphasis on artistic quality was incongruous with the therapy philosophy. The succession of patients also did not facilitate skilled training or achievement. He left the pottery in 1913.

175

Vase, 1911–13

Earthenware
6⅛ x 5¾ (diam.) in.
(15.6 x 14.6 cm)
Marks: under base, in underglaze blue on circular pad of white tinglaze, AREQUIPA | CALIFORNIA | [1934] | outline of pot beside tree; incised 30; incised R
M.89.119.4
Art Museum Council Fund

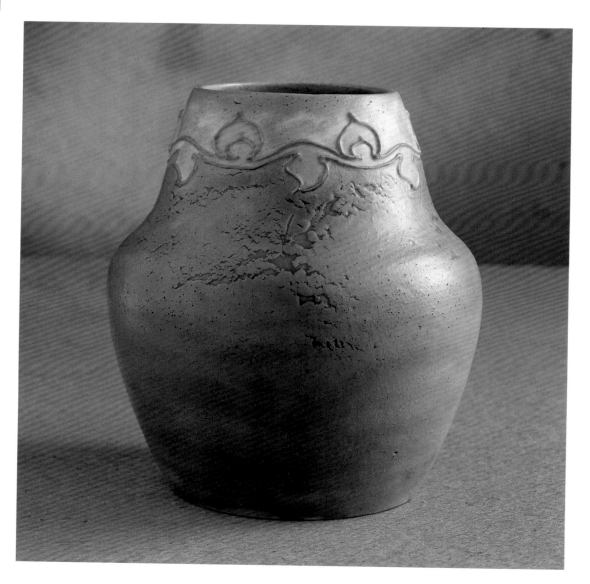

FREDERICK HURTEN RHEAD

England, 1880–1942,

active United States

■ ■

RHEAD POTTERY

1914–17

Santa Barbara

176a–c

Tea Set, 1914–17

Earthenware

Teapot: 2⅞ x 6½ x 4 (diam.) in.
(7.3 x 16.5 x 10.2 cm)

Sugar bowl: 3 x 4½ x 3⅝ (diam.) in.
(7.6 x 11.4 x 9.2 cm)

Creamer: 1¹⁵⁄₁₆ x 3½ x 3 (diam.) in.
(4.9 x 8.9 x 7.6 cm)

Marks: under base of each,
impressed RHEAD POTTERY |
SANTA BARBARA in circular
formation enclosing potter at
wheel next to kiln; on teapot,
impressed 161; on sugar bowl,
impressed 162; on creamer,
impressed 163

M.89.119.14a–d
Art Museum Council Fund

The spout of this set's teapot
was evidently chipped before
the decoration was completed,
but it survived en suite with
its finished mates, providing
graphic evidence of Rhead's
techniques of incising and glaze
inlay.

Following the Arequipa experience, Rhead remained in California, founding his own pottery in 1914 in the wealthy coastal resort of Santa Barbara. "It was my intention to produce architectural details, wall panels, small fountain pieces, lighting fixtures … [and] a series of bowls and ornamental pieces for sale in the craft shops."[81] He followed the familiar labor formula of hiring men to construct vessels and young women to decorate the wares. Rhead prescribed the shapes, glazes, and decoration.[82]

Free to pursue his own artistic interests, something he was unable to do at commercial potteries, Rhead continued the incised decoration he had employed at University City but also began intensive experiments with glazes. His Santa Barbara products varied from the decorative English style of stylized design to the simple oriental union of form and glaze free of applied decoration. Rhead had ready access to oriental art and porcelains through a local dealer, Nathan Bentz, who also sold Rhead's pottery.[83]

Running his own pottery not only gave Rhead artistic license, it also gave him the responsibility of operating a business, something he could not manage, even amidst the carriage trade of Santa Barbara. He lamented: "An indefinite idea in the mind of a wealthy person of questionable taste is not easily executed, especially if that person is prepared to pay neither a deposit nor an adequate remuneration for the finished product."[84] Unable to establish a stable financial footing for the firm, he closed it in 1917 and returned to employment with a commercial pottery.

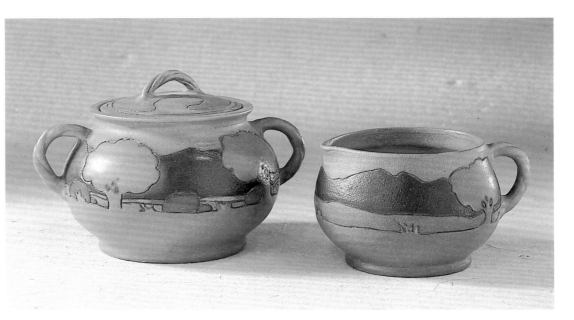

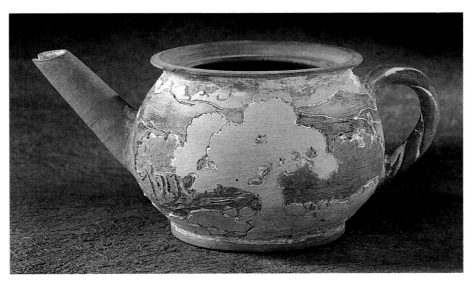

177

Hanging Light Fixture, 1914–17

Earthenware
4⅜ x 15¼ (diam.) in.
(11.1 x 38.7 cm)
M.88.194.8
Decorative Arts Council Fund
in honor of David S. Dvorak

Rhead mentioned lighting fix-
tures among the products of his
pottery. This example was
designed for Edwin and Carolyn
Gledhill, photographers in Santa
Barbara.[85] Around the central,
pierced, floral medallion, six
tree-trunk shapes are crowned
with sprays of foliage. The thick,
blue flambé glaze adds texture to
the abstracted composition.

178

Vase, 1914–17

Earthenware
6 x 4½ (diam.) in.
(15.2 x 11.4 cm)
Marks: under base, impressed
RHEAD POTTERY | SANTA BARBARA
in circular formation enclosing
potter at wheel next to kiln
L.88.31.60
Promised gift of Max Palevsky
and Jodie Evans

The incised and inlaid decora-
tion on this vase shows Rhead's
reliance on stylized English
design, particularly that pro-
moted by Walter Crane in *Line
and Form*, an influential treatise
that Rhead referred to frequently
in his writings.

FREDERICK HURTEN RHEAD

England, 1880–1942,

active United States

. .

AMERICAN ENCAUSTIC TILING COMPANY

1875–c. 1945

Zanesville, Ohio

The dissonance between arts and crafts ideals and economic reality was exemplified by Rhead's move to a commercial ceramics manufacturer, American Encaustic Tiling Company, after the financial failure of his own pottery in Santa Barbara. As research director from 1917 to 1927 he assured for himself an influential role in a large and profitable operation. But such a move was not without compromises, as Rhead noted:

The ceramic craftsman creates and produces only those things which satisfy his creative instinct. This is supposed to be the spirit of the true artist and incidentally it is the spirit and faculty which is most harmful to the creative artist in a large industrial plant. The art engineer or art director in a large ceramic organization may have strong personal preferences, but these must be entirely subordinate to market requirements without in any way affecting the quality of his work as far as technique and faithful artistic interpretation are concerned.[86]

The molded dish (cat. no. 179) is a departure from the traditional hand-decorated wares Rhead made at Roseville, University City, Arequipa, and Rhead Pottery. Molded wares facilitated mass production on a commercial scale, emphasizing design over construction. Tile was the mainstay of the company, but decorative specialties such as this object were a sideline under Rhead's supervision. The style was probably derived or even copied from oriental porcelains in his collection. This piece formerly belonged to Rhead's second wife, Lois Whitcomb Rhead.[87]

179

Bowl, c. 1925

Earthenware
1 ¾ x 5 ⅜ (diam.) in.
(4.4 x 13.7 cm)
Marks: under base, conjoined
AETCO painted in underglaze blue
89.2.1
Purchased with funds provided by Mrs. Logan Henshaw, Caroline Blanchard Brownstein, and Mrs. Edwin Greble

ALEXANDER WILLIAM ROBERTSON

England, 1840–1925,

active United States

Oakland

The Robertson family was associated with a number of important American art potteries from 1865 to 1952. Alexander William Robertson and his brother Hugh Cornwall Robertson (England, 1844–1908, active United States) were the fifth generation in a line of Scotch-English potters. Alexander established the first of the family's workshops in America in Chelsea, Massachusetts, in 1865. Hugh joined him in 1868 to form A. W. and H. C. Robertson. When their father, James, and brother George banded together with them in 1872, the firm was renamed the Chelsea Keramic Art Works (see separate entry). George left in 1878 when one of the company's craftsmen, John G. Low, founded the Low Art Tile Works. James Robertson died in 1880.[88]

Alexander left Massachusetts in 1884 to travel to California and explore the quality of its clays. California's extensive clay deposits contributed to a thriving ceramic industry throughout the first half of the twentieth century. Alexander was among the first ceramists to recognize the potential of California clay. He settled in Oakland and began experimenting with local varieties.

Unlike Hugh, who specialized in glaze experimentation, Alexander preferred throwing and excelled at creating simple, classic forms. His choice of shapes was undoubtedly inspired by Grecian ceramics; the family firm had copied "antique models in the homes of wealthy Bostonians."[89] His work in California is characterized by unglazed bisque surfaces that highlight the refinement and colors of the state's clays (see cat. nos. 180–81). He glazed the interior of the mug (cat. no. 181) as a utilitarian concession necessary with porous earthenware. The green glaze is virtually identical to one used at Chelsea.

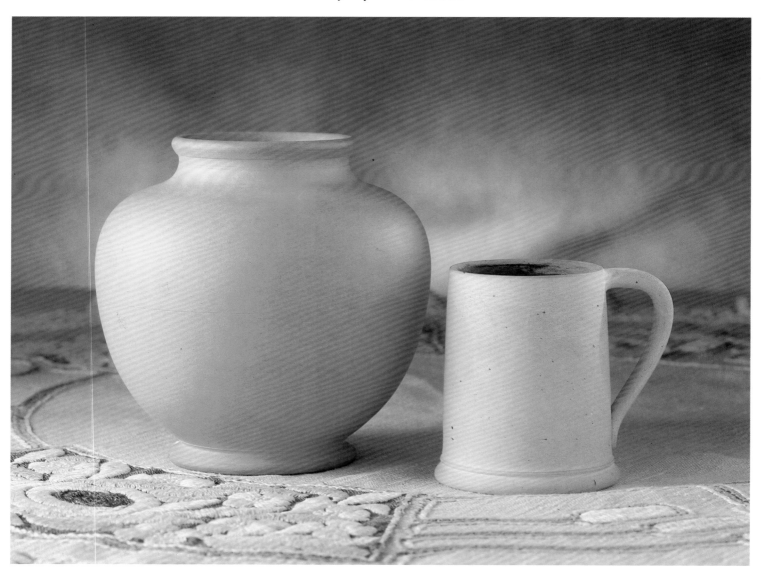

ALEXANDER WILLIAM ROBERTSON

England, 1840–1925, active United States

ROBLIN ART POTTERY

1898–1906

San Francisco

While working alone and experimenting with California clays, Robertson met the state mineralogist's wife, Linna Irelan, because of a treatise she had written on ceramics.[90] With a common interest in promoting the state's clay resources, they founded Roblin Pottery (a name formed from the combination of his last name and her first name).[91] After two false starts the venture finally succeeded in 1898.[92]

Irelan's skills as a decorator complemented Robertson's talents at the wheel. She described their partnership this way: "Mr. Robertson and the writer labored with true love for the cause, working side by side with the steady purpose in view of creating original ware, independent of stereotyped usages and patterns, no moulds, no casting, the numerous varying shapes 'thrown' on the potter's wheel, deftly formed by inspired, skilful hands with wonderful rapidity."[93] Irelan decorated Robertson's "classic ... Grecian forms ... [with] dainty lichens, mushrooms and toadstools ... graceful lizards ... wide-eyed frogs ... [and] fungi."[94]

The subtle, incised and beaded border found on the pitcher (cat. no. 182) is the work of Robertson. Its glaze color is the characteristic green used at Chelsea. The inscription indicates that the pitcher was made at a November 17, 1898, meeting of the Ebell Society, a woman's club dedicated to education, philanthropy, and culture that was founded in Oakland in 1876 by Dr. Adrian Ebell. Indeed the *Oakland Enquirer* of November 18, 1898, recorded that "the Ceramic Section of the Ebell provided a most delightful and instructive entertainment for the club and their guests last evening.... A large potter's wheel ... was ... skillfully manipulated by Mr. A. W. Robertson.... Specimens of beautiful shape were wrought in the presence of the audience and all viewed the work with much enjoyment."[95]

Roblin was destroyed in the 1906 San Francisco earthquake, after which Robertson moved south, eventually becoming associated with the Halcyon Art Pottery.

< 180

Vase, c. 1895

Earthenware
6 x 6⅛ (diam.) in.
(15.2 x 15.6 cm)
Marks: under base, incised script
AWR | OAKLAND | CAL; incised 3
M.89.119.3
Art Museum Council Fund

< 181

Mug, 1897

Earthenware
3¾ x 4⅛ x 3¾ (diam.) in.
(9.5 x 10.5 x 9.5 cm)
Marks: under base, incised SF/97;
incised script AWR; incised SI-
M.89.10.6
Gift of Bryce and Elaine
Bannatyne

182

Pitcher, 1898

Earthenware
3⅛ x 2⅞ x 2⅜ (diam.) in.
(7.9 x 7.3 x 6.0 cm)
Inscriptions: under base, incised
MADE 17TH | NOV | 1898 | EBEL [*sic*]
SOCIETY
Marks: under base, incised script
A. W. R. | OAKL | CAL. | impressed
ROBLIN | incised F. [S.] F.
89.2.20
Purchased with funds provided
by Mrs. Edward A. Wolpin and
Mrs. Leonard Martin

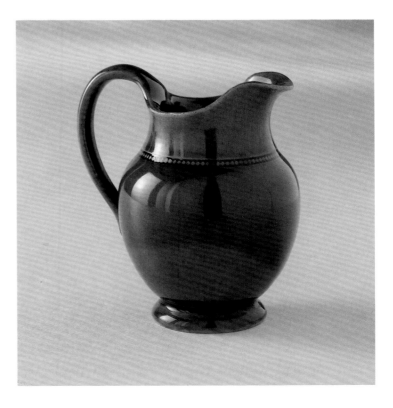

ALEXANDER WILLIAM ROBERTSON

England, 1840–1925,

active United States

∙ ∙

HALCYON ART POTTERY

1910–13

Halcyon, California

183

Vase, 1911

Earthenware

3¼ x 4⅛ (diam.) in.

(8.3 x 10.5 cm)

Marks: under base, impressed HALCYON CAL in triangular formation within two concentric circles; incised 10/21/11; incised script AWR

89.2.15

Purchased with funds provided by Jane Himmelein and the Estate of L. McClain, Jr.

The Halcyon Art Pottery was a commercial venture of the Halcyon Colony, a utopian community founded in California near Pismo Beach in 1903.[96] By 1910, with Robertson as art director, the pottery was producing vases, pitchers, and bowls, as well as a variety of trinkets such as incense burners and whistles.[97] The pieces were left unglazed in order to reveal the quality of the local red clay. Robertson left Halcyon when the community began to founder in 1912; the pottery closed in 1913.

The work shown here (cat. no. 183) bears the typical lizard model that was applied to many of Halcyon's wares. This decorative element was introduced by Robertson and resulted from his partnership with Linna Irelan at Roblin. Although Robertson's own design aesthetic favored unadorned forms, he implemented some of Irelan's methods both at Halcyon and Alberhill. The naturalistic brown and green glazes of this vase are atypical of Halcyon's bisque wares and may indicate a special variation by Robertson, as a similar piece survives in his family.

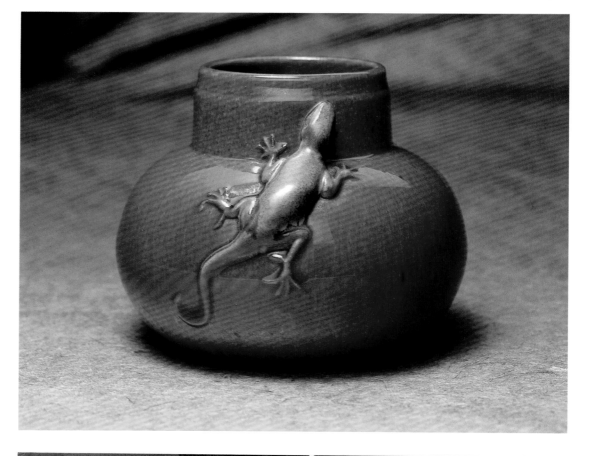

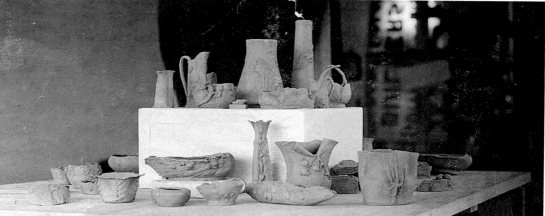

Halcyon wares on display at the community sometime between 1910 and 1913

ALEXANDER WILLIAM ROBERTSON

England, 1840–1925,

active United States

■ ■

ALBERHILL POTTERY

1912–14

Alberhill, California

Alberhill Pottery was the artistic offshoot of a large commercial operation, the Alberhill Coal and Clay Company in Riverside County, California. A major clay supplier with an output of seventy thousand tons a year, Alberhill extracted clays varying in quality from coarse commercial types to refined plastic varieties.[98] In 1912 Alberhill's president, James H. Hill, hired Robertson to promote the quality of the high-grade clays by producing art pottery.[99]

Robertson responded with glazed and unglazed wheel-thrown wares but primarily produced bisque vessels similar to those he had crafted at Roblin and Halcyon. The refined quality of the clays was best appreciated in this unglazed state. Most Alberhill examples are of white, red, or yellow bisque with surfaces that are evocative of the California desert. This is certainly evident in the white vase with the modeled, applied lizard (cat. no. 185). Once again Robertson drew his inspiration from Irelan.

The green mat glaze of the bowl (cat. no. 184) relates to its incised decoration, which is also characteristically regional: water bugs trailing swirling ripples across a pond. Locally inspired subjects must have appealed to the crowds at the county fairs where Robertson displayed his skills and publicized the Alberhill Pottery. His work for Alberhill won a gold medal at the San Diego Exposition of 1915. The pottery venture ended when Robertson retired in 1914.

184

Bowl, 1912–14

Earthenware

3⅜ x 4⅞ (diam.) in.
(8.6 x 12.4 cm)

Marks: under base, impressed
ALBERHILL; impressed A. W. R.

M.89.119.1

Art Museum Council Fund

185

Vase, 1914

Earthenware

4½ x 4¼ (diam.) in.
(11.4 x 10.8 cm)

Marks: under base, impressed
ALBERHILL; incised 1914 | 4/24;
incised CAL; incised script A. W. R.

M.89.119.2

Art Museum Council Fund

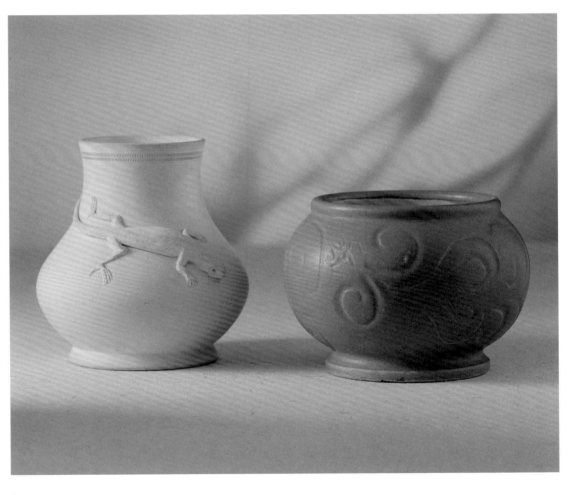

Cat. nos. 185, 184

FRED H. ROBERTSON

United States, 1868–1952

Los Angeles

Fred H. Robertson trained with both Alexander Robertson, his father, and Hugh Robertson, his uncle, at the Chelsea Keramic Art Works. He remained at Chelsea when his father departed for California in 1884, but followed in 1903 to work at Roblin. After its destruction in 1906 Fred took a position as a clay specialist with the Los Angeles Pressed Brick Company, where he developed a line of art pottery (with his own mark) that was capable of being fired at the higher temperatures necessary for commercial brick and tile.[100]

Undoubtedly influenced by his uncle's glaze experiments, Fred focused on developing luster glazes (see cat. no. 186) and crystalline glazes (see cat. no. 187). Fulper's nationally famous Vase-kraft wares also served as inspiration.[101] His works abided by the same oriental philosophy of form and glaze preached by Charles Binns. Robertson's results won a gold medal at the San Diego Exposition in 1915. He continued to produce art ceramics at the Los Angeles Pressed Brick Company until 1921, when he became supervisor of another Los Angeles firm, Claycraft. Fred's son, George, joined Claycraft in 1925. Both father and son left in 1935 when George founded Robertson Pottery in Los Angeles. The last of the family's firms, the Robertson Pottery remained in business until 1952.

Fred Robertson, c. 1920.

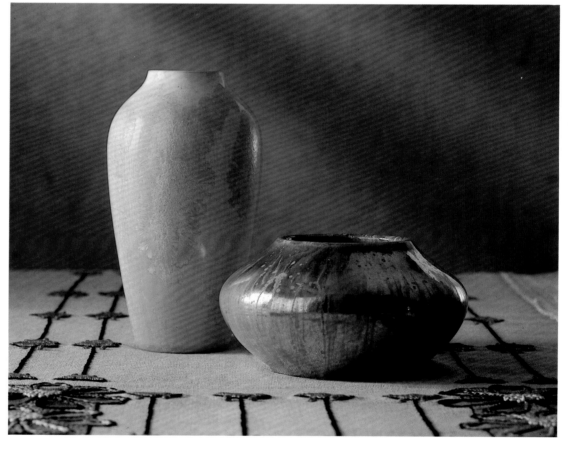

Cat. nos. 187, 186

186

Bowl, c. 1915

Stoneware

3 x 5 ½ (diam.) in.

(7.6 x 14.0 cm)

Marks: under base, impressed

F. H. R. | LOS ANGELES

M.89.119.15

Art Museum Council Fund

187

Vase, c. 1915

Stoneware

6 ¹¹⁄₁₆ x 3 ¾ (diam.) in.

(17.0 x 9.5 cm)

Marks: under base, impressed

[F. H. R. | L]OS ANGEL[ES]

M.90.25.10

Art Museum Council Fund

HUGH CORNWALL
ROBERTSON
England, 1844–1908,
active United States

■ ■

CHELSEA
KERAMIC
ART WORKS
1872–89
Chelsea, Massachusetts

"Boston has a Bernard Palissy. He lives to be sure in Chelsea."[102] Boston's Palissy was Hugh Robertson, who, like his French counterpart, was driven to penury in pursuit of exotic glazes. Inspired by Chinese wares at the Centennial Exhibition in Philadelphia in 1876, Robertson increasingly devoted his energies to replicating "lost" Chinese formulas, in particular the prized *sang de boeuf* (oxblood) glaze seen here (cat. no. 188). He assumed control of the family pottery, Chelsea Keramic Art Works, in 1884, when his brother Alexander moved to California. Commercial production fell as Hugh devoted the pottery's resources to glaze experimentation. By 1888 he had perfected the elusive oxblood glaze, which was described as having a "beauty of color, which is that of fresh arterial blood, possessing a golden lustre, which in the light glistens with all the varying hues of a sunset sky."[103] In deference to his glazes he favored simple shapes, like that of this vase. Caught in the ever present conflict between art and commerce, he bankrupted Chelsea by 1889.

188

Vase, 1884–89

Stoneware
7⅞ x 3⅞ (diam.) in.
(20.0 x 9.8 cm)
Marks: under base, impressed
CKAW in diamond formation
L.88.30.9
Collection of Max Palevsky
and Jodie Evans

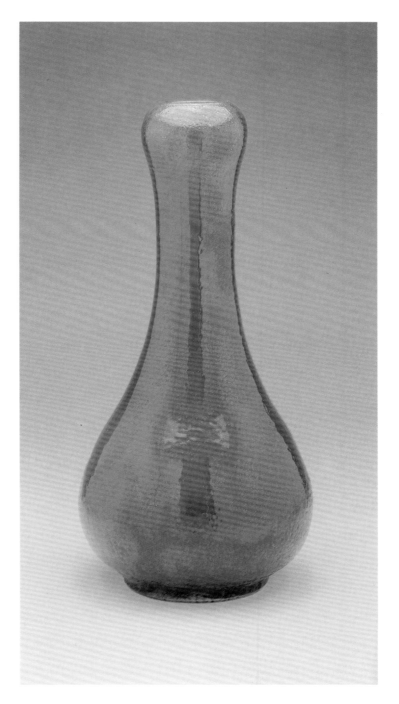

HUGH CORNWALL ROBERTSON

England, 1844–1908, active United States

■ ■

DEDHAM POTTERY

1896–1943

Dedham, Massachusetts

After closing Chelsea Keramic Art Works, Hugh Robertson found financial backing to reopen the pottery in Chelsea in 1891. He moved it to Dedham, Massachusetts, in 1896, renaming it for its new location. As a sideline to Dedham's commercial production of crackle-glazed tablewares, Robertson continued his artistic glaze experiments. His oriental inspiration was referred to in an 1896 brochure: "Mr. *Robertson's* remarkable discoveries … are entirely different from … anything ever produced in our own country,—suggesting rather the masterpieces of *Chinese* and *Japanese* pottery,—and are of a quality that awakens the enthusiasm of all who appreciate beautiful texture, color, and lustre in Ceramic Art."[104]

189

Vase, c. 1900

Stoneware

8½ x 5⅜ (diam.) in.

(21.6 x 13.7 cm)

Marks: under base, incised
DEDHAM | POTTERY | conjoined
HCR

L.89.38.1

Collection of Max Palevsky and Jodie Evans

On this vase Robertson combined additional glazes with his famous red oxblood variety to achieve a melting flambé effect caused by the vicissitudes of the kiln fire.

Cat. nos. 192, 191, 190

190

Vase, c. 1900

Stoneware
7⅛ x 4⅞ (diam.) in.
(18.1 x 12.4 cm)
Marks: under base, incised
DEDHAM | POTTERY; incised BW;
thistle painted in blue; 2[D]
handwritten in black crayon
89.2.10
Purchased with funds provided
by the William Randolph Hearst
Collection

Robertson first achieved the Chinese crackle glaze in his experiments at Chelsea Keramic Art Works. By 1891 he had perfected it for controlled use on commercial tableware, but continued to exploit its artistic possibilities on experimental pieces at Dedham. In contrast with the thin, gray crackle glaze of his standard production, the glaze on this vase is thickly applied and pink in hue.

191

Vase, c. 1900

Stoneware
7⅝ x 7⅞ (diam.) in.
(19.4 x 20.0 cm)
Marks: under base, incised
DEDHAM | POTTERY | conjoined
HCR; DP21D painted in black
89.2.11
Purchased with funds provided
by the Los Angeles County

This vase highlights Robertson's volcanic glazes, which were produced in his experiments at Dedham. The lavalike effect of these blistered and melted coverings resulted in some of the most abstract and expressionist ceramics of the period, comparable with works by the "mad potter of Biloxi," George Ohr.

192

Vase, c. 1900

Stoneware
6¾ x 4 (diam.) in.
(17.1 x 10.2 cm)
Marks: under base, incised script
DEDHAM | POTTERY | conjoined
HCR; incised X; #74 and 74
handwritten in pencil
M.88.194.11
Decorative Arts Council Fund

This vase is another example of Robertson's famous oxblood glaze.

ADELAIDE ALSOP ROBINEAU

United States, 1865–1929

Syracuse

Adelaide Alsop Robineau, c. 1900

193a–b

Doorknobs, c. 1904

Porcelain

Each: 1 x 2⅛ (diam.) in.
(2.5 x 5.4 cm)

Marks: a) on front, excised conjoined AR within a circle; inside knob, incised III–II; b) inside knob, incised AI–10

M.90.25.11–12

Art Museum Council Fund

Robineau built a studio to house her pottery in 1903–4. These doorknobs were produced shortly thereafter as part of her plan to recoup building expenses through the sale of molded utilitarian wares. She evidently abandoned the plan within a year or so.[106]

If one were to select a single ceramist to symbolize the finest achievements of the American art pottery movement, that artist would have to be Adelaide Alsop Robineau.[105] Not an immigrant skilled in European techniques, like Frederick Rhead or Taxile Doat, Robineau created some of the most outstanding works of the period, in the most technically challenging ceramic body, porcelain. Important not only because of her skilled craftsmanship, Robineau embodies the tremendous contributions made by women in the arts and crafts movement, especially in the field of ceramics, and serves as a reminder that individual artists did flourish outside of industry. She was a clear forerunner of the studio pottery movement.

Robineau, like Mary Louise McLaughlin and Maria Longworth Nichols (see Rookwood entry), was a china painter. She had studied watercolor with William Merritt Chase in New York but specialized in painting on porcelain. In 1899 she married fellow porcelain enthusiast, the Paris-born Samuel Edouard Robineau (France, 1856–1936, active United States). They settled in New York and began publishing a journal devoted to the ceramic arts, *Keramic Studio*. The magazine expanded from its china painting emphasis to become the organ of the American art pottery movement, with articles on all aspects of creating and decorating ceramics by such luminaries as Rhead, Doat, and Charles Binns.

Robineau broke free of the limitations concomitant with china decorating, largely due to her husband's translation of articles by Doat, which appeared in *Keramic Studio* in 1903. The French master potter wrote about *grand feu* (high-fire) porcelains, and Robineau resolved to experiment with his formulas for glazes. She enrolled in a course taught by Binns and began creating and firing her own wares. Her efforts were so successful that she was able to exhibit her porcelains at the Louisiana Purchase Exposition in 1904, and by 1905 her work was sold in New York by Tiffany and Company. Samuel assisted his wife as a firing technician. So highly regarded was the team that in 1910 they were invited to join Doat and Rhead on the staff of Edward Lewis's pottery at University City (see Rhead entry for more information on University City). While there she created the famed Scarab Vase, the grand prize winner at the 1910 International Exposition in Turin. She also continued her glaze experiments.

The Robineaus returned to New York and reopened their studio when University City encountered financial difficulties in 1911. At the Panama-Pacific Exposition in San Francisco in 1915 Robineau was again awarded the grand prize. In 1920 she joined the faculty of Syracuse University. She continued to produce extraordinary wares until her death in 1929.

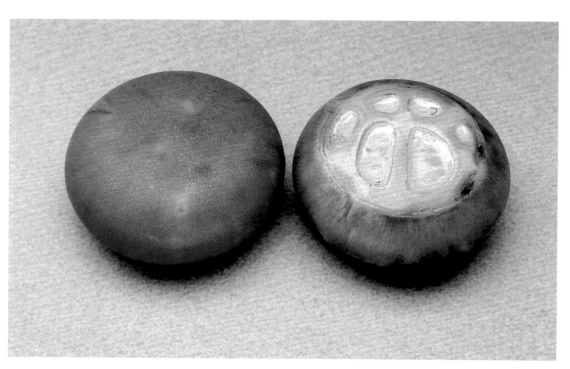

194

Vase, c. 1905–6

Porcelain
6⅛ x 2¼ (diam.) in.
(15.6 x 5.7 cm)
Marks: under base, impressed RP
enclosed within a square
M.88.194.1
Decorative Arts Council Fund

Robineau first achieved a suc-
cessful crystalline glaze in 1904,
and most of her best work in
this vein dates from this period
of early experimentation. Her
impetus was provided by the
writings and formulas of Taxile
Doat. The RP mark on this
piece stands for Robineau Pot-
tery and was used only on wares
that were molded, a technique
soon abandoned by Robineau in
favor of hand-thrown pieces.[107]

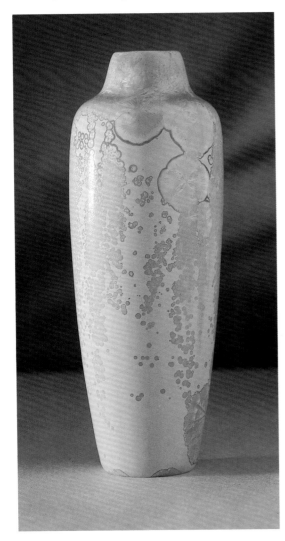

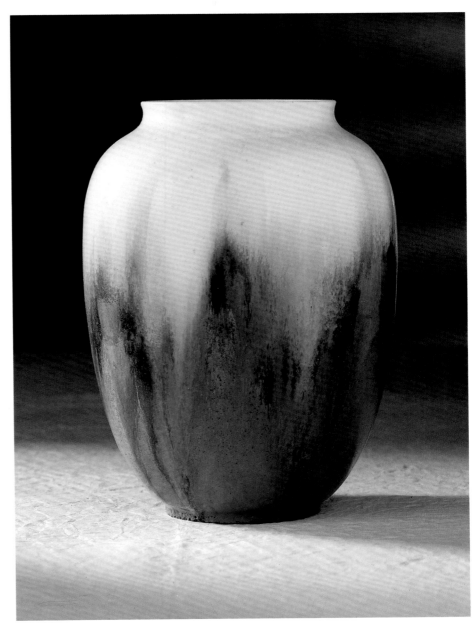

195 ∧

Vase, 1910

Porcelain
6⅝ x 5⅛ (diam.) in.
(16.8 x 13.0 cm)
Marks: under base, incised 22;
excised conjoined AR within a
circle flanked by U C over incised
1910
M.90.25.14
Art Museum Council Fund

While Robineau is best known
for the spectacular carved pieces
she did while at University City,
she also experimented with
glazes, as in this example with
multiple mat and high-gloss
varieties.[108] This vase was a gift
to her colleague and former
student, Kathryn Cherry.[109]

Cat. nos. 198, 196, 199

196

Vase, 1912

Porcelain
3½ x 3 (diam.) in.
(8.9 x 7.6 cm)
Marks: under base, excised
conjoined AR within a circle;
incised 1912
L.88.31.68
Promised gift of Max Palevsky
and Jodie Evans

Robineau regarded oriental por-
celains as the ultimate standard
of perfection and strove to re-
create various "lost" Chinese
glazes, as did fellow potters
like Hugh Robertson. This vase
shows her version of the most
challenging Chinese glaze,
the oxblood.

198

Vase, 1926

Porcelain
6⅝ x 4⅛ (diam.) in.
(16.8 x 10.5 cm)
Marks: under base, excised
conjoined AR within a circle;
incised 1926
M.88.195.1
Art Museum Council Fund

199

Vase, 1927

Porcelain
7¾ x 3⅛ (diam.) in.
(19.7 x 7.9 cm)
Marks: under base, excised
conjoined AR; incised 1927
M.88.194.3
Decorative Arts Council Fund

Robineau frequently employed
glazes as the sole decoration on
simple, elegant forms. These
vases illustrate both a flowing
blue-and-tan flambé glaze (cat.
no. 198) and a lavender crackle
glaze of oriental inspiration
(cat. no. 199).

197

Vase, 1924

Porcelain
4⅜ x 4 (diam.) in.
(11.1 x 10.2 cm)
Marks: under base, excised
conjoined AR within a circle;
incised 8; incised 1924
L.88.31.66
Promised gift of Max Palevsky
and Jodie Evans

Robineau excised the design
on this piece and then inlaid the
glazes. Frederick Rhead also
employed this technique (for
examples see cat. nos. 171–74,
176a–c, 178).

200

Portrait Bust, c. 1920

Earthenware
11⅛ x 5¼ x 4⅞ in.
(28.3 x 13.3 x 12.4 cm)
Marks: on back, impressed
conjoined AR; on side,
impressed [P]R
89.2.19
Purchased with funds provided
by the William Randolph Hearst
Collection

This bust is thought to be a
portrait of one of Robineau's
daughters, Priscilla (United
States, 1902–78). This assump-
tion is based on the similarity of
the likeness to photographs of
Priscilla as well as a barely legi-
ble mark that appears to be an
impressed PR. Peg Weiss recalls
a similar or identical portrait
bust in Elisabeth Robineau's New
York apartment and confirms
that if one had been made for
Elisabeth, one undoubtedly
would have been made for Pris-
cilla as well.[110]

ROOKWOOD POTTERY

1880–1960

Cincinnati

Among the earliest and most influential art potteries in America was the Rookwood Pottery of Cincinnati. Although never formally associated with the firm, Mary Louise McLaughlin (United States, 1847–1939) pioneered the processes that became famous there. An accomplished china painter, she was inspired by ceramics exhibits at the Centennial Exposition in Philadelphia in 1876, the French *barbotine* wares in particular. These wares resulted from the European realist tradition; French potters treated vessels as canvases, painting them with colored slips and achieving an effect not unlike impasto. McLaughlin was fascinated with the results and returned to Cincinnati to experiment with the technique. By 1877 she had developed her own version of slip painting that was more expressive than French wares.[111] Her procedure was successfully adapted to the art pottery industry by fellow china painter Maria Longworth Nichols (United States, 1849–1932). Nichols's father, a wealthy Cincinnati art patron, lent support to his daughter's interests by providing her with the capital to found Rookwood in 1880.

Unlike commercial potteries, which produced art ceramics as a sideline, developing wares able to stand industrial firing temperatures and kilns, Rookwood was founded specifically as an art pottery, with facilities designed for hand construction and decorating. Nichols had also visited the Centennial Exposition and was greatly inspired by the Japanese ceramics. Accordingly the pottery's earliest works were derivative of Japanese design, with asymmetrical compositions of flowers, insects, birds, dragons, and sea creatures. She hired young, locally trained artists to assist her in decorating the pieces.

As the company grew and faced the realities of the business world, pottery forms and designs were numbered and standardized, and labor division was implemented. Subject and style were dictated; mail order catalogues necessitated replications of exact patterns. Rookwood's manager (and later president), William Watts Taylor (United States, 1847–1913), claimed otherwise in language reminiscent of arts and crafts advertising:

Whatever of artistic satisfaction there lies in Rookwood is due first to the individuality of its artists, to their freedom of expression in the ever changing language of an art that never repeats itself, that has in each vase some new message of beauty. Rookwood cannot be understood without an appreciation of its radical difference from commercial industries. Its whole history and development centres upon the one idea of individualism, the entire absence of duplication, and the constant progress towards new forms of artistic expression. Rookwood, therefore, does not say to its artists you must do this thing or that thing in this way or that way.[112]

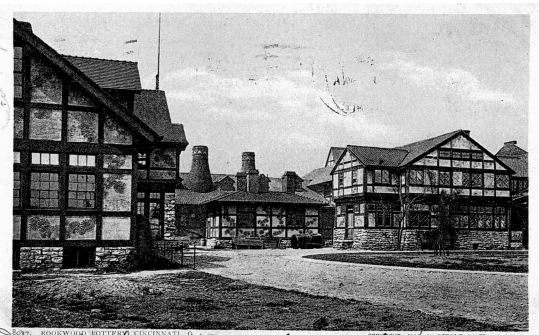

8037. ROOKWOOD POTTERY, CINCINNATI, O. COPYRIGHT, 1904, BY DETROIT PHOTOGRAPHIC CO.

Decorator Albert Robert Valentien (United States, 1862–1925) was closer to the truth when he complained about the strict guidelines and lack of freedom for artists to alter the Rookwood style by introducing their own design ideas.[113] This situation undermined the myth cultivated by the presence of artists' marks on pieces. These supposedly identified craftsmen who shaped their own ideas, but actually they recorded the work of highly skilled technicians who enjoyed artistic license only in interpreting prescribed concepts. This is not to imply that many of Rookwood's decorators were not capable of artistic achievements, only that they were rarely given the opportunity to work as artists, controlling all aspects of a form.

Rookwood's early style resulted from another new technique. In 1884 one of the decorators, Laura Ann Fry (United States, 1857–1943), used an atomizer to apply glaze, permitting smooth transitions in background colors. This brought about Rookwood's most famous line, Standard ware. Characterized by slip-painted subjects on earth-toned backgrounds "air-brushed" from yellows and oranges to dark greens or browns and finished with a honey-colored high-gloss glaze, Standard ware dominated Rookwood's production and defined the company's style from 1886 to about 1910.

By the mid-1890s Rookwood had introduced paler, cooler colors, called Sea Green, Iris (see cat. no. 205), and Aerial Blue. The firm had perfected a mat glaze in the late 1880s, well before William Grueby, but postponed production of it in favor of the successful Standard line. At the Paris Exposition in 1900 Rookwood Standard and Tiger Eye pieces took gold medals. The similar success of Grueby's mat-glazed examples at the same fair probably inspired Rookwood to revive and develop such glazes in various colors. The first pieces were of solid, opaque colors (see cat. no. 206), but at the Louisiana Purchase Exposition in 1904 Rookwood unveiled a technical marvel, a transparent mat glaze that permitted underglaze slip decoration. Called Vellum, the results were moody and atmospheric, particularly well suited to landscape scenes (see cat. nos. 207–8).

Rookwood's commercial success is partially attributable to the pottery's adaptability to changing tastes. As mentioned, when the popularity of the business's acclaimed high-gloss wares was eclipsed by the success of mat-glazed products early in the twentieth century, it altered its line and pioneered new developments. Designs became less naturalistic and increasingly stylized in the second decade of the new century. Rookwood's style had been consistently representational and reliant on underglaze decoration, but by 1920 glazes as decoration were developed (see cat. no. 212) in deference to the success of the oriental form-and-glaze approach popularized by Fulper.

Rookwood weathered the Depression with difficulty, and its production of art wares dwindled in favor of commercially viable, utilitarian lines. Artist-signed wares were not made after 1950.[114]

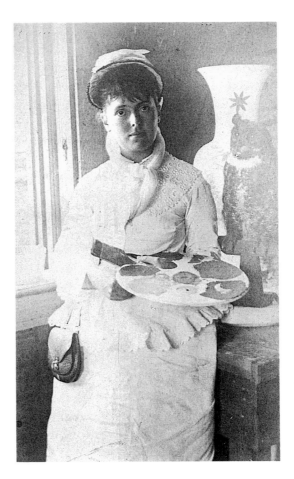

Maria Longworth Nichols, 1880

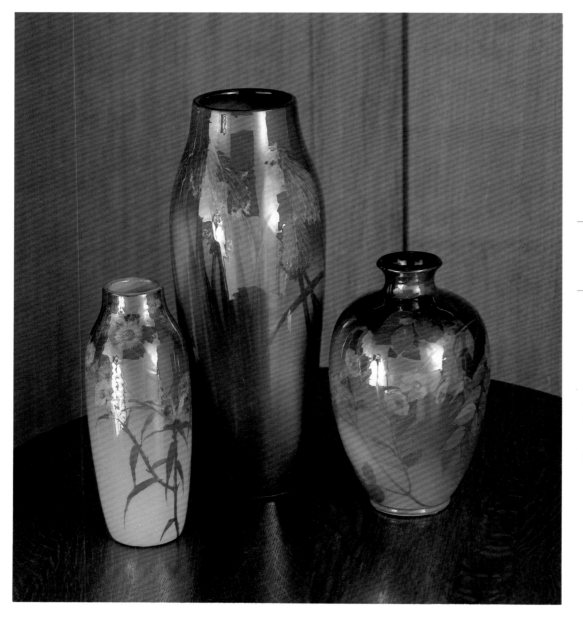

205 >

Vase, 1900

Decorated by Charles (Carl) Schmidt (United States, 1875–1959)
Earthenware
8⅜ x 4 (diam.) in.
(21.3 x 10.2 cm)
Marks: under base, impressed conjoined RP within fourteen flames | 901 | C; incised conjoined CS within a circle; incised W
L.89.38.4
Collection of Max Palevsky and Jodie Evans

Iris ware was described by Albert Valentien as having "delicate pinks, soft blues and greens, creamy whites and yellows [that] play tenderly into the gray scheme." [116] Note the use of a peacock feather as decoration.

Cat. nos. 201–3

201

Vase, 1902

Decorated by Kitaro Shirayamadani (Japan, 1865–1948, active United States)
Earthenware
11⅜ x 4½ (diam.) in.
(28.9 x 11.4 cm)
Marks: under base, impressed conjoined RP within fourteen flames | II | 932C; incised Japanese characters for Kitaro Shirayamadani
L.88.30.24
Collection of Max Palevsky and Jodie Evans

202

Vase, 1902

Decorated by Kitaro Shirayamadani (Japan, 1865–1948, active United States)
Earthenware
18 x 7 (diam.) in.
(45.7 x 17.8 cm)
Marks: under base, impressed conjoined RP within fourteen flames | II | 30A; incised Japanese characters for Kitaro Shirayamadani
L.88.30.26
Promised gift of Max Palevsky and Jodie Evans

203

Vase, 1902

Decorated by Kitaro Shirayamadani (Japan, 1865–1948, active United States)
Earthenware
11½ x 7¹/₁₆ (diam.) in.
(29.2 x 17.9 cm)
Marks: under base, impressed conjoined RP within fourteen flames | II | 787C; incised Japanese characters for Kitaro Shirayamadani
L.88.30.28
Collection of Max Palevsky and Jodie Evans

Typical of Rookwood's Standard wares, these vases (cat. nos. 201–3) depict floral subjects in botanical detail that pay homage to Japanese asymmetry in their arrangements. Enchanted with the Japanese exhibits at the Centennial Exhibition, Nichols toyed with the idea of importing an entire Japanese pottery to Cincinnati. In the end she enlisted the services of a Japanese potter, Kitaro Shirayamadani, who had toured the United States with a "Japanese Village" troupe between 1885 and 1887. [115] Shirayamadani was one of Rookwood's finest decorators, working there from 1887 to 1915 and from 1925 until his death in 1948.

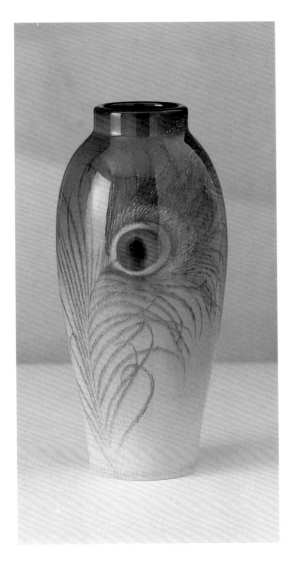

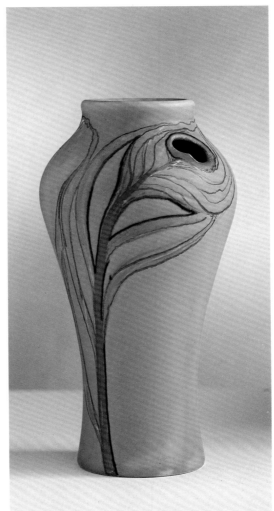

206

Vase, 1901

Decorated by John Dee Wareham (United States, 1871–1954)

Earthenware

11⅛ x 6¼ (diam.) in.

(28.3 x 15.9 cm)

Marks: under base, impressed conjoined RP within fourteen flames | 1 | 909B; incised script J. D. W.

M.88.35.1

Museum Acquisition Fund

Produced within a year of Rookwood's introduction of mat glazes, this vase illustrates the contrasting aesthetics of Rookwood's output. The thick, almost viscous quality of mat glazes dictated an abstracted style with broad painting, a radical change from the detailed, realistic scenes of the high-gloss period. Contrast the more sculptural quality of this peacock feather decoration, especially the pierced eye, with the more representational style of Schmidt's vase (cat. no. 205).

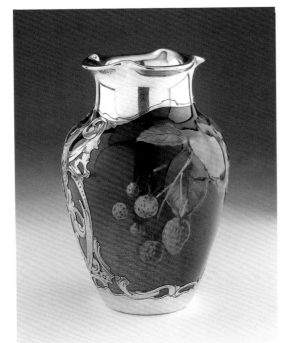

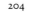

204

Vase, 1892–93

Silver mount by Gorham Manufacturing Company, Providence (1863–present)

Decorated by Kate C. Matchette (United States, 1875–1953)

Earthenware and silver

5⅜ x 3⅝ (diam.) in.

(13.7 x 9.2 cm)

Marks: under base, impressed conjoined RP | 162D | W; incised K. C. M.; on silver foot rim, engraved S 1234 S and impressed GORHAM MFG. CO.

M.85.47

Gift of Mrs. Harold Ullman

Between 1892 and 1900 Rookwood collaborated with the Gorham Manufacturing Company to produce art pottery with silver overlay. Gorham used an electroplating process to selectively deposit the silver, which was subsequently engraved. The results are usually rococo revival in style.

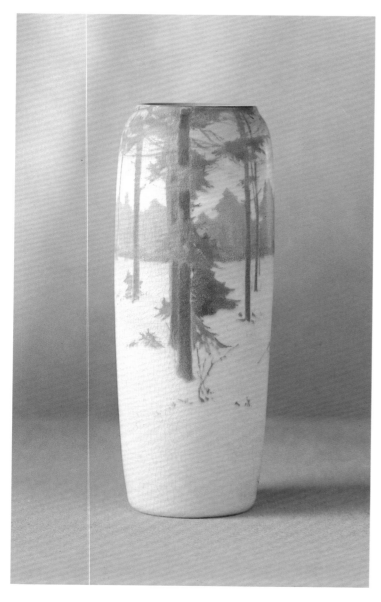

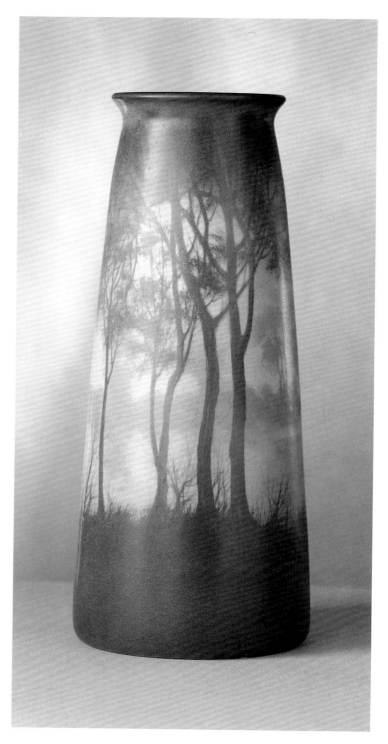

207

Vase, 1905

Decorated by Albert Robert
Valentien (United States,
1862–1925)
Earthenware
10½ x 4⅛ (diam.) in.
(26.7 x 10.5 cm)
Marks: under base, impressed
conjoined RP within fourteen
flames | v | 951C | incised v; incised
A. R. VALENTIEN

L.88.30.25
Collection of Max Palevsky
and Jodie Evans

Snow scenes are rare among
Rookwood's popular Vellum-
glazed landscapes. This vase's
decorator, Albert Valentien, was
the first hired by Nichols in 1881,
one year after the founding of
the pottery. He distinguished
himself as one of the company's
most eminent artists.

208

Vase, 1909

Decorated by Edward
Timothy Hurley (United States,
1869–1950)
Earthenware
16⅛ x 7 (diam.) in.
(41.0 x 17.8 cm)
Marks: under base, impressed
conjoined RP within fourteen
flames | IX | 1660A | v; incised
E. T. H.

M.89.151.18
Gift of Max Palevsky
and Jodie Evans

The mystical quality of this
moonlit landscape is a tribute to
the artist, Edward Timothy
Hurley, who joined Rookwood in
1896. He photographed country
landscapes at all hours for por-
trayal on his vases.[117]

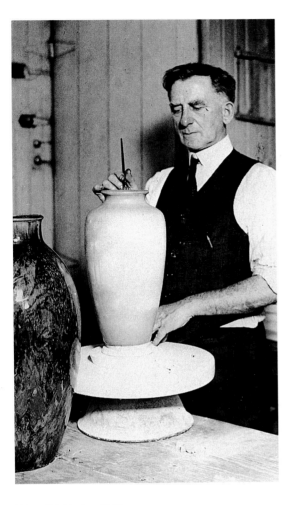

Edward T. Hurley, 1930

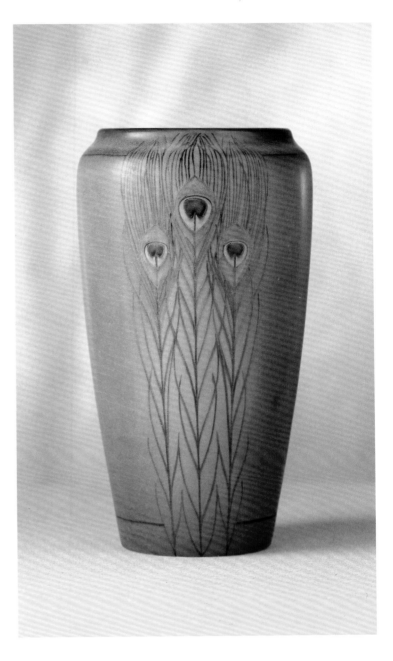

209

Vase, 1916

Decorated by Sarah Sax
(United States, 1870–1949)
Earthenware
11½ x 6½ (diam.) in.
(29.2 x 16.5 cm)
Marks: under base, impressed
conjoined RP within fourteen
flames | XVI | 1369C | V; incised V;
incised conjoined SX
L.89.38.3
Collection of Max Palevsky
and Jodie Evans

This vase, decorated by Sarah
Sax, presents a third variation
on the peacock feather motif
as interpreted by Rookwood's
artists. In contrast with Carl
Schmidt's realistic, yet lyrical
art nouveau interpretation (cat.
no. 205) and John Wareham's
sculptural version (cat. no. 206),
Sax's work displays feathers that
are rigid and stylized in a man-
ner akin to that of contemporary
German and Austrian poster
illustrations.[118]

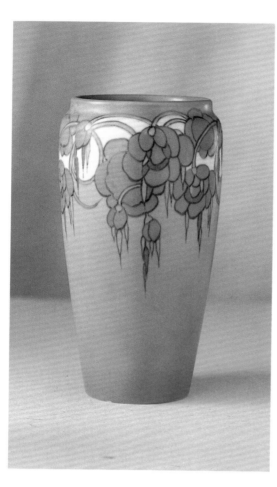

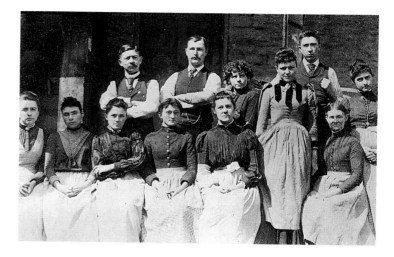

Rookwood decorators, c. 1890

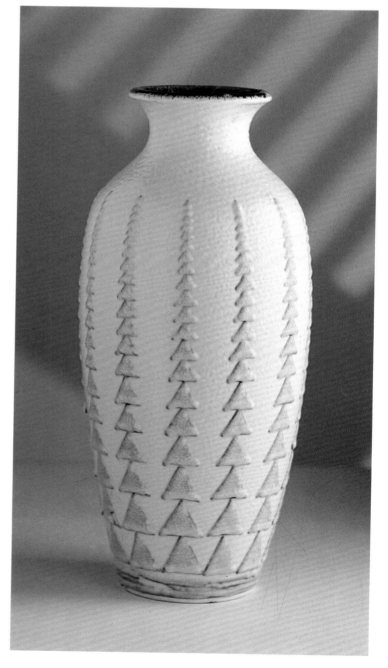

210

Vase, 1930

Decorated by Lenore Asbury
(United States, 1866–1933)
Earthenware
11⅜ x 6⅜ (diam.) in.
(28.9 x 16.2 cm)
Marks: under base, impressed
crowned conjoined RP within
fourteen flames | xxx | 1369C;
incised v; incised L. A.
L.88.30.20
Collection of Max Palevsky
and Jodie Evans

An example of stylized deco-
ration with a Vellum glaze,
this vase reflects Rookwood's
increasingly abstracted designs
of the 1920s and 1930s. The artist,
Lenore Asbury, was a mainstay
at the firm, working there from
1894 to 1931. The crown impressed
over the Rookwood symbol was
the fiftieth anniversary mark
used in 1930.

211 >

Vase, 1928

Decorated by William Ernst
Hentschel (United States,
1892–1962)
Earthenware
16 x 7½ (diam.) in.
(40.6 x 19.1 cm)
Marks: under base, impressed
conjoined RP within fourteen
flames | xxviii | 2984; incised con-
joined WEH
L.88.30.21
Collection of Max Palevsky
and Jodie Evans

This geometric, art deco vase
is a superb, early example of
Rookwood's innovative "butter-
fat" glaze, so called because
of its creamy color and thick,
curdlike texture. The darker,
applied, red earthenware tri-
angles show through the translu-
cent covering. Rookwood pro-
duced the glaze from about 1928
to 1932.[119]

212

Vase, 1920

Decorated by Sara Alice (Sallie) Toohey (United States, 1872–1941) and unknown artist, H. I.
Porcelain
18⅜ x 6⅜ (diam.) in.
(46.7 x 16.2 cm)
Marks: under base, impressed conjoined RP within fourteen flames | xx | 2499A; ST painted in black (smeared); HI painted in black
L.89.38.5
Collection of Max Palevsky and Jodie Evans

Glazes as decoration suited to form became increasingly important at Rookwood by the 1920s, perhaps in response to the success of competitors like Fulper. This spectacular example is signed by the head of the glazing department, Sallie Toohey, and an unidentified glazer, H. I. They must have praised the fire for dramatizing the flambé and crystalline qualities to such advantage.[120]

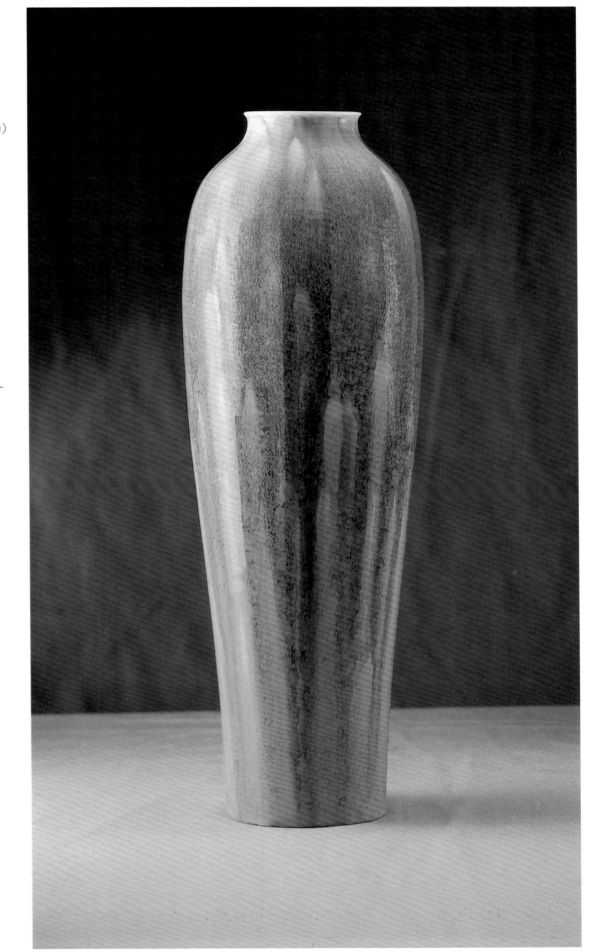

TECO
(GATES POTTERIES)

c. 1885–1941

Terra Cotta, Illinois

Teco was the art ceramics line of Gates Potteries, a subsidiary of American Terra Cotta and Ceramic Company. The parent firm, founded by William Day Gates (United States, 1852–1935) in 1881 as the Spring Valley Tile Works, produced architectural terra-cotta; the art pottery, established about 1885, at first made plain vases and garden ornaments. Gates initiated art ceramics experiments late in the 1880s and introduced the Teco line in 1900.[121] He aimed "to produce an art pottery having originality and true artistic merit, at a comparatively slight cost, and thus make it possible for every lover of art pottery to number among his treasures one or more pieces of this exquisite ware."[122] Indeed his pieces are among the most original designs of the period, and their molded forms kept them quite affordable.

The colors and styles of Teco ware were distinctive. Although produced in a range of tones, the most successful was a soft, sea-colored mat glaze with a smooth texture. "Teco green" capitalized on the popularity of both the newly developed mat glazes and the period craze for the hue.[123] A 1906 Gates Potteries catalogue stated: " 'Teco Green' is impossible to describe, and very difficult to depict in prints. It is a cool, healthful, restful tone, unnamed by colorists except as above; spiritual in a sense, yet sturdy in its distinctiveness. It is a happy and fortunate color to live with." [124] Teco forms were more stylized and geometric than competitor's wares, at times architectonic and monumental. Gates was, after all, a prairie school pottery; designs for many of the objects were supplied by local Chicago architects, Frank Lloyd Wright among them.

Gates Potteries mold shop, c. 1905

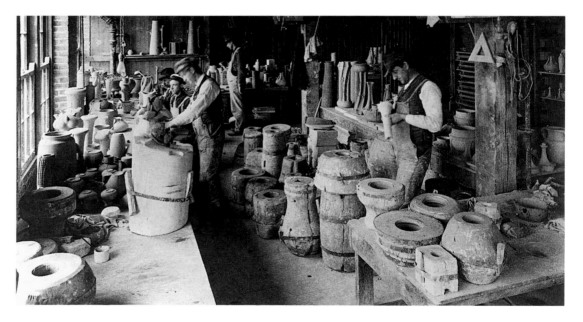

213 >

Vase, c. 1900

Designed by William Day Gates
(United States, 1852–1935)
Earthenware
6⅝ x 3⅜ (diam.) in.
(16.8 x 8.6 cm)
Marks: under base, impressed twice, vertical TECO; incised 347.
89.2.2
Purchased with funds provided by the William Randolph Hearst Collection

This small polychrome vase is a rare and atypical example of Teco ware. The addition of contrasting decorative glazes departed from the firm's monochrome glaze procedure, which served to keep prices low. The texture is also unusual for Teco; the glaze is thicker and separates from the body in areas, like a Grueby glaze. The 1906 trade catalogue illustrates the form as a Gates design (number 347, "Beauty in severity"); it was available for three dollars but without the special glaze treatment.[125] The work might have been a special production piece or quite possibly was made in the period of glaze experimentation in 1899–1900.

214

Vase, c. 1905

Designed by William James
Dodd (United States, 1862–1930)
Earthenware
11¾ x 4⅝ (diam.) in.
(29.8 x 11.7 cm)
Marks: under base, impressed
twice, vertical TECO; impressed 85
L.89.38.6
Collection of Max Palevsky
and Jodie Evans

This vase was designed by archi-
tect William James Dodd, who
joined the company in 1902.
It achieves a dramatic tension
between architectonic rigidity
and organic movement. Note
how the tightly compressed
leaves resemble buttresses.
Pictured as number eighty-five
("Detached leaves") in the 1906
catalogue, the vase originally
sold for seven dollars.[126]

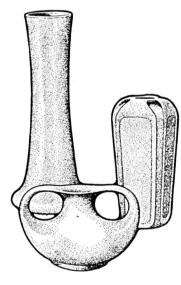

Vases from a Teco advertisement,
1905

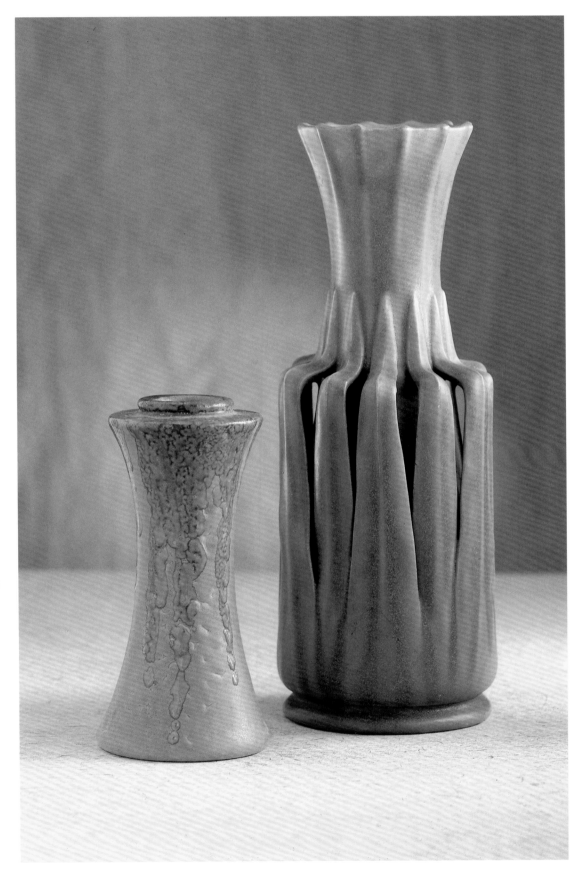

Cat. nos. 213–14

Van Briggle Pottery

1902–present

Colorado Springs, Colorado

Cat. nos. 217, 216, 215

Artus Van Briggle (United States, 1869–1904) was one of Rookwood's most talented decorators. Indeed the firm sent him to study in Paris for three years, beginning in 1893. He returned to Cincinnati inspired by the sculptural, art nouveau forms he had seen in France. He developed mat glazes for the pottery and began to experiment with molded vessels until tuberculosis forced him to leave Ohio and settle in Colorado.[127]

He resumed ceramics experiments in Colorado Springs and founded the Van Briggle Pottery Company in 1902. He implemented the formula already successfully employed at Gates Potteries, molding designs and using glazes to enhance forms. (Grueby followed much the same approach, except its forms were not molded.) Artus designed many of the early pieces, but his

wife, Anne Gregory Van Briggle (United States, 1868–1929), and other designers also contributed patterns.

Van Briggle's admiration of art nouveau is evident in his designs. Attentive to the call that ornament should be integral to form, he sculpted decorations that appear to emerge from the vessels themselves (see cat. nos. 215–17). The works, with their sleek, semimat glazes, are more sinuous than Teco, more stylized and elegant than Grueby, and less literal than Tiffany.[128]

Van Briggle died of tuberculosis only two years after establishing his pottery, while his award-winning display at the Louisiana Purchase Exposition was still on view. Anne Gregory Van Briggle continued to operate the firm until about 1912, when it was sold.[129]

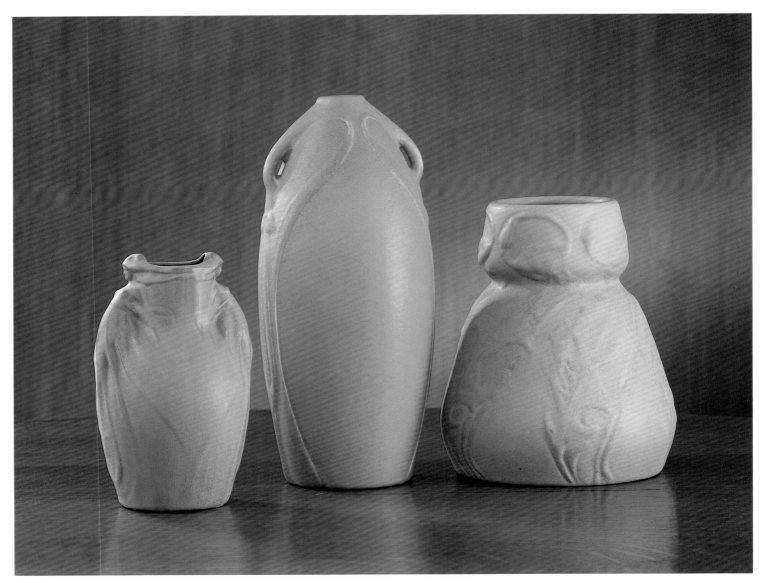

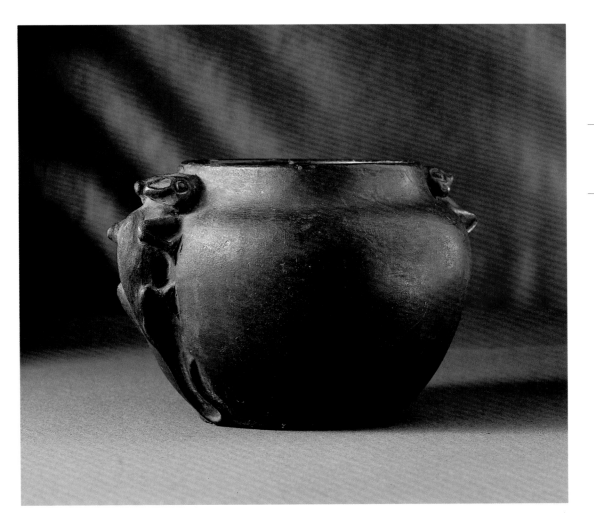

218

Bowl, 1908

Earthenware and copper
5 x 8¼ x 6¾ (diam.) in.
(12.7 x 21.0 x 17.1 cm)
Marks: under base, incised
conjoined AA within a rectangle
flanked by 11 and 13 | VAN
BRIGGLE | COLO. SPGS. | 702. | S. W.
M.89.151.30
Gift of Max Palevsky
and Jodie Evans

Metal-clad Van Briggle pieces
are extremely rare and were
probably the work of an itinerant
electroplater.[133] They were never
produced in commercial quan-
tities, although at least one other
vase like this one has appeared
in the marketplace. Designed
after Van Briggle's death in 1904,
this object is not art nouveau in
style. Its lizard handles relate it
to vases by other Western art
potteries such as Redlands, Hal-
cyon, and Alberhill (see cat. nos.
167–70, 183–85).

215

Vase, 1903

Designed by Artus Van Briggle
(United States, 1869–1904)
Earthenware
8¾ x 7⅝ (diam.) in.
(22.2 x 19.4 cm)
Marks: under base, incised con-
joined AA within a rectangle | VAN
BRIGGLE | 1903 | indecipherable
Roman numeral
M.84.118.2
Gift of the Jordan-Volpe Gallery,
New York, New York

This piece is recorded as number
137 ("Flowers and leaves") in a
catalogue of Van Briggle designs.[130]

216

Vase, 1904

Designed by Artus Van Briggle
(United States, 1869–1904)
Earthenware
12⅛ x 5⅝ (diam.) in.
(30.8 x 14.3 cm)
Marks: under base, incised con-
joined AA within a rectangle;
impressed shape number 172;
impressed 1904; incised v
L.88.30.31
Collection of Max Palevsky
and Jodie Evans

This spiderwort design is an
eloquent and sinuous example of
decoration integral to form.[131]

217

Vase, 1907

Designed by Artus Van Briggle
(United States, 1869–1904)
Earthenware
7⅝ x 4⅞ x 4½ in.
(19.4 x 12.4 x 11.4 cm)
Marks: under base, incised
conjoined AA within a rectangle
flanked by 5 and [8] | VAN
BRIGGLE | COLO. SPRINGS | 1907
TR.9498.1
Collection of Max Palevsky
and Jodie Evans

One of Van Briggle's earliest
designs, this vase was named
Dos Cabezas (two heads)
by employees of the pottery.
Models with human figures are
rare in Van Briggle's oeuvre,
probably because Americans
preferred tamer art nouveau dec-
orations such as flowers. Only
five figural styles were designed
by Van Briggle.[132]

WALRATH POTTERY

1908–18

Rochester, New York

Frederick E. Walrath (United States, 1871–1921) was another student of Charles Binns. Indeed his speckled glazes and subdued style are similar to those of another Binns protégé, Arthur Baggs of Marblehead Pottery. In 1908 Walrath assumed a teaching position in the art department of the Mechanics Institute in Rochester, New York, where he was free to use the equipment of the school's pottery. He was not a commercial ceramist and evidently produced each piece from start to finish. His decorative style was restrained and stylized, although less repetitive and geometric than that of Marblehead. Walrath won a bronze medal at the Louisiana Purchase Exposition in 1904.[134]

The vase shown here (cat. no. 219) is characteristically subdued, with subtle color contrasts and naturalistic renderings. A 1912 *Craftsman* article stated: "It is impossible to show Mr. Walrath's pottery to the best advantage in reproduction, as the designs and the colors used are so subtle that they escape the camera and the engraver's tools."[135] The article went on to praise the pottery's affordability: "The price … [places] it within the means of the busy, intelligent working people of this country. There is no reason in the world why those who care for such things should not have many household details for which this pottery is suited, made beautiful in place of the types of things which are usually considered necessarily ugly and to be purchased only from the stores handling machine products."[136]

219

Vase, 1908–18

Earthenware
6⅛ x 4 (diam.) in.
(15.6 x 10.2 cm)
Marks: under base, incised
WALRATH | POTTERY in slight circular formation enclosing conjoined M. I.
TR.9349.29
Promised gift of Max Palevsky and Jodie Evans

Frederick Walrath, c. 1910

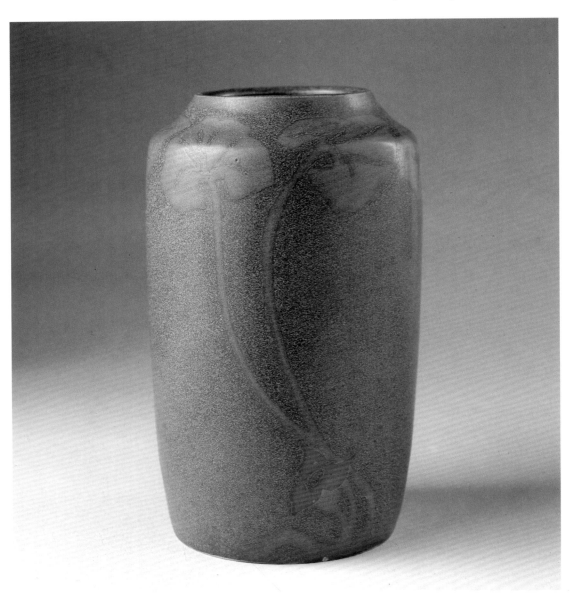

ZARK
(OZARK POTTERY)

c. 1906–c. 1910

St. Louis

220

Vase, c. 1910

Stoneware

5¾ x 6 (diam.) in.

(14.6 x 15.2 cm)

Marks: under base, impressed ZARK; incised 3

89.2.22

Purchased with funds provided by the Los Angeles County

Zark art pottery was produced by the Ozark Pottery of St. Louis from about 1906 to about 1910. Organized by Robert Porter Bringhurst (United States, 1855–1925), Clarence H. Howard, and Arthur T. Morey, Ozark was probably under the artistic direction of Bringhurst, who had achieved a reputation as a sculptor. While most surviving examples are earthenware, this high-fired stoneware vase with a crystalline glaze suggests the influence of Taxile Doat's exhibits at the 1904 Louisiana Purchase Exposition in St. Louis or possibly direct contact with University City when it opened in 1910.[137]

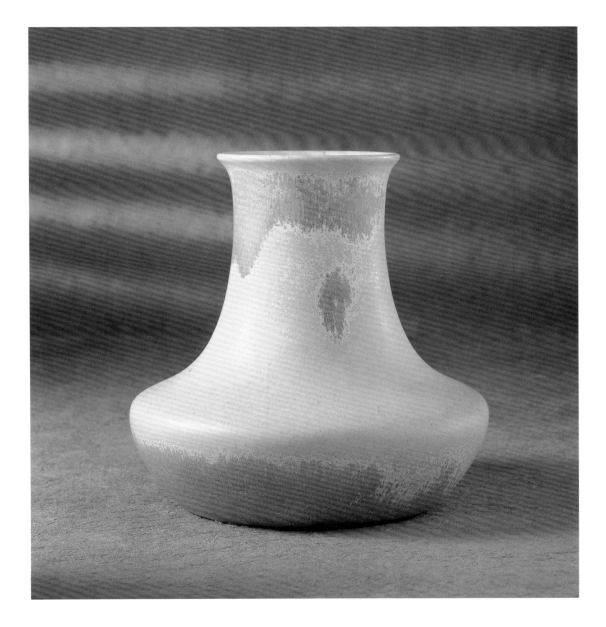

NOTES

1. House Beautiful 1899b, pp. 156–57.

2. Batchelder 1909, p. 68.

3. The museum is grateful to Ron Roell for his generous assistance in the acquisition of some of these pieces.

4. Batchelder 1927a, p. 302. Note that this catalogue was published by the Batchelder-Wilson Company. Batchelder's firm went by different names, here due to a partnership with Lucian H. Wilson (United States, 1888–1982).

5. Batchelder 1923, p. 30.

6. Batchelder 1927a, p. 307.

7. Batchelder 1923, p. 3.

8. Batchelder 1927b, p. 420.

9. The Rookwood Pottery in Cincinnati pioneered the use of the French style on a commercial basis and was widely copied by many other American potteries.

10. For more information on Bennett see Kaplan 1987, pp. 68–69, cat. no. 8; Frelinghuysen 1986a, pp. 217–19; and Voorsanger 1986, pp. 402–3.

11. Binns 1903, p. 372.

12. For more information on Bragdon and California Faience see Evans 1987, pp. 40–42.

13. Todd 1921, p. 149.

14. As quoted in Keen 1978, p. 67.

15. The Fulper entries are not organized chronologically, but by form, and within form groupings, by glaze.

16. The author is grateful to Ulysses Dietz for his assistance with the Fulper entries, particularly in identifying glazes.

17. The advertisement is reproduced in Blasberg 1979, p. 65, fig. 57.

18. Kaplan 1987, pp. 262–63, cat. no. 124.

19. For a similar example see Blasberg 1979, p. 30, pl. 9.

20. Teco 1906, unpaginated ("Vase or lamp base," no. 119). For another illustration of the Teco vase see Christie's 1989, lot 120.

21. Evans, Paul. Telephone conversation with author, 28 December 1989. See also Evans 1987, p. 404, and Washington University 1880, p. 136.

22. Los Angeles 1913, p. 327.

23. Brauckman 1913.

24. Bray 1978, p. 17, and Museum of History 1916, p. 12.

25. Evans 1987, p. 116.

26. Grand Feu n.d., p. [2]. The author is grateful to Paul Evans for supplying a copy of this document and for his generous assistance with the Grand Feu research.

27. Ibid., p. [1].

28. Two Sun Rays examples in the Smithsonian's collection (National Museum of American History [NMAH], cat. nos. 279,769 and 279,770) are incised with the number 1730, as is this volume's cat. no. 133 (preceded by the number 10). Another Sun Rays piece, in the permanent collection of the Los Angeles County Museum of Art (not included in this catalogue), is also numbered 1730. Seventy-one is incised on both cat. no. 136 as well as on a Mission piece owned by the Smithsonian (NMAH, cat. no. 279,768).

29. See Blasberg 1981 for more information on Grueby.

30. Grueby 1904, p. [2].

31. Ibid., p. [3].

32. See Clark 1972, p. 137, cat. no. 185, and Blasberg 1981, p. 6, fig. 3, for examples with handles.

33. Keramic Studio 1905, p. 217.

34. Grueby 1904, pp. [3–4].

35. Volpe and Cathers 1988, p. 157.

36. Marblehead 1919, p. [2].

37. See Evans 1987, pp. 157–60, for more information on Marblehead.

38. Marblehead 1919, p. [3].

39. Ibid., pp. [15, 17].

40. Ibid., p. [4].

41. Ibid., p. [18].

42. Lillian Gray Jarvie, *Sketch Book*, as quoted in Markham n.d., p. [5].

43. Evans 1987, p. 163.

44. As quoted in Poesch 1984, p. 18. See this source for more information on Newcomb.

45. Ibid. See p. 26 for information on Dow.

46. Poesch 1984, pp. 26–28.

47. Dietz 1984, pp. 82–83, cat. no. 174.

48. Poesch 1984, p. 135, cat. no. 151.

49. As quoted in Blasberg 1971, p. 251.

50. Selby Noel Mayfield, *Times-Picayune*, as quoted in Poesch 1984, p. 66.

51. Poesch 1984, pp. 66–67. For a discussion of tonalism see Corn 1972.

52. As quoted in Blasberg 1971, pp. 250–51.

53. For more information see Evans 1987, pp. 195, 373, and Darling 1979, pp. 70–72, 168–69.

54. W. A. King, as quoted in Evans 1987, p. 28.

55. For dating of Ohr marks and the latest information on this potter see Clark, Ellison, and Hecht 1989.

56. For more information on the Overbecks and their pottery see Evans 1987, pp. 203–5, and Postle 1978.

57. Tribune 1914, p. 3.

58. General Federation 1914, pp. 15–16.

59. Ibid. For a listing of Overbeck sketches published in *Keramic Studio*, see Postle 1978, pp. 97–100. The two from the sketchbook that were published appear in Keramic Studio 1904 and Keramic Studio 1910b (cat. no. 163a). A third sketch of a claret pitcher bears the same design as a published drawing of a stein in Keramic Studio 1910a.

60. For more information see Kaplan 1987, pp. 312–13, cat. no. 164, and Evans 1987, pp. 213–16.

61. For a similar example see Kaplan 1987, p. 33, cat. no. 164.

62. Redlands n.d., pp. [2–4].

63. Ibid., p. [4].

64. Evans 1987, p. 383.

65. Redlands n.d., p. [3] (tile), and Evans 1980, p. 38 (San Francisco sales). The author is grateful to Paul Evans for supplying a photocopy of p. 19 from the 1905 catalogue of the Paul Elder Company of San Francisco, from which Trippett's wares were sold.

66. Redlands n.d., p. [10].

67. 1905 Paul Elder catalogue, p. 19. See note 65.

68. Redlands n.d., p. [9].

69. Rhead had been associated with Vance/Avon Faience and Weller Pottery. For a thorough survey of his career at American potteries see Dale 1986.

70. Rhead 1917a, p. 57.

71. Rhead 1909b, p. 180.

72. The name of the "new ware was . . . formed from the firm name and the Zanesville location where it was produced." Evans 1987, p. 264.

73. Clark 1972, p. 156, cat. no. 229.

74. Dale 1986, p. 64, fig. 72; p. 74, color pl. 7.

75. See Kaplan 1987, pp. 38, 328–29, cat. no. 183; Dale 1986, pp. 66–67, fig. 74; and Volpe and Cathers 1988, pp. 116–17, cat. no. 75, for more information regarding this vase. The author is grateful to Bert Denker for his assistance in determining the marks on this piece.

76. Downey 1985, p. 49.

77. For a discussion of the social therapy aspects of the arts and crafts movement see Kaplan 1987, pp. 307–14, cat. nos. 159–65.

78. Rhead 1911, p. [2].

79. Rhead 1909a, p. 137.

80. Crane 1908, pp. 44–45.

81. Rhead 1917c, p. 95. This article from *The Potter* was part of a series written by "A Studio Potter," presumably Rhead, the editor of the journal. The article was illustrated by Rhead's soon-to-be wife, Lois De H. Whitcomb, an artist at the pottery.

82. See Dale 1986, pp. 93–107, for more information on the Rhead Pottery.

83. Ibid., p. 93, and Potter 1916, p. IV.

84. Rhead 1917b, p. 60. See note 81. Here the potter refers to his "studio in California," adding more evidence that the author of the series was Rhead.

85. Dale 1986, p. 103.

86. As quoted in Dale 1986, pp. 112, 115.

87. Dale 1986, p. 110, fig. 108.

88. Biographical information regarding the Robertson family was drawn from Evans 1987.

89. Hawes 1968, p. 16.

90. See Evans 1987, p. 250, and Irelan 1890.

91. Evans 1987, p. 250.

92. Indeed the mug (cat. no. 181) might be an early Roblin example.

93. Irelan n.d., pp. 2–3.

94. Keramic Studio 1902, p. 190.

95. Enquirer 1898, p. 1. The author is grateful to Bill Sturm for his research assistance and for providing a copy of the article.

96. Evans 1987, p. 124.

97. Ibid., p. 125.

98. Sill and Sill 1922, pp. 461–62.

99. Evans 1987, pp. 9–10.

100. Bray 1978, p. 16.

101. Fulper advertised nationally, and its products were available in Los Angeles. Indeed Fred produced a lamp design nearly identical to examples marketed by Fulper. See Evans 1987, p. 239.

102. Newspaper article from c. 1893 in the collection of the Robertson family.

103. Edwin AtLee Barber, *The Pottery and Porcelain of the United States*, as quoted in Kaplan 1987, p. 148, cat. no. 31a and b.

104. Dedham 1896, p. [2].

105. See Weiss 1981 for a thorough look at Robineau and her work.

106. Ibid., pp. 18–19.

107. Frelinghuysen 1989, p. 277, cat. no. 109.

108. For examples of Robineau's incised pieces see Weiss 1981, p. 41, pl. 47; p. 103, pl. 112.

109. Frelinghuysen 1989, pp. 284–85, cat. no. 113.

110. Weiss, Peg. Interview with author, 12 December 1989. For a period photograph of Priscilla Robineau see Weiss 1981, p. 29, fig. 33.

111. McLaughlin used colored slips on unfired bodies, while the French used glazes made from fritted clay (colored and fired clay that is ground and then added to glaze) on their bisque-fired wares. See Kaplan 1987, pp. 249–50, n. 3.

112. Taylor 1910, pp. 213–14.

113. Trapp 1980, p. 28.

114. The Rookwood entries are organized chronologically by glaze type and decorative treatment. For example, Standard glazes were introduced in the late 1880s; the silver overlay process in the 1890s. Thus the silver overlay piece (cat. no. 204), although dated earlier, follows the group of Standard wares (cat. nos. 201–3), despite their later dates. Within glaze groupings, entries are ordered by object dates.

115. Trapp 1981, pp. 64–66. This article provides a thorough study of the Japanese influence at Rookwood.

116. As quoted in Trapp 1980, p. 30.

117. Trapp, Kenneth, and Anita Ellis. Interview with author, 17 June 1988. Kenneth Trapp relates Hurley's style to tonalism in contemporary painting and photography. See Trapp 1980, p. 36.

118. Trapp, Kenneth. Interview with author, October 1987, and telephone conversation with author, 29 December 1989.

119. Ellis, Anita. Telephone conversation with author, 9 November 1989.

120. The author is grateful to Kenneth Trapp and Anita Ellis for their assistance with all of the Rookwood entries.

121. Teco's name was formed from the first two letters of "terra" and "cotta." For more information on Gates and his companies see Darling 1989; Darling 1979, pp. 54–70, 169–70; and Evans 1987, pp. 278–81.

122. *Teco Art Pottery*, as quoted in Kaplan 1987, p. 260, cat. no. 121.

123. See Stradling 1983 for an analysis of the green phenomenon.

124. Teco 1906, unpaginated. The author is grateful to John Vanco for providing a copy of this catalogue. The original is in the collection of the Erie Art Museum.

125. Ibid.

126. Ibid. The author is grateful to Sharon Darling and John Vanco for their assistance with the Teco entries.

127. Kaplan 1987, p. 154, cat. no. 40.

128. For illustrations of Tiffany pottery see Kaplan 1987, p. 153, cat. no. 39, and Eidelberg 1987, pp. 80–81, cat. nos. 141–44.

129. The most complete survey of Van Briggle pottery is Nelson 1986.

130. Nelson 1986, p. 148.

131. Ibid., p. 150, no. 172.

132. Arnest 1975, p. 12.

133. Ibid., p. 25, color pl. 1, no. 4.

134. For more information on Walrath see Evans 1987, pp. 399–400, and Clark 1972, p. 180.

135. Craftsman 1912, p. 567.

136. Ibid.

137. For more information see Evans 1987, pp. 403–4, and Rhead 1911, p. [2].

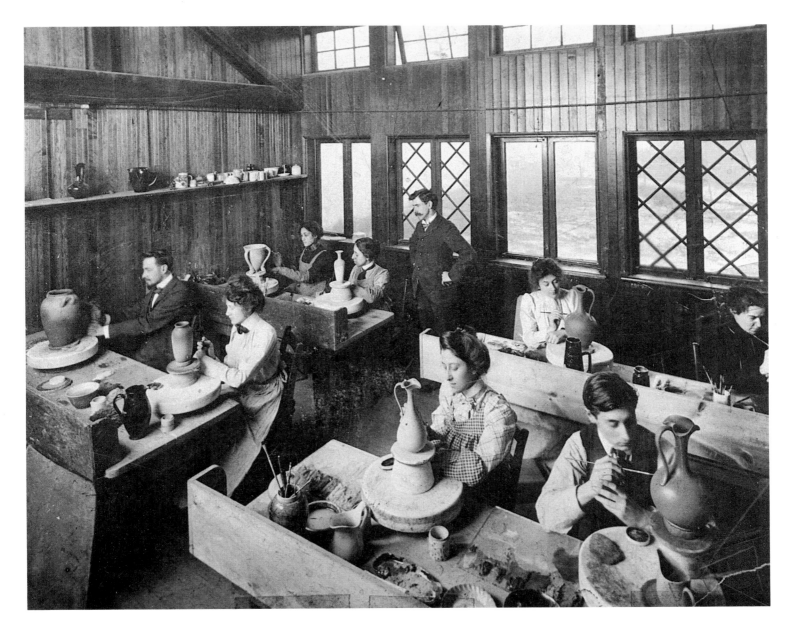

Rookwood decorators, 1900

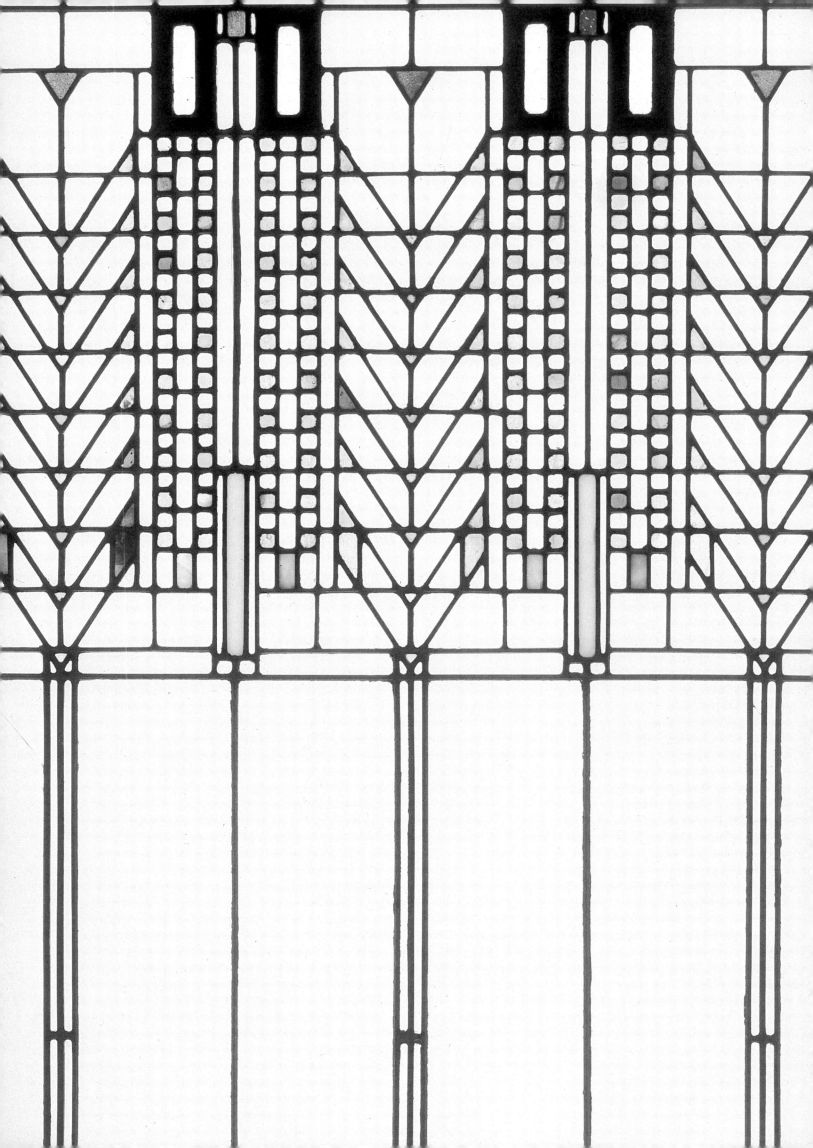

GLASS

Cat. no. 230 (detail)

GEORGE WASHINGTON MAHER

United States, 1864–1926

Chicago

221

Fireplace Surround from the Patrick J. King House, Chicago, 1901

Oak, glass mosaic, and gold enamel
Overall: 58 x 81½ x 12½ in.
(147.3 x 207.0 x 31.8 cm)
Glass mosaic: 49½ x 64¼ x ¾ (approx.) in.
(125.7 x 163.2 x 1.9 cm)
M.89.151.8
Gift of Max Palevsky and Jodie Evans

Prairie school architect George Washington Maher had worked in Louis Sullivan's office before establishing his own practice in 1888. An advocate of unified design, he characteristically created a special motif for each commission, repeating it throughout interior and exterior spaces. He called this concept the "motif rhythm theory," explaining that it "completely harmonizes all portions of the work until in the end it becomes a unit in composition . . . since each detail is designed to harmonize with the guiding motif which in turn was inspired by the necessity of the situation and local color and conditions."[1]

For the King House, Maher designed elaborate glass mosaic fireplaces with stylized thistles.[2] In their dense, dynamic, and organic appearance, the patterns hark back to Maher's mentor, Louis Sullivan.

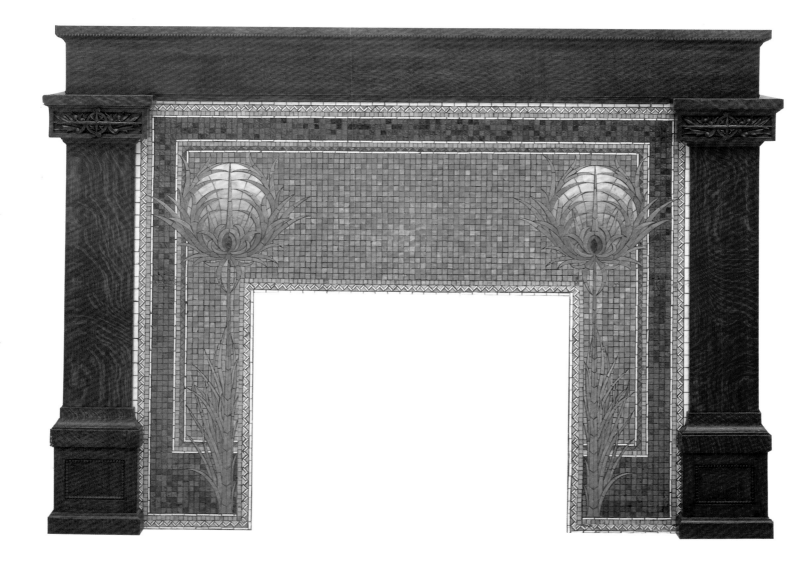

STEUBEN GLASS WORKS

1903–present

Corning, New York

Because glassmaking required hot furnaces, large factories, and extensive capital, art glass did not lend itself to production by individual artisans or small studios. Americans had led the way in mechanizing production of the material early in the nineteenth century; handcrafting wares was an expensive proposition attempted by far fewer manufacturers than those active in other areas of the arts and crafts movement. The field was dominated by just two individuals: Louis C. Tiffany and Frederick Carder.

Carder (England, 1863–1963, active United States), an accomplished English craftsman, was persuaded by T. G. Hawkes, president of a glass-decorating firm, to immigrate to New York in 1903, where they founded the Steuben Glass Works in Corning. A greater technician than Tiffany, Carder, along with his staff, produced an astonishing array of hand-blown art glass in more than 140 colors. Aurene, one of Carder's

first achievements, is comparable with Tiffany's Favrile (see Tiffany entry). Both men were inspired by the iridescent patina on ancient Roman glass, not realizing it was acquired from burial in the ground. The effect was achieved on new glass by spraying it "at the fire" with stannous chloride. Carder rarely added additional decoration to his Aurene vases (see cat. no. 222), preferring the interplay of solid colors with satiny surfaces. Cluthra (see. cat. no. 223) referred to a form of glass riddled with air bubbles, which was achieved by sandwiching powdered glass mixed with a chemical additive between the blown layers.

Steuben's prolific art glass period ended with World War I, which forced the sale of the company to the nearby Corning Glass Works. Carder continued his experiments with the new firm, but art ware production slackened in favor of optical-quality glass and crystal.[3]

222

Gold Aurene Vase, c. 1910

Glass

11⅝ x 7⅛ x 6⅜ (diam.) in.
(29.5 x 18.1 x 16.2 cm)

Marks: under base, engraved
STEUBEN AURENE 663P in slight
circular formation

M.79.148.1

Gift of Mrs. Scott Allen

223

Cluthra Vase, c. 1920

Glass

10½ x 9¾ (diam.) in.
(26.7 x 24.8 cm)

M.79.148.2

Gift of Mrs. Scott Allen

Cat. no. 222

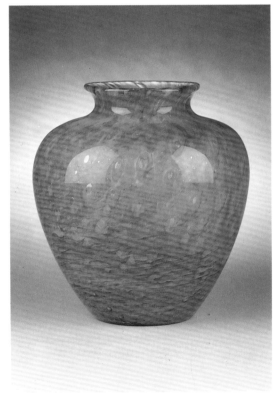

Cat. no. 223

LOUIS COMFORT TIFFANY

United States, 1848–1933

Corona and New York,

New York

Louis Comfort Tiffany, c. 1910

224a–b

Pair of Windows, c. 1900

Leaded glass
Each: 51 x 28½ in.
(129.5 x 72.4 cm)
TR.9412a–b
Collection of Max Palevsky
and Jodie Evans

Louis C. Tiffany focused on art glass forms at his Tiffany Studios after 1900. He had previously developed Favrile glass, a material well suited to vases, windows, lamps, and paperweights because of its iridescent, satiny properties. Favrile, Tiffany's trade name for all of his art glass, is derived from the word meaning "handmade" in Old English, a further reference to Tiffany's arts and crafts methods.[4]

These windows illustrate Tiffany's mastery of realism in stained glass. He employed color variations to define light and shadow and skillful caming to delineate and enhance the design. The opalescent glass adds volume and perspective to the composition.

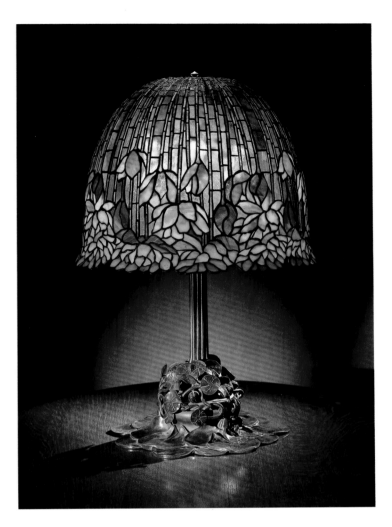

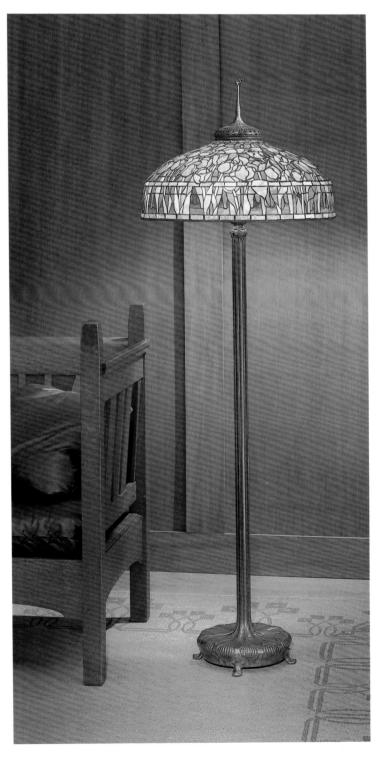

225

Pond Lily Lamp, 1900–1902

Leaded glass with bronze base
27 x 18 (diam. of shade)
x 13 ½ (width of base) in.
(68.6 x 45.7 x 34.3 cm)
Marks: under base, struck incuse
conjoined TGDCO | TIFFANY STU-
DIOS | NEW YORK | 2134; on shade,
under top rim, on applied metal
tag, struck incuse [TIFFA]NY STU-
DIOS | NEW YORK
M.85.128
Gift of Mr. David Geffen

One of Tiffany's classic lamps,
the design and proportions of
this example are masterful. The
drooping lily shade, which is
suspended over a bronze lily pad
base, has a floating, dreamlike
quality. A 1906 Tiffany price list
recorded this lamp as being avail-
able for four hundred dollars.[5]

226

Tulip Floor Lamp, c. 1905

Leaded glass with bronze base
66 ¾ x 22 ¼ (diam. of shade)
x 12 (diam. of base) in.
(169.5 x 56.5 x 30.5 cm)
Marks: under base, struck incuse
TIFFANY STUDIOS. | NEW YORK;
struck incuse 379; on shade, on
bottom rim, on applied metal
tag, struck incuse TIFFANY
STUDIOS NEW YORK 1548
TR.9365.20
Collection of Max Palevsky
and Jodie Evans

The base of this lamp was
described as a "Piano, floor"
type in the 1906 price list.[6]
Tiffany's elaborate bases were
not only decorative, they also
served to anchor the weighty
shades.

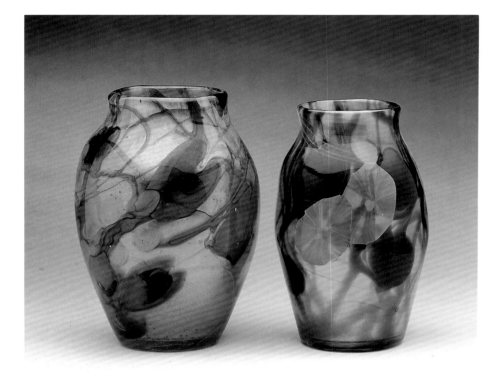

FRANK LLOYD WRIGHT

United States, 1867–1959

Oak Park, Illinois

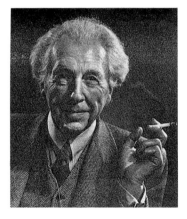

Frank Lloyd Wright, c. 1953

227

Favrile Vase, c. 1905

Glass
7 x 4½ (diam.) in.
(17.8 x 11.4 cm)
Marks: under base, engraved
L. C. T. and Y3080
M.81.13.11
Gift of Irving Mills

228

Favrile Vase, c. 1905

Glass
7½ x 5½ (diam.) in.
(19.1 x 14.0 cm)
Marks: under base, engraved
L. C. T. and Y6070
M.81.13.12
Gift of Irving Mills

These vases (cat. nos. 227–28) are examples of Tiffany's paper-weight glass, which was particularly suited for such organic, abstracted designs as the lilies seen here.

Cat. nos. 228, 227

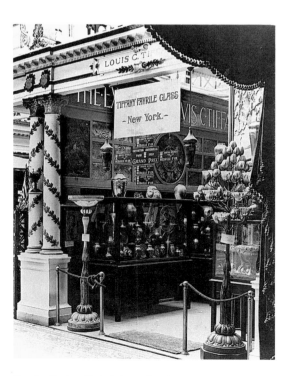

Favrile display, Paris International Exposition, 1900

Consistently rebelling against the "senselessly ornate" in the decorative arts, Frank Lloyd Wright criticized contemporary art glass for its realism: "Nothing is more annoying to me than any tendency toward realism of form in window-glass, to get mixed up with the view outside."[7] In sharp contrast with windows by Tiffany and other art glass manufacturers, Wright's are geometric abstractions, often of plant forms. As with furniture he sought to expound upon the inherent aesthetic properties of the materials themselves. He explained: "The windows usually are provided with characteristic straight line patterns, absolutely in the flat and usually severe. The nature of the glass is taken into account in

these designs as is also the metal bar used in their construction, and most of them are treated as metal 'grilles' with glass inserted forming a simple rhythmic arrangement of straight lines and squares made as cunning as possible so long as the result is quiet."[8]

Wright's use of art glass characterizes his prairie school period, from the late 1890s to about 1915.[9] In the Martin and Bradley houses, as with others from this period, he used rows of vertical windows as bands of light, "screens" that substituted for walls and destroyed the traditional "box." The individual windows counterbalanced the dominant horizontal nature of both the rows of glass and the structure of the house.

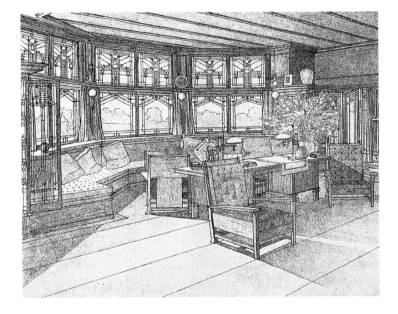

Sketch of the living room, B. Harley Bradley House, 1910 (note cabinet door at left)

229a–b

Pair of Windows from the B. Harley Bradley House, Kankakee, Illinois, 1900

Probably executed by Giannini and Hilgart, Chicago (1899–present) Leaded glass Each: 53 x 11⅝ in. (134.6 x 29.5 cm) TR.9430.3–4 Collection of Max Palevsky and Jodie Evans

The Bradley House windows are among the best of Wright's early models because of their intricate patterns and dramatic vertical stylization of floral forms. The triangular shapes repeat the hipped roofline of the home, while small pieces of colored glass form geometric tulips. These two windows were installed with six others in two groups of four, as cabinet doors in a vestibule connecting the living and dining rooms.[10]

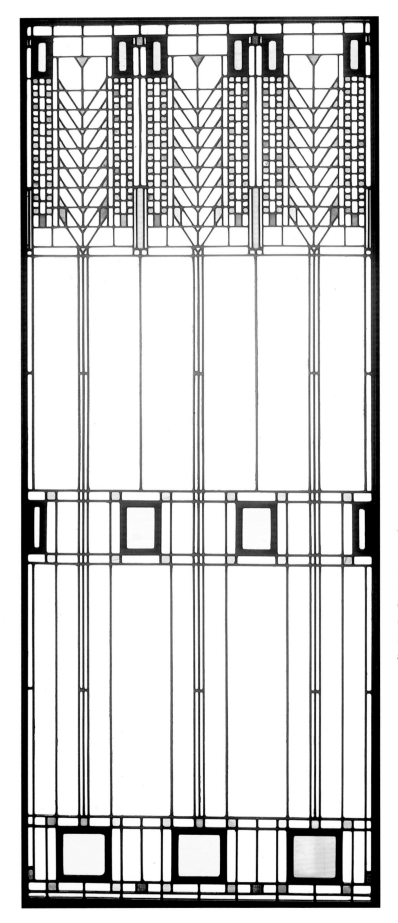

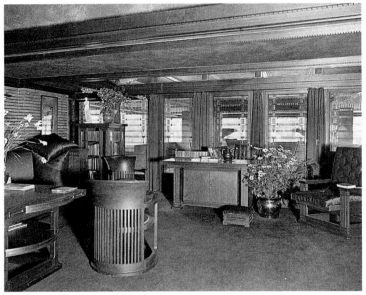

Living room, Darwin D. Martin House, 1906 (note wisteria doors in the background)

230

Window from the Darwin D. Martin House, Buffalo, 1903–5

Executed by Linden Glass Company, Chicago (c. 1888–1934)
Leaded glass
65 ¼ x 25 ¾ in.
(165.7 x 65.4 cm)
Promised gift of Max Palevsky and Jodie Evans

231 >

Window from the Darwin D. Martin House, Buffalo, 1903–5

Executed by Linden Glass Company, Chicago (c. 1888–1934)
Leaded glass
63 x 26 in.
(160.0 x 66.0 cm)
Collection of Max Palevsky and Jodie Evans

The Darwin D. Martin House was a masterpiece of Wright's prairie school period, largely because Martin gave Wright free rein to design all interior furnishings without budgetary limits.[11] The windows were a significant element in the overall design scheme and varied from dramatic tree-of-life abstractions (cat. no. 230) to stylized wisteria patterns (cat. no. 231). The tree-of-life window was installed in a bedroom door; the wisteria window, in one of a set of living room doors.[12]

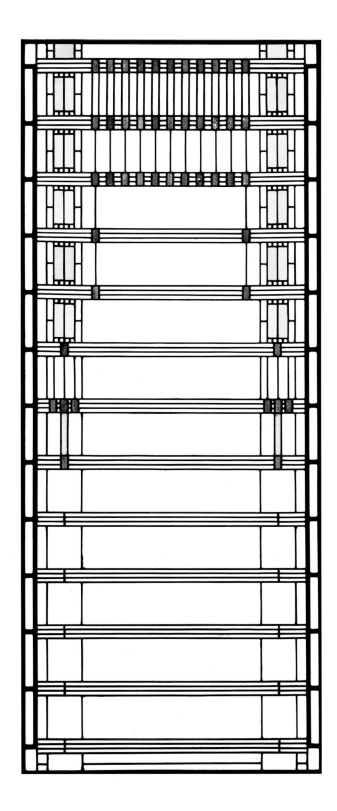

NOTES

1. As quoted in Darling 1984, p. 250.

2. For an illustration of another of the King House fireplaces see Hanks 1985, p. 30, fig. 1.29. The author is grateful to Tim Samuelson for his assistance with this entry.

3. For more information on Carder see Gardner 1985.

4. For more information on Tiffany see Frelinghuysen 1986b, pp. 188–89, 192–95; Voorsanger 1986, pp. 474–75; Koch 1971; and Duncan, Eidelberg, and Harris 1989.

5. Koch 1971, p. 169, no. 344.

6. Ibid., p. 170, no. 379.

7. As quoted in Hanks 1979, pp. 29, 56.

8. Ibid., p. 56.

9. He last used art glass, however, in the Ennis House, now called the Ennis-Brown House, in Los Angeles in 1923. See Hanks 1979, p. 52.

10. The author is grateful to John Eifler for his assistance with this entry.

11. The success of this commission and the Dana House, equally lavish in expense, belied Wright's fledgling philosophy that good design need not be expensive, as a result of machinery. The arts and crafts movement proved that machinery could be harnessed to produce good, affordable design, but the greatest interiors of the period, by Greene and Greene and Wright, were also among the most expensive.

12. The author is grateful to John O'Hearn for his assistance with the Martin House entries.

MISCELLANEOUS MEDIUMS

Cat. no. 240 (detail)

BOOKS

ROBERT WILSON HYDE

United States, 1875–1951

Santa Barbara

232

A House Book, 1906

Cover attributed to
Charles Frederick Eaton
(United States, 1842–1930)
Cover: suede and brass
Text: suede fly leaves, parchment, and wove rag paper, with black, gold, green, yellow, light pink, salmon, primrose, magenta, violet, and dark blue inks
11½ x 8¾ x 1⅜ in.
(29.2 x 22.2 x 3.5 cm)
Inscriptions and marks: in front, HAIL SWEET | RETIREMENT | LEAD ME TO THY | BOWER WHERE | FAIR CONTENT | HATH SPREAD HER | LOVELIEST FLOWER | AND LET NOUGHT | BREAK UPON THY | SACRED HOUR | SAVE SOME | TRUE FRIEND. in calligraphy; in back, A HOUSE BOOK | AT THE HOME OF | MR. & MRS. D. D. | WALKER AT | SANTA BARBARA | ROBERT W. HYDE | MAKER OF BOOKS | SANTA BARBARA | CALIFORNIA 1906 in calligraphy
M.89.151.31
Gift of Max Palevsky
and Jodie Evans

Ranging from commercial press editions to private issues to custom-made single volumes, such as this example, the arts and crafts movement revived the art form of fine book production.

San Francisco arts and crafts retailer Paul Elder advertised guest and wedding books by Robert Wilson Hyde of Santa Barbara in a 1910 catalogue of books and cards. Verses were penned by Arthur Guiterman; it is possible that he wrote the verse for this book.[1] The cover is similar to the work of Charles Frederick Eaton, also of Santa Barbara. A 1903 *House Beautiful* article refers to Eaton and his associates, one an illuminator (possibly Hyde), and lists wedding books among their products.[2]

Robert Wilson Hyde, c. 1930

THE ROYCROFT PRESS

1895–1938

East Aurora, New York

The Roycroft Press, the founding impetus for the Roycroft community, was a workshop in the manner of William Morris's Kelmscott Press, which Elbert Hubbard had visited in 1894. Hubbard founded his establishment in 1895, and his early products were decidedly indebted to the Kelmscott style. He used the print shop to publish his books and magazines as well as works by well-known authors. The quality improved dramatically from the first amateurish efforts; Roycroft's best editions featured fine European papers, hand illumination, special typefaces, and tooled leather or vellum covers. Hubbard's active promotion of Roycroft products introduced fine art books to middle-class America.[3]

233

Sonnets from the Portuguese,
by Elizabeth Barrett Browning,
1898

Designed by William Wallace
Denslow (United States,
1856–1915)
Cover: cloth spine extending
onto paper-covered boards
Text: rag paper with black, red,
and blue inks
11 ⅜ x 9 1/16 x 7/16 in.
(28.9 x 23.0 x 1.1 cm)

Inscriptions and marks: on third page, OF THIS EDITION THERE WERE PRINTED FOUR HUNDRED AND EIGHTY | COPIES AND THE TYPES THEN DISTRIBUTED. THIS BOOK IS NO. 35, all printed in red ink except for numerals hand-written in brown ink over script signature ELBERT HUBBARD hand-written in brown ink; on several pages, watermark, JOHN DICKINSON & CO.; on last printed page, seahorse superimposed on orb and double-barred cross enclosing R, all printed in red ink
TR.9408.2
Collection of Max Palevsky
and Jodie Evans

Issued only three years after the press's founding, *Sonnets from the Portuguese* was published in one edition of 480 copies, of which this is number 35. Browning's classic was a favorite with private art presses; Roycroft's version features gilding and hand-rendered uncial initials designed by William Wallace Denslow.[4] Denslow was Hubbard's favorite illustrator and is best known for his artwork for L. Frank Baum's *The Wonderful Wizard of Oz*.[5]

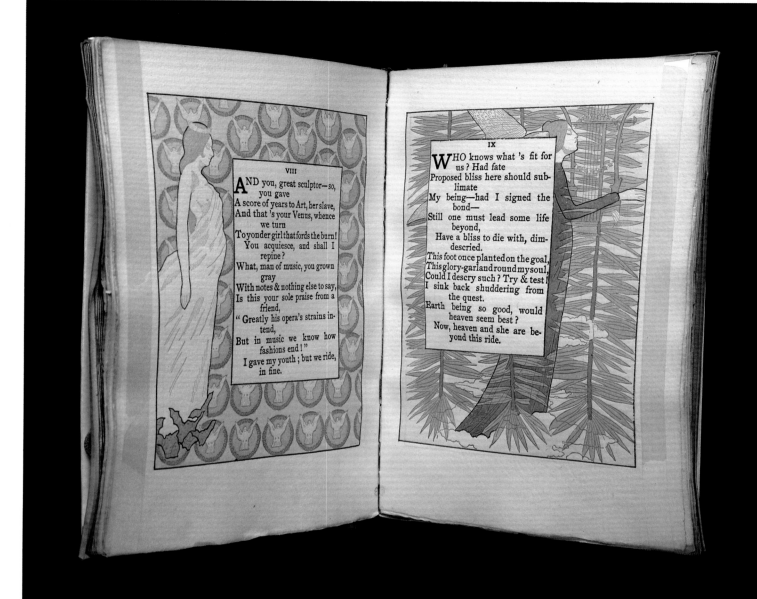

234

The Last Ride,
by Robert Browning, 1900

Designed by Samuel Warner
(England, 1872–1947, active
United States)
Illuminated by Lily Ess (active
c. 1900)
Cover: vellum with yapp edges
and linen tie ribbons
Text: rag paper with black,
yellow, green, peach, beige, gray,
blue, and gold inks
7¾ x 5⅞ x 7/16 in.
(19.7 x 14.9 x 1.1 cm)

Inscriptions and marks: on third
page, OF THIS EDITION THERE
WERE PRINTED AND SPECIALLY
HAND | ILLUMINED NINE HUNDRED
AND FORTY COPIES. THIS BOOK | IS
NUMBER 573, all printed in black
ink except numerals handwritten
in brown ink over script signa-
ture ELBERT HUBBARD handwrit-
ten in brown ink | ILLUMINED BY |
script signature LILY ESS. super-
imposed on orb and double-
barred cross enclosing R, all
handwritten in black, green, and
red inks; on last page, water-
marks, script ROYCROFT and
seahorse superimposed on orb
and double-barred cross enclos-
ing R

M.89.151.32
Gift of Max Palevsky
and Jodie Evans

One of Roycroft's most out-
standing publications, *The Last
Ride* was designed by Samuel
Warner in 1900. London trained,
Warner was the first professional
designer employed by Hubbard,
and his work elevated the quality
of Roycroft books significantly.
This volume features elaborate
hand-illuminated borders with
drawings copied by Warner
from an earlier French art book,
Octave Uzanne's *Voyage autour
de sa Chambre*, published in
1896.[6]

235

Little Journeys to the Homes of English Authors: William Morris, by Elbert Hubbard, 1900

Title page designed by Samuel Warner (England, 1872–1947, active United States)
Cover: paper with cloth spine
Text: rag paper with black ink
7¹³/₁₆ x 6 x ⅜ in.
(19.8 x 15.2 x 1.0 cm)
Inscriptions and marks: on several pages, watermarks, script ROYCROFT, seahorse superimposed on orb and double-barred cross enclosing R, and orb and double-barred cross enclosing R
L.89.17.4
Collection of Max Palevsky and Jodie Evans

Famous people were the subject of *Little Journeys*, a monthly inspirational magazine written by Hubbard. Between 1894 and 1900 the journal was published by G. P. Putnam's Sons of New York; from 1900 to 1909 it was a Roycroft publication. Selected titles were bound separately, with none more suitable for such treatment than this issue about Hubbard's hero, William Morris.

236

Manhattan,
by Joseph I. C. Clarke,
and *Henry Hudson,*
by Elbert Hubbard, 1910

Designed by Dard Hunter
(United States, 1883–1966)
Cover: paper with cloth spine
Text: rag paper with black and red inks
8 x 6 x ½ in.
(20.3 x 15.2 x 1.3 cm)
Inscriptions and marks: on cover, conjoined DH; on several pages, watermarks, script ROYCROFT and orb and double-barred cross enclosing R
L.89.17.3
Collection of Max Palevsky and Jodie Evans

Roycroft's best early book designers, William Denslow and Samuel Warner, both left about 1900. Roycroft's style changed dramatically under the hand of their successor, the brilliant,

young Dard Hunter, who came to Roycroft in 1903 at the age of nineteen. At Roycroft, Hunter became interested in Viennese design. He later recalled that "each month at the Roycroft Shop we received a number of European art magazines, notably *Dekorative Kunst, Deutsche Kunst und Dekoration*, and *Dekorative Vorbilder*, and through these publications I became interested in the 'modern' tendency in design."[7] He was so intrigued with the style that he went to Vienna to study in 1908. His facility with the stylized, geometric secessionist aesthetic is evident in the cover of this volume. The use of small squares can be traced back to Mackintosh through works by Hoffmann and his contemporaries. Hunter also designed furniture, lighting, and metalwork for the Roycrofters (see metalwork section).

FRANK LLOYD WRIGHT

United States, 1867–1959

Oak Park, Illinois

The Auvergne Press was a partnership of William Herman Winslow (United States, 1857–1934) and Chauncey Lawrence Williams (United States, 1872–1924). Wright's first architectural commission independent of Louis Sullivan was for Winslow's house; he also designed one for Williams. A home operation, Auvergne only produced two art books. Wright designed the title page of John Keats's *The Eve of St. Agnes* in 1896 and all of William C. Gannet's *The House Beautiful* (cat. no. 237) the following year.[8]

The title page is the most elaborate of Wright's designs for the book and shows the development of his geometric abstraction of natural motifs. Here the leaves and branches are treated realistically, albeit in stylized relationships. Within a few years he reduced such motifs to geometric forms, as illustrated by his art glass (see cat. nos. 229a–b, 230–31). The horizontal row of vertical elements presaged the arrangement of "window walls" in many of the prairie school houses. Just as the vertical windows punctuate the horizontals of the long, low residences, the panels with male caryatids balance the dominant horizontal emphasis of the page.

William C. Gannet was a Unitarian minister, and the text was based on one of his sermons, a suitably arts and crafts treatise on the ideal home.[9] Only ninety copies of the book were issued, of which this is number sixty-six.

237

The House Beautiful, by William C. Gannet, 1896–97

Published by Auvergne Press, River Forest, Illinois (1896–97)
Cover: quarter leather with paper
Text: rag paper with black and red inks
13 15/16 x 11 15/16 x 9/16 in.
(35.4 x 30.3 x 1.4 cm)

Inscriptions and marks: in back, in black ink, conjoined w&w enclosed within a shield| AUVERGNE PRESS enclosed within a rectangle, all superimposed on logo with tree design in rectangle, all enclosed within a rectangle, beside WE HAVE PRINTED NINETY COPIES OF | THIS BOOK. THIS IS COPY NO...SIXTY-SIX, all printed in red ink except for the number handwritten in black ink, over script signatures W. H.

WINSLOW. | FRANK L. WRIGHT. handwritten in black ink; on second to last page, watermark, J WHAT[MAN]
TR.9408.1
Collection of Max Palevsky and Jodie Evans

DRAWINGS

FRANK LLOYD WRIGHT

United States, 1867–1959

Oak Park, Illinois

238

Preliminary Sketch for the Francis W. Little House, Peoria, Illinois, 1902–3

Brown ink, watercolor, and gilt on paper
11¹⁵⁄₁₆ x 16¼ in.
(30.3 x 41.3 cm)
TR.9340.2
Collection of Max Palevsky and Jodie Evans

239

Presentation Drawing for the Francis W. Little House, Peoria, Illinois, 1902–3

Black ink, watercolor, and gilt on parchment
12¾ x 23¹¹⁄₁₆ in.
(32.4 x 60.2 cm)
Inscriptions and marks: in upper proper right corner, RESIDENCE | FOR | MR. E. [*sic*] W. LITTLE | FRANK LLOYD WRIGHT | ARCHITECT, all handwritten in black ink
TR.9430.1
Collection of Max Palevsky and Jodie Evans

These drawings for the Little House (cat. nos. 238–39) illustrate Wright's prairie school architectural style: broad, slightly pitched, overhanging rooflines protecting long, ground-hugging masses with banks of windows, linked to the site with low terraces and enclosed gardens. Mr. and Mrs. Francis W. Little commissioned Wright to design their Peoria home in 1902; it was completed in 1903. The sketch (cat. no. 238) differs from the presentation drawing (cat. no. 239), which reflects more closely what was built.[10] When the Littles moved to Wayzata, Minnesota, in 1908, they again secured Wright to design their home.[11] These two drawings descended in the Little family.

TEXTILES

GUSTAV STICKLEY'S CRAFTSMAN WORKSHOPS

1899–1916

Eastwood and New York,

New York

Gustav Stickley's Craftsman Workshops had expanded by 1910 to include, in addition to furniture construction, the making of metalwork, lighting, textiles, and embroidery. The design and weave of the rug shown here (cat. no. 240) suggest an attribution to Stickley.

Because of its associations with nature, green was a favored color in the arts and crafts movement, and it was frequently prescribed in decorating manuals.[12] One such source described a common color scheme for a bungalow as "a soft green stain for the outside with a lighter tone of the same color for all the inside woodwork, a frieze of tan burlap, dark red brick fireplaces and touches of bright yellow in the curtains and cushions, just four blending colors everywhere through the house, repeating so quietly the tones of the surrounding hills and trees."[13] This reversible ingrain rug has precisely the proper earthen hues. Its stylized border design is analogous to patterns illustrated in Stickley's catalogues.[14]

240

Rug, c. 1910

Double-faced plain weave with
jute warp and jute-and-cotton
weft
123 ¾ x 105 ¾ in.
(314.3 x 268.6 cm)
L.88.30.40
Collection of Max Palevsky
and Jodie Evans

UNKNOWN CRAFTSMAN

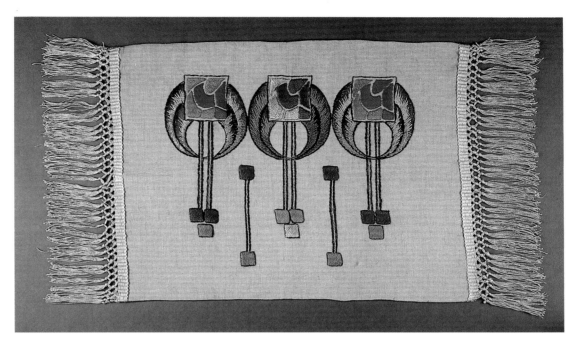

241

Table Runner, c. 1910

Flax with floss silk threads
16 x 29¾ in.
(40.6 x 75.6 cm)
L.88.30.39
Collection of Max Palevsky
and Jodie Evans

Arts and crafts needlework kits permitted hobbyists to make suitable embroideries for their homes. This design was quite popular and appears on cushion covers as well as table runners. Incorporating the Glasgow rose, it was copied from similar motifs found in the works of Charles Rennie Mackintosh and E. A. Taylor (see cat. no. 7). It bears comparison with other derivations such as the inlay designs of Harvey Ellis (see cat. nos. 51–55).

NOTES

1. Elder 1910. The author is grateful to D. J. Puffert for supplying a copy of this catalogue. References to Hyde and Guiterman can be found on pp. 13–15.

2. McDougall 1903, p. 74.

3. The author is indebted to D. J. Puffert, Robert Rust, and David Ogle for their assistance with the Roycroft Press entries. Ogle's copious research provided the factual information on the various titles.

4. See Kaplan 1987, pp. 289, 291–92, cat. no. 153, and Elder 1910, pp. [x], 3, for other publishers' editions of this work.

5. Koch 1967, p. 71.

6. Vilain 1986, p. 7.

7. As quoted in Koch 1967, p. 80, n. 15.

8. Kaplan 1987, pp. 197–99, cat. no. 87.

9. Hanks 1979, p. 174. For more information on and illustrations of Wright's graphic designs see pp. 169–84.

10. See Wright 1911, p. 31, for a period photograph of the house.

11. The living room of the Wayzata home is installed at the Metropolitan Museum of Art. See Kaufmann 1985.

12. See Stradling 1983, pp. 10–12.

13. *Indoors and Out*, as quoted in Robertson 1987, p. 350.

14. For examples of similar designs see Stickley n.d., pp. 42, 62; for examples of Craftsman rugs see Stickley 1910, pp. 122–25.

APPENDIX OF MARKS

Note: This appendix includes all marks that are photographically reproducible. Each is identified with its catalogue number (textual descriptions of the marks are provided in the catalogue entries). In those cases where more than one object has the same mark, the clearest mark is shown and identified by its catalogue number, while the catalogue numbers of the other pieces with the same mark are listed in parentheses. Because of such grouping, some marks may fall slightly out of numerical order. The reader should also be aware that a few pieces have two mark photographs. These are published in close proximity to one another. A table of catalogue numbers is provided below to assist in identifying marks from different sections of the catalogue.

Europe	Cat. nos. 1–11
Furniture	Cat. nos. 12–66
Metalwork	Cat. nos. 67–102
Ceramics	Cat. nos. 103–220
Glass	Cat. nos. 221–31
Miscellaneous Mediums	Cat. nos. 232–41

3a–b

4a–b

5

9

9

10

19 (20, 21)

22

30 (25, 26)

27

28

29

234

31 (32a)

32b

33 (34, 35)

38

36 (37a)

41 (57)

43 (44, 46)

49 (56, 59)

CRAFTSMAN

TRADE MARKS REG'D — IN U. S. PATENT OFFICE

Stickley

THIS PASTER TOGETHER WITH MY DEVICE AND SIGNATURE (BRANDED) ON A PIECE OF FURNITURE STANDS AS MY GUARANTEE TO THE PURCHASER THAT THE PIECE IS MADE WITH THE SAME CARE AND EARNESTNESS THAT HAS CHARACTERIZED ALL MY EFFORTS FROM THE BEGINNING, AND IS MEANT TO IMPLY THAT I HOLD MYSELF RESPONSIBLE FOR ANY DEFECTS IN MATERIAL, WORKMANSHIP OR FINISH THAT MAY BE DISCOVERED BY THE PURCHASER EVEN AFTER THE PIECE HAS BEEN IN USE FOR A REASONABLE LENGTH OF TIME, AND THAT I WILL EITHER MAKE GOOD ANY DEFECTS OR TAKE BACK THE PIECE AND REFUND THE PURCHASE PRICE.

THIS PIECE WAS MADE IN MY CABINET SHOPS AT EASTWOOD, N. Y.

GUSTAV STICKLEY

41 (57)

48

52

53 (40, 55)

L &J.G.STICKLEY FAYETTEVILLE.NY
HANDCRAFT

60

58 (50, 56)

60 (61)

63 (62)

67

68a–c

69

71

70

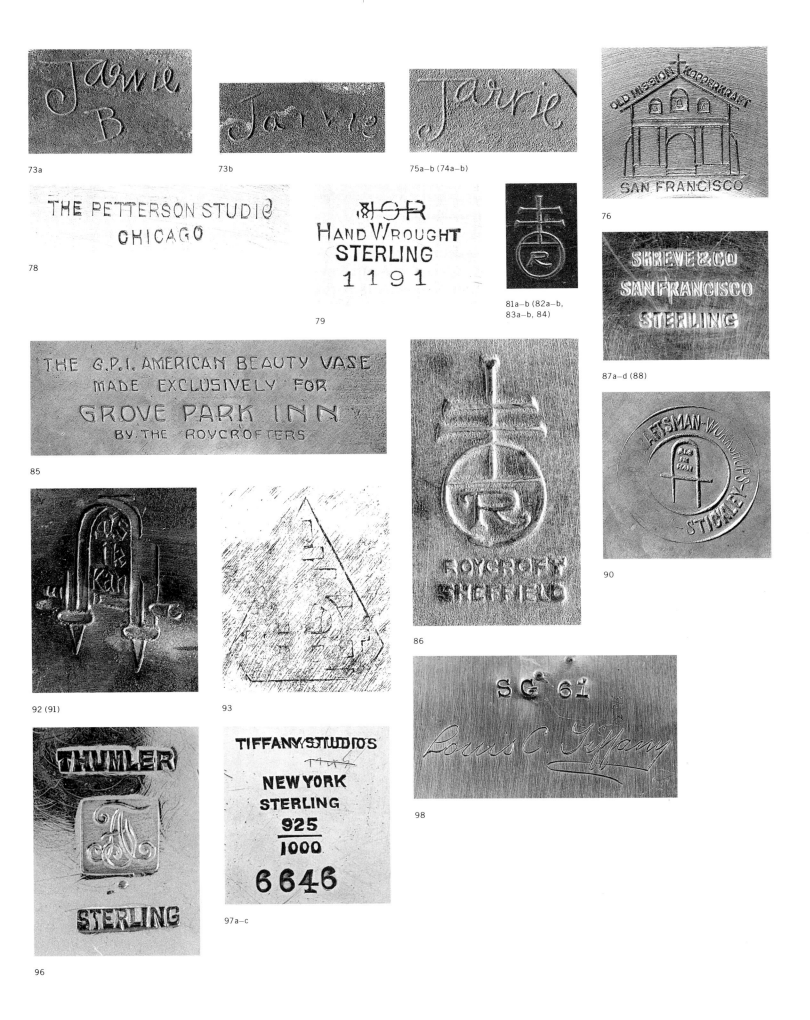

73a

73b

75a–b (74a–b)

76

THE PETTERSON STUDIO
CHICAGO

78

HAND WROUGHT
STERLING
1191

79

81a–b (82a–b,
83a–b, 84)

SHREVE&CO
SAN FRANCISCO
STERLING

87a–d (88)

THE G.P.I. AMERICAN BEAUTY VASE
MADE EXCLUSIVELY FOR
GROVE PARK INN
BY THE ROYCROFTERS

85

ROYCROFT
SHEFFIELD

86

90

92 (91)

93

SG 61
Louis C Tiffany

98

THUMLER
STERLING

96

TIFFANY STUDIOS
NEW YORK
STERLING
925
1000
6646

97a–c

99a–b

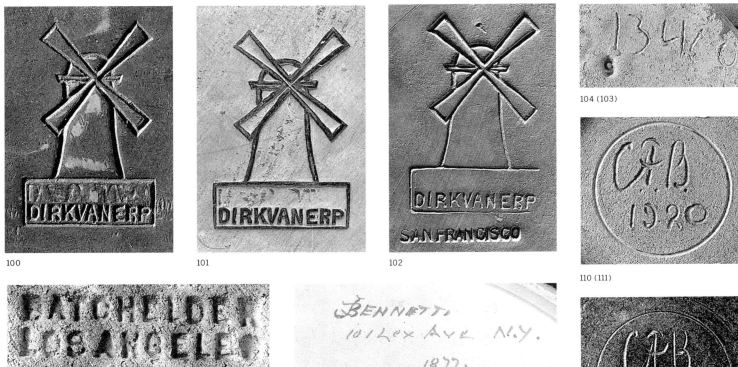

100

101

102

104 (103)

110 (111)

105

109

112

106

113a

114 (115–16, 117a–b,
118–19, 121, 123, 125)

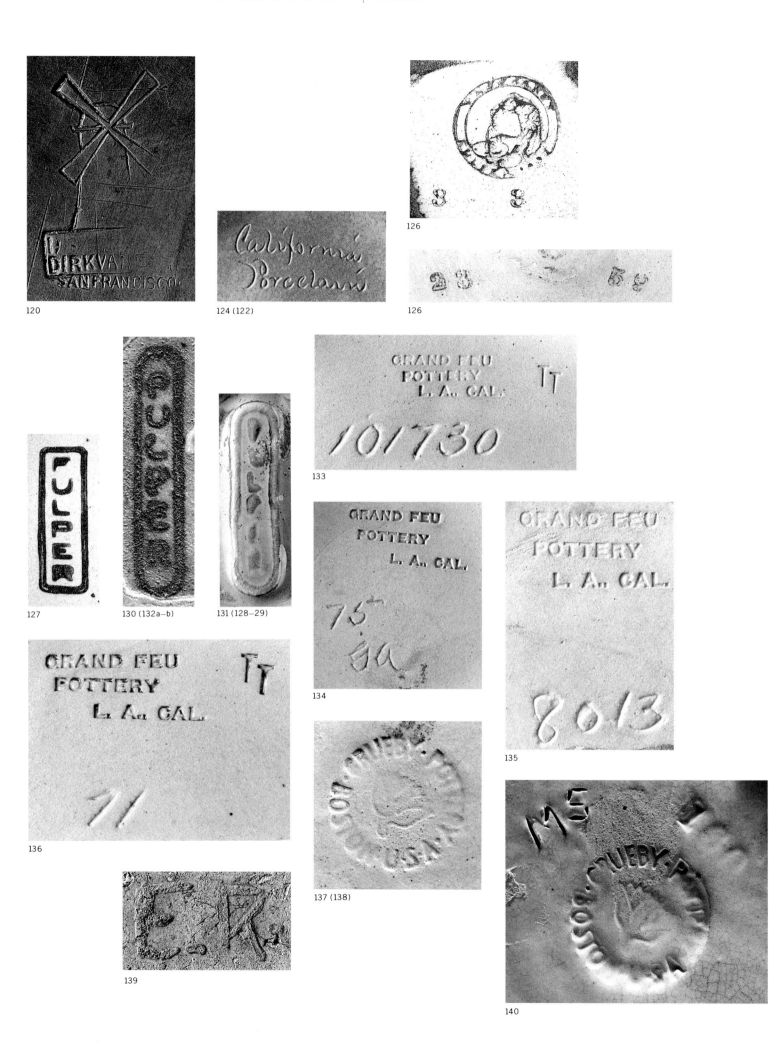

120

124 (122)

126

126

127

130 (132a–b)

131 (128–29)

133

134

135

136

137 (138)

139

140

140

142

143

149

146

141

144 (145, 147)

148

149

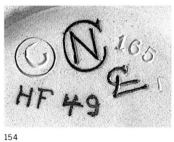

150

152

151

154

155

153

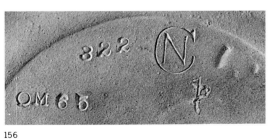

156

157

158

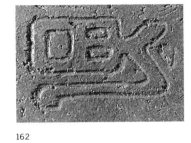

159

160

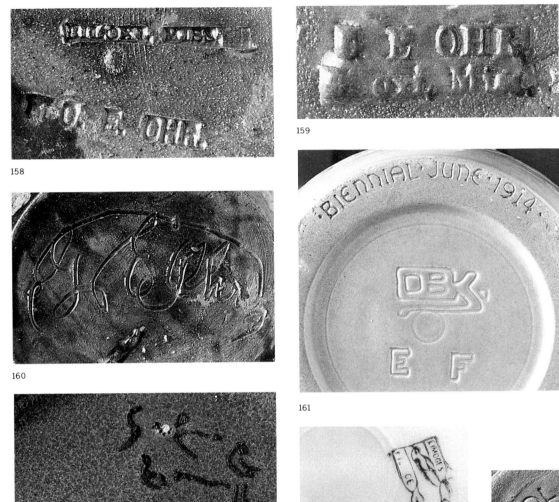

161

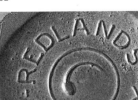

162

170 (167–68)

165

164

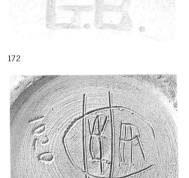

169

ROZANE WARE

171

171

H. Smith

171

G.B.

172

AGNES AND FREDERICK RHEAD.

173

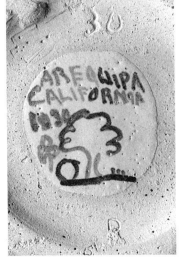

1920

1911

174

AREQUIPA CALIFORNIA

175

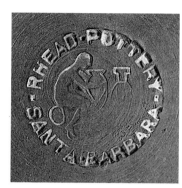

176a–c (178)

179

180

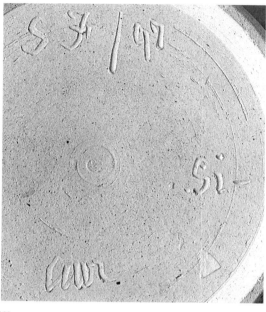

181

182

183

186 (187)

184

185

188

189 (191)

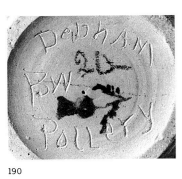

190

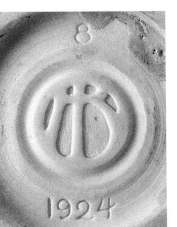

194

195

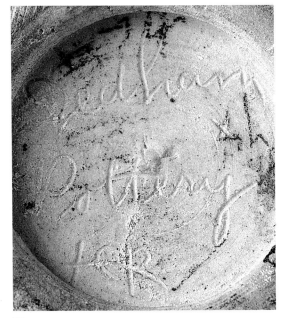

192

196

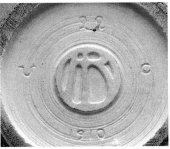

197

198

199

200

202

203

201

204

205

206

207

208

209

210

211

212

213

214

219

217

218

222

220

225

225

226

226

A House Book
at the Home of
Mr. & Mrs. O. D.
Walker · · at
Santa Barbara.

Robert W. Lyde.
Maker of Books ·
Santa Barbara ·
California · 1906 ·

232

Of this edition there were printed Four Hundred and Eighty copies and the types then distributed. This book is No. 35

Elbert Hubbard

233

236

Of this edition there were printed and specially hand illumined nine hundred and forty copies. This book is Number 573

Elbert Hubbard

ILLVMINED BY

234

AUVERGNE PRESS

WE HAVE PRINTED NINETY COPIES OF THIS BOOK. THIS IS COPY NO. Sixty-six

Frank L. Wright.

237

BIBLIOGRAPHY

Note: Two sources, Wendy Kaplan's *"The Art that is Life": The Arts and Crafts Movement in America, 1875–1920* and Paul Evans's *Art Pottery of the United States: An Encyclopedia of Producers and Their Marks*, were extremely valuable in confirming basic facts about individuals, companies, exhibitions, and awards. When not noted in the text, such information is often from these two sources.

ALTENBRANDT 1909.
Altenbrandt, Edward, ed. *The Men Behind the Guns in the Making of Greater Grand Rapids*. Grand Rapids: Dean-Hicks Printing Company, 1909.

ANDERSEN, MOORE, and WINTER 1974.
Andersen, Timothy J., Eudorah M. Moore, and Robert W. Winter, eds. *California Design 1910*. Exh. cat. Pasadena: California Design, 1974.

ANSCOMBE and GERE 1978.
Anscombe, Isabelle, and Charlotte Gere. *Arts and Crafts in Britain and America*. New York: Rizzoli, 1978.

ARNEST 1975.
Arnest, Barbara M., ed. *Van Briggle Pottery: The Early Years*. Exh. cat. Colorado Springs, Colorado: Colorado Springs Fine Arts Center, 1975.

BATCHELDER 1909.
Batchelder, Ernest A. "Carving as an Expression of Individuality: Its Purpose in Architecture." *The Craftsman* 16, no. 1 (April 1909): 60–69.

BATCHELDER 1923.
The Batchelder Tiles. 4th ed. Sales cat. Los Angeles: Batchelder-Wilson Company, 1923.

BATCHELDER 1927a.
Batchelder Pavers: A Catalog of Tiles and Pavement Designs. 2d ed. Sales cat. Los Angeles: Batchelder-Wilson Company, 1927.

BATCHELDER 1927b.
Batchelder Tiles: A Catalog of Mantel Designs. 3d ed. Sales cat. Los Angeles: Batchelder-Wilson Company, 1927.

BILLCLIFFE 1986.
Billcliffe, Roger. *Charles Rennie Mackintosh: The Complete Furniture, Drawings, and Interior Designs*, 3d ed. New York: E. P. Dutton, 1986.

BILLCLIFFE 1988.
Billcliffe, Roger. "Introduction." In Nuttgens 1988, 6–7.

BINNS 1903.
Binns, Charles F. "In Defence of Fire." *The Craftsman* 3, no. 6 (March 1903): 369–72.

BLASBERG 1971.
Blasberg, Robert W. "The Sadie Irvine Letters: A Further Note on the Production of Newcomb Pottery." *Antiques* 100, no. 2 (August 1971): 250–51.

BLASBERG 1979.
Blasberg, Robert W., with Carol L. Bohdan. *Fulper Art Pottery: An Aesthetic Appreciation 1909–1929*. Exh. cat. New York: Jordan-Volpe Gallery, 1979.

BLASBERG 1981.
Blasberg, Robert W. *Grueby*. Exh. cat. Syracuse: Everson Museum of Art, 1981.

BORIS 1986.
Boris, Eileen. *Art and Labor: Ruskin, Morris, and the Craftsman Ideal in America*. Philadelphia: Temple University Press, 1986.

BOWMAN 1986.
Bowman, Leslie Greene. "Arts and Crafts Silversmiths: Friedell and Blanchard in Southern California." In Morse 1986, 41–55.

BRANDON-JONES 1978.
Brandon-Jones, John, et al. *C. F. A. Voysey: Architect and Designer 1857–1941*. Exh. cat. Brighton, England: Brighton Art Gallery and Museum, 1978.

BRANDT 1985.
Brandt, Frederick R. *Late Nineteenth and Early Twentieth Century Decorative Arts*. Richmond: Virginia Museum of Fine Arts, 1985.

BRAUCKMAN 1913.
Brauckman, Cornelius. Letter to Library of Congress, 30 April 1913. Accession 55899. National Museum of American History, Smithsonian Institution, Washington, D.C.

BRAY 1978.
Bray, Hazel V. *The Potter's Art in California 1885 to 1955*. Exh. cat. Oakland: Oakland Museum, 1978.

BURKE 1986.
Burke, Doreen Bolger, et al. *In Pursuit of Beauty: Americans and the Aesthetic Movement*. Exh. cat. New York: Metropolitan Museum of Art, 1986.

CARDWELL 1977.
Cardwell, Kenneth H. *Bernard Maybeck: Artisan, Architect, Artist*. Salt Lake City: Peregrine Smith, 1977.

CARPENTER 1980.
Carpenter, Charles H., Jr. "The Silver of Louis Comfort Tiffany." *Antiques* 117, no. 2 (February 1980): 390–97.

CARPENTER 1982.
Carpenter, Charles H., Jr. *Gorham Silver 1831–1981*. New York: Dodd, Mead and Company, 1982.

CATHERS 1981.
Cathers, David M. *Furniture of the American Arts and Crafts Movement: Stickley and Roycroft Mission Oak*. New York: New American Library, 1981.

CHAMPNEY 1968.
Champney, Freeman. *Art and Glory: The Story of Elbert Hubbard*. New York: Crown Publishers, 1968.

CHRISTIE'S 1985.
Important American Architectural Designs and Commissions. Auc. cat. New York: Christie's, 14 June 1985.

CHRISTIE'S 1987.
Important American Architectural Designs and Commissions Including Arts and Crafts. Auc. cat. New York: Christie's, 20 June 1987.

CHRISTIE'S 1989.
Important American Arts and Crafts and Architectural Designs and Commissions Including Ceramics. Auc. cat. New York: Christie's, 9 December 1989.

CHRONICLE 1917.
"Miss Lillian Palmer." *San Francisco Chronicle*, 17 January 1917, p. 51, col. 7.

CLARK, ELLISON, and HECHT 1989.
Clark, Garth, Robert A. Ellison, Jr., and Eugene Hecht. *The Mad Potter of Biloxi: The Art and Life of George E. Ohr*. New York: Abbeville, 1989.

CLARK 1972.
Clark, Robert Judson, ed. *The Arts and Crafts Movement in America 1876–1916*. Exh. cat. Princeton: Princeton University Art Museum, 1972.

CLARK and KAPLAN 1987.
Clark, Robert Judson, and Wendy Kaplan. "Arts and Crafts: Matters of Style." In Kaplan 1987, 78–100.

COOKE 1987.
Cooke, Edward S., Jr. "Frank Lloyd Wright." In Kaplan 1987, 391–93.

CORN 1972.
Corn, Wanda M. *The Color of Mood: American Tonalism 1880–1910*. Exh. cat. San Francisco: M. H. de Young Memorial Museum/California Palace of the Legion of Honor, 1972.

CRAFTSMAN 1903a.
"Two Book Cabinets." *The Craftsman* 4, no. 5 (August 1903): 390–92.

CRAFTSMAN 1903b.
"An Appreciation of the Work of Robert Jarvie." *The Craftsman* 5, no. 3 (December 1903): 271–76.

CRAFTSMAN 1904a.
"Structure and Ornament in the Craftsman Workshops." *The Craftsman* 5, no. 4 (January 1904): 391–96.

CRAFTSMAN 1904b.
"A Child's Bedroom." *The Craftsman* 6, no. 4 (July 1904): 285–87, 289.

CRAFTSMAN 1904c.
Advertisement. *The Craftsman* 7, no. 3 (December 1904): xxi.

CRAFTSMAN 1906.
Advertisement. *The Craftsman* 11, no. 2 (November 1906): xxiv.

CRAFTSMAN 1912.
"Modern Craft Work in America." *The Craftsman* 21, no. 5 (February 1912): 562–68.

CRAFTSMAN 1915.
"Craftsman Advertising Department: Suggestions for Men's Xmas Gifts." *The Craftsman* 29, no. 2 (November 1915): 42a.

CRANE 1908.
Crane, Walter. *Line and Form*. London: George Bell and Sons, 1908.

CRAWFORD 1985.
Crawford, Alan. *C. R. Ashbee: Architect, Designer, and Romantic Socialist*. New Haven: Yale University Press, 1985.

DALE 1986.
Dale, Sharon. *Frederick Hurten Rhead: An English Potter in America*. Exh. cat. Erie, Pennsylvania: Erie Art Museum, 1986.

DARLING 1977.
Darling, Sharon S. *Chicago Metalsmiths*. Exh. cat. Chicago: Chicago Historical Society, 1977.

DARLING 1979.
Darling, Sharon S. *Chicago Ceramics and Glass*. Exh. cat. Chicago: Chicago Historical Society, 1979.

DARLING 1984.
Darling, Sharon S. *Chicago Furniture: Art, Craft, and Industry 1833–1983*. Chicago: Chicago Historical Society, 1984.

DARLING 1989.
Darling, Sharon S. *Teco: Art Pottery of the Prairie School*. Exh. cat. Erie, Pennsylvania: Erie Art Museum, 1989.

DEDHAM 1896.
Dedham Pottery. Sales brochure. Dedham, Massachusetts: Dedham Pottery, 1896.

DEKORATIVE KUNST 1900.
"Ein Amerikanischer Möbel-Künstler: Ch. Rohlfs–Buffalo." *Dekorative Kunst* 4, no. 2 (October 1900): 74–79.

DIETZ 1984.
Dietz, Ulysses G. *The Newark Museum Collection of American Art Pottery*. Newark: Newark Museum, 1984.

DOWNEY 1985.
Downey, Lynn Alison. "Philip King Brown and the Arequipa Sanatorium." *The Pacific Historian* 29, no. 1 (Spring 1985): 47–55.

DUNCAN 1982.
Duncan, Alastair. *Art Nouveau Furniture*. New York: Clarkson N. Potter, 1982.

DUNCAN, EIDELBERG, and HARRIS 1989.
Duncan, Alastair, Martin Eidelberg, and Neil Harris. *Masterworks of Louis Comfort Tiffany*. New York: Abrams, 1989.

EDWARDS 1987.
Edwards, Robert. "The Art of Work." In Kaplan 1987, 223–36.

EIDELBERG 1987.
Eidelberg, Martin, ed. *From Our Native Clay: Art Pottery from the Collections of the American Ceramic Arts Society*. Exh. cat. New York: American Ceramic Arts Society, 1987.

ELDER 1910.
Pleasant Pages. Sales cat. San Francisco: Paul Elder and Company, 1910.

ENQUIRER 1898.
"An Instructive Evening." *Oakland Enquirer*, 18 November 1898, 1.

EVANS 1980.
Evans, Paul. "Redlands Art Pottery." *Spinning Wheel* 36, no. 1 (January/February 1980): 38.

EVANS 1987.
Evans, Paul. *Art Pottery of the United States: An Encyclopedia of Producers and Their Marks*. 2d ed. New York: Feingold and Lewis, 1987.

FRELINGHUYSEN 1986a.
Frelinghuysen, Alice Cooney. "Aesthetic Forms in Ceramics and Glass." In Burke 1986, 199–251.

FRELINGHUYSEN 1986b.
Frelinghuysen, Alice Cooney. "A New Renaissance: Stained Glass in the Aesthetic Period." In Burke 1986, 177–97.

FRELINGHUYSEN 1989.
Frelinghuysen, Alice Cooney. *American Porcelain: 1770–1920*. Exh. cat. New York: Metropolitan Museum of Art, 1989.

GARDNER 1985.
Gardner, Paul V. *Frederick Carder: Portrait of a Glassmaker*. Exh. cat. Corning, New York: Corning Museum of Glass, 1985.

GEBHARD 1960.
Gebhard, David. "Louis Sullivan and George Grant Elmslie." *Journal of the Society of Architectural Historians* 19, no. 2 (May 1960): 62–68.

GEBHARD 1975.
Gebhard, David. *Charles F. A. Voysey, Architect*. Los Angeles: Hennessey and Ingalls, 1975.

GENERAL FEDERATION 1914.
"The Prize Winners: The Making of the Pottery Cup." *General Federation of Women's Clubs Magazine* 13, no. 1 (July 1914): 15–16.

GRAND FEU n.d.
Grand Feu Art Pottery. Sales brochure. Los Angeles: Grand Feu Art Pottery, n.d.

GRAND RAPIDS 1903.
Advertisement. The Grand Rapids Furniture Record, February 1903, 222.

GRAY 1983.
Gray, Stephen, ed. The Mission Furniture of L. and J. G. Stickley. Compiled reprints. New York: Turn of the Century Editions, 1983.

GRAY 1987.
Gray, Stephen. The Early Work of Gustav Stickley. Compiled reprints. New York: Turn of the Century Editions, 1987.

GRAY and EDWARDS 1981.
Gray, Stephen, and Robert Edwards, eds. Collected Works of Gustav Stickley. Compiled reprints. New York: Turn of the Century Editions, 1981.

GRUEBY 1904.
Grueby Faience Company. Grueby Pottery. Sales brochure. 1904. Reprint. In "Addison B. Le Boutillier: Developer of Grueby Tiles," by Neville Thompson. Tiller 1, no. 2 (November/December 1982): 25.

HAMILTON 1980.
Hamilton, Charles F. Roycroft Collectibles. San Diego: A. S. Barnes and Company, 1980.

HANKS 1979.
Hanks, David A. The Decorative Designs of Frank Lloyd Wright. New York: E. P. Dutton, 1979.

HANKS 1985.
Hanks, David A., with Jennifer Toher. "Tradition and Reform." In High Styles: Twentieth-Century American Design, 3–45. Exh. cat. New York: Whitney Museum of American Art, 1985.

HAWES 1968.
Hawes, Lloyd E. The Dedham Pottery. Exh. cat. Dedham, Massachusetts: Dedham Historical Society, 1968.

HIESINGER 1988.
Hiesinger, Kathryn Bloom, ed. Art Nouveau in Munich: Masters of Jugendstil. Exh. cat. Philadelphia: Philadelphia Museum of Art, 1988.

HOUSE BEAUTIFUL 1899a.
"Illumination in the Home." The House Beautiful 5, no. 4 (March 1899): 174–79.

HOUSE BEAUTIFUL 1899b.
"Newcomb Pottery." The House Beautiful 5, no. 4 (March 1899): 156–58.

HOUSE BEAUTIFUL 1903.
"House Beautiful Advertisements." The House Beautiful 13, no. 6 (May 1903): xxiv.

HOWARTH 1977.
Howarth, Thomas. Charles Rennie Mackintosh and the Modern Movement, 2d ed. London: Routledge and Kegan Paul, 1977.

INTERNATIONAL STUDIO 1904.
"Notes on the Crafts." The International Studio 23, no. 91 (September 1904): 359–67.

IRELAN n.d.
Irelan, Linna. "Possibilities of Pottery in California." Enterprise, n.d., 2–3.

IRELAN 1890.
Irelan, Linna. "Pottery." In Ninth Annual Report of the State Mineralogist, by William Irelan, Jr., 240–61. Sacramento: California State Mining Bureau, 1890.

JAMES 1987.
James, Michael. "The Philosophy of Charles Rohlfs: An Introduction." Arts and Crafts Quarterly 1, no. 3 (April 1987): 1, 14–18.

JONES 1972.
Jones, Harvey L. Mathews: Masterpieces of the California Decorative Style. Exh. cat. Oakland: Oakland Museum, 1972.

JORDY 1986.
Jordy, William H. "The Tall Buildings." In Louis Sullivan: The Function of Ornament, edited by Wim de Wit, 65–157. Exh. cat. Chicago: Chicago Historical Society, 1986.

KALEC 1988.
Kalec, Don. "Frank Lloyd Wright: An American Architect." In Nuttgens 1988, 75–89.

KAPLAN 1987.
Kaplan, Wendy. "The Art that is Life": The Arts and Crafts Movement in America, 1875–1920. Exh. cat. Boston: Museum of Fine Arts, 1987.

KAUFMANN 1985.
Kaufmann, Edgar, Jr. Frank Lloyd Wright at the Metropolitan Museum of Art. New York: Metropolitan Museum of Art, 1985.

KAUFMANN and RAEBURN 1960.
Kaufmann, Edgar, and Ben Raeburn. Frank Lloyd Wright: Writings and Buildings. 1960. Reprint. New York: New American Library, 1974.

KEEN 1978.
Keen, Kirsten Hoving. American Art Pottery 1875–1930. Exh. cat. Wilmington: Delaware Art Museum, 1978.

KERAMIC STUDIO 1902.
"Roblin Ware of Mrs. Linna Irelan." Keramic Studio 3, no. 9 (January 1902): 190–91.

KERAMIC STUDIO 1904.
Robineau, Adelaide Alsop. "Trillium." Keramic Studio 6, no. 5 (September 1904): 104–9.

KERAMIC STUDIO 1905.
"Louisiana Purchase Exposition Ceramics: Grueby Faience." Keramic Studio 6, no. 10 (February 1905): 216–17.

KERAMIC STUDIO 1910a.
Overbeck, Hannah B. "Stein, Christmas Rose." Keramic Studio 11, no. 9 (January 1910): 202–3.

KERAMIC STUDIO 1910b.
Overbeck, Hannah B. "Wild Rose." Keramic Studio 11, no. 9 (January 1910): 203.

KOCH 1967.
Koch, Robert. "Elbert Hubbard's Roycrofters as Artist-Craftsmen." Winterthur Portfolio 3 (1967): 67–82.

KOCH 1971.
Koch, Robert. Louis C. Tiffany's Glass, Bronzes, Lamps. 1971. Reprint. New York: Crown Publishers, 1989.

LAMBOURNE 1980.
Lambourne, Lionel. Utopian Craftsmen: The Arts and Crafts Movement from the Cotswolds to Chicago. Salt Lake City: Peregrine Smith, 1980.

LAMOUREUX 1989.
Lamoureux, Dorothy. The Arts and Crafts Studio of Dirk van Erp. Exh. cat. San Francisco: San Francisco Craft and Folk Art Museum, 1989.

L. and J. G. STICKLEY n.d.
L. and J. G. Stickley. The Work of L. and J. G. Stickley. Sales cat. N.d. Reprint. In Stickley Craftsman Furniture Catalogs, introduction by David M. Cathers. New York: Dover Publications, 1979.

LARNER and LARNER 1979.
Larner, Gerald, and Celia Larner. The Glasgow Style. New York: Taplinger Publishing Company, 1979.

LEARS 1981.
Lears, T. J. Jackson. No Place of Grace: Antimodernism and the Transformation of American Culture 1880–1920. New York: Pantheon Books, 1981.

LEVY 1986.
Levy, Mervyn. Liberty Style: The Classic Years, 1898–1910. New York: Rizzoli, 1986.

LIMBERT n.d. a.
Charles P. Limbert Company. *Limbert's Holland Dutch Arts and Crafts Furniture*, no. 100. Sales cat. N.d. Reprint. In *The Arts and Crafts Furniture of Charles P. Limbert*, introduction by Robert L. Edwards. Watkins Glen, New York: American Life Foundation, 1982.

LIMBERT n.d. b.
Charles P. Limbert Company. *Limbert's Holland Dutch Arts and Crafts Furniture*, no. 112. Sales cat. N.d. Reprint. New York: Turn of the Century Editions, 1981.

LIMBERT n.d. c.
Charles P. Limbert Company. *Limbert's Holland Dutch Arts and Crafts Furniture*, no. 119. Sales cat. N.d. Reprint (published with Limbert n.d. b.).

LOS ANGELES 1913.
Los Angeles City Directory. Los Angeles: Los Angeles City Directory Company, 1913.

MACMILLAN 1988.
MacMillan, Andrew. "Mackintosh in Context." In Nuttgens 1988, 25–31.

MADSEN 1967.
Madsen, S. Tschudi. *Art Nouveau*. Translated by R. I. Christopherson. 1967. Reprint. New York: McGraw-Hill, 1976.

MAKINSON 1977.
Makinson, Randell L. *Greene and Greene: Architecture as a Fine Art*. Salt Lake City: Peregrine Smith, 1977.

MAKINSON 1979.
Makinson, Randell L. *Greene and Greene: Furniture and Related Designs*. Salt Lake City: Peregrine Smith, 1979.

MARBLEHEAD 1919.
Marblehead Pottery: An American Industrial Art of Distinction. Sales brochure. Marblehead, Massachusetts: Marblehead Potteries, 1919.

MAREK 1987.
Marek, Don. *Arts and Crafts Furniture Design: The Grand Rapids Contribution 1895–1915*. Exh. cat. Grand Rapids: Grand Rapids Art Museum, 1987.

MARKHAM n.d.
The Markham Pottery. Sales brochure. Ann Arbor, Michigan: Markham Pottery, n.d.

McDOUGALL 1903.
McDougall, Isabel. "Some Recent Arts and Crafts Work." *The House Beautiful* 14, no. 2 (July 1903): 69–75.

MOFFITT 1900.
Moffitt, Charlotte. "The Rohlfs Furniture." *The House Beautiful* 7, no. 2 (January 1900): 81–85.

MONKHOUSE and MICHIE 1986.
Monkhouse, Christopher P., and Thomas S. Michie. *American Furniture in Pendleton House*. Exh. cat. Providence: Museum of Art, Rhode Island School of Design, 1986.

MORSE 1986.
Morse, Edgar W., ed. *Silver in the Golden State: Images and Essays Celebrating the History and Art of Silver in California*. Oakland: Oakland Museum History Department, 1986.

MUSEUM OF HISTORY 1916.
First Annual Arts and Crafts Salon. Exh. brochure. Los Angeles: Museum of History, Science, and Art, 1916.

NELSON 1986.
Nelson, Scott H., et al. *A Collector's Guide to Van Briggle Pottery*. Indiana, Pennsylvania: A. G. Halldin Publishing Company, 1986.

NUTTGENS 1988.
Nuttgens, Patrick, ed. *Mackintosh and His Contemporaries in Europe and America*. London: John Murray, 1988.

PAGE 1980.
Page, Marian. *Furniture Designed by Architects*. New York: Whitney Library of Design, 1980.

PARRY 1983.
Parry, Linda. *William Morris Textiles*. New York: Viking Press, 1983.

PEARCE 1910.
Pearce, Miriam B. "A Practical Application of the Japanese Stencil." *Handicraft* 3, no. 8 (November 1910): 270–77.

POESCH 1984.
Poesch, Jessie. *Newcomb Pottery: An Enterprise for Southern Women, 1895–1940*. Exh. cat. Exton, Pennsylvania: Schiffer Publishing, 1984.

POSTLE 1978.
Postle, Kathleen R. *The Chronicle of the Overbeck Pottery*. Indianapolis: Indiana Historical Society, 1978.

POTTER 1916.
"The Potter Advertising Department." *The Potter* 1, no. 1 (December 1916): IV.

REDLANDS n.d.
"Shapes of Clay" from the Redlands Pottery. Sales brochure. Redlands, California: Redlands Pottery, n.d.

RHEAD 1909a.
Rhead, Frederick H. "Pottery Class." *Keramic Studio* 11, no. 6 (October 1909): 137–38.

RHEAD 1909b.
Rhead, Frederick H. "Pottery Class." *Keramic Studio* 11, no. 8 (December 1909): 180–81.

RHEAD 1911.
Rhead, Frederick H. Letter to Taxile Doat, 8 December 1911. Frederick H. Rhead Papers, University City Public Library, University City, Missouri.

RHEAD 1917a.
Rhead, Frederick H. "Developing a New Process in a Commercial Art Pottery: An Experiment with Unskilled Help." *The Potter* 1, no. 2 (January 1917): 55–58.

RHEAD 1917b.
Rhead, Frederick H. "Planning and Operating a Studio Pottery," pt. 2. *The Potter* 1, no. 2 (January 1917): 59–62.

RHEAD 1917c.
Rhead, Frederick H. "Planning and Operating a Studio Pottery," pt. 3. *The Potter* 1, no. 3 (February 1917): 95–97.

ROBERTSON 1987.
Robertson, Cheryl. "House and Home in the Arts and Crafts Era: Reforms for Simpler Living." In Kaplan 1987, 336–57.

ROHLFS 1907.
Charles Rohlfs. Sales cat. Buffalo: Charles Rohlfs, 1907.

ROYCROFTERS n.d.
The Roycrofters. *A Catalog of the Roycrofters Featuring Metalwork and Lighting Fixtures*. Sales cat. N.d. Reprint (edited by Stephen Gray, introduction by Raymond Groll). New York: Turn of the Century Editions, 1989.

ROYCROFTERS 1912.
The Roycrofters. Sales cat. 1912. Reprint. In *Roycroft Handmade Furniture*. East Aurora, New York: House of Hubbard, 1973.

ROYCROFTERS 1919.
The Roycrofters. *The Book of the Roycrofters: Being a Catalog of Copper, Leather, and Books*. Sales cat. 1919. Reprint. East Aurora, New York: House of Hubbard, 1977.

ROYCROFTERS 1926.
The Roycrofters. *The Book of the Roycrofters: Being a Catalog of Hand-Wrought Copper*. Sales cat. 1926. Reprint (published with Roycrofters 1919).

RUSKIN 1851.
Ruskin, John. *The Stones of Venice*. 3 vols. Boston: Dana Estes and Company, 1851.

SANDERS 1978.
Sanders, Barry, ed. *The Craftsman: An Anthology*. Salt Lake City: Peregrine Smith, 1978.

SCHWEIGER 1984.
Schweiger, Werner J. *Wiener Werkstätte: Design in Vienna 1903–1932.* New York: Abbeville, 1984.

SEARES 1931.
Seares, M. Urmy. "The Art of Metal Crafts." *California Arts and Architecture* 40, no. 6 (December 1931): 11, 13.

SHOP OF THE CRAFTERS 1906.
Shop of the Crafters. *The Shop of the Crafters at Cincinnati.* Sales cat. 1906. Reprint. In *Arts and Crafts Furniture: Shop of the Crafters at Cincinnati*, edited by Stephen Gray, introduction by Kenneth R. Trapp. New York: Turn of the Century Editions, 1983.

SILL and SILL 1922.
Sill, Rush T., and Harley A. Sill. "Clay Industry in Riverside County." In *History of San Bernardino and Riverside Counties*, vol. 1, edited by John Brown, Jr., and James Boyd, 461–63. Chicago: Western Historical Association, 1922.

SIMPSON 1979.
Simpson, Duncan. *C. F. A. Voysey: An Architect of Individuality.* London: Lund Humphries, 1979.

SKINNER 1988a.
Arts and Crafts. Auc. cat. Bolton, Massachusetts: Skinner, Inc., 23 April 1988.

SKINNER 1988b.
Arts and Crafts. Auc. cat. Bolton, Massachusetts: Skinner, Inc., 23 October 1988.

SKINNER 1989a.
Arts and Crafts. Auc. cat. Bolton, Massachusetts: Skinner, Inc., 22 April 1989.

SKINNER 1989b.
Arts and Crafts. Auc. cat. Bolton, Massachusetts: Skinner, Inc., 21 October 1989.

SMITH 1983.
Smith, Mary Ann. *Gustav Stickley: The Craftsman.* Syracuse: Syracuse University Press, 1983.

STANSKY 1984.
Stansky, Peter. *William Morris, C. R. Ashbee, and the Arts and Crafts.* London: Nine Elms Press, 1984.

STANSKY 1985.
Stansky, Peter. *Redesigning the World: William Morris, the 1880s, and the Arts and Crafts.* Princeton: Princeton University Press, 1985.

STICKLEY n.d.
Stickley, Gustav. *Craftsman Fabrics and Needlework.* Sales cat. N.d. Reprint. Madison, Wisconsin: Razmataz Press, 1989.

STICKLEY 1901.
Stickley, Gustav. "Foreword." *The Craftsman* 1, no. 1 (October 1901): i–ii.

STICKLEY 1903.
Stickley, Gustav. "The Structural Style in Cabinet-Making." *The House Beautiful* 15, no. 1 (December 1903): 19–23.

STICKLEY 1904.
Stickley, Gustav. *What Is Wrought in the Craftsman Workshops.* 1904. Reprint. Watkins Glen, New York: American Life Books, 1982.

STICKLEY 1905.
Stickley, Gustav. *The Craftsman's Story.* Sales cat. [Eastwood, New York: Craftsman Workshops], 1905.

STICKLEY 1910.
Stickley, Gustav. *Craftsman Furniture Made by Gustav Stickley.* Sales. cat. 1910. Reprint (published with L. and J. G. Stickley n.d.).

STICKLEY BROTHERS n.d.
Stickley Brothers Company. *Quaint Furniture in Arts and Crafts.* Sales cat. N.d. Reprint. New York: Turn of the Century Editions, 1981.

STRADLING 1983.
Stradling, Diana. "Teco Pottery and the Green Phenomenon." *Tiller* 1, no. 4 (March/April 1983): 9–36.

TAYLOR 1910.
Taylor, William Watts. "The Rookwood Pottery." *Forensic Quarterly* 1, no. 4 (September 1910): 203–18.

TECO 1906.
Teco Pottery: America. Sales cat. Chicago: Gates Potteries, 1906.

THOMPSON 1977.
Thompson, E. P. *William Morris: Romantic to Revolutionary.* New York: Pantheon Books, 1977.

TILBROOK and HOUSE 1976.
Tilbrook, A. J., and Gordon House, eds. *The Designs of Archibald Knox for Liberty and Company.* London: Ornament Press, 1976.

TODD 1921.
Todd, Frank Morton. *The Story of the Exposition*, vol. 4. New York: G. P. Putnam's Sons, 1921.

TRAPP 1980.
Trapp, Kenneth R. *Ode to Nature: Flowers and Landscapes of the Rookwood Pottery 1880–1940.* Exh. cat. New York: Jordan-Volpe Gallery, 1980.

TRAPP 1981.
Trapp, Kenneth R. "Rookwood and the Japanese Mania in Cincinnati." *The Cincinnati Historical Society Bulletin* 39, no. 1 (Spring 1981): 51–75.

TRAPP 1986.
Trapp, Kenneth R. "The Shop of the Crafters at Cincinnati, 1904–1920." *Tiller* 2, no. 5 ([January/February 1986]): 8–25.

TRIBUNE 1914.
Cambridge City Tribune, 4 June 1914, 3.

VILAIN 1986.
Vilain, Jean-François. "The Last Ride." *Arts and Crafts Quarterly* 1, no. 1 (October 1986): 1, 7–8.

VOLPE and CATHERS 1988.
Volpe, Tod M., and Beth Cathers, comps. *Treasures of the American Arts and Crafts Movement 1890–1920.* Text by Alastair Duncan. New York: Abrams, 1988.

VOORSANGER 1986.
Voorsanger, Catherine Hoover. "Dictionary of Architects, Artisans, Artists, and Manufacturers." In Burke 1986, 401–87.

WASHINGTON UNIVERSITY 1880.
A Catalogue of the Officers and Students in the Several Departments of Washington University. St. Louis: Washington University, 1880.

WEISBERG 1988.
Weisberg, Gabriel P. *Stile Floreale: The Cult of Nature in Italian Design.* Miami: Wolfsonian Foundation, 1988.

WEISS 1981.
Weiss, Peg, ed. *Adelaide Alsop Robineau: Glory in Porcelain.* Syracuse: Syracuse University Press in association with Everson Museum of Art, 1981.

WILLIAMS 1985.
Williams, Susan. *Savory Suppers and Fashionable Feasts: Dining in Victorian America.* New York: Pantheon Books in association with the Strong Museum, 1985.

WILSON 1987.
Wilson, Richard Guy. "American Arts and Crafts Architecture: Radical though Dedicated to the Cause Conservative." In Kaplan 1987, 101–31.

WOOD CRAFT 1905.
"Roycroft Ideals and Cabinetmaking." *Wood Craft* 4, no. 1 (October 1905): 10–16.

WOOD CRAFT 1906.
"The Craftsman Shops." *Wood Craft* 5, no. 3 (June 1906): 69–72.

WRIGHT 1911.
Frank Lloyd Wright: Ausgeführte Bauten. 1911. Reprint. In *The Early Work of Frank Lloyd Wright.* New York: Dover Publications, 1982.

ZUSY 1987.
Zusy, Catherine. "Gustav Stickley and the Craftsman Workshops." In Kaplan 1987, 243–44.

SUGGESTED READINGS

Note: In addition to the sources listed below, readers may wish to consult period journals such as *The Craftsman*, *Handicraft*, *The House Beautiful*, *The International Studio*, *Keramic Studio*, *The Potter*, and *Wood Craft*. A recent journal, *Tiller*, is also of interest.

American Art Pottery. New York: Cooper-Hewitt Museum, 1987.

Arts and Crafts in Detroit 1906–1976: The Movement, the Society, the School. Exh. cat. Detroit: Detroit Institute of Arts, 1976.

Ayres, William, ed. *A Poor Sort of Heaven, a Good Sort of Earth: The Rose Valley Arts and Crafts Experiment*. Exh. cat. Chadds Ford, Pennsylvania: Brandywine River Museum, 1983.

Batchelder, Ernest A. *Design in Theory and Practice*. New York: Macmillan Company, 1910.

———. *The Principles of Design*. 3d ed. Chicago: Inland Printer Company, 1908.

Blasberg, Robert W. *George E. Ohr and His Biloxi Art Pottery*. Port Jervis, New York: J. W. Carpenter, 1973.

———. *The Unknown Ohr: A Sequel to the 1973 Monograph*. Milford, Pennsylvania: Peaceable Press, 1986.

Brooks, H. Allen. *Frank Lloyd Wright and the Prairie School*. New York: George Braziller, Inc., in association with the Cooper-Hewitt Museum, 1984.

The Byrdcliffe Arts and Crafts Colony: Life by Design. Exh. cat. Wilmington, Delaware: Delaware Art Museum, 1984.

Cathers, David. *Genius in the Shadows: The Furniture Designs of Harvey Ellis*. Exh. cat. New York: Jordan-Volpe Gallery, 1981.

Charles Rennie Mackintosh. Salt Lake City: Peregrine Smith, 1988.

Clark, Garth. *American Ceramics: 1876 to the Present*. Rev. ed. New York: Abbeville, 1987.

———. *The Biloxi Art Pottery of George Ohr*. Exh. cat. Jackson, Mississippi: Mississippi State Historical Museum, 1978.

Conforti, Michael P. "Orientalism on the Upper Mississippi: The Work of John S. Bradstreet." *The Minneapolis Institute of Arts Bulletin* 65 (1981–82): 2–35.

Cooper, Jeremy. *Victorian and Edwardian Furniture and Interiors: From the Gothic Revival to Art Nouveau*. London: Thames and Hudson, 1987.

Crane, Walter. *The Claims of Decorative Art*. Boston: Houghton, Mifflin, and Company, 1892.

Crawford, Alan, ed. *By Hammer and Hand: The Arts and Crafts Movement in Birmingham*. Birmingham, England: Birmingham Museums and Art Gallery, 1984.

Current, William R., and Karen Current. *Greene and Greene: Architects in the Residential Style*. Exh. cat. Fort Worth, Texas: Amon Carter Museum of Western Art, 1974.

Dirlam, H. Kenneth, and Ernest E. Simmons. *Sinners, This Is East Aurora: The Story of Elbert Hubbard and the Roycroft Shops*. New York: Vantage Press, 1964.

Duncan, Alastair. *Fin de Siècle Masterpieces from the Silverman Collection*. New York: Abbeville, 1989.

Dunn, Roger T. *On the Threshold of Modern Design: The Arts and Crafts Movement in America*. Exh. cat. Framingham, Massachusetts: Danforth Museum of Art, 1984.

Feldstein, William, Jr., and Alastair Duncan. *The Lamps of Tiffany Studios*. New York/London: Abrams/ Thames and Hudson, 1983.

Frank Lloyd Wright: A Modern Aesthetic. Exh. cat. Chicago: Struve Gallery, 1986.

Frank Lloyd Wright and Viollet-le-Duc: Organic Architecture and Design from 1850 to 1950. Exh. cat. Chicago: Kelmscott Gallery, 1986.

Frank Lloyd Wright: Architectural Drawings and Decorative Art. Exh. cat. London: Fischer Fine Art Limited, 1985.

Gardner, Paul V. *The Glass of Frederick Carder*. New York: Crown Publishers, 1971.

Graham, F. Lanier. *Hector Guimard*. Exh. cat. New York: Museum of Modern Art, 1970.

Greene and Greene Interiors '83: The Duncan-Irwin House. Exh. cat. Pasadena: Friends of the Gamble House/University of Southern California, 1983.

Greene and Greene: The Architecture and Related Designs of Charles Sumner Greene and Henry Mather Greene, 1894–1934. Exh. cat. Los Angeles: Municipal Art Gallery, 1977.

Hamilton, Charles F., Kitty Turgeon, and Robert Rust. *History and Renaissance of the Roycroft Movement*. Buffalo: Buffalo and Erie County Historical Society, 1984.

Henzke, Lucile. *American Art Pottery*. Camden, New Jersey: Thomas Nelson Inc., 1970.

Herr, Jeffrey. *California Art Pottery: 1895–1920*. Exh. cat. Northridge: California State University, 1988.

Hoffmann, Donald. *Frank Lloyd Wright's Robie House: The Illustrated Story of an Architectural Masterpiece*. New York: Dover Publications, 1984.

Hunter, Dard. *My Life with Paper: An Autobiography.* New York: Alfred A. Knopf, 1958.

Hunter, Dard, II. *The Life Work of Dard Hunter: A Progressive Illustrated Assemblage of His Works as Artist, Craftsman, Author, Papermaker, and Printer,* vol. 1. Chillicothe, Ohio: Mountain House Press, 1981.

Kaplan, Wendy, ed. *The Encyclopedia of Arts and Crafts: The International Arts Movement, 1850–1920.* New York: E. P. Dutton, 1989.

Koch, Robert. *Louis C. Tiffany, Rebel in Glass.* New York: Crown Publishers, 1964.

Ludwig, Coy L. *The Arts and Crafts Movement in New York State 1890s–1920s.* Exh. cat. Hamilton, New York: Gallery Association of New York State, 1983.

Macleod, Robert. *Charles Rennie Mackintosh.* Feltham, Middlesex, England: Hamlyn Publishing Group, 1968.

Maybeck, Jacomena. *Maybeck: The Family View.* Berkeley: Berkeley Architectural Heritage Association, 1980.

Mr. S. G. Burt's Record Book of Ware at Art Museum: 2,292 Pieces of Early Rookwood Pottery in the Cincinnati Art Museum in 1916. Cincinnati: Cincinnati Historical Society, 1978.

Naylor, Gillian. *The Arts and Crafts Movement: A Study of Its Sources, Ideals, and Influence on Design Theory.* Cambridge, Massachusetts: MIT Press, 1980.

Peck, Herbert. *The Book of Rookwood Pottery.* New York: Crown Publishers, 1968.

Pfeiffer, Bruce Brooks, and Gerald Nordland, eds. *Frank Lloyd Wright in the Realm of Ideas.* Exh. cat. Carbondale: Southern Illinois University Press, 1988.

Porcelains from the Robineau Pottery. Sales cat. New York: Tiffany and Company, 1906.

A Rediscovery — Harvey Ellis: Artist, Architect. Exh. cat. Rochester, New York: Memorial Art Gallery, University of Rochester, and Margaret Woodbury Strong Museum, 1972.

Reed, Cleota. *Henry Chapman Mercer and the Moravian Pottery and Tile Works.* Philadelphia: University of Pennsylvania Press, 1987.

The Roycrofters. *Roycroft Furniture.* Sales cat. 1906. Reprint. New York: Turn of the Century Editions, 1981.

Scully, Vincent, Jr. *Frank Lloyd Wright.* New York: George Braziller, Inc., 1960.

Sedding, John. *Art and Handicraft.* New York: Garland Publishing, 1977.

Stickley, Gustav. *Craftsman Homes: Architecture and Furnishings of the American Arts and Crafts Movement.* 1909. Reprint. New York: Dover Publications, 1979.

————. *More Craftsman Homes.* 1912. Reprint. New York: Dover Publications, 1982.

Storrer, William Allin. *The Architecture of Frank Lloyd Wright: A Complete Catalog.* 2d ed. Cambridge, Massachusetts: MIT Press, 1978.

Stott, Mary Roelofs. *Elbert Hubbard: Rebel with Reverence, a Granddaughter's Tribute.* 2d ed. Watkins Glen, New York: American Life Foundation, 1984.

Trapp, Kenneth R. *Toward the Modern Style: Rookwood Pottery, the Later Years, 1915–1950.* Exh. cat. New York: Jordan-Volpe Gallery, 1983.

Triggs, Oscar Lovell. *Chapters in the History of the Arts and Crafts Movement.* Chicago: Bohemia Guild of the Industrial Art League, 1902.

Twombly, Robert. *Louis Sullivan: His Life and Work.* New York: Viking, 1985.

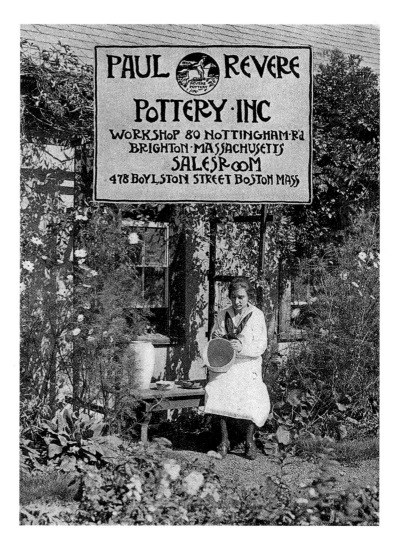

Weitze, Karen J. *California's Mission Revival.* California Architecture and Architects, edited by David Gebhard, no. 3. Los Angeles: Hennessey and Ingalls, 1984.

Wright, Frank Lloyd. *An Autobiography.* New York: Duell, Sloan and Pearce, 1943.

INDEX